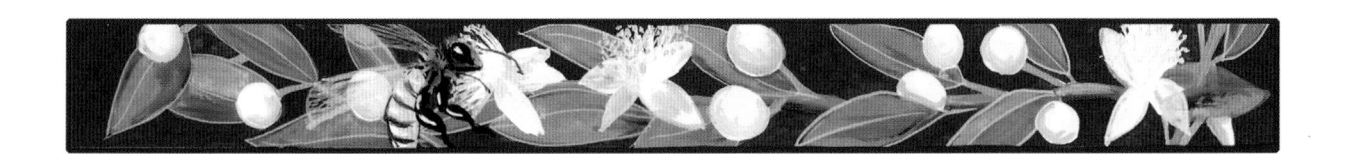

KABBALAT SHABBAT
THE GRAND UNIFICATION

ILLUMINATIONS AND COMMENTARY BY
DEBRA BAND

TRANSLATIONS AND LITERARY COMMENTARY BY
RAYMOND P. SCHEINDLIN

PREFACE BY ARTHUR GREEN

FOREWORD BY RABBI LORD JONATHAN SACKS

WITH PROSE AND MAARIV TRANSLATIONS
FROM THE KOREN SACKS SIDDUR

2016 5776

Honeybee in the Garden, LLC
dband@honeybeeinthegarden.com
www.honeybeeinthegarden.com

Unless otherwise specified, Bible translations are from *JPS Hebrew-English TANAKH: The Traditional Hebrew Text and the New JPS Translation*, 2nd edition (Philadelphia: Jewish Publication Society, 1990); used with permission of the Jewish Publication Society.

"A Song of You," from Peter Cole, trans. and annotator, and Aminadav Dykman, *The Poetry of Kabbalah* (New Haven, Conn.: Yale University Press, 2012); used with permission of Yale University Press.

Excerpts from "Kingdom's Crown," from Peter Cole, trans. and ed., *Selected Poems of Solomon Ibn Gabirol* (Princeton, N.J.: Princeton University Press, 2001); used with permission of Princeton University Press.

"Offerings of Love" and "Perfect Unity," from Aliza Lavie, ed., *A Jewish Woman's Prayer Book* (New York: Spiegel & Grau, 2008); used with permission of Aliza Lavie.

"As Sabbath Enters: After Candlelighting," from *Hours of Devotion: Fanny Neuda's Book of Prayers for Jewish Women,* by Dinah Berland, copyright © 2007 by Dinah Berland. Used by permission of Schocken Books, an imprint of the Knopf Doubleday Publishing Group, a division of Penguin Random House LLC. All rights reserved.

Al haNissim for Israel's Independence Day (Birkat HaMazon), adapted from *Siddur Sim Shalom*, 1985, p. 761; used with permission of the Rabbinical Assembly and Joshua Cahan.

English translations of Maariv service, "With What May We Light," and *Birkat Hamazon*, by Rabbi Lord Jonathan Sacks copyright © Jonathan Sacks 2009, reproduced with permission of Koren Publishers, Jerusalem.

English type set in Williams Caslon and Trajan Pro. Hebrew type set in DavkaWriter Gefen.

Composition and design by Ken Falk and Debra Band

Printed and bound in China through Four Colour Print Group, Louisville, Kentucky

12 13 14 16 17 10 9 8 7 6 4 3 2 1

ISBN—10: 0985799641
ISBN—13: 978-0-9857996-4-9

Library of Congress Control Number: 2015918749

The publication of this book
was made possible by a generous gift from
Sharon and Steven Lieberman

in honor of their children
Rachel Shoshana, Jessica Michal & Benjamin Shai;
and their parents
Phyllis Silverman & Ruben Silverman *z"l*
Caryl Lieberman & Herbert Lieberman *z"l*

For Michael

TABLE OF CONTENTS

FOREWORD

ew things in Judaism—music, poetry, and mysticism—have evoked more beauty than Kabbalat Shabbat, the ceremony of welcoming the Sabbath as if it were a bride, inaugurating, for a day each week, a spiritual marriage between us and the divine presence. Debra Band has now added visual beauty to this enchanting encounter, and what a wonderful job she has done! This is a work of *hadrat kodesh*, "the beauty of holiness," evoking the magic of this special twilight time in which angels are our guests, divine light flows down as a river of light, the home resonates with the music of heaven, and the family is robed in the charisma of love—a lovely, enchanting, life-enhancing work of spirituality at its best.

—Rabbi Lord Jonathan Sacks

ACKNOWLEDGMENTS

After blessing the Shabbat candles, I recite my own private prayer, thanking God for the family and friends with whom I am blessed, and praying for the wisdom with which to guide my family and instill my work, and so hopefully help heal our challenging world. Many of these same blessings have graced the creation of this work. Chief among these blessings is my husband, Michael Diamond, whom I met and joined under the *ḥuppa* during the course of this project, and whose wise and loving soul has inspired every painting created and word written since our first encounter. This work has grown from the pleasures of sharing the Shabbat table with my family: in the present with Michael and my children, Zvi and Alexandra Band and Gabriel Band; in days past with my beloved late husband, David Band, *z"l*, whose passion for astrophysics suffuses these pages; and in the future, anticipating joyful Shabbat meals with children and grandchildren.

After years of friendship, it has been an honor and adventure to work with Raymond Scheindlin on this project. His passion for the medieval Hebrew poets and his liturgical scholarship have inspired all my previous books, and have resulted in the mellifluous new translations and literary analyses that you will find here. These contributions have opened new windows onto a liturgy that I have known since childhood. Arthur Green has generously advised my reading in the mystical sources since this project's inception, and I am honored to be able to offer you his essay on the history of Kabbalat Shabbat. Rabbi Lord Jonathan Sacks has inspired me through his writings and community leadership for many years; his gracious words at the front of this volume and his consent to include his translations of Shabbat Maariv and other prayers have added greatly to this book.

Judry Subar has been a valued and generous partner in studying obscure but important kabbalistic texts with me throughout the course of this project, to which Michael has added his own knowledge of the mystical lore. A small study group reading Hasidic texts led by my rabbi, Nissan Antine, has offered continuing inspiration in exploring the impact of Jewish mysticism on Jewish life. Howard Smith's innovative work reconciling kabbalah and modern cosmology provided intellectual reinforcement for my first thoughts about the concordance of these two fields of thought. Janice Meyerson has again lovingly edited this work, as she did my last book. Ken Falk has contributed his patience, skill, and imagination to the graphic design of the lovely book. Ben-Ami Gradwohl first suggested this project during Zvi and Alex's engagement party—a fertile evening, indeed.

The painstaking work of proofreading the entire body of Hebrew calligraphy in this work was accomplished joyfully by Dov Pluznik, *z"l*. Dov passed away shortly before this volume went to print. A distinguished microbiologist born in Vienna and raised in his beloved Israel, he fused his devotion to European high culture with consummate passion for vibrant Jewish life and learning. He inspired all those around him. His memory will remain a blessing.

Publication of this work, as with my previous book, would have been impossible without the gracious interest and support of Steven and Sharon Lieberman. Other generous contributors are listed on a special page at the end of this volume.

Many others have contributed to this work in specific ways: Rabbi Avis Miller, Laura Kruger, Jon and Ruth Tepper, Michael Monheit, Chuck Wheeler, Arnie Hiller, Valerie Scharfman, Barbara and David Karp, Lisa Kogen, Sharon Weiss-Greenberg, Rachel Lieberman, Rabbi Beth Lieberman, Joanne Wolf, my new daughter Rachel Diamond, and Matthew Miller of Koren Publications. Rene Nedelkoff, Cindy Jones, and Jared Stevens of Four Colour Printing have nursed the production of this beautiful volume.

Welcoming the Shabbat bride into the home is, of course, an intensely family-oriented experience. My ultimate model for Jewish life altogether stems from my grandparents Rabbi Harris and Mrs. Bessie Swift, *z"l*, whose spirits I have sensed over my shoulder throughout all my book projects. My late father, Daniel C. B. Levy, *z"l*, recited the first Friday night kiddush that I remember. I continue to owe my father-in-law, Arnold Band, profound gratitude for many years of mentoring. I must express a lifetime of gratitude to my stepfather, Arthur Roskies, and to my mother, Josephine Swift Roskies, who has handed down to me our family traditions and, even before she gave me my first paintbrushes, taught me to light the Shabbat candles.

Debra Band

he Kabbalat Shabbat service is a relatively newfangled notion in Jewish liturgy. It was added to prayer books first published in Venice in the late sixteenth century, following the new practice created by the kabbalists of Safed. Their prestige largely allowed this innovation to be widely accepted by Jewish communities throughout the world, although it has no official halakhic standing.

Let us turn first to the phrase "Kabbalat Shabbat." Early sources used two terms to designate the beginning of Shabbat: *kenisat hashabbat* and *kabbalat shabbat*, from the verb roots *kbl* and *kns*, respectively. *Kenisa* ("bringing in") goes back to a famous Talmudic passage in which R. Yose says: "May my lot be with those who bring in the Sabbath in Tiberias," referring to those who "bring it in" at the earliest hour. The ambiguous intent of this phrase (exactly into what are they bringing Shabbat? Into the world? Into their homes? Into their hearts?) may have a role in the later development of Shabbat's rich and varied imagery.

The earliest meaning of the phrase "Kabbalat Shabbat" seems to be halakhic, referring to the acceptance of Sabbath obligations and the obligation to cease work. This applies particularly when one follows the rabbinic urging to begin Shabbat before its solar occurrence. In that case, a person who has recited Shabbat prayers, either the *'arvit* service or the kiddush, has performed an act of Kabbalat Shabbat and is obligated to observe it. Here, "accept" seems to be the proper translation for the kabbalah of Kabbalat Shabbat. Of the many examples of this usage, one from the fourteenth-century rabbi David Abudarham is particularly striking: "If the day is cloudy and one believes that the sun has set before it really has and he (for that mistaken reason) *kibbel 'alav Shabbat*, 'accepted the Sabbath upon himself,' he may light fire and add oil to the lamps, since the acceptance was mistaken."

Here we see the phrase "Kabbalat Shabbat" in a clearly halakhic/instrumental usage that is entirely non-mythical in character. Another dimension of Kabbalat Shabbat has equally ancient roots. The Talmud describes Rabbi Ḥanina as saying: "Let us go forth to greet the Shabbat queen!" and tells of Rabbi Yannai, who would enwrap himself and proclaim: "Come, O bride, come, O bride." While neither description uses the verb *KaBBeL*, both offer a sense of greeting—going forth to greet Shabbat as one would an honored guest. With time, Kabbalat Shabbat came to have this meaning as well, derived from the *hif'il* use of the stem *lehakbil* ("to greet"). Also associated with this motif of greeting is an aggadah whose source is lost but that is quoted by the Tosafists, in which God calls for the singing of Psalm 92 as a song to Shabbat under the rubric of greeting a guest: "a new face has arrived; let us recite a verse." In this case, *hakhnasat shabbat* is parallel to *hakhnasat ore'aḥ*, greeting and welcoming a newly arrived guest.

The term *latset*, "to go forth," in the Talmudic source was understood literally by the Safed kabbalists; this "greeting" aspect of Kabbalat Shabbat included an obligation to go outdoors. For all kabbalists, the Talmudic references referring to Shabbat as *kalla* ("bride") and *malka* ("queen") have been fully integrated into the kabbalistic symbol system, where Shabbat is associated with the Shekhinah and Kabbalat Shabbat is greeting the Shekhinah. The male/female aspects of Shabbat—represented by the duality of *zakhor veshamor* ("remember and keep") in the two versions of the Sabbath command, along with a host of other symbols— refer to *yesod* and *malkhut*; but the overwhelmingly female symbolism, especially of the Sabbath eve, makes this the festival of the Shekhinah. All later kabbalistic embellishments are based on that foundation.

But a third sort of kabbalah in Kabbalat Shabbat is of greatest interest. Here "kabbalah" has its most usual meaning: "to receive." What one receives at the moment of Shabbat's beginning is the *neshama yetera*, that "extra soul," or extra degree of soulfulness that a Jew has on the Sabbath. The notion is based on a single Talmudic source, a saying of R. Shimon ben Lakish: "On the Sabbath eve, God gives an extra soul to the person; and as the Sabbath departs, it is taken away. Thus it is written (Gen. 2:3), *shavat vayinafash*—once the rest has departed, Woe! the soul is lost."

This highly graphic description of the coming and going of Shabbat from the human soul is open to a number of interpretations. Rashi has a notably naturalistic view of it. He defines *nefesh yetera* as *roḥav lev*—relaxation, one might say. Living at a slower pace in rest and joy allows one to be more expansive and openhearted and allows one to eat and drink more lavishly than usual, without revulsion. Sources quoted by Elliot Ginsburg locate R. Abraham Ibn Ezra and Maimonides, as would be expected, in this same vein of naturalistic understanding.[i]

The kabbalists, understanding *neshama yetera* supra-literally—not as mere metaphor but as describing an ontological reality—make it into a pillar of Shabbat symbolism. The exact moment when we receive the extra soul is demarcated in several ways. The completion of pre-Sabbath bathing, *ha'aliya min haraḥtsa* (expressed in the poetic language of the Song of Songs), is the first stage in that process—allowing for the possibility of the soul to enter the body, since she, too, has been bathed in the waters of Eden to prepare for her descent into the world, like the bride immersing herself before entering the bridal canopy. In the famous *raza deshabbat* ("secret of the Sabbath") passage, the Zohar seems to say that the new soul has entered before the beginning of Sabbath eve prayers: "All of them [Israel] are crowned with new souls, and then the prayer begins." Elsewhere, the *Hashkiveinu* prayer and *kedushat hayom* in the 'Amidah are seen as moments of receiving the extra soul. In fact, the most complete and beautiful description of that soul's arrival is associated with *Hashkiveinu*:

> Come and see: In the hour when Israel bless and welcome that Tabernacle of Peace, a holy guest, saying, "who spreads the Tabernacle of Peace," a sublime holiness descends and spreads its wings over Israel, sheltering them as a mother does her child. All sorts of evil are removed from the world, and Israel dwell beneath the holiness of their Lord. Then the Tabernacle of Peace bestows new souls to Her children. Why? Because that is where souls dwell and from which they come forth. When She is present, spreading Her wings over Her children, She causes a new soul to enter each one of them.[ii]

The nature of this event of receiving the *neshama yetera* is described in several ways. Here, it is intimate communion between mother and child, in which the Shekhinah, in bird-like fashion, feeds her child as she hovers over the nest. Elsewhere, it is described in the language of a coronation rite—Israel crowned with new souls in the same moment, or as an earthly embodiment of the Shekhinah being crowned under the *ḥuppa* as she is united with her spouse and king.

The idea of greeting Shabbat *beshirot vetishbaḥot*, "with hymns and praises," without further definition, begins to appear in medieval France and Spain. It is mentioned in the *Sefer Hamanhig* of R. Avraham ha-Yarḥi (ca. 1155–1215) and in a number of sources in the late fourteenth and fifteenth centuries. R. Ovadia of Bertinoro, writing from Jerusalem to his father back home in Italy, refers to this as "a custom [of the Jews] throughout the Islamic world." Even earlier, there is evidence that Psalm 92, the song for the Sabbath day, was added before the evening service. *Sefer Hakaneh*, a highly inventive kabbalistic work probably written in early-fifteenth-century Byzantium, reflects a home-based version of what may be considered a prototype of Kabbalat Shabbat: "Afterward, one should wrap oneself in a tallit, calling out to one's companions, one's wife, and one's household: 'Let us go forth and greet the Sabbath queen!' They join together and respond: 'Come, O bride,

come, O bride!' " The most detailed description of the Kabbalat Shabbat ritual is found in R. Ḥayyim Vital's *Sha'ar hakavvanot*:

> Here is a brief order of Kabbalat Shabbat: Go out to the field and say: "Come, let us go forth to greet Shabbat the queen, field of holy apples."... Stand still in a fixed place in the field, better if atop a high hill. The place should be as clean as need be in front of him, as far as he can see, and for a space of four ells behind him. Turn your face to the west, where the sun is setting. Just as it sets, close your eyes, place your left hand on your chest and your right hand over your left. Have the intent, in the fear and awe of one standing before the King, to receive the addition of Sabbath holiness [*neshama yetera*]. Begin by reciting "Ascribe to the Lord, you sons of the mighty" (Psalm 29), all of it with a melody. Then say three times "Come, O bride, come, O bride, Sabbath queen!" Then recite "A Psalm for the Sabbath Day" (Psalm 92) in its entirety, and then "The Lord Reigns" (Psalm 93) up to "for all time." Then open your eyes and go home.[iii]

This is a most interesting account of what is clearly a developing ritual. There does not seem to be a full "Lekha dodi" here (although perhaps its omission is what is meant by "a brief order"), nor are the full six previous psalms mentioned. The ritual positioning of the hands and the closing of eyes have about them the sense of a newly created and intentionally elaborate ritual practice of the kabbalistic community, one meant to deeply impress the participant with the seriousness of the moment.

This volume includes a separate commentary on "Lekha dodi," so I shall not discuss it here. But allow me to add a comment on "Lekha dodi" and its relationship to the *neshama yetera*. I agree with Reuven Kimelman[iv] and others that the main subject of the song is the Shekhinah, her arrival on Shabbat, her joy in uniting with her divine as well as her human spouses, and, especially, the longing for her complete redemption. But the poem was also written to serve as the climax of Kabbalat Shabbat in the sense of receiving, to be recited at the moment when the *neshama yetera* enters the person, immediately before the beginning of the evening service. The final verse, *bo'i veshalom* ("come in peace"), is precisely a celebration of that moment. Of it, *Ḥemdat yamim* says: "Here one should intend to receive the additional *nefesh*." Versions of this understanding of the final verse of "Lekha dodi" persist even in recently printed prayer books. A siddur that I own, published in Jerusalem for the Iraqi community in 1960, says, just before the final *bo'i kalla* ("come, O bride"): *yekhaven lekabbel tosefet neshama yetera* ("one should intend to receive the addition of the extra soul").

If this final verse is indeed the climax of Kabbalat Shabbat, I contend that a purpose of "Lekha dodi," along with its other meanings, is to arouse the worshiper to receive this extra soul. Part of the poem's richness lies in the ambiguity of the phrase *lekha dodi likrat kalla* ("Go forth, my beloved, to greet the bride"). Who is the *dod* ("beloved")? Whose is the bride? Of course, one is addressing God, and the Sabbath is the bride of both God and Israel. But I propose another level of meaning hidden within the song. "Lekha dodi" addresses itself to the *neshama yetera*, hidden within the person. During the week, it is too frightened and shy to emerge. As Shabbat begins, we call it forth, telling it that it is now safe to let itself be revealed. "Lekha dodi" may be read, if you will, as a flirtation or seduction song to the *neshama yetera*, seeking to coax her out of hiding.

—Arthur Green

ollowing the lighting of Sabbath candles shortly before sundown on Friday evenings, Jews welcome the Sabbath bride with Kabbalat Shabbat, the Sabbath eve prayer service and subsequent festive home meal that infuse the beginning of the sacred day with celestial imagery and vivid human experiences of divine and human love and companionship among family and friends at the festive dinner table.

The liturgy, whether chanted in synagogue or at home, brings us into intimate connection with the Creator, whose seventh-day rest we reexperience, immersing us in dramatic imagery of the glories of the flow of divine energy through the universe, of the longing of the masculine and feminine aspects of divinity for each other. Preparing the home offers many families, particularly the homemakers, not only a routine of cooking, cleaning, and table-setting chores but a time to connect subliminally to family memories and traditions stretching back for generations. In these pages, I offer you an illuminated manuscript of the Kabbalat Shabbat liturgy and rituals, a fusion of words and artwork, to interpret and enlighten these beloved customs. Let me introduce you to the wide spectrum of thought and experience that inspires these painted words.

The Shabbat table—in my case, a beloved heirloom that has brought together five generations of us on three continents—becomes a focus not only of weekly habit or divine service alone but also of cherished lifetime memories bonding individuals, families, and communities, tracing the course of weeks, years, and lifetimes. Abraham Joshua Heschel characterizes Judaism as a "religion of time … attached to sacred events," consecrating "sanctuaries that emerge from the magnificent stream of a year," among which "the Sabbaths are our great cathedrals."[1] Our synagogues and our homes have perforce replaced the Temple, yet the twenty-five sacred hours inaugurated by Kabbalat Shabbat afford us a weekly audience with the Eternal. As we sit down to Shabbat dinner with song and blessings, these traditions invite the angels as well as the humans to join us—the loved ones newly added to our lives, the friends with whom we share our families' lives, and, always at the back of our minds, those departed loved ones once at our tables who now live in the memories of those gathered around.

Not only do the Friday night festivities bond us to the divine, our families, and communities. The ideas expressed in the prayers, songs, and rituals and in the ecstatic words and melodies were inspired and compiled by the Jewish mystics of sixteenth-century Safed (Tsfat), who themselves drew upon a continual thread of mystical studies winding back through Castile, Catalonia, Italy, and Provence, to Byzantine-period Israel and beyond. We embrace these traditions while also carrying the portfolio of a different intellectual world from that of the medievals who composed them. Whether or not we are fully aware, in many ways our Shabbat practices also reflect characteristics of our current daily lives—for instance, the deliberate choice to turn off our mobile phones and disconnect from the ever-distracting world around us, now a commonplace for observant Jews but utterly impossible to imagine in the days of the medieval mystics. Our approach to the words, melodies, and acts of Friday evening thus embody essential qualities of evolving Jewish culture. This visual interpretation of Kabbalat Shabbat offers a chance to experience the panoply of Jewish culture that has proceeded us and whose evolution we continue to effect.

Given the two worlds that compete for our attention during Shabbat, the question of how to find and reveal the intersections of the tradition and our contemporary intellectual culture arises. Indeed, this project has brought me to a new stage in the evolution in my own religious thought and in my approach to developing the visual midrash that is the hallmark of my work in Hebrew illuminated manuscripts. Illuminating Kabbalat Shabbat offers an opportunity to interpret the beloved rituals and words through the lens of the essentially

medieval Jewish mysticism that developed these customs—but there is more now. Consciously or not, we approach our traditions through the modern scientific worldview that suffuses the twenty-first-century environment in which we live, work, and raise our families—and as the sun nears the horizon on Friday evening, we welcome Shabbat.

STEREO VISION

The evident juxtaposition of kabbalah and the Grand Unification Theory in the title of this work is not casual. Physics seeks to unite all subatomic physical forces in the Grand Unification Theory; kabbalah describes the unification of all matter in its divine origin. We will look through both these lenses to find our focus on Kabbalat Shabbat.

When I set out on this project, I realized that I needed to immerse myself in the Jewish mystical tradition that led to the Lurianic kabbalistic community that developed so much of the Kabbalat Shabbat liturgy and practice. Despite my family's descent from the celebrated Hasidic master Levi Yitsḥak of Berditchev, the family consciousness has become more aligned in recent generations with rationalist Jewish rabbinic thought than with the primarily mystical. My thirty-year marriage to an astrophysicist (indeed, a man descended from an even more thoroughly rationalist Lithuanian background) made me entirely comfortable in the intellectual world of modern physics and science and more than slightly skeptical about a more mystical approach to existence than that native to mainstream traditional Judaism.

However, almost immediately after beginning my immersion in studies of Jewish mysticism, I discovered—to my complete incredulity—that the questions and concerns probed in kabbalah were strikingly similar to those at the heart of the scientific world in which I'd lived my entire adult life. Kabbalah seemed to share the same concerns as cosmology and perhaps even string theory: questions concerning the beginnings of the world, the unity of all matter, and appreciating and perpetuating the glorious order of the world around us. Certain that I'd made some terrible mistake, I soon found that prominent scientists had not only come to similar realizations but had actually explored and written about these parallels. I also discovered that the sages who originated key concepts in Jewish mysticism themselves understood the mystical realm of their own experience through the use of metaphor—extreme midrash, if you will—for rendering the otherwise inaccessible reality of the divine accessible to human imagination.

Metaphor, midrash—these are concepts to which I relate, and indeed, around which I have always constructed my visual interpretations of biblical text. Moreover, while I had never found the bride-and-groom imagery in the service intellectually satisfying—as emotionally delectable as it may be—suddenly a wholly compelling framework for this project occurred to me. Illuminating Kabbalat Shabbat would offer a means of fusing the mystical tradition underlying its liturgy and customs with the scientific worldview of our own day, in order to broaden our understanding of Shabbat to reflect not only a spiritual sense of the completion of the world through the metaphorical transference of human eros to the divine plane but also a view of the tangible unity of all matter understood through cosmology and physics. We, after all, live in the millennium in which astrophysicists pinpointed the Big Bang through the cosmic microwave background radiation—we have dated the moment of "in the beginning."

In his 2011 work, *The Great Partnership: Science, Religion, and the Search for Meaning*, Rabbi Lord Jonathan Sacks applies ideas of Wittgenstein to describe the place of religion in understanding reality, writing eloquently of the way science and religion offer not conflicting accounts of the universe but, rather, two complementary points of view: the first demonstrating the mechanism, and the second giving us the meaning:

There is an internal logic of the system—the laws of banking, the rules of football—but the meaning of the system lies elsewhere, and it can only be understood through some sense of the wider human context in which it is set. To do this you have to step outside the system and see why it was brought into being. There is no way of understanding the meaning of football by merely knowing its rules. They tell you how to play the game, but not why people do so and why they invest in it the passions they do. The internal workings of a system do not explain the place the system holds in human lives.[2]

I introduce not only religious but also modern scientific ideas to interpret the Kabbalat Shabbat liturgy, to reflect the unity of all matter and the unity of our spiritual and physical worlds. Imagery within the illuminations thus draws not only upon the traditional rabbinic and mystical interpretations of the texts and related biblical sources but also from the astronomy, physics, and biology that shape our twenty-first-century environment. Through this fusion, I offer you a means of experiencing the Kabbalat Shabbat liturgy that is native to the world of our own experience and is yet suffused with all the spiritual ecstasy of the medieval mystical world that compiled it.

Before immersing ourselves in the pleasures of color and gold, blessings and verse, let us briefly explore the theological roots of the Kabbalat Shabbat services and touch upon the scientific roots of the worldview from which you and I enter this "cathedral in time."

Lurianic Kabbalah and the Development of Kabbalat Shabbat Custom

On pages 62–63, you will find my illuminations of the song "Shalom aleikhem" ("Welcome"; lit., "peace upon you"), with which the Friday night Sabbath feast begins—those gathered around the table welcome the angels arrived to bless them. This song derives from the practices established in the circle of Rabbi Isaac Luria, the celebrated mystical rabbi of sixteenth-century Safed (indeed, the song has far earlier roots). Prior to Luria, the Jewish mystical tradition (kabbalah) had for more than a millennium and a half been considered the exclusive realm of a scholarly elite. This scholarly elitism stemmed from concern that the radical ideas of the flow of energy within the Almighty were too dramatic and too easily confused with polytheism to be safely absorbed by those who were less than fully grounded in both biblical text and the full system of rabbinic thought. The medieval tradition upon which Luria drew directly emerged in twelfth-century Provence and spread gradually to Castile, Catalonia, and, later, Italy. The foundational medieval works include the *Sefer Yetsira*, a short, fragmentary compendium of discussions of Creation dating from the third through sixth centuries CE; the *Sefer Bahir* (Book of Brightness or Clarity), from mid-thirteenth-century Provence, although attributed to a second-century source; and best known, the Zohar, composed by Moses de León, in thirteenth-century Castile (although he attributed it to the second-century sage Rabbi Shimon bar Yoḥai).

In the form of a commentary on the Five Books of Moses, the Zohar tells how, at the beginning of time, the Godhead, *ein sof*, withdraws upon Itself (*tsimtsum*), creating in the potential space left in its wake a vessel of light that held the potential for all phenomena. That vessel suddenly exploded, sending sparks embedded in its shards across the Creation generated by its explosion. A hierarchy of ten emanations, *sefirot*, of the divine personality appeared within this chaos. Above all is the unknowable essence of the divine, the *ein sof*, "the Infinite" from which flows the *shefa*, the energetic everflow that serves as the enabling, nourishing lifeblood of all existence.[3] The most elevated emanation of the *ein sof* is *keter*, the crown. Arrayed progressively closer to the human sphere lie *ḥokhma* (wisdom), *bina* (understanding), *ḥesed* (loving-kindness), *gevura* (power), *tiferet* (beauty), *netsaḥ* (endurance), *hod* (splendor), *yesod* (foundation), and, closest to the human realm, *malkhut*, also called Shekhinah (kingdom).[4]

The Zohar and the mystical traditions that are descended from it describe the constant interplay among the *sefirot*, each of which has specific qualities. Particular groupings of *sefirot* carry masculine or feminine gender attribution, and the texts express their often-erotic longing for union and supernal bliss. The Song of Songs takes a central role as the expression of the sefirotic desire for union. God's chosen people, the people of Israel, play a crucial

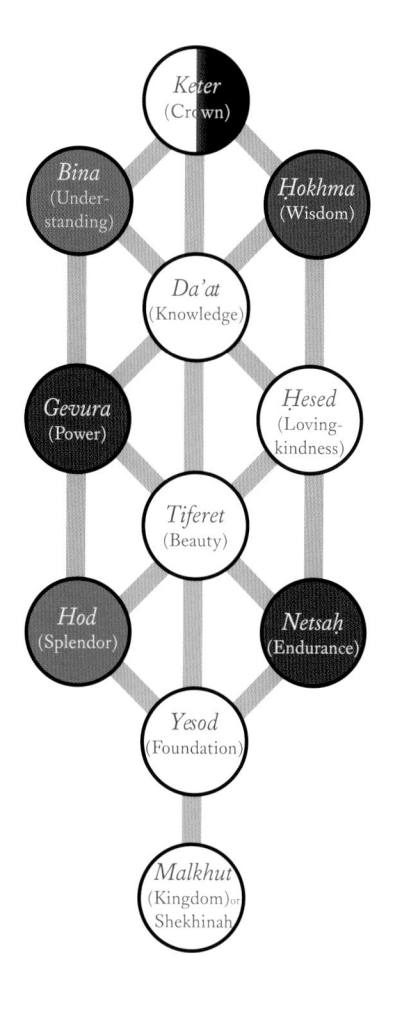

role in restoring divine unity. Each commandment that each Jew fulfills—knowingly or not—gathers sparks in this world and thus effects the union of the masculine and feminine elements in the upper world, within the Godhead, producing supernal bliss. This concept of gathering the sparks in this world is the original meaning of the term *tikkun olam* (repairing the world), which figures prominently in contemporary Jewish progressive thought.

These medieval European works drew upon an earlier esoteric tradition known as merkava mysticism, dating back to the rabbis of the Second Temple period in Israel and Babylonia, focused on the first chapter of Ezekiel and on the figure of the Prophet Elijah, taken up to heaven alive. While the biblical sources and figures that inspired the earlier merkava mystics as well as the medieval European tradition were known to all, the mystical literature itself was closely guarded from view by the general, less scholarly, community. Exclusive and elitist as they were in their mystical discussion and writing, however, many of these scholars of medieval Provence, Castile, Catalonia, and Italy were also important community rabbis. Their daily concerns involved the ongoing response of Talmudic law to daily community needs and representing their often-embattled Jewish communities to the surrounding Christian and Muslim authorities. Indeed, modern scholars such as Gershom Scholem have suggested that kabbalah, with its focus on the emotional passions among the *sefirot*, offered a compelling emotional and metaphysical explanation of the world for scholars caught up in the maelstrom of the medieval Jewish predicament, who were otherwise wrapped up in dispassionate rational legal analysis and community affairs.[5]

Isaac Luria (1534–72), the leading figure of sixteenth-century Jewish mysticism, was born in Jerusalem, of mixed Ashkenazi and Sephardi background. A wunderkind, he joined the mystical community in Safed only two years before his early death, at age thirty-eight. During his last two years, he revolutionized the approach to Jewish mysticism, developing popular ritual openly based on mystical thought, paving the way for virtually all kabbalistic exploration that followed. As Arthur Green has written, while the full liturgy of the service evolved over perhaps half a century, Luria's concept of welcoming the Sabbath bride—an outstanding example of his open sharing of mystical thought with the wider Jewish community—inspired this set of customs that Jewish tradition now regards as almost normative practice.[6]

Gershom Scholem describes Luria as both conservative of the traditional lines of rabbinic authority and daringly novel. How could Luria accomplish so dramatic and so creative a reinterpretation of Jewish thought? He invoked the authority of the Prophet Elijah, inserting his own revelation firmly into the established chain of authority. While standing on the shoulders of rabbinic and prophetic leaders preceding him, Luria used his own perceptions of divine will to draw innovative community practices from accepted mystical and Talmudic tradition.[7]

Ḥayyim Vital, Luria's disciple who organized and published most of his comments and writing, compared Luria's evident divine gifts—his revelation from Elijah—to a pomegranate full of seeds (in midrash, the pomegranate is compared to the number of mitzvot): "God has sent the great rabbi, our saintly teacher, our

rabbi and master, Isaac Luria Ashkenazi, may his name be an everlasting blessing, filled like a pomegranate with [knowledge of] Scripture, Mishnah, Talmud, *pilpul* [Talmudic legal debate], midrashim, *ma'aseh bereishit* [the act of Creation], and *ma'aseh merkava* [the act of the chariot]."[8]

The sixteenth- and seventeenth-century Moroccan and Israeli mystic Abraham Azulai, a follower of Luria's, described the divine everflow, the *shefa*, into the material world as light:

> We have a fixed and indubitable belief that everything that flows is established, exists, is alive, etc., has its very being through the mystery of the light of the Infinite Godhead, may He be blessed. For [this light] is in what is emanated, created, formed and made, both pure and impure.... There is no light, small or great, or activity, little or large, which is not in existence through the light of the Infinite Godhead, which spreads from above down to the end of all levels. This is because there is no movement, trivial or great, which does not come from the illumination of the Infinite Godhead to all beings. The life force within every existent is only from Him, and He shines through them.[9]

In the paintings that follow, the *shefa* is represented by splashes of celestial blue and gold arabesques. In addition to this spiritual understanding, the scientific culture within which we live today has brought us a concrete physical understanding of the radiance of Creation. My challenge in this work is to fuse the modern physical understanding of the energy that composes all physical matter, on the one hand, with the kabbalistic imagery of the divine light that creates and suffuses all matter, on the other hand. In these painted texts, I transform this fusion of physical and spiritual light into an illuminated manuscript of the Kabbalat Shabbat rituals and texts, in order to enrich our prayer and our homes with a contemporary celebration of Creation.

WOMAN AND WISDOM

As Shabbat dinner begins, the last twenty-one verses of the book of Proverbs, *Mishlei*, are sung at many traditional Sabbath tables as a paean of praise to the Sabbath queen and her human double, the homemaker. My inspiration in this work draws not only from the prayers and mystical and scientific writings but also from my own life experience. The oak-tree imagery in my illuminations of this passage, "A Powerful Woman," first sprang to mind in connection with my maternal grandmother, Rebbetsin Bessie Swift, *z"l*, as you will read in my commentary on those paintings. Despite two-career households, the preparation of the home for the Sabbath most often falls primarily into the domain of the wife and mother. I am particularly interested in the image and place of the woman in the liturgy—indeed, the image of the woman is an essential tenet in this liturgy. Divine wisdom is personified as a woman in Proverbs 8, a fundamental source text in Jewish mysticism; and the most accessible divine *sefira*, the Shekhinah, is feminine. The Zohar, Lurianic kabbalah, and particularly the Kabbalat Shabbat traditions are replete with erotic imagery of the love between the Shekhinah and other masculine emanations and draw deeply also from the Song of Songs, following a tradition that precedes even the Zohar.

The mystical commentary on the Song of Songs written by the thirteenth-century Catalonian kabbalist Ezra of Gerona has become an important source of visual symbolism for this work. The beloved wife becomes the embodiment of the Shekhinah, the ultimate conduit of divine wisdom and divine light into the world. In "A Powerful Woman" ("Eishet ḥayil"), while the verses describe a vision of divine wisdom as an efficient homemaker, the husband will often chant it with a sense of romantic devotion to his wife—the woman responsible for the laid table and the feast to come—with whom he may later seek union in the human quest (whether intentionally or not, to be sure) to unite the masculine and feminine aspects of the Godhead. Indeed, the culminating song of the synagogue Kabbalat Shabbat service is the sixteenth-century "Arise, my beloved, to greet the bride," that is, the divine Shekhinah who descends to Earth on Shabbat. Human women's words also figure in these paintings. Several historical Jewish traditions—in particular, that of the Ashkenazi—preserve a

whole literature of informal women's prayers, known as *teḥines*, that appear throughout these illuminations. An important way we welcome Shabbat precedes even the candle-lighting. The activities involved in preparing the home—which, for me, as for my mother and grandmothers before me, and many traditional homemakers (women and men both)—set the rhythm for much of the week, frequently dominate the hours before Shabbat arrives, and, as they do for me, often figure in spiritual preparation for the coming day. Surprisingly, while the needs for table and meal are clear, and every homemaker has her or his own ways of doing things, there has been relatively little formal mystical interpretive writing about these weekly household rituals. An anonymous seventeenth-century work, likely written in Jerusalem or Izmir (Smyrna), titled *Ḥemdat yamim*,[10] does just this, purporting to present an image of the way Shabbat and the festivals are celebrated in the messianic era, certainly reflecting the practices of Luria's own community in Safed. A generation before Luria, *Sod Hashabbat* ("The Mystery of Shabbat"),[11] by the early-sixteenth-century kabbalist Meir ibn Gabbai, provides another mystical interpretation of the Sabbath home and rituals. My presentation of the home throughout these pages draws on both these works. Some *teḥines* describe the spiritual feelings around particular aspects of Shabbat preparation and will also figure here.

THE COSMIC BACKGROUND

We in these early decades of the twenty-first century in the Western world enter into the beloved "cathedral in time" from a workaday world that generally finds its answers to every question about the tangible world around us—from how to care for a child's skinned knee to the age of the universe not only in religion but also in the scientific model of the universe that has developed by leaps and bounds since the days of the early-fifteenth-century Polish astronomer Nicolaus Copernicus. Modern scientists have dated the moment of the Big Bang—Creation—and actually do count and understand the stars of the night sky. We daily understand more about the chemistry, evolution, and genetics that turned disconnected amino acids into bacteria, dinosaurs, and mammals—and now into homo sapiens. The day that I first drafted this paragraph, thrilling news spread that nerve cells from a man's nose and ankle had been transformed into neurons that had healed his severed spinal cord. And neither cosmology nor biology accords with the literal biblical dating. Yet consciously or subconsciously, this worldview colors our experience of the Shabbat liturgy.

Some of us surely still individually deny Big Bang or evolution; but by and large, modern traditional Jews have a different sense of divine involvement in the material world from that of the medievals who composed our liturgy. We have already touched upon Rabbi Jonathan Sacks's ideas about how religion and science may complement each other rather than compete within human consciousness—one offering meaning, and the other offering method. Since these illuminations offer much imagery drawn not only from mysticism but also from modern science, let us lay out some of the basic concepts we encounter herein.

Before rocketing into the science, it is worth noting that Jewish thinkers were not always comfortable with notions of the structure of the universe that did not agree literally with biblical texts. The Catholic Church's long resistance to modern astronomy is well known, but many Jewish scholars had similar qualms about science that seemed to conflict with sacred text. Physician and historian of science Jeremy Brown[12] has documented the difficult and gradual Jewish acceptance of the modern astronomy founded upon Copernicus's observational discovery, published in 1543, shortly before his death, that Earth and other planets circle the sun. The difficulty arose from the traditional Jewish principle that the chain of transmission of history and law from God to Moses—and, ultimately, the rabbinate—guaranteed correctness in a way that human observation could not. Since several biblical passages seemed to indicate that the entire universe revolved around Earth, Jewish scholars and scientists raised in the culture of biblical literalism and the Aristotelian, geocentric, scientific culture of the Mishnaic sages only slowly and haltingly came to accept the validity of empirical scientific observation. Rabbinic doubts about the validity of empirical astronomy were not largely abandoned until the latter half of the nineteenth century. We shall see, however, that modern cosmology and the basic

ideas of Jewish mysticism address similar questions and assert similar answers (while certainly couched in different language) about the beginnings and nature of the universe. Before moving into a discussion about the similarities in mysticism and science, let us explore the basic concepts about the structure of nature reflected in the illuminations before you.

The modern empirical paradigm of the structure of the material universe, based on mathematical physical modeling and supported by observation, accepts that all matter, all time, and all space commenced by exploding from a single indefinable point at the moment of the Big Bang, now dated at 13.7 million years ago. And it is still expanding outward. Light travels at 186,000 miles (300,000 kilometers) per second, so as we peer into the night sky through our own eyes or a telescope, we see not only stars but also time. The farther we see, the longer ago we see. The smallness of a star we see with our eyes may indicate its actual size, but it may also indicate great distance from Earth. We describe the distance of, say, Alpha Centauri, the nearest star to our sun, not in miles or kilometers but in time—photons from this neighbor travel 4.37 light-years to reach us. Given the vast distances in the cosmos, we do not see that star in its actual state at the moment we gaze at it but as it was when its light particles—its photons—left its surface to eventually hit our retinas or telescope detectors. Even now, we see the faint echoes of the Big Bang in the cosmic microwave radiation that suffuses the entire universe, first thought to be static caused by bird droppings on a Bell Telephone Labs antenna. Astrophysicists consider the discovery of that microwave background among humankind's greatest achievements. Indeed, it has inspired two Nobel Prizes for Physics: its 1968 discovery by Arno Penzias and Robert Wilson won the 1978 prize; its 2003 use in dating Big Bang at 13.7 billion years ago won the prize in 2006 for John C. Mather and George F. Smoot. Nobel Prize–winning theoretical physicist Steven Weinberg offers an elegant and accessible account of Big Bang and the early universe in *The First Three Minutes: A Modern View of the Origin of the Universe*.[13] Cosmic energy enters our world in a literal spectrum of frequencies; the illuminations ahead will allude to several of these.

All chemicals in the universe, whether in the plastics in my computer keys, my dog's fur, or the rain falling outside my window, come from energy processed and reorganized over and over again through stars; my beloved first husband, an astrophysicist, was fond of saying that "we are all stardust." As atoms of each chemical float through space and are irradiated by cosmic energy, whether in interstellar space or on a lab bench, they emit unique patterns of "spectral lines" that serve as their cosmic signatures. These patterns and ideas occur in these paintings before you, as I interpret the works of Creation of the sacred texts and the material world around us.

These chemicals find their way through the stars to Earth, where they blend into the sugars and the amino acids that yield the proteins that compose all life forms on Earth. The story of the 1953 discovery of the complex structure of sugars and proteins known as the DNA molecule, which carries all the information defining every individual life form is well known. Two of the scientists who developed the double-helix model, James Watson and Francis Crick, won the Nobel Prize in Medicine in 1962. Endless combinations of only four base pairs, complex combinations of sugars, hydrogen, and proteins, construct an endless variety of DNA and give every living creature its unique character.

Paleontologist Neil Shubin traces the relatedness of all life and all matter through the stars in *The Universe Within*: "Worms, fish, and algae are but gateways to ever deeper connections—ones that extend back billions of years before the presence of life and of earth itself. Written inside us is the birth of the stars, the movement of heavenly bodies across the sky, even the origin of days themselves."[14] The paintings of the deep sky—based on views from the Hubble Space Telescope—of gazelles nestled into the forest floor near streams and of sound waves reverberating from earthquakes that you will find here remind us of the unity of all matter in Creation.

COSMOLOGY AND KABBALAH

Let us review the words of Abraham Azulai, the seventeenth-century follower of Isaac Luria: "We have a fixed and indubitable belief that everything that flows is established, exists, is alive, etc., has its very being through the mystery of the light of the Infinite Godhead, may He be blessed." Employing a different vernacular from modern science—working from faith rather than empirical observation but nonetheless showing striking similarity to modern cosmology—the kabbalistic tradition that developed the Kabbalat Shabbat liturgy tracks the existence of all matter to energy radiating from a single, infinite point, described as the *ein sof*, the Infinite, or, at the moment of Creation, *reishit*. Astrophysicist Howard Smith has analyzed this concordance in *Let There Be Light: Modern Cosmology and Kabbalah—A New Conversation between Science and Religion*.[15] Physics unites the fundamental forces of nature, electromagnetism, and the weak and strong forces into the Grand Unification Theory. At the time of this writing, physics needs only to fully merge gravity into the model to create a Theory of Everything.[16]

Smith compares the Zohar's notion of the simultaneous discreteness and unity of all things in *Ehyeh*, "I am," the name by which God identified Himself to Moses at the Burning Bush, to general relativity, the theory relating gravity, space, and time proposed by Albert Einstein in 1905. "The general relativistic description of the universe, self-referential and complete, captures a sense of the oneness of space in a way that helps us grasp what such inclusive oneness means."[17]

I offer you here, then, traditional liturgy and new paintings illuminating the grand unification not only of all the physical forces but of the physical and spiritual worlds themselves, which Jewish tradition celebrates as it observes the completion of Creation with the arrival of Shabbat. Ultimately, I look to Psalm 8 for inspiration to interpret these sacred customs using humanity's God-given ability to learn about the world around us:

> [4]When I behold Your heavens, the work of Your fingers,
> the moon and stars that You set in place,
> [5]what is man that You have been mindful of him,
> mortal man that You have taken note of him,
> [6]that You have made him little less than divine,
> and adorned him with glory and majesty.

WITHIN THE BOOK

Illuminating Kabbalat Shabbat has brought me great joy and enriched my appreciation of Friday evening festivities, and I hope to share that pleasure with you. Let me acquaint you with the materials that you will find herein. Before moving to interpretive matters, it is important to note that this book conforms to the Ashkenazic rite[18] and presents the liturgy for non-festival Friday nights. However, additions for special Sabbaths are included in the back of the book. The Maariv service for Friday evening, not intrinsically part of the synagogue Kabbalat Shabbat, is included following the "At the Sabbath Table" section. The Sabbath table songs presented include not only those specifically appointed (in *The Koren Sacks Siddur*, my general model here) for Friday evening but also most of those for Sabbath lunch; the traditions associating almost any given song with one meal or another are weak, and many families sing them at either meal. Overall, this volume includes the entire Ashkenazic liturgy for Friday night observances. Out of respect for the Hebrew liturgy at its heart, the book flows from right to left in the Hebrew fashion; English sections flow also from the right page to the left.

Readers of my earlier works, *The Song of Songs: The Honeybee in the Garden* (2005), *I Will Wake the Dawn: Illuminated Psalms* (2007), and *Arise! Arise! Deborah, Ruth and Hannah* (2012), may already be acquainted with my approach to crafting visual interpretations of traditional Jewish texts. As I have written in those works, my compositions begin with a representation of reality that usually makes sense in the world of our

own experience—or even the mystical world that some of these texts describe. Following Erwin Panofsky's[19] analysis of "disguised symbolism" in the work of the masters of medieval northern Europe—particularly, van Eyck, a reproduction of whose *Arnolfini Wedding Portrait* has hung over my worktable since college—I introduce values and ideas related to the story at hand through symbolic images in ways that usually make logical sense. While the overall painting usually creates a coherent, easily understood material reality, examining the symbolism of individual items within it reveals a more complex world of ideas. In our increasingly visual age, when the word "icon" has sprung from relatively obscure religious and art-historical roots into everyday conversation, a vibrant Jewish visual vocabulary—able to convey complex abstract spiritual (and here, related scientific) ideas in a glance, using imagery rooted in millennia of diverse Jewish sources—acquires a new relevance in Jewish society. It is this kind of Jewish symbolic vocabulary that I have attempted to develop in my work over nearly three decades and that I expand in this project. Within this book, as in my previous works, the full meaning of the symbolism—the full message of each painting—is laid out in the commentary that corresponds to each illuminated page.

As we have seen above, liturgical texts as well as paintings present complex ideas drawn from science, biblical text, Jewish tradition, and Jewish mysticism. While I hope that you will enjoy the illuminations on a purely aesthetic and sensual level, understanding them fully requires some explanation. The introductory pieces by Rabbi Sacks, Arthur Green, and myself provide valuable orientation to the book and to Kabbalat Shabbat in general. We offer other materials to explain the illuminations themselves. Hence, following each of the sections for preparing the home, the synagogue service, and the dinner-table rituals, you will find a section of notes corresponding to the illuminations for each blessing, psalm, *piyyut*, or song. There you will find Raymond Scheindlin's concise and accessible analysis of each text's literary qualities, followed by my own presentation of the symbolism of the visual imagery. Endnotes often include additional pertinent information besides simply sources. I hope that you will dip into all these materials to increase your pleasure in the paintings.

Many readers may have questions about the physical nature of the original paintings. The original artwork is a classical illuminated manuscript employing, with few exceptions, the same materials that have been used by European manuscript illuminators since the beginnings of the codex—the bound book—during the first millennium. I created the 12-inch by 15-inch paintings on kosher slunk vellum—calfskin taken from a very young calf. It is the favorite, most luxurious, surface for the combination of media used in European illuminations. This vellum is also the preferred material for the finest Torah scrolls and hence is particularly appropriate, if not required, for the sacred texts within. The papercuts are done on paper with blades. The gold is 23-karat gold leaf and powdered gold, the silver is palladium leaf, and the paint is the most delicate and brilliant gouache (opaque watercolor) available to me. I developed the Hebrew calligraphic hand here for my first book, *The Song of Songs: The Honeybee in the Garden*, combining elements of several historical Hebrew hands in a style that I find both elegant and energetic. The English calligraphic hand is my adaptation of the italics developed by Renaissance Italian humanists. Throughout these pages, you will find many designs composed of lines of tiny writing. This art, known as micrography, is an innovation of Jewish scribes and artists found in Jewish books of all traditions, especially Bibles, since early medieval times. While I hardly expect viewers to read the tiny script, micrography is my favorite way to allude to the relationship of additional texts to the ideas at hand.

I hope that these illuminations and commentaries enhance your and your loved ones' pleasure in synagogue service, private home study and prayer, and your own Shabbat table as Jews across the world enter the "cathedral in time" to welcome the Shabbat queen.

—*Debra Band*
Potomac, Maryland
October 25, 2015, 12 Heshvan 5776

THE BRIDE APPROACHES

Evening came and morning came—

the sixth day.

The sky, the earth, and all their vast contents were completed.

By the seventh day, God had finished all the work that He had done,

and so He rested on the seventh day from all His work that He had done.

He blessed the seventh day and set it apart as holy,

for that was when He rested from making all the things that God created.

Such is the story of heaven and earth when they were created.

—Genesis 2:1–4

אָבִינוּ שֶׁבַּשָׁמַיִם

בְּמִצְוֹתֶיךָ הַקְּדוֹשָׁה אֲנִי מַפְרִישָׁה שִׁעוּר מִן הַחַלָּה. עוֹד אֶזְכְּרָה שָׁנִים קַדְמוֹנִיּוֹת שֶׁבָּהֶן,

בְּלֵב חָפֵץ, הֶעֱלוּ אֲבוֹתֵינוּ עַל מִזְבַּחֲךָ אֶת בִּכּוּרֵיהֶם. גַּם הַיּוֹם, אֱלֹהֵינוּ, אָנוּ מַעֲלִים לְפָנֶיךָ

קָרְבְּנוֹת אַהֲבָה שֶׁיֵּרְצוּ לְפָנֶיךָ, בְּשָׁעָה שֶׁאָנוּ מַשְׂבִּיעִים אֶת רַעֲבוֹנוֹ שֶׁל הַנִּצְרָךְ

מִזְקְלִים עַל מְצוּקָתוֹ וְחֶסְרוֹנוֹ, וּמְסַלְּקִים אֶת הַדְּאָגוֹת פַּרְנָסָתוֹ, אָנוּ מַעֲלִים קָרְבָּן

לְפָנֶיךָ, אֲבִי דַלִּים וַעֲנִיִּים. אָבִינוּ שֶׁבַּשָּׁמַיִם, קַבֵּל בְּרַחֲמִים וּבְרָצוֹן אֶת תְּרוּמָתִי וְתֵן

לִי לֵב חָזָק וְנֶאֱמָן, וְגַם אִם תִּדְרֹשׁ מִמֶּנִּי קָרְבָּנוֹת גְּדוֹלוֹת וַעֲצוּמִים, אֶעֱלֶה אוֹרִים

וְאֶשְׂמַח בֶּאֱמוּנָתִי. תֵּן לָנוּ לְהַרְוִיחַ אֶת לֶחֶם יוֹמֵנוּ בְּכָבוֹד וְלֹא בְּמוֹרָא, וְתֵן שֶׁנֹּאכַל

מִזֶּמֶנוּ וְשֶׁיַּשְׁפִּיעַ עָלֵינוּ בְּרָכָה וְשִׂגְשׂוּג. וּבְרֹב בְּרִיאוּת וְכֹחַ נִשְׂמַח בַּחַיִּים וּבְחַסְדָּם.

וּבְלֵב שָׂמֵחַ וּבְרוּחַ טוֹבָה נְהַלֶּלְךָ הַטּוֹב וְהַמֵּטִיב. וּשְׁלַח בְּרָכָה וְהַצְלָחָה בְּמַעֲשֵׂי יָדֵינוּ.

בָּרוּךְ אַתָּה יהוה אֱלֹהֵינוּ מֶלֶךְ הָעוֹלָם

אֲשֶׁר קִדְּשָׁנוּ בְּמִצְוֹתָיו וְצִוָּנוּ

לְהַפְרִישׁ חַלָּה.

Our Father in Heaven

By Your holy command, I am separating a measure of challah. At the same time, I recall ancient times when, with a willing heart, our forefathers would offer the first of their produce upon Your altar. Today, too, our God, we offer up offerings of love—may they find favor before You. Whenever we satisfy the hunger of those in need, easing their distress and their deprivation and relieving their concerns for their sustenance, we are offering a sacrifice before You, Father of the poor and the destitute. Our Father in heaven—accept my gift with mercy and favor and grant me a strong and loyal heart; then even if You demand great and difficult sacrifices of me, I shall offer them up and rejoice in my faith. Allow us to earn our daily bread with dignity and not in dread. May we eat of it and may it bring us an abundance of blessing and prosperity. With good health and vigor may we rejoice in life and its grace, and with joyful heart and a good spirit, we shall praise You Who are good and Who performs good, and may You send blessing and success to our endeavors.

Blessed are You, Lord our God, King of the Universe, Who has sanctified us with His commandments and commanded us to separate—challah.

The sun

has sunk below the trees.
Let's go to welcome the sabbath, the queen.
Come, watch her descending, holy and blessed,
and with her, angels of peace and of rest.

Come, come, sabbath queen!
Come, come, sabbath bride!
Welcome, welcome, angels of peace!

We've greeted the sabbath with prayer and with song.
And now from the synagogue, back to our home.
The table is set, the candles are gleaming:
every part of the household is beaming
A sabbath of blessing, a sabbath of peace!
A sabbath of blessing, a sabbath of peace!
Come in peace, angels of peace!

מֵרֹאשׁ הָאִילָנוֹת נִסְתַּלְּקָה
בֹּאוּ וְנֵצֵא לִקְרַאת שַׁבָּת הַמַּלְכָּה
הִנֵּה הִיא יוֹרֶדֶת הַקְּדוֹשָׁה, הַבְּרוּכָה
עִמָּהּ מַלְאָכִים צְבָא שָׁלוֹם וּמְנוּחָה
בֹּאִי בֹּאִי הַמַּלְכָּה !
בֹּאִי בֹּאִי הַמַּלְכָּה !
שָׁלוֹם עֲלֵיכֶם, מַלְאֲכֵי הַשָּׁלוֹם!

קִבַּלְנוּ פְּנֵי שַׁבָּת בִּרְנָנָה וּתְפִלָּה.
הַבַּיְתָה נָשׁוּבָה בְּלֵב מָלֵא גִילָה,
שָׁם עָרוּךְ הַשֻּׁלְחָן הַנֵּרוֹת יָאִירוּ,
כָּל פִּנּוֹת הַבַּיִת יִזְרָחוּ, יַזְהִירוּ:
שַׁבָּת שָׁלוֹם וּמְבֹרָךְ !
שַׁבָּת שָׁלוֹם וּמְבֹרָךְ!
בּוֹאֲכֶם לְשָׁלוֹם, מַלְאֲכֵי הַשָּׁלוֹם!

Stay with us, pure one. For a night and a day
grant us your light, and then go your way.
We will honor you, wearing our best,
With hymns and with prayers and with three solemn feasts,
and perfect rest,
delightful rest.
Bless us with peace, angels of peace!

The sun has again sunk below the trees.
Let's go and bid the sabbath farewell.
Farewell, holy sabbath, at the last rays.
We will await your return in six days.
May the next sabbath be like the last!
May the next sabbath be like the last!
Go in peace, angels of peace.

שְׁבִי זַכָּה, עִמָּנוּ וּבְזִיוֵךְ נָא אוֹרִי
לַיְלָה וָיוֹם, אַחַר תַּעֲבֹרִי.
וַאֲנַחְנוּ נְכַבְּדֵךְ בְּבִגְדֵי חֲמוּדוֹת,
בִּזְמִירוֹת וּתְפִלּוֹת וּבְשָׁלֹשׁ סְעֻדּוֹת,
וּבִמְנוּחָה שְׁלֵמָה.
וּבִמְנוּחָה נְעִימָה –
בָּרְכוּנוּ לְשָׁלוֹם, מַלְאֲכֵי הַשָּׁלוֹם!

הַחַמָּה מֵרֹאשׁ הָאִילָנוֹת נִסְתַּלְּקָה –
בֹּאוּ וּנְלַוֶּה אֶת שַׁבָּת הַמַּלְכָּה.
צֵאתֵךְ לְשָׁלוֹם הַקְּדוֹשָׁה, הַזַּכָּה –
דְּעִי, שֵׁשֶׁת יָמִים אֶל שׁוּבֵךְ נְחַכֶּה...
כֵּן לַשַּׁבָּת הַבָּאָה!
כֵּן לַשַּׁבָּת הַבָּאָה!
צֵאתְכֶם לְשָׁלוֹם, מַלְאֲכֵי הַשָּׁלוֹם!

21

בָּרוּךְ
אַתָּה יְיָ אֱלֹהֵינוּ מֶלֶךְ הָעוֹלָם,
אֲשֶׁר קִדְּשָׁנוּ בְּמִצְוֹתָיו
וְצִוָּנוּ לְהַדְלִיק נֵר שֶׁל שַׁבָּת.

Blessed
are You, Lord our God,
King of the world
Who set us apart with the commandments
and commanded us to light
the sabbath lamp.

Blessed be the name of the Lord of the universe.

Blessed be Thy crown and Thy abiding-place.

May Thy favor ever be with the people of Israel.

Reveal to Thy people in Thy sanctuary the redeeming power

of Thy right hand.

Give unto us the good gift of Thy light,

and in mercy accept our prayers.

—Zohar

יְדִיד נֶפֶשׁ

אָב הָרַחֲמָן מְשֹׁךְ עַבְדְּךָ אֶל רְצוֹנֶךָ

יָרוּץ עַבְדְּךָ כְּמוֹ אַיָּל יִשְׁתַּחֲוֶה אֶל מוּל הֲדָרֶךָ

כִּי יֶעֱרַב לוֹ יְדִידוֹתֶךָ מִנֹּפֶת צוּף וְכָל טָעַם

הָדוּר נָאֶה זִיו הָעוֹלָם נַפְשִׁי חוֹלַת אַהֲבָתֶךָ

אָנָּא אֵל נָא רְפָא נָא לָהּ בְּהַרְאוֹת לָהּ נֹעַם זִיוֶךְ

אָז תִּתְחַזֵּק וְתִתְרַפֵּא וְהָיְתָה לָךְ שִׁפְחַת עוֹלָם

וָתִיק יֶהֱמוּ רַחֲמֶיךָ וְחוּס נָא עַל בֵּן אוֹהֲבָךְ

כִּי זֶה כַּמָּה נִכְסוֹף נִכְסַף לִרְאוֹת בְּתִפְאֶרֶת עֻזֶּךָ

אָנָּא אֵלִי מַחְמַד לִבִּי חוּשָׁה נָא וְאַל תִּתְעַלָּם

הִגָּלֶה נָא וּפְרֹשׂ חֲבִיב עָלַי אֶת סֻכַּת שְׁלוֹמֶךָ

תָּאִיר אֶרֶץ מִכְּבוֹדֶךָ נָגִילָה וְנִשְׂמְחָה בָךְ

מַהֵר אֱהֹב כִּי בָא מוֹעֵד וְחָנֵּנִי כִּימֵי עוֹלָם

Soul's beloved, kindly father
draw your service to your pleasure.
He will hasten on swift deer-feet,
will bow in homage to your splendor
for to him your love is sweeter
than honeycomb or any dainty

Splendid Lovely, Universal Light
my soul is faint with love of You
Heal, oh heal her, God of grace,
reveal to her your lovely light.
Then she will be strong and well.
and ever be your serving-girl.

Steadfast One, arouse your love.
Take pity on your loving son.
How long it is that he has yearned
to live to see your mighty splendor.
O my God, my heart's desire,
hurry, do not keep concealed.

Reveal yourself my dear, and spread
your tent of peace above my head.
Make the world gleam with your glory.
we will rejoice in you with glee.
Hurry, love, for the time has come.
Show me grace as you did of old.

לְכוּ נְרַנְּנָה לַיהֹוָה

נָרִיעָה לְצוּר יִשְׁעֵנוּ׃

נְקַדְּמָה פָנָיו בְּתוֹדָה בִּזְמִרוֹת נָרִיעַ לוֹ׃

כִּי אֵל גָּדוֹל יְהֹוָה וּמֶלֶךְ גָּדוֹל עַל־כָּל־אֱלֹהִים׃

אֲשֶׁר בְּיָדוֹ מֶחְקְרֵי־אָרֶץ וְתוֹעֲפוֹת הָרִים לוֹ׃

אֲשֶׁר־לוֹ הַיָּם וְהוּא עָשָׂהוּ וְיַבֶּשֶׁת יָדָיו יָצָרוּ׃

בֹּאוּ נִשְׁתַּחֲוֶה וְנִכְרָעָה נִבְרְכָה לִפְנֵי־יְהֹוָה עֹשֵׂנוּ׃

כִּי הוּא אֱלֹהֵינוּ וַאֲנַחְנוּ עַם מַרְעִיתוֹ וְצֹאן יָדוֹ
הַיּוֹם אִם־בְּקֹלוֹ תִשְׁמָעוּ׃

אַל־תַּקְשׁוּ לְבַבְכֶם כִּמְרִיבָה כְּיוֹם מַסָּה בַּמִּדְבָּר׃

אֲשֶׁר נִסּוּנִי אֲבוֹתֵיכֶם בְּחָנוּנִי גַּם־רָאוּ פָעֳלִי׃

אַרְבָּעִים שָׁנָה אָקוּט בְּדוֹר וָאֹמַר עַם תֹּעֵי לֵבָב הֵם
וְהֵם לֹא־יָדְעוּ דְרָכָי׃

אֲשֶׁר־נִשְׁבַּעְתִּי בְאַפִּי אִם־יְבֹאוּן אֶל־מְנוּחָתִי׃

Come let us shout to the Lord

Let us cry aloud to the Rock who saves us!
2 Let us greet Him with an offering of thanks!
With hymns let cry to Him aloud!
3 Indeed, the Lord is a great God, a King greater than all powers,
4 In whose hands are the earth's depths,
Who owns the mountain tops.
5 Who owns the sea, for He made it,
and the dry land, shaped by His own hands.
6 Come let us bow and prostrate ourselves,
Bend the knee before the Lord, our maker.
7 For He is our God;
We are the nation He pastures, the sheep His hand tends,
If only you would heed His voice this day!
8 Do not harden your hearts as at Meribah,
As on the day of Massah in the wilderness,
9 When your ancestors tried me,
Tested me though they had seen my deeds.
10 Forty years I was in disgust with that generation,
And I said, "They are a people of fickle heart;
They do not know my ways;
11 When in my anger I vowed
That they would never come into my rest.

sing

שִׁירוּ

a new song to the Lord,

Sing to the Lord, all the earth!

Sing to the Lord, bless His name,

Proclaim His victory's tidings daily.

Speak of His glory among the nations,

His marvels among all peoples.

For the Lord is great and greatly praised,

More fearsome than all other gods.

For all the nations' gods are godlets,

But the Lord made the heavens!

Splendor and beauty are in His presence,

Might and glory in His holy place.

Attribute to the Lord, O families of the nations,

Attribute to the Lord glorious might.

Attribute to the Lord the glory of His name,

Bring Him tribute as you come into His courts.

Bow to the Lord in His splendid sanctuary.

לַיהוה שִׁיר חָדָשׁ,

שִׁירוּ לַיהוה כָּל־הָאָרֶץ:

שִׁירוּ לַיהוה, בָּרְכוּ שְׁמוֹ;

בַּשְּׂרוּ מִיּוֹם־לְיוֹם יְשׁוּעָתוֹ:

סַפְּרוּ בַגּוֹיִם כְּבוֹדוֹ,

בְּכָל־הָעַמִּים נִפְלְאוֹתָיו:

כִּי גָדוֹל יהוה וּמְהֻלָּל מְאֹד,

נוֹרָא הוּא עַל־כָּל־אֱלֹהִים:

כִּי כָּל־אֱלֹהֵי הָעַמִּים אֱלִילִים,

וַיהוה שָׁמַיִם עָשָׂה:

הוֹד־וְהָדָר לְפָנָיו,

עֹז וְתִפְאֶרֶת בְּמִקְדָּשׁוֹ:

הָבוּ לַיהוה מִשְׁפְּחוֹת עַמִּים,

הָבוּ לַיהוה כָּבוֹד וָעֹז:

הָבוּ לַיהוה כְּבוֹד שְׁמוֹ,

שְׂאוּ־מִנְחָה וּבֹאוּ לְחַצְרוֹתָיו:

הִשְׁתַּחֲווּ לַיהוה בְּהַדְרַת־קֹדֶשׁ,

חִילוּ מִפָּנָיו כָּל־הָאָרֶץ:

Tremble before Him all the earth;
Say to the nations, O the Lord is now King,
The earth is fixed, it cannot be moved.
He judges the nations in equity.
Let the heavens rejoice and the earth be glad,
Let the sea and all that is in it thunder,
Let the fields rejoice and all they contain,
Then will all the forest's trees sing.
Before the Lord, for He comes!
He comes to judge the earth,
He judges the world in justice
And the nations with His truth.

חִילוּ מִפָּנָיו כָּל־הָאָרֶץ:
אִמְרוּ בַגּוֹיִם יְהוָה מָלָךְ,
אַף־תִּכּוֹן תֵּבֵל בַּל־תִּמּוֹט,
יָדִין עַמִּים בְּמֵישָׁרִים:
יִשְׂמְחוּ הַשָּׁמַיִם וְתָגֵל הָאָרֶץ,
יִרְעַם הַיָּם וּמְלֹאוֹ:
יַעֲלֹז שָׂדַי וְכָל־אֲשֶׁר־בּוֹ,
אָז יְרַנְּנוּ כָּל־עֲצֵי־יָעַר:
לִפְנֵי יְהוָה כִּי בָא,
כִּי בָא לִשְׁפֹּט הָאָרֶץ
יִשְׁפֹּט־תֵּבֵל בְּצֶדֶק,
וְעַמִּים בֶּאֱמוּנָתוֹ:

The Lord rules! Let the earth rejoice,

 May the multitudinous regions be glad:

Cloud and darkness surround Him:

 Justice and judgment are His throne's foundation.

Fire goes before Him,

 Burning around His foes.

His flashes illumine the world,

 The earth sees and trembles,

Mountains melt like wax before the Lord,

 Before the Lord of all the world.

The heavens declare His righteousness,

 And all the nations see His glory.

יְהוָה מָלָךְ תָּגֵל הָאָרֶץ

יִשְׂמְחוּ אִיִּים רַבִּים:

עָנָן וַעֲרָפֶל סְבִיבָיו

צֶדֶק וּמִשְׁפָּט מְכוֹן כִּסְאוֹ:

אֵשׁ לְפָנָיו תֵּלֵךְ

וּתְלַהֵט סָבִיב צָרָיו:

הֵאִירוּ בְרָקָיו תֵּבֵל

רָאֲתָה וַתָּחֵל הָאָרֶץ:

הָרִים כַּדּוֹנַג נָמַסּוּ מִלִּפְנֵי יְהוָה

מִלִּפְנֵי אֲדוֹן כָּל הָאָרֶץ:

הִגִּידוּ הַשָּׁמַיִם צִדְקוֹ

וְרָאוּ כָל הָעַמִּים כְּבוֹדוֹ:

Shamed are all the idolaters,

Who boast of their godlets;

All gods bow down to Him.

Zion rejoices to hear,

Judea's daughters are happy,

Because of Your judgments, O Lord.

For You, O Lord, are exalted above all the earth,

You have risen high above all the gods.

O you who love the Lord: despise evil!

He protects the lives of His adherents,

Saves them from the wicked.

Light is strewn upon the righteous,

Joy to those who are good at heart.

Rejoice, O righteous, in the Lord,

And praise His holy name.

יֵבֹשׁוּ כָּל־עֹבְדֵי פֶסֶל

הַמִּתְהַלְלִים בָּאֱלִילִים

הִשְׁתַּחֲווּ־לוֹ כָּל־אֱלֹהִים׃

שָׁמְעָה וַתִּשְׂמַח צִיּוֹן

וַתָּגֵלְנָה בְּנוֹת יְהוּדָה

לְמַעַן מִשְׁפָּטֶיךָ יְהוָה׃

כִּי־אַתָּה יְהוָה עֶלְיוֹן עַל־כָּל־הָאָרֶץ

מְאֹד נַעֲלֵיתָ עַל־כָּל־אֱלֹהִים׃

אֹהֲבֵי יְהוָה שִׂנְאוּ רָע

שֹׁמֵר נַפְשׁוֹת חֲסִידָיו

מִיַּד רְשָׁעִים יַצִּילֵם׃

אוֹר זָרֻעַ לַצַּדִּיק

וּלְיִשְׁרֵי־לֵב שִׂמְחָה׃

שִׂמְחוּ צַדִּיקִים בַּיהוָה

וְהוֹדוּ לְזֵכֶר קָדְשׁוֹ׃

מִזְמוֹר שִׁירוּ

לַיהוה שִׁיר חָדָשׁ, כִּי־נִפְלָאוֹת עָשָׂה,

הוֹשִׁיעָה־לּוֹ יְמִינוֹ וּזְרוֹעַ קָדְשׁוֹ:

הוֹדִיעַ יהוה יְשׁוּעָתוֹ,

לְעֵינֵי הַגּוֹיִם גִּלָּה צִדְקָתוֹ:

זָכַר חַסְדּוֹ וֶאֱמוּנָתוֹ לְבֵית יִשְׂרָאֵל,

רָאוּ כָל־אַפְסֵי־אָרֶץ אֵת יְשׁוּעַת אֱלֹהֵינוּ:

הָרִיעוּ לַיהוה כָּל־הָאָרֶץ,

פִּצְחוּ וְרַנְּנוּ וְזַמֵּרוּ:

זַמְּרוּ לַיהוה בְּכִנּוֹר,

בְּכִנּוֹר וְקוֹל זִמְרָה:

בַּחֲצֹצְרוֹת וְקוֹל שׁוֹפָר,

הָרִיעוּ לִפְנֵי הַמֶּלֶךְ יהוה:

יִרְעַם הַיָּם וּמְלֹאוֹ,

תֵּבֵל וְיֹשְׁבֵי בָהּ:

נְהָרוֹת יִמְחֲאוּ־כָף,

יַחַד הָרִים יְרַנֵּנוּ:

לִפְנֵי־יהוה כִּי בָא לִשְׁפֹּט הָאָרֶץ,

יִשְׁפֹּט־תֵּבֵל בְּצֶדֶק, וְעַמִּים בְּמֵישָׁרִים:

A Psalm. Sing

a new song to the Lord, for He has done wonders.

His right hand and His holy arm

Have given Him victory.

The Lord has proclaimed His saving help.

He has revealed His victory to the nations.

He remembered to do acts of kindness and loyalty to the house of Israel

All the ends of the earth have observed the victory of our God.

Shout to the Lord, all the earth!

Open your mouths, shout, and sing!

Sing to the Lord with the lyre,

With the lyre and the sound of singing.

To the sound of trumpets and horn blasts.

Shout in acclaim of the Lord, the King.

Let the sea and all that is in it thunder,

The earth and those who dwell on it.

Let the rivers clap their hands,

the mountains shout together

Before the Lord, for He comes to judge the earth.

He judges the world with justice and the nations in equity.

The Lord

reigns! Let the nations tremble— מֶלֶךְ יִרְגְּזוּ עַמִּים,

He is enthroned on the Cherubim. Let the earth shake! יֹשֵׁב כְּרוּבִים תָּנוּט הָאָרֶץ:

The Lord is great in Zion, יְהוָה בְּצִיּוֹן גָּדוֹל,

Exalted over all the nations. וְרָם הוּא עַל־כָּל־הָעַמִּים:

Let them acknowledge Your name— יוֹדוּ שִׁמְךָ

Great and terrible One, גָּדוֹל וְנוֹרָא

Holy is He! קָדוֹשׁ הוּא:

And this mighty King loves justice. וְעֹז מֶלֶךְ מִשְׁפָּט אָהֵב,

You established righteousness, אַתָּה כּוֹנַנְתָּ מֵישָׁרִים,

performed justice and fairness מִשְׁפָּט וּצְדָקָה

In the house of Jacob. בְּיַעֲקֹב אַתָּה עָשִׂיתָ:

Exalt the Lord our God,

 Prostrate yourselves at His footstool.

 Holy is He!

Moses and Aaron were among His priests,

 Samuel among those who called upon His name:

 They called upon the Lord, and He would answer them.

He spoke to them in a pillar of cloud.

 They observed His testimonies,

 And the law that He gave to them.

O Lord, God: You answered them.

 You were a forgiving God to them,

 But took revenge for their misdeeds.

Exalt the Lord our God,

 Prostrate yourselves at His holy mountain,

 For holy is the Lord our God.

רוֹמְמוּ יְהוָה אֱלֹהֵינוּ

וְהִשְׁתַּחֲווּ לַהֲדֹם רַגְלָיו

קָדוֹשׁ הוּא:

מֹשֶׁה וְאַהֲרֹן בְּכֹהֲנָיו

וּשְׁמוּאֵל בְּקֹרְאֵי שְׁמוֹ

קֹרִאים אֶל־יְהוָה וְהוּא יַעֲנֵם:

בְּעַמּוּד עָנָן יְדַבֵּר אֲלֵיהֶם,

שָׁמְרוּ עֵדֹתָיו

וְחֹק נָתַן־לָמוֹ:

יְהוָה אֱלֹהֵינוּ אַתָּה עֲנִיתָם,

אֵל נֹשֵׂא הָיִיתָ לָהֶם,

וְנֹקֵם עַל־עֲלִילוֹתָם:

רוֹמְמוּ יְהוָה אֱלֹהֵינוּ

וְהִשְׁתַּחֲווּ לְהַר קָדְשׁוֹ,

כִּי־קָדוֹשׁ יְהוָה אֱלֹהֵינוּ:

37

מִזְמוֹר לְדָוִד

הָבוּ לַיהוה כָּבוֹד וָעֹז: לַיהוה בְּנֵי אֵלִים

הִשְׁתַּחֲווּ לַיהוה בְּהַדְרַת־קֹדֶשׁ: הָבוּ לַיהוה כְּבוֹד שְׁמוֹ

יהוה עַל־מַיִם רַבִּים: אֵל־הַכָּבוֹד הִרְעִים, קוֹל יהוה עַל־הַמָּיִם,

קוֹל יהוה בֶּהָדָר: קוֹל יהוה בַּכֹּחַ,

וַיְשַׁבֵּר יהוה אֶת־אַרְזֵי הַלְּבָנוֹן: קוֹל יהוה שֹׁבֵר אֲרָזִים,

לְבָנוֹן וְשִׂרְיֹן כְּמוֹ בֶן־רְאֵמִים: וַיַּרְקִידֵם כְּמוֹ־עֵגֶל,

קוֹל יהוה חֹצֵב לַהֲבוֹת אֵשׁ:

יָחִיל יהוה מִדְבַּר קָדֵשׁ: קוֹל יהוה יָחִיל מִדְבָּר

וַיֶּחֱשֹׂף יְעָרוֹת, קוֹל יהוה יְחוֹלֵל אַיָּלוֹת

וּבְהֵיכָלוֹ כֻּלּוֹ אֹמֵר כָּבוֹד:

וַיֵּשֶׁב יהוה מֶלֶךְ לְעוֹלָם: יהוה לַמַּבּוּל יָשָׁב,

יהוה יְבָרֵךְ אֶת־עַמּוֹ בַשָּׁלוֹם: יהוה עֹז לְעַמּוֹ יִתֵּן,

A psalm of David

Acclaim the Lord, O sons of gods,
Acclaim the Lord in His glory and might
Acclaim the Lord in His glorious name— Bow to the Lord in his glorious sanctuary.

The voice of the Lord was over the waters, The Lord over the endless waters.
The God of Glory thundered
The voice of the Lord came in power The voice of the Lord came in splendor.
The voice of the Lord split the cedars The Lord cracked the cedars of Lebanon,
them dance like calves Lebanon and Sirion like wild oxen.
The voice of the Lord, splitting flames of fire.
The voice of the Lord made the desert quake, the Lord made the desert of Kadesh quake.
The voice of the Lord made gazelles drop their young, stripped the forests.
Meanwhile, all in His palace were telling of His glory.

The Lord presided over the flood, The Lord presides as king forever.
May the Lord give strength to His folk, May the Lord bless His folk with peace.

אָנָּא, כֹּחַ גְּדֻלַּת יְמִינְךָ, תַּתִּיר צְרוּרָה.

קַבֵּל רִנַּת עַמְּךָ, שַׂגְּבֵנוּ, טַהֲרֵנוּ, נוֹרָא.

אָ בּוֹר דוֹרְשֵׁי יִחוּדְךָ, כְּבָבַת שָׁמְרֵם.

בָּרְכֵם, טַהֲרֵם, רַחֲמֵם, צִדְקָתְךָ תָּמִיד גָּמְלֵם.

חֲסִין קָדוֹשׁ, בְּרֹב טוּבְךָ נַהֵל עֲדָתֶךָ

יָחִיד גֵּאֶה, לְעַמְּךָ פְּנֵה, זוֹכְרֵי קְדֻשָּׁתֶךָ.

שַׁוְעָתֵנוּ קַבֵּל, וּשְׁמַע צַעֲקָתֵנוּ, יוֹדֵעַ תַּעֲלוּמוֹת.

בָּרוּךְ שֵׁם כְּבוֹד מַלְכוּתוֹ לְעוֹלָם וָעֶד.

O, with the might of Your great right hand, release the captive one. Accept Your people's prayer. Lift us up, purify us, Fearsome One. O Mighty, One, protect those who promote Your unity like the pupil of Your eye. Bless them, purify them, have mercy on them, grant them Your righteousness ever. Mighty, Holy One, in Your great kindness lead Your community. Proud, Unique One, turn to Your people, who speak of Your holiness. Accept our prayer and hear our cry, O You who know the mysteries. Blessed is the name of His glorious majesty forever and ever.

לְכָה דוֹדִי

Come my friend

to greet the bride. Let us welcome the Sabbath.

לְקְרַאת כַּלָּה פְּנֵי שַׁבָּת נְקַבְּלָה

שָׁמוֹר וְזָכוֹר בְּדִבּוּר אֶחָד

הִשְׁמִיעָנוּ אֵל הַמְיֻחָד.

יהוה אֶחָד וּשְׁמוֹ אֶחָד

לְשֵׁם וּלְתִפְאֶרֶת וְלִתְהִלָּה.

"Observe and Remember" in a single word

the one God gave us the command.

The Lord is one, and His name is one—

in honor and splendor and praise.

לְכָה דוֹדִי לִקְרַאת כַּלָּה
פְּנֵי שַׁבָּת נְקַבְּלָה.

Come, my friend, to greet the bride—
Let us welcome the Sabbath.

לִקְרַאת שַׁבָּת לְכוּ וְנֵלְכָה,

כִּי הִיא מְקוֹר הַבְּרָכָה

מֵרֹאשׁ מִקֶּדֶם נְסוּכָה

סוֹף מַעֲשֶׂה בְּמַחֲשָׁבָה תְחִלָּה.

Come, let us all go to welcome the Sabbath,

for she is the source of blessing.

Crowned from the first, from of old.

the last of God's deeds, the first in His plan.

לְכָה דוֹדִי לִקְרַאת כַּלָּה
פְּנֵי שַׁבָּת נְקַבְּלָה.

Come, my friend, to greet the bride—
Let us welcome the Sabbath.

מִקְדַּשׁ מֶלֶךְ עִיר מְלוּכָה

קוּמִי צְאִי מִתּוֹךְ הַהֲפֵכָה

רַב לָךְ שֶׁבֶת בְּעֵמֶק הַבָּכָא

וְהוּא יַחֲמֹל עָלַיִךְ חֶמְלָה.

O Royal Temple, O Royal City!

Rise up! Come forth out of your ruins!

Long enough have you dwelt in the valley of tears.

He will take pity on you, He will take pity.

לְכָה דוֹדִי לִקְרַאת כַּלָּה
פְּנֵי שַׁבָּת נְקַבְּלָה.

Come, my friend, to greet the bride—
Let us welcome the Sabbath.

הִתְנַעֲרִי, מֵעָפָר קוּמִי

לִבְשִׁי בִּגְדֵי תִפְאַרְתֵּךְ עַמִּי

עַל יַד בֶּן יִשַׁי בֵּית הַלַּחְמִי

קָרְבָה אֶל נַפְשִׁי גְאָלָה.

לְכָה דוֹדִי לִקְרַאת כַּלָּה
פְּנֵי שַׁבָּת נְקַבְּלָה

Shake yourself off from the dust, and arise!

Put on your splendid robes, O my people.

Through Jesse's son, the man of Bethlehem,

come near to my soul and save it.

Come my friend to greet the bride.
Let us welcome the Sabbath.

הִתְעוֹרְרִי הִתְעוֹרְרִי

כִּי בָא אוֹרֵךְ קוּמִי אוֹרִי

עוּרִי! עוּרִי! שִׁיר דַּבֵּרִי

כְּבוֹד יהוה עָלַיִךְ נִגְלָה.

לְכָה דוֹדִי לִקְרַאת כַּלָּה
פְּנֵי שַׁבָּת נְקַבְּלָה

Wake up! Wake up!

Your light has come! Get up and shine!

Wake! Wake! Utter song!

God's glory is revealed upon you.

Come my friend to greet the bride.
Let us welcome the Sabbath.

לֹא תֵבוֹשִׁי וְלֹא תִכָּלְמִי

מַה תִּשְׁתּוֹחֲחִי וּמַה תֶּהֱמִי?

בָּךְ יֶחֱסוּ עֲנִיֵּי עַמִּי

וְנִבְנְתָה עִיר עַל תִּלָּהּ.

לְכָה דוֹדִי לִקְרַאת כַּלָּה
פְּנֵי שַׁבָּת נְקַבְּלָה

Do not be ashamed, do not be abashed

Why are you downcast, why upset?

My people's poor will take refuge in you,

and the city will be built on the mounds of its ruins.

Come my friend to greet the bride.
Let us welcome the Sabbath.

וְהָיוּ לִמְשִׁסָּה שֹׁאסָיִךְ

וְרָחֲקוּ כָּל מְבַלְּעָיִךְ

יָשִׂישׂ עָלַיִךְ אֱלֹהָיִךְ

כִּמְשׂושׂ חָתָן עַל כַּלָּה.

Despoiled will be those who took your spoils
and those who devoured you will be removed afar.
Your God will rejoice in you
as a new husband rejoices in his bride.

לְכָה דוֹדִי לִקְרַאת כַּלָּה
פְּנֵי שַׁבָּת נְקַבְּלָה

Come, my friend to greet the bride:
Let us welcome the Sabbath.

יָמִין וּשְׂמֹאל תִּפְרֹצִי

וְאֶת יהוה תַּעֲרִיצִי

עַל יַד אִישׁ בֶּן פַּרְצִי

וְנִשְׂמְחָה וְנָגִילָה.

Rightward, leftward you will spread,
offering praises to the Lord
through the man descended from Peretz,
and we will be happy and rejoice.

לְכָה דוֹדִי לִקְרַאת כַּלָּה
פְּנֵי שַׁבָּת נְקַבְּלָה

Come, my friend to greet the bride:
Let us welcome the Sabbath.

בּוֹאִי בְשָׁלוֹם עֲטֶרֶת בַּעְלָהּ

גַּם בְּשִׂמְחָה וּבְצָהֳלָה

תּוֹךְ אֱמוּנֵי עַם סְגֻלָּה

בּוֹאִי כַלָּה! בּוֹאִי כַלָּה!

Enter in peace, O crown of your husband,
Both in jubilation and in joy
among the treasured people's faithful.
Enter, O bride! Enter, O bride!

לְכָה דוֹדִי לִקְרַאת כַּלָּה
פְּנֵי שַׁבָּת נְקַבְּלָה

Come, my friend to greet the bride:
Let us welcome the Sabbath.

45

מִזְמוֹר שִׁיר לְיוֹם הַשַּׁבָּת

טוֹב לְהֹדוֹת לַיהוה וּלְזַמֵּר לְשִׁמְךָ עֶלְיוֹן:

לְהַגִּיד בַּבֹּקֶר חַסְדֶּךָ וֶאֱמוּנָתְךָ בַּלֵּילוֹת:

עֲלֵי־עָשׂוֹר וַעֲלֵי־נָבֶל עֲלֵי הִגָּיוֹן בְּכִנּוֹר:

כִּי שִׂמַּחְתַּנִי יהוה בְּפָעֳלֶךָ בְּמַעֲשֵׂי יָדֶיךָ אֲרַנֵּן:

מַה־גָּדְלוּ מַעֲשֶׂיךָ יהוה מְאֹד עָמְקוּ מַחְשְׁבֹתֶיךָ:

אִישׁ־בַּעַר לֹא יֵדָע וּכְסִיל לֹא יָבִין אֶת־זֹאת:

בִּפְרֹחַ רְשָׁעִים כְּמוֹ עֵשֶׂב וַיָּצִיצוּ כָּל־פֹּעֲלֵי אָוֶן לְהִשָּׁמְדָם עֲדֵי־עַד:

וְאַתָּה מָרוֹם לְעֹלָם יהוה:

כִּי הִנֵּה אֹיְבֶיךָ יהוה כִּי־הִנֵּה אֹיְבֶיךָ יֹאבֵדוּ יִתְפָּרְדוּ כָּל־פֹּעֲלֵי אָוֶן:

וַתָּרֶם כִּרְאֵים קַרְנִי בַּלֹּתִי בְּשֶׁמֶן רַעֲנָן:

וַתַּבֵּט עֵינִי בְּשׁוּרָי בַּקָּמִים עָלַי מְרֵעִים תִּשְׁמַעְנָה אָזְנָי:

צַדִּיק כַּתָּמָר יִפְרָח כְּאֶרֶז בַּלְּבָנוֹן יִשְׂגֶּה:

שְׁתוּלִים בְּבֵית יהוה בְּחַצְרוֹת אֱלֹהֵינוּ יַפְרִיחוּ:

עוֹד יְנוּבוּן בְּשֵׂיבָה דְּשֵׁנִים וְרַעֲנַנִּים יִהְיוּ:

לְהַגִּיד כִּי־יָשָׁר יהוה צוּרִי וְלֹא־עַוְלָתָה בּוֹ:

46

A psalm. A song for the Sabbath day.

It is good to give thanks to the Lord, to sing to Your name, O Most High!

To speak of Your favors at morning, and Your steadfastness at night:

On a ten-string lyre, upon the lute, humming with a harp.

For You have gladdened me with Your deeds. I sing of what Your hands have wrought.

How great are Your deeds, O Lord, How profound Your thoughts.

A brutish man cannot know, a fool cannot grasp this:

When the wicked flourish like grass, when wrongdoers blossom,

It is only for their eternal ruin, but You are forever on high, O Lord.

For lo, Your enemies, O Lord, for lo, Your enemies will perish, all evildoers will be undone.

But You have raised my horn like a wild bull. I am anointed with refreshing oil.

My eyes observed my enemies; When the wicked rose against me, my ears were informed.

The righteous will flourish like a palm tree, grow lofty as a cedar in Lebanon.

Planted in the house of the Lord, blooming in the courts of our God.

Giving fruit into old age, Luxuriant and verdant will they be.

Telling that God is good— my rock, with no wickedness in Him.

The Lord

reigns! He is robed in majesty.
The Lord is robed, girded in might!
The world too is set firm.
It does not totter.
Your throne has been firmly set from of old.
You are eternal.

The rivers raise, O Lord,
The rivers raise their voice,
The rivers raise their surge.
Mightier than the voices of multitudinous waters,
Than the mighty breakers of the sea,
Lord is mighty on high.
Your covenants are surely steadfast.
For Your house, the Holy Sanctuary,
O Lord, for ever more.

יִתְגַּדַּל וְיִתְקַדַּשׁ שְׁמֵהּ רַבָּא אָמֵן

בְּעָלְמָא דִּי בְרָא כִרְעוּתֵהּ

וְיַמְלִיךְ מַלְכוּתֵהּ

בְּחַיֵּיכוֹן וּבְיוֹמֵיכוֹן וּבְחַיֵּי דְכָל בֵּית יִשְׂרָאֵל

בַּעֲגָלָא וּבִזְמַן קָרִיב,

וְאִמְרוּ אָמֵן. אָמֵן יְהֵא שְׁמֵהּ רַבָּה מְבָרַךְ לְעָלַם וּלְעָלְמֵי עָלְמַיָּא.

יִתְבָּרַךְ וְיִשְׁתַּבַּח וְיִתְפָּאַר

וְיִתְרוֹמַם וְיִתְנַשֵּׂא וְיִתְהַדָּר

וְיִתְעַלֶּה וְיִתְהַלָּל שְׁמֵהּ דְּקֻדְשָׁא בְּרִיךְ הוּא בְּרִיךְ הוּא

לְעֵלָּא מִן כָּל בִּרְכָתָא וְשִׁירָתָא תֻּשְׁבְּחָתָא וְנֶחֱמָתָא דַּאֲמִירָן בְּעָלְמָא,

וְאִמְרוּ אָמֵן. אָמֵן

יְהֵא שְׁלָמָא רַבָּא מִן שְׁמַיָּא, וְחַיִּים, עָלֵינוּ וְעַל כָּל יִשְׂרָאֵל

וְאִמְרוּ אָמֵן. אָמֵן

עֹשֶׂה שָׁלוֹם בִּמְרוֹמָיו, הוּא יַעֲשֶׂה שָׁלוֹם עָלֵינוּ, וְעַל כָּל יִשְׂרָאֵל,

וְאִמְרוּ אָמֵן. אָמֵן

Magnified and sanctified be the Great Name
In accordance with His will, in the world that He created,
May His Kingdom be established
In your lives and in your days and in the lifetime of all Israel.
Speedily and soon.
Say: Amen. Amen. May the Great Name be blessed forever and ever.

Blessed, praised, extolled,
elevated, raised up,
glorified, lauded, and exalted
be the name of the Holy One, blessed is He
high above all songs and blessings, praises and hymns that are spoken
in the world.
Say: Amen. Amen

May great peace and life from heaven be upon us and all Israel.
Say: Amen. Amen

May He who makes peace in His heaven make peace for us and all Israel.
Say: Amen. Amen

בַּמֶּה מַדְלִיקִין וּבַמָּה אֵין מַדְלִיקִין. אֵין מַדְלִיקִין לֹא בְלֶכֶשׁ, וְלֹא בְחֹסֶן, וְלֹא בְכַלָּךְ,
וְלֹא בִּפְתִילַת הָאִידָן, וְלֹא בִּפְתִילַת הַמִּדְבָּר, וְלֹא בִירוֹקָה שֶׁעַל פְּנֵי הַמָּיִם. וְלֹא
בְזֶפֶת, וְלֹא בְשַׁעֲוָה וְלֹא בְשֶׁמֶן קִיק וְלֹא בְשֶׁמֶן שְׂרֵפָה וְלֹא בְאַלְיָה וְלֹא בְחֵלֶב. נַחוּם הַמָּדִי
אוֹמֵר: מַדְלִיקִין בְּחֵלֶב מְבֻשָּׁל, וַחֲכָמִים אוֹמְרִים; אֶחָד מְבֻשָּׁל וְאֶחָד שֶׁאֵינוֹ מְבֻשָּׁל. אֵין
מַדְלִיקִין בּוֹ.

אֵין מַדְלִיקִין בְּשֶׁמֶן שְׂרֵפָה בְּיוֹם טוֹב. רַבִּי יִשְׁמָעֵאל אוֹמֵר: אֵין מַדְלִיקִין בְּעִטְרָן
מִפְּנֵי כְבוֹד הַשַּׁבָּת. וַחֲכָמִים מַתִּירִין בְּכָל הַשְּׁמָנִים, בְּשֶׁמֶן שֻׁמְשְׁמִין, בְּשֶׁמֶן אֱגוֹזִים,
בְּשֶׁמֶן צְנוֹנוֹת, בְּשֶׁמֶן דָּגִים, בְּשֶׁמֶן פַּקּוּעוֹת, בְּעִטְרָן וּבְנֵפְט. רַבִּי טַרְפוֹן אוֹמֵר: אֵין מַדְלִיקִין
אֶלָּא בְּשֶׁמֶן זַיִת בִּלְבַד.

כָּל הַיּוֹצֵא מִן הָעֵץ אֵין מַדְלִיקִין בּוֹ, אֶלָּא פִשְׁתָּן. וְכָל הַיּוֹצֵא מִן הָעֵץ אֵינוֹ מִטַּמֵּא
טֻמְאַת אֹהָלִים, אֶלָּא פִשְׁתָּן. פְּתִילַת הַבֶּגֶד שֶׁקִּפְּלָהּ וְלֹא הִבְהֲבָהּ, רַבִּי אֱלִיעֶזֶר אוֹמֵר:
טְמֵאָה הִיא, וְאֵין מַדְלִיקִין בָּהּ. רַבִּי עֲקִיבָא אוֹמֵר: טְהוֹרָה הִיא, וּמַדְלִיקִין בָּהּ.

לֹא יִקֹּב אָדָם שְׁפוֹפֶרֶת שֶׁל בֵּיצָה וִימַלְּאֶנָּה שֶׁמֶן וְיִתְּנֶנָּה עַל פִּי הַנֵּר, בִּשְׁבִיל שֶׁתְּהֵא
מְנַטֶּפֶת, וַאֲפִילוּ הִיא שֶׁל חֶרֶס. וְרַבִּי יְהוּדָה מַתִּיר. אֲבָל אִם חִבְּרָהּ הַיּוֹצֵר מִתְּחִלָּה
מֻתָּר, מִפְּנֵי שֶׁהוּא כְלִי אֶחָד. לֹא יְמַלֵּא אָדָם אֶת הַקְּעָרָה שֶׁמֶן וְיִתְּנֶנָּה בְּצַד הַנֵּר וְיִתֵּן
רֹאשׁ הַפְּתִילָה בְּתוֹכָהּ, בִּשְׁבִיל שֶׁתְּהֵא שׁוֹאֶבֶת, וְרַבִּי יְהוּדָה מַתִּיר.

1 With what wicks may we light the sabbath lamp and with what may we not light? We may not use a wick of cedar bast, or uncombed flax, or raw silk, or a wick made of willow bast or desert weed, or seaweed. (For oil) we may not use pitch or wax, or cottonseed oil or (contaminated consecrated) oil that must be destroyed by burning, or fat from sheeps' tail or tallow. Nahum the Mede says: We may use boiled tallow. But the Sages say: Whether boiled or not boiled, we may not use it.

2 (Contaminated consecrated) oil that must be destroyed by burning may not be used for a festival lamp. Rabbi Ishmael says: We may not use tar out of respect for the honor due to the Sabbath. But the Sages permit all these oils: sesame oil, nut oil, radish oil, fish oil, gourd oil, tar or naptha. Rabbi Tarfon, however, says: We may use only olive-oil.

3 No product from a tree may be used as a wick for the sabbath lamp, except flax. Also no product of a tree can contract "tent" uncleanness, except flax. If a wick was made from a cloth that has been twisted but not singed, Rabbi Eliezer declares, it is susceptible to contamination and may not be used for the sabbath lamp.

4 One may not pierce an eggshell, fill it with oil, and put it over the mouth of a lamp so that the oil may drip from it into the lamp, even if the vessel is of earthenware, but Rabbi Judah permits it. If, however, the potter had originally attached it to the lamp, it is permitted because it constitutes a single vessel. One may not fill a bowl with oil, put it beside a lamp, and put the end of the wick in it so that it draws oil from the bowl; but Rabbi Judah permits this.

הַמְכַבֶּה אֶת הַנֵּר מִפְּנֵי שֶׁהוּא מִתְיָרֵא מִפְּנֵי גוֹיִם, מִפְּנֵי לִסְטִים, מִפְּנֵי רוּחַ רָעָה,

אִ בִּשְׁבִיל הַחוֹלֶה שֶׁיִּישָׁן, פָּטוּר. כְּחָס עַל הַנֵּר, כְּחָס עַל הַשֶּׁמֶן, כְּחָס עַל

הַפְּתִילָה, חַיָּב. רַבִּי יוֹסֵי פוֹטֵר בְּכֻלָּן חוּץ מִן הַפְּתִילָה, מִפְּנֵי שֶׁהוּא עוֹשָׂה פֶּחָם.

עַל שָׁלֹשׁ עֲבֵרוֹת נָשִׁים מֵתוֹת בִּשְׁעַת לֵדָתָן, עַל שֶׁאֵינָן זְהִירוֹת בַּנִּדָּה, בַּחַלָּה,

וּבְהַדְלָקַת הַנֵּר.

שְׁלֹשָׁה דְבָרִים צָרִיךְ אָדָם לוֹמַר בְּתוֹךְ בֵּיתוֹ עֶרֶב שַׁבָּת עִם חֲשֵׁכָה: עִשַּׂרְתֶּם,

עֵרַבְתֶּם, הַדְלִיקוּ אֶת הַנֵּר. סָפֵק חֲשֵׁכָה סָפֵק אֵינָה חֲשֵׁכָה, אֵין מְעַשְּׂרִין אֶת הַוַּדַּאי, וְאֵין

מַטְבִּילִין אֶת הַכֵּלִים, וְאֵין מַדְלִיקִין אֶת הַנֵּרוֹת. אֲבָל מְעַשְּׂרִין אֶת הַדְּמַאי, וּמְעָרְבִין

וְטוֹמְנִין אֶת הַחַמִּין.

תַּנְיָא, אָמַר רַבִּי חֲנִינָא: חַיָּב אָדָם לְמַשְׁמֵשׁ בְּגָדָיו בְּעֶרֶב שַׁבָּת עִם חֲשֵׁכָה,

שֶׁמָּא יִשְׁכַּח וְיֵצֵא. אָמַר רַב יוֹסֵף: הִלְכְתָא רַבְּתָא לְשַׁבְּתָא.

אָמַר רַבִּי אֶלְעָזָר, אָמַר רַבִּי חֲנִינָא: תַּלְמִידֵי חֲכָמִים מַרְבִּים שָׁלוֹם בָּעוֹלָם,

שֶׁנֶּאֱמַר: וְכָל-בָּנַיִךְ לִמּוּדֵי יהוה, וְרַב שְׁלוֹם בָּנָיִךְ: אַל תִּקְרֵי בָּנָיִךְ, אֶלָּא בּוֹנָיִךְ. שָׁלוֹם רָב לְאֹהֲבֵי

תוֹרָתֶךָ וְאֵין-לָמוֹ מִכְשׁוֹל: יְהִי-שָׁלוֹם בְּחֵילֵךְ, שַׁלְוָה בְּאַרְמְנוֹתָיִךְ. לְמַעַן אַחַי וְרֵעָי אֲדַבְּרָה-נָּא שָׁלוֹם

בָּךְ: לְמַעַן בֵּית-יהוה אֱלֹהֵינוּ אֲבַקְשָׁה טוֹב לָךְ: יהוה עֹז לְעַמּוֹ יִתֵּן, יהוה יְבָרֵךְ אֶת-עַמּוֹ בַשָּׁלוֹם.

5 One who extinguishes a lamp because he is afraid of heathens, robbers, or depression, or to enable a sick person to sleep, is not liable (for violating the Sabbath). If he did it to spare the lamp or the oil, or the wick, he is liable. Rabbi Yose absolves him in all these cases except that of sparing the wick, because he thereby turns it into charcoal.

6 For three transgressions women may die in childbirth: for being careless in observing the laws of menstruation, separating challah (dough-offering), and lighting the Sabbath light.

7 One should say three things at home on the eve of the Sabbath just before dark: have you tithed? Have you prepared the Eruv? Light the Sabbath lamp. If there is doubt whether or not darkness has fallen, we may not tithe definitely tithed produce, nor immerse (unclean) vessels, nor light the Sabbath lamp. We may tithe produce about which there is doubt whether it has been tithed or not, we may prepare an Eruv, and insulate hot food.

It was taught, Rabbi Hanina said: One should examine his clothing on the eve of the Sabbath before nightfall (to ensure that one is not carrying anything), for one may forget and go out. Rav Yosef said: This is an important law about the Sabbath (for it is easy to forget, and thus inadvertently violate the holiness of the day).

Rabbi Eliezer said in the name of Rabbi Hanina: The disciples of the sages increase peace in the world, as it is said, "And all your children shall be taught of the Lord and great shall be the peace of your children (banayikh)." Read not banayikh, "your children," but bonayikh, "your builders." Those who love Your Torah have great peace; there is no stumbling block for them. May there be peace within your ramparts, prosperity in your palaces. For the sake of my brothers and friends, I shall say, "Peace be within you." For the sake of the House of the Lord our God, I will seek your good. May the Lord grant strength to His people; may the Lord bless His people with peace.

יִתְגַּדַּל

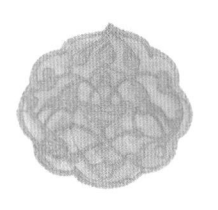

וְיִתְקַדַּשׁ שְׁמֵהּ רַבָּה אָמֵן

בְּעָלְמָא דִּי בְרָא כִרְעוּתֵהּ

וְיַמְלִיךְ מַלְכוּתֵהּ

בְּחַיֵּיכוֹן וּבְיוֹמֵיכוֹן וּבְחַיֵּי דְכָל בֵּית יִשְׂרָאֵל

בַּעֲגָלָא וּבִזְמַן קָרִיב וְאִמְרוּ אָמֵן. אָמֵן

יְהֵא שְׁמֵהּ רַבָּא מְבָרַךְ לְעָלַם וּלְעָלְמֵי עָלְמַיָּא.

יִתְבָּרַךְ וְיִשְׁתַּבַּח וְיִתְפָּאַר וְיִתְרוֹמַם וְיִתְנַשֵּׂא

וְיִתְהַדָּר וְיִתְעַלֶּה וְיִתְהַלָּל שְׁמֵהּ דְּקֻדְשָׁא בְּרִיךְ הוּא בְּרִיךְ הוּא

לְעֵלָּא מִן כָּל בִּרְכָתָא

(בשבת שובה לְעֵלָּא לְעֵלָּא מִכָּל בִּרְכָתָא) וְשִׁירָתָא. תֻּשְׁבְּחָתָא וְנֶחֱמָתָא, דַּאֲמִירָן בְּעָלְמָא,

וְאִמְרוּ אָמֵן. אָמֵן

עַל יִשְׂרָאֵל וְעַל רַבָּנָן

וְעַל תַּלְמִידֵיהוֹן וְעַל כָּל תַּלְמִידֵי תַלְמִידֵיהוֹן

וְעַל כָּל מָאן דְּעָסְקִין בְּאוֹרַיְתָא

דִּי בְאַתְרָא (ישראל קַדִּישָׁא) הָדֵין. וְדִי בְכָל אֲתַר וַאֲתַר

יְהֵא לְהוֹן וּלְכוֹן שְׁלָמָא רַבָּא

חִנָּא וְחִסְדָּא, וְרַחֲמֵי

וְחַיֵּי אֲרִיכֵי. וּמְזוֹנֵי רְוִיחֵי וּפֻרְקָנָא מִן קֳדָם אֲבוּהוֹן דִּי בִשְׁמַיָּא

וְאִמְרוּ אָמֵן. אָמֵן

יְהֵא שְׁלָמָא רַבָּא מִן שְׁמַיָּא וְחַיִּים (טוֹבִים) עָלֵינוּ וְעַל כָּל יִשְׂרָאֵל

וְאִמְרוּ אָמֵן. אָמֵן

עֹשֶׂה שָׁלוֹם (בשבת שובה הַשָּׁלוֹם) בִּמְרוֹמָיו הוּא יַעֲשֶׂה בְרַחֲמָיו שָׁלוֹם, עָלֵינוּ

וְעַל כָּל יִשְׂרָאֵל וְאִמְרוּ אָמֵן. אָמֵן

Magnified and sanctified be the Great Name

In accordance with His will, in the world that He created,

May His kingdom be established

In your lives and in your days and in the lifetime of all Israel,

Speedily and soon. Say: Amen.

May the Great Name be blessed forever and ever:

Blessed, praised, extolled,

elevated, raised up,

glorified, lauded, and exalted

be the name of the Holy One, blessed is He,

high above all songs and blessings, praises and hymns that are spoken in the world.

Say: Amen

Upon Israel and its rabbis,

Their disciples and their disciples' disciples,

And all who occupy themselves with the Torah,

In this place and in every place

—upon them and upon you—

May there be much peace, favor, grace and mercy,

Long life, abundant food, and salvation from their Father in heaven. Say: Amen.

May great peace and good life from heaven be upon us and all Israel. Say: Amen.

May He who makes peace in His heaven make peace for us and all Israel in His mercy.

Say: Amen.

Happy are all who fear the Lord,

who follow His ways.

You shall enjoy the fruit of your labors;

you shall be happy and you shall prosper.

Your wife shall be like a fruitful vine within your house;

your sons, like olive sprouts around your table.

So shall the man who fears the Lord be blessed.

May the Lord bless you from Zion;

may you share the prosperity of Jerusalem

all the days of your life,

and live to see your children's chidren.

Peace upon Israel!

—Psalm 128




יְבָרֶכְךָ

יהוה וְיִשְׁמְרֶךָ:

יָאֵר יהוה פָּנָיו אֵלֶיךָ וִיחֻנֶּךָּ:

יִשָּׂא יהוה פָּנָיו אֵלֶיךָ וְיָשֵׂם לְךָ שָׁלוֹם:

60

They . shall . come . and . sing . in . the . height . of . Zion . and . shall . flow . to . the . bounty . of . the . Lord, . for . wheat . and . for . wine . and . for . oil . and . for . the . young . of . the . flock . and . of . the . herd . and . their . soul . shall . be . like . a . watered . garden .

May God make you like Ephraim and Menasseh

May God make you like Sarah, Rebecca, Rachel and Leah.

May

the Lord bless you and protect you.
May the Lord shine His face upon you and favor you.
May the Lord lift His face toward you and grant you peace.

Welcome servant-angels,

messengers of the Highest

from the King, the King of Kings, the Blessed Holy One.

שָׁלוֹם עֲלֵיכֶם

מַלְאֲכֵי הַשָּׁרֵת, מַלְאֲכֵי עֶלְיוֹן,

מִמֶּלֶךְ מַלְכֵי הַמְּלָכִים הַקָּדוֹשׁ בָּרוּךְ הוּא

Come in peace,

angels of peace, messengers of the Highest,

from the King, the King of Kings, the Blessed Holy One.

בּוֹאֲכֶם לְשָׁלוֹם,

מַלְאֲכֵי הַשָּׁלוֹם, מַלְאֲכֵי עֶלְיוֹן,

מִמֶּלֶךְ מַלְכֵי הַמְּלָכִים, הַקָּדוֹשׁ בָּרוּךְ הוּא.

Bless me with peace,

angels of peace, messengers of the Highest

from the King, the King of Kings, the Blessed Holy One.

בָּרְכוּנִי לְשָׁלוֹם,

מַלְאֲכֵי הַשָּׁלוֹם, מַלְאֲכֵי עֶלְיוֹן,

מִמֶּלֶךְ מַלְכֵי הַמְּלָכִים, הַקָּדוֹשׁ בָּרוּךְ הוּא.

Go in peace,

angels of peace, messengers of the Highest

from the King, the King of Kings, the Blessed Holy One.

צֵאתְכֶם לְשָׁלוֹם,

מַלְאֲכֵי הַשָּׁלוֹם, מַלְאֲכֵי עֶלְיוֹן,

מִמֶּלֶךְ מַלְכֵי הַמְּלָכִים, הַקָּדוֹשׁ בָּרוּךְ הוּא.

For He will order His angels in your behalf

to protect you wherever you go.

The Lord will guard your comings and goings

now and forever.

כִּי מַלְאָכָיו יְצַוֶּה-לָּךְ

לִשְׁמָרְךָ בְּכָל-דְּרָכֶיךָ

יְהוה יִשְׁמָר-צֵאתְךָ וּבוֹאֶךָ,

מֵעַתָּה וְעַד-עוֹלָם.

A powerful woman — who can find one?
Her worth would be far beyond pearls.
Her husband's heart can count on her,
and lack no gain.
She does him good and never harm
All her life-long.
She goes looking for wool and flax.
Her hands work with a will.
Like a merchant ship she is —
From afar she brings her bread.
She rises while it is still night
To give food to her family
And their due to her maids.
She considers a field and buys it.
Plants a vineyard with her hands' yield.
She ties her belt on firmly,
braces her arms.
She realizes that her business goes well.
Her lamp does not go out at night.
She sets her hand to the distaff.
Her palms hold up the spindle.
She opens her palm to the poor.
She stretches her hand to the pauper.

אֵשֶׁת חַיִל מִי יִמְצָא,
וְרָחֹק מִפְּנִינִים מִכְרָהּ:
בָּטַח בָּהּ לֵב בַּעְלָהּ, וְשָׁלָל לֹא יֶחְסָר:
גְּמָלַתְהוּ טוֹב וְלֹא־רָע כֹּל יְמֵי חַיֶּיהָ:
דָּרְשָׁה צֶמֶר וּפִשְׁתִּים, וַתַּעַשׂ בְּחֵפֶץ כַּפֶּיהָ:
הָיְתָה כָּאֳנִיּוֹת סוֹחֵר, מִמֶּרְחָק תָּבִיא לַחְמָהּ:
וַתָּקָם בְּעוֹד לַיְלָה וַתִּתֵּן טֶרֶף לְבֵיתָהּ,
וְחֹק לְנַעֲרֹתֶיהָ:
זָמְמָה שָׂדֶה וַתִּקָּחֵהוּ,
מִפְּרִי כַפֶּיהָ נטע כָּרֶם:
חָגְרָה בְעוֹז מָתְנֶיהָ, וַתְּאַמֵּץ זְרוֹעֹתֶיהָ:
טָעֲמָה כִּי־טוֹב סַחְרָהּ,
לֹא־יִכְבֶּה בליל נֵרָהּ:
יָדֶיהָ שִׁלְּחָה בַכִּישׁוֹר, וְכַפֶּיהָ תָּמְכוּ פָלֶךְ:
כַּפָּהּ פָּרְשָׂה לֶעָנִי, וְיָדֶיהָ שִׁלְּחָה לָאֶבְיוֹן:
לֹא־תִירָא לְבֵיתָהּ מִשָּׁלֶג,

She has no fear for her household in snow
for all her household wear scarlet wool
She provides bedding for herself,
Linen and crimson are her garments.
Her husband is distinguished in the city gates,
sitting among the elders of the land.
She makes wraps and sells them,
supplies sashes to merchants.
Her own clothing is strength and splendor,
she can laugh at the future
She opens her mouth with wisdom,
on her tongue are kindly adages.
She keeps an eye on the doings of her household
and never eats idle bread.
Her children rise to bless her,
Her husband, to praise her.
Many women are powerful
but you excel them all.
Charm is false and beauty fleeting,
a God-fearing woman alone deserves praise.
Celebrate the fruit of her two hands
Her accomplishments praise her
in the city square.

כִּי כָל־בֵּיתָהּ לָבֻשׁ שָׁנִים:

מַרְבַדִּים עָשְׂתָה־לָּהּ שֵׁשׁ וְאַרְגָּמָן לְבוּשָׁהּ:

נוֹדָע בַּשְּׁעָרִים בַּעְלָהּ בְּשִׁבְתּוֹ עִם־זִקְנֵי־אָרֶץ:

סָדִין עָשְׂתָה וַתִּמְכֹּר וַחֲגוֹר נָתְנָה לַכְּנַעֲנִי:

עֹז־וְהָדָר לְבוּשָׁהּ

וַתִּשְׂחַק לְיוֹם אַחֲרוֹן:

פִּיהָ פָּתְחָה בְחָכְמָה

וְתוֹרַת־חֶסֶד עַל־לְשׁוֹנָהּ:

צוֹפִיָּה הֲלִיכוֹת בֵּיתָהּ

וְלֶחֶם עַצְלוּת לֹא תֹאכֵל:

קָמוּ בָנֶיהָ וַיְאַשְּׁרוּהָ בַּעְלָהּ וַיְהַלְלָהּ:

רַבּוֹת בָּנוֹת עָשׂוּ חָיִל וְאַתְּ עָלִית עַל־כֻּלָּנָה:

שֶׁקֶר הַחֵן וְהֶבֶל הַיֹּפִי

אִשָּׁה יִרְאַת־יְהוָה הִיא תִתְהַלָּל:

תְּנוּ־לָהּ מִפְּרִי יָדֶיהָ

וִיהַלְלוּהָ בַשְּׁעָרִים מַעֲשֶׂיהָ:

Prepare the feast of perfect faith,
the joy of the Holy King.
Prepare the feast of the King.
This is the feast of the Holy Apple Orchard,
And the Impatient One and the Ancient Holy One
come to dine with her.

I now sing songs of praise
to enter the gates
of the Field of Apple Trees
that are holy.

We herewith welcome Her
with a new table
and a well-trimmed lamp
shining on every head,

one on the right and one on the left,
and the bride walks between them
with her ornaments,
fine clothes and raiment.

אַתְקִינוּ סְעוּדָתָא דִּמְהֵימְנוּתָא שְׁלִימְתָא
חֶדְוָתָא דְּמַלְכָּא קַדִּישָׁא.
אַתְקִינוּ סְעוּדָתָא דְּמַלְכָּא.
דָּא הִיא סְעוּדָתָא דַּחֲקַל תַּפּוּחִין קַדִּישִׁין
וּזְעֵיר אַנְפִּין וְעַתִּיקָא קַדִּישָׁא אָתְיָן לְסַעֲדָא בַּהֲדַהּ.

אֲזַמֵּר בִּשְׁבָחִין
לְמֵיעַל גּוֹ פִתְחִין
דְּבַחֲקַל תַּפּוּחִין
דְּאִנּוּן קַדִּישִׁין.

נְזַמֵּן לַהּ הַשְׁתָּא
בִּפְתוֹרָא חַדְתָּא
וּבִמְנַרְתָּא טָבְתָא
דְּנַהֲרָא עַל רֵישִׁין.

יְמִינָא וּשְׂמָאלָא
וּבֵינַיְהוּ כַלָּה
בְּקִשּׁוּטִין אָזְלָא
וּמָאנִין וּלְבוּשִׁין.

Her husband embraces Her,
and into Her foundation
he pours His pressings.
which give Her pleasure.

Cries and suffering
are canceled and annulled,
but every face rejoices;
every soul and spirit.

Great joy comes,
in a double measure.
Light reaches Her,
abundant blessings, too.

Groomsmen, come here
and make the preparations!
Set out abundant food,
fish and fowl.

making new
souls and spirits
by virtue of the Thirty-Two
and the Three Twigs.

יְחַבֵּק לַהּ בַּעְלָהּ

וּבִיסוֹדָא דִילָהּ

דְּעָבֵד נַיְחָא לַהּ

יְהֵא כַּתֵּשׁ כַּתִּישִׁין

צְוָחִין אַף עָקָתִין

בְּטִילִין וּשְׁבִיתִין

בְּרַם אַנְפִּין חַדְתִּין

וְרוּחִין עִם נַפְשִׁין

חֲדוּ סַגִּי וְיֵיתֵי

וְעַל חֲדָא תַּרְתֵּי

נְהוֹרָא לַהּ יִמְטֵי

וּבִרְכָאן דְּנָפְשִׁין

קְרִיבוּ שׁוֹשְׁבִינִין

עֲבִידוּ תִקּוּנִין

לְאַפָּשָׁא זִינִין

וְנוּנִין עִם רַחֲשִׁין

לְמֶעְבַּד נִשְׁמָתִין

וְרוּחִין חַדְתִּין

בְּתַרְתֵּין וּבִתְלָתִין

וּבִתְלָתָא שְׁבִישִׁין

Seventy crown She has,
with the king above—
that all may be crowned
by the holiest of the holy ones.

Engraved and hidden
In her are all the worlds,
but the Ancient of Days
treads them out with His treading.

May it be His will
that She abide with His people—
who, for His name's sake,
take pleasure in honey and sweets.

On the south I place
the mystic lamp
and on the north I set
a table with abundant bread,

with wine in a goblet,
and bunches of myrtle
for the Groom and bride
to fortify the wine.

וְעִטּוּרִין שַׁבְעִין לַהּ.

וּמַלְכָּא דִּלְעֵלָּא

דְּיִתְעַטַּר כֹּלָּא

בְּקַדִּישׁ קַדִּישִׁין.

רְשִׁימִין וּסְתִימִין

בְּגוֹ כָּל עָלְמִין.

בְּרַם עַתִּיק יוֹמִין

הֲלָא בָטַשׁ בַּטִּישִׁין.

יְהֵא רַעֲוָא קַמֵּהּ

דְּיִשְׁרֵי עַל עַמֵּהּ

דְּיִתְעַנַּג לִשְׁמֵהּ

בְּמִתְקִין וְדֻבְשִׁין.

אֲסַדֵּר לִדְרוֹמָא

מְנַרְתָּא דִּסְתִימָה

וְשֻׁלְחָן עִם נַהֲמָא

בִּצְפוֹנָא אַרְשִׁין.

בְּחַמְרָא גוֹ כָסָא

וּמְדָאנֵי אָסָא

לְאָרוֹס וַאֲרוּסָה

לְהִתָּקְפָא חַלָּשִׁין.

Let us make them crowns
of precious words
with seventy ornaments
and fifty more– besides.

The Shekhinah is adorned
with six loaves on each side,
bound with two times six
and all the articles assembled.

Voided and abandoned
are impure causes of affliction,
oppressive, destroying spirits,
and all kinds of witchcraft.

The loaf is broken
into olive- and egg-size pieces
a loaf that grasps two yods,
one manifest, one hidden,.

Pure olive oil
is pressed by millstone-s
so that rivers of it flow
into Her with a whisper.

נַעֲבֵד לְהוֹן כִּתְרִין
בְּמִלִּין יַקִּירִין
בְּשַׁבְעִין עִטּוּרִין
דְּעַל גַּבֵּי חַמְשִׁין.

שְׁכִינְתָּא תִּתְעַטַּר
בְּשִׁית נַהֲמֵי לִסְטַר
בְּוָוִין תִּתְקַשַּׁר
וְזִינִין דִּכְנִישִׁין.

שְׁבִיתִין וּשְׁבִיקִין
מְסָאֲבִין דִּרְחִיקִין
חֲבִילִין דִּמְעִיקִין
וְכָל זִינֵי חֲבוּשִׁין.

לְמִבְצַע עַל רִפְתָּא
כְּזֵיתָא וּכְבֵיעֲתָה
תְּרֵין יוּדִין נָקְטָא
סְתִימִין וּפְרִישִׁין.

מְשַׁח זֵיתָא דַּכְיָא
דְּטָחֲנִין רֵיחַיָּא
וְנָגְדִין נַחֲלַיָּא
בְּגַוַּהּ בִּלְחִישִׁין.

We speak of mysteries,
esoteric words.
things not clearly seen
but hidden and obscured,

that we may crown the *Bride*
with supernal mysteries
in the wedding feast
of the Holy Watchers.

הֲלָא נֵימָא רָזִין
וּמִלֵּי דִגְנִיזִין
דְּלֵיתֵיהוֹן מִתְחַזְּרִין
טְמִירִין וּכְבִישִׁין.

אִתְעַטְּרַת כַּלָּה
בְּרָזִין דִּלְעֵלָּא
בְּגוֹ הַאי הִלּוּלָא
דְּעִירִין קַדִּישִׁין.

70

וַיְהִי עֶרֶב וַיְהִי בֹקֶר יוֹם הַשִּׁשִּׁי

וַיְכֻלּוּ הַשָּׁמַיִם וְהָאָרֶץ

וְכָל צְבָאָם

וַיְכַל אֱלֹהִים בַּיּוֹם הַשְּׁבִיעִי

מְלַאכְתּוֹ אֲשֶׁר עָשָׂה,

וַיִּשְׁבֹּת בַּיּוֹם הַשְּׁבִיעִי,

מִכָּל מְלַאכְתּוֹ אֲשֶׁר עָשָׂה. וַיְבָרֶךְ אֱלֹהִים אֶת יוֹם

הַשְּׁבִיעִי וַיְקַדֵּשׁ אֹתוֹ, כִּי בוֹ שָׁבַת מִכָּל

מְלַאכְתּוֹ, אֲשֶׁר בָּרָא אֱלֹהִים לַעֲשׂוֹת.

סַבְרִי מָרָנָן וְרַבָּנָן וְרַבּוֹתַי:

בָּרוּךְ אַתָּה יְהֹוָה

אֱלֹהֵינוּ מֶלֶךְ הָעוֹלָם,

בּוֹרֵא פְּרִי הַגָּפֶן.

בָּרוּךְ אַתָּה יהוה, אֱלֹהֵינוּ מֶלֶךְ הָעוֹלָם,

אֲשֶׁר קִדְּשָׁנוּ בְּמִצְוֹתָיו וְרָצָה בָנוּ, וְשַׁבַּת קָדְשׁוֹ

בְּאַהֲבָה וּבְרָצוֹן הִנְחִילָנוּ, זִכָּרוֹן לְמַעֲשֵׂה בְרֵאשִׁית,

כִּי הוּא יוֹם תְּחִלָּה לְמִקְרָאֵי קֹדֶשׁ, זֵכֶר לִיצִיאַת

מִצְרָיִם, כִּי בָנוּ בָחַרְתָּ וְאוֹתָנוּ קִדַּשְׁתָּ מִכָּל הָעַמִּים,

וְשַׁבַּת קָדְשְׁךָ בְּאַהֲבָה וּבְרָצוֹן הִנְחַלְתָּנוּ. בָּרוּךְ

אַתָּה יהוה מְקַדֵּשׁ הַשַּׁבָּת.

Evening came and morning came —
the sixth day.

The sky, the earth and all their vast contents
were completed.
By the seventh day, God had finished
all the work that he had done,
and so He rested on the seventh day
from all His work that He had done.
He blessed the seventh day
and set it apart as holy,
for that was when He rested from
making all the things that God created.
With the consent of all present

Blessed are you, Lord our God,
who created the fruit of the vine.
Blessed are you, Lord our God,
who set us apart by His commandments,
was pleased with us
and made His holy sabbath ours
in love and pleasure,
a remembrance of the work of creation.
indeed it is the first of all holy festivals,
a remembrance of the Exodus from Egypt.
Indeed you chose us
and set us apart among the nations,
and made Your holy sabbath
ours in love and pleasure.
Blessed are You Lord,
who makes the sabbath holy.

Blessed are You,
Lord our God
Ruler of the Universe,
Who has sanctified us
with Your commandments
and commanded us about
washing the hands.

בָּרוּךְ אַתָּה יהוה

אֱלֹהֵינוּ מֶלֶךְ הָעוֹלָם

אֲשֶׁר קִדְּשָׁנוּ בְּמִצְוֹתָיו

וְצִוָּנוּ עַל נְטִילַת יָדָיִם.

רִבּוֹנוֹ שֶׁל עוֹלָם, מְבַקֶּשֶׁת אֲנִי מִלְּפָנֶיךָ-

אָנָּא עֲזֹר לִי שֶׁכְּשֶׁיְּהֵא לֵוִי יִצְחָק שֶׁלִּי מְבָרֵךְ בַּשַּׁבָּת עַל

רַחֲלוֹת הָאֵלֶּה, יְכַוֵּן בְּלִבּוֹ אוֹתָן הַכַּוָּנוֹת שֶׁאֲנִי מְכַוֶּנֶת

בְּשָׁעָה זוֹ שֶׁאֲנִי לָשָׁה וְאוֹפָה.

Master of the world, I ask of You—
please help me, such that when my Levi Yitzhak recites the blessing over these loaves
on Shabbat, he should have in his heart the same meditations that I have
at this time, as I knead and bake—

בָּרוּךְ אַתָּה יהוה אֱלֹהֵינוּ מֶלֶךְ הָעוֹלָם,
הַמּוֹצִיא לֶחֶם מִן הָאָרֶץ.

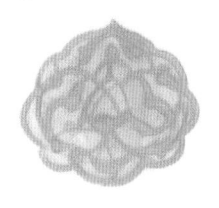

Blessed are You, Lord our God, Ruler of the Universe,
Who brings forth bread from the Earth.

מְקַדֵּשׁ שְׁבִיעִי כָּרָאוּי לוֹ
עַל שׁוֹמֵר שַׁבָּת כַּדָּת, בְּחַלְּלוֹ
שְׂכָרוֹ הַרְבֵּה מְאֹד עַל פִּי פָעֳלוֹ
אִישׁ עַל־מַחֲנֵהוּ וְאִישׁ עַל־דִּגְלוֹ

אוֹהֲבֵי יהוה הַמְחַכִּים לְבִנְיַן אֲרִיאֵל
בְּיוֹם הַשַּׁבָּת שִׂישׂוּ וְשִׂמְחוּ כִּמְקַבְּלֵי מַתַּן נַחֲלִיאֵל
גַּם שְׂאוּ יְדֵיכֶם קֹדֶשׁ וְאִמְרוּ לָאֵל
בָּרוּךְ יהוה אֲשֶׁר נָתַן מְנוּחָה לְעַמּוֹ יִשְׂרָאֵל

דּוֹרְשֵׁי יהוה זֶרַע אַבְרָהָם אוֹהֲבוֹ
הַמְאַחֲרִים לָצֵאת מִן הַשַּׁבָּת וּמְמַהֲרִים לָבוֹא
וּשְׂמֵחִים לְשָׁמְרוֹ וּלְעָרֵב עֵרוּבוֹ
זֶה־הַיּוֹם עָשָׂה יהוה, נָגִילָה וְנִשְׂמְחָה בוֹ

זִכְרוּ תּוֹרַת מֹשֶׁה בְּמִצְוַת שַׁבָּת גְּרוּסָה
חֲרוּתָה לַיּוֹם הַשְּׁבִיעִי, כְּכַלָּה בֵּין רֵעוֹתֶיהָ מְשֻׁבָּצָה
טְהוֹרִים יִירָשׁוּהָ, וִיקַדְּשׁוּהָ בְּמַאֲמַר כָּל אֲשֶׁר עָשָׂה
וַיְכַל אֱלֹהִים בַּיּוֹם הַשְּׁבִיעִי מְלַאכְתּוֹ אֲשֶׁר עָשָׂה

All who sanctify the Sabbath as it deserves,
All who keep the day from profanation
Will be rewarded in accordance with their deeds.
Each one in its camp, each one by his standard.

Friends of God who await the Temple's restoration:
Rejoice on the Sabbath like those who first received the Torah.
Lift up your hands in holiness and say to God,
Blessed is the Lord, who has given Israel rest.

You who seek the Lord, the seed of Abraham, His friend,
You who begin the Sabbath early, and keep it until late,
Who observe it gladly, and gladly set its boundaries—
This is the day the Lord has made! On it, let us rejoice and be happy.

Remember my servant, Moses's Law with its Sabbath teaching,
The seventh day engraved therein, like a bride amid her bridesmaids.
The pure will acquire it and sanctify it in obedience to God who made all things:
And on the seventh day, God completed the work that He had done.

יוֹם קָדוֹשׁ הוּא, מִבּוֹאוֹ וְעַד צֵאתוֹ

כָּל זֶרַע יַעֲקֹב יְכַבְּדוּהוּ, כִּדְבַר הַמֶּלֶךְ וְדָתוֹ

לָנוּחַ בּוֹ וְלִשְׂמֹחַ בְּתַעֲנוּג אָכוֹל וְשָׁתֹה

כָּל עֲדַת יִשְׂרָאֵל יַעֲשׂוּ אֹתוֹ:

מֶשֶׁךְ חַסְדְּךָ לְיוֹדְעֶיךָ אֵל קַנּוֹא וְנוֹקֵם

נוֹטְרֵי יוֹם הַשְּׁבִיעִי זָכוֹר וְשָׁמוֹר לְהָקֵם

שַׂמְּחֵם בְּבִנְיַן שָׁלֵם, בְּאוֹר פָּנֶיךָ תַּבְהִיקֵם

יִרְוְיֻן מִדֶּשֶׁן בֵּיתֶךָ וְנַחַל עֲדָנֶיךָ תַשְׁקֵם:

עֲזֹר לַשּׁוֹבְתִים בַּשְּׁבִיעִי, בֶּחָרִישׁ וּבַקָּצִיר עוֹלָמִים

פּוֹסְעִים בּוֹ פְּסִיעָה קְטַנָּה, סוֹעֲדִים בּוֹ, לְבָרֵךְ שָׁלֹשׁ פְּעָמִים

צִדְקָתָם תַּצְהִיר כְּאוֹר שִׁבְעַת הַיָּמִים

יהוה אֱלֹהֵי יִשְׂרָאֵל הָבָה תָמִים:

A holy day it is from its beginning until its end.
All Jacob's seed revere it as the royal word and law,
Resting on it and rejoicing with delight in food and drink.
The whole congregation of Israel will observe it.

O God of zeal and vengeance, draw Your favor over those who know You,
Those who keep the seventh day, remembering and observing.
Give them joy of Jerusalem rebuilt, make them gleam with Your face's light;
May they eat their fill of Your house's fat: let them quaff Your rivers of delight.

Help those who ever rest on the seventh day in plow- and harvest time,
Who walk gently on that day, who dine three times, each time reciting Grace.
Make their righteousness shine like the light of days of Creation.
O Lord, God of Israel, grant a perfect outcome.

הזו ליהיהו קדא! בשבי הודיעו ב, עמס עליוחני שידו לו זברו לו שיחו בכל נפלאותין התגלל בשם קדש! ישם לב צבקשי יהוה דרשו לו שיחו ומיו בקשי פניו ועבד זכרו נפלאותי אשר עשה בפתו
ושפטי-פיו זרשמרהם עבדו בני יעקב בחורין הוא יהוה אלהינו בכל האוץ בשפטי זכר לעולם ברית! צוה לאלף דור אל נדת אתג.אבדהם ושבועתו לישחק י עבדיה ליעקב
ליחק לישראל ברית עולם אל אוה לעו חבל נחלתכם בהיותם בתי מספר
ויתנלכו בגוי אל גוי אל דיממא ובפלכה אר לו אן שא אחד כל נבואי הדש ויקרא יל נביאל הש לענ
רע על הארץ כל בטה לחם שלה לפניהם עטיא
עבכר יוסף ענו נכבל רגלו בא לא הניח אדם לעשקם ויוכד על דם נאב נפש עטיאת
בא-זבדו אברת יהוה צרקתה ויפרהו ה

Rest for the Jews and Joy and Light

the sabbath day!—Light and delight.
By keeping it in mind and deed,
we testify that on the sixth
all Creation stood comple-te—

the highest heaven, land and seas,
the high and lofty throngs above,
ocean creatures, man, and beast—
God shaped them from
the letters of His name.

He bade His treasured people keep
it holy from start to finish—
the sabbath, day of His delight,
the day the Lord took rest
from making all His works.

יוֹם שַׁבָּתוֹן, יוֹם בַּחֲמוּדִים,

שׁוֹמְרָיו וְזוֹכְרָיו הֵמָּה מְעִידִים,

כִּי לְשִׁשָּׁה כֹל בְּרוּאִים וְעוֹמְדִים.

שְׁמֵי שָׁמַיִם, אֶרֶץ וְיַמִּים,

כָּל צְבָא מָרוֹם גְּבוֹהִים וְרָמִים,

תַּנִּין וְאָדָם וְחַיַּת רְאֵמִים,

כִּי בְּיָהּ יְהוָה צוּר עוֹלָמִים.

הוּא אֲשֶׁר דִּבֶּר לְעַם סְגֻלָּתוֹ,

שָׁמוֹר לְקַדְּשׁוֹ מִבּוֹאוֹ עַד צֵאתוֹ,

שַׁבַּת קֹדֶשׁ יוֹם חֶמְדָּתוֹ,

כִּי בוֹ שָׁבַת אֵל מִכָּל מְלַאכְתּוֹ.

By the sabbath law, God gives you rest.
Go pray to Him, and He will give you strength.
Recite Nishmat and Qedusha,
then go, eat your bread in joy,
for He is pleased with you.

Two loaves and Kiddush of the day,
Food aplenty and a hearty spirit—
Those who enjoy it gain much reward
When the Messiah arrives:
Life in the World to Come.

בְּמִצְוַת שַׁבָּת אֵל יַחֲלִיצֶךָ
קוּם קְרָא אֵלָיו, חִישׁ לְאַמִּצֶךָ
נִשְׁמַת כָּל חַי וְגַם נַעֲרִיצֶךָ
אֱכֹל בְּשִׂמְחָה כִּי כְבָר רָצֶךָ

בְּמִשְׁנֶה לֶחֶם וְקִדּוּשׁ רַבָּה,
בְּרֹב מַטְעַמִּים וְרוּחַ נְדִיבָה,
יִזְכּוּ לְרַב טוּב הַמִּתְעַנְּגִים בָּהּ,
בְּבִיאַת גּוֹאֵל לְחַיֵּי הָעוֹלָם הַבָּא.

How lovely is your rest,
O Sabbath queen
We run to greet you—
Come, anointed bride——
We wear our festive clothing,
We light the lamp, recite the blessing
Finish all our chores as bidden:
"Do no labor."
What a pleasure, what delight,
swans and quail and fish!

On Friday, we assemble
food of every kind.
Before sunset we prepare
fattened fowl aplenty.
Varied foods are set out there,
fragrant wines to drink.
delicious delicacies
for each of the three meals.
What a pleasure, what delight,
swans and quail and fish!

מַה יְּדִידוּת מְנוּחָתֵךְ

אַתְּ שַׁבָּת הַמַּלְכָּה
בְּכֵן נָרוּץ לִקְרָאתֵךְ
בּוֹאִי כַלָּה נְסוּכָה,
לְבוּשׁ בִּגְדֵי חֲמוּדוֹת
לְהַדְלִיק נֵר בִּבְרָכָה,
וַתֵּכֶל כָּל הָעֲבוֹדוֹת,
לֹא תַעֲשׂוּ מְלָאכָה.
לְהִתְעַנֵּג בְּתַעֲנוּגִים
בַּרְבּוּרִים וּשְׂלָו וְדָגִים

מֵעֶרֶב מַזְמִינִים,
כָּל מִינֵי מַטְעַמִּים,
מִבְּעוֹד יוֹם מוּכָנִים,
תַּרְנְגוֹלִים מְפֻטָּמִים,
וְלַעֲרֹךְ בּוֹ כַּמָּה מִינִים,
שְׁתוֹת יֵינוֹת מְבֻשָּׂמִים,
וְתַפְנוּקֵי מַעֲדַנִּים
בְּכָל שָׁלֹשׁ פְּעָמִים
לְהִתְעַנֵּג בְּתַעֲנוּגִים
בַּרְבּוּרִים וּשְׂלָו וְדָגִים

84

The estate of father Jacob
A legacy unlimited:
Observe it, rich and poor,
and thus deserve redemption.
If you keep the sabbath day,
if you are My treasured folk,
do your work on six weekdays,
and pass the seventh day in joy.
What a pleasure, what delight,
swans and quail and fish!

No tending to your business
or reckoning accounts,
but you may do your planning
or arrange a marriage.
Teach your child his lessons,
recite the psalms in song,
think about the Torah's words
where-ever you may dwell.
What a pleasure, what delight,
swans and quail and fish!

נַחֲלַת יַעֲקֹב יִירָשׁ,
בְּלִי מְצָרִים נַחֲלָה
וְכַבְּדוּהוּ עָשִׁיר וָרָשׁ
וְתִזְכּוּ לִגְאֻלָּה
יוֹם שַׁבָּת אִם תְּכַבְּדוּן,
וִהְיִיתֶם לִי סְגֻלָּה,
שֵׁשֶׁת יָמִים תַּעֲבֹדוּ
וּבַשְּׁבִיעִי נָגִילָה.
לְהִתְעַנֵּג בְּתַעֲנוּגִים
בַּרְבּוּרִים וּשְׂלָו וְדָגִים

חֲפָצֶיךָ אֲסוּרִים
וְגַם לַחְשֹׁב חֶשְׁבּוֹנוֹת
הִרְהוּרִים מֻתָּרִים
וּלְשַׁדֵּךְ הַבָּנוֹת.
וְתִינוֹק לְלַמְּדוֹ סֵפֶר,
לַמְנַצֵּחַ בִּנְגִינוֹת,
וְלַהֲגוֹת בְּאִמְרֵי שֶׁפֶר
בְּכָל פִּנּוֹת וּמַחֲנוֹת.
לְהִתְעַנֵּג בַּתַעֲנוּגִים
בַּרְבּוּרִים וּשְׂלָו וְדָגִים

No bustling, no hurrying:
Make the Sabbath pleasant!
Sleep, too, is a good thing,
Sufficient to restore your strength.
And so my spirit longs for you,
when it can take its rest in love,—
when every man and woman rests
as if within a rosy hedge,—
What a pleasure, what delight,
swans and quail and fish!

The day of Sabbath rest
is like the World to Come—.
All who take delight in it
will one day see great joy.
Saved from the turmoil of the messianic age
they enter a realm of comfort.
Then our salvation will flourish,
and sighs and sorrow vanish.
What a pleasure, what delight,
swans and quail and fish!

הִלּוּכָךְ יְהֵא בְנַחַת
עֹנֶג קְרָא לַשַּׁבָּת,
וְהַשֵּׁנָה מְשֻׁבַּחַת,
כְּדַת נֶפֶשׁ מְשִׁיבַת,
בְּכֵן נַפְשִׁי לְךָ עָרְגָה
וְלָנוּחַ בְּחִבַּת,
כַּשּׁוֹשַׁנִּים סוּגָה.
בּוֹ יָנוּחוּ בֵּן וּבַת
לְהִתְעַנֵּג בְּתַעֲנוּגִים,
בַּרְבּוּרִים וּשְׂלָו וְדָגִים.

מֵעֵין עוֹלָם הַבָּא,
יוֹם שַׁבָּת מְנוּחָה,
כָּל הַמִּתְעַנְּגִים בָּהּ,
יִזְכּוּ לְרֹב שִׂמְחָה,
מֵחֶבְלֵי מָשִׁיחַ,
יֻצָּלוּ לִרְוָחָה,
פְּדוּתֵנוּ תַצְמִיחַ
וְנָס יָגוֹן וַאֲנָחָה,
לְהִתְעַנֵּג בְּתַעֲנוּגִים
בַּרְבּוּרִים וּשְׂלָו וְדָגִים

This day is Israel's light and joy: Sabbath rest! יוֹם זֶה לְיִשְׂרָאֵל אוֹרָה וְשִׂמְחָה: שַׁבַּת מְנוּחָה.!

At sinais assembly You commande-d me—
To keep the Sabbath and festivals all my life,
to set before me- goodly portions;
Sabbath rest
This day is Israel's light and joy: Sabbath rest!

צִוִּיתָ פִּקּוּדִים בְּמַעֲמַד סִינַי
שַׁבָּת וּמוֹעֲדִים לִשְׁמוֹר בְּכָל שָׁנַי
לַעֲרֹךְ לְפָנַי מַשְׂאֵת וַאֲרוּחָה
שַׁבַּת מְנוּחָה!
יוֹם זֶה לְיִשְׂרָאֵל אוֹרָה וְשִׂמְחָה: שַׁבַּת מְנוּחָה,

For a broken people, a delight to the heart:
For aching spirits, an extra soul.
Relief for suffering spirits from sorrow.
Sabbath rest
This day is Israel's light and joy: Sabbath rest!

חֶמְדַּת הַלְּבָבוֹת לְאֻמָּה שְׁבוּרָה
לִנְפָשׁוֹת נִכְאָבוֹת נְשָׁמָה יְתֵרָה
לְנֶפֶשׁ מְצֵרָה יָסִיר אֲנָחָה
שַׁבַּת מְנוּחָה!
יוֹם זֶה לְיִשְׂרָאֵל אוֹרָה וְשִׂמְחָה: שַׁבַּת בִּינִיחָה,

You hallowed it and blessed it above the other days,
In six days, You finished making all the worlds.
The sorrowing find calm and security then.
Sabbath rest!
This day is Israel's light and joy: Sabbath rest!

קִדַּשְׁתָּ בְּרַכְתָּ אוֹתוֹ מִכָּל יָמִים
בְּשֵׁשֶׁת כִּלִּיתָ מְלֶאכֶת עוֹלָמִים
בּוֹ מָצְאוּ עֲגוּמִים הַשְׁקֵט וּבִטְחָה
שַׁבַּת מְנוּחָה!
יוֹם זֶה לְיִשְׂרָאֵל אוֹרָה וְשִׂמְחָה:שַׁבַּת מְנוּחָה!

You forbade us labor, fearsome God,
Promised royal splendor if I keep the Sabbath,
So I bring a fragrant offering to the fearsome God:
Sabbath rest!
This day is Israel's light and joy: Sabbath rest!

לֶאֱסוֹר מְלָאכָה צִוִּיתָנוּ נוֹרָא
אֶזְכֶּה הוֹד מְלוּכָה אִם שַׁבָּת אֶשְׁמֹרָה
אַקְרִיב שַׁי לַמּוֹרָא מִנְחָה מֶרְקָחָה
שַׁבַּת מְנוּחָה!
יוֹם זֶה לְיִשְׂרָאֵל אוֹרָה וְשִׂמְחָה:שַׁבַּת מְנוּחָה!

Restore our Temple, God, remember the ruined city!
Grant Your bounty, Savior, to the sorrowing one—
who passes every Sabbath in song and praise to You.
Sabbath rest!
This day is Israel's light and joy: Sabbath rest!

חַדֵּשׁ מִקְדָּשֵׁנוּ זָכְרָה נֶחֱרֶבֶת
טוּבְךָ מוֹשִׁיעֵנוּ, תְּנָה לַנֶּעֱצֶבֶת
בְּשַׁבָּת יוֹשֶׁבֶת בְּזֶמֶר וּשְׁבָחָה
שַׁבַּת מְנוּחָה!
יוֹם זֶה לְיִשְׂרָאֵל אוֹרָה וְשִׂמְחָה: שַׁבַּת מְנוּחָה!

89

Lord, Master of the world, all worlds
You are the king, the king of kings
to speak of Your might works and miracles
is all my pleasure.

Morning and evening I set out praise-s
to You holy God, who created all life—
holy angels, human beings,
beasts of the field and birds that ply the sky.

יָהּ רִבּוֹן עָלַם וְעָלְמַיָּא,
אַנְתְּ הוּא מַלְכָּא מֶלֶךְ מַלְכַיָּא,
עוֹבַד גְּבוּרְתָּךְ וְתִמְהַיָּא,
שְׁפַר קֳדָמָךְ לְהַחֲוָיָא.

שְׁבָחִין אֲסַדֵּר צַפְרָא וְרַמְשָׁא,
לָךְ אֱלָהָא קַדִּישָׁא דִּי בְרָא כָל נַפְשָׁא,
עִירִין קַדִּישִׁין וּבְנֵי אֱנָשָׁא,
חֵיוַת בָּרָא וְעוֹפֵי שְׁמַיָּא.

Multitudinous Your works and mighty,
You bring down the proud, lift up the lowly.
If a person should live a thousand years,
he could not enumerate Your wonders.

God of glory, God of power,
save Your flocks from the lion's jaws,
and bring Your people out of exile
the folk You chose from among the nations.

Come back to Your Temple and its holiest chamber
where our spirits and our souls will take delight,
and all will sing hymns and praises to You
in Jerusalem, the city of all beauties.

רַבְרְבִין עוֹבְדָיךְ וְתַקִיפִין,
מָכֵךְ רָמַיָא וְזָקֵף כְּפִיפִין,
לוּ יְחֵי גְבַר שְׁנִין אַלְפִין,
לָא יֵעַל גְּבוּרְתָּךְ בְּחֻשְׁבְּנַיָּא.

אֱלָהָא דִי לֵהּ יְקָר וּרְבוּתָא,
פְּרוֹק יָת עָנָךְ מִפֻּם אַרְיְוָתָא,
וְאַפֵּיק יָת עַמָּךְ מִגּוֹ גָלוּתָא,
עַמָּא דִי בְחַרְתְּ מִכָּל אֻמַּיָּא.

לְמַקְדְּשָׁךְ תּוּב וּלְקֹדֶשׁ קֻדְשִׁין,
אֲתַר דִּי בֵהּ יֶחֱדוּן רוּחִין וְנַפְשִׁין,
וִיזַמְּרוּן לָךְ שִׁירִין וְרַחֲשִׁין,
בִּירוּשְׁלֵם קַרְתָּא דְשֻׁפְרַיָּא.

91

My soul is thirsting for the living God

My heart, my flesh sing to the living God.

God, who is One, created me, · And said, "As I live—

No man shall gaze upon me and remain alive."

My soul is thirsting for the living God

My heart, my flesh sing to the living God.

He made—— all things with wisdom, sagacity and counsel.

He is altogether hidden · from the sight of all alive.

His glory is above all. · Every mouth proclaims His glory.

Blessed is He in whose hand · Is the soul of all that lives

My soul is thirsting for the living God

My heart, my flesh sing to the living God.

He set Jacob's seed apart · · To teach them His commandments,

Which a person should · Observe— that he may live—.

How can one who is mere dust · Claim that he is sinless?

Truly, in Your sight, no one — is righteous among the living.

My soul is thirsting for the living God.

צָמְאָה נַפְשִׁי לֵאלֹהִים לְאֵל חָי:

לִבִּי וּבְשָׂרִי יְרַנְּנוּ אֶל אֵל חָי:

אֵל אֶחָד בְּרָאַנִי וְאָמַר חַי אָנִי

כִּי לֹא יִרְאַנִי הָאָדָם וָחָי:

צָמְאָה נַפְשִׁי לֵאלֹהִים לְאֵל חָי

לִבִּי וּבְשָׂרִי יְרַנְּנוּ אֶל אֵל חָי:

בָּרָא כֹל בְּחָכְמָה בְּעֵצָה וּבִמְזִמָּה

נֶאְדָּר נֶעְלָה מֵעֵינֵי כָל חָי:

רָם עַל כֹּל כְּבוֹדוֹ כָּל פֶּה יַחֲוֶה הוֹדוֹ

בָּרוּךְ אֲשֶׁר בְּיָדוֹ נֶפֶשׁ כָּל חָי:

צָמְאָה נַפְשִׁי לֵאלֹהִים לְאֵל חָי,

לִבִּי וּבְשָׂרִי יְרַנְּנוּ אֶל אֵל חָי:

הִבְדִּיל זֶרַע יַעֲקֹב חֻקִּים לְהוֹרוֹתָם

אֲשֶׁר יַעֲשֶׂה אוֹתָם הָאָדָם וָחָי:

כִּי זֶה יִצְטַדָּק נִמְשַׁל לְאָבָק דָּק

אֱמֶת כִּי לֹא יִצְדַּק לְעֵינֶיךָ כָל חָי:

צָמְאָה נַפְשִׁי לֵאלֹהִים לְאֵל חָי:

לִבִּי וּבְשָׂרִי יְרַנְּנוּ אֶל אֵל חָי:

The impulses of the heart · Are like an adder's venom. בְּלֵב יֵצֶר חָשׁוּב כִּדְמוּת חֲמַת עַכְשׁוּב

How, then, can the flesh · return again and live? וְאֵיכָכָה יָשׁוּב הַבָּשָׂר הֶחָי.

If sinners have the will · They may repent their ways, נְסוֹגִים אִם אָנוּ וְגַם דַּרְכָּם שָׁנוּ

Before they take the place · Assigned to all who live. טֶרֶם יִשְׁכְּבוּ בֵית מוֹעֵד לְכָל חָי.

My soul is thirsting for the living God. צָמְאָה נַפְשִׁי לֵאלֹהִים לְאֵל חָי.

My heart, my flesh sing to the living God. לִבִּי וּבְשָׂרִי יְרַנְּנוּ אֶל אֵל־חָי

For everything, I thank You. · All mouths proclaim Your unity. עַל כָּל אֲרוּחֶךָ כָּל פֶּה תְּיַחֲדֶךָ

You Whose hand is open · To satisfy all who live. פּוֹתֵחַ אֶת יָדֶךָ וּמַשְׂבִּיעַ לְכָל חָי.

Remember Your ancient love, · Restore the sleeping folk, זְכֹר אַהֲבַת קְדוּמִים וְתַחֲיֶה נִרְדָּמִים

And bring about the day · When Jesse's son will live. וּקְרֵב הַיָּמִים אֲשֶׁר בֶּן יִשַׁי חָי.

My soul is thirsting for the living God. צָמְאָה נַפְשִׁי לֵאלֹהִים לְאֵל חָי.

My heart, my flesh sing to the living God. לִבִּי וּבְשָׂרִי יְרַנְּנוּ אֶל־אֵל־חָי.

See how the concubine · says to the true wife, רְאֵה לִגְבֶרֶת אֲמַת שִׁפְחָה נוֹאֶמֶת

"Your son is the dead one; · It is my son who lives." לֹא כִי בְּנֵךְ הַמֵּת וּבְנִי הֶחָי.

Down to the ground I bow, · And spread my hands toward You, אֶקֹּד עַל אַפִּי וְאֶפְרֹשׂ לְךָ כַּפִּי

As now I open my mouth to recite · "The breath of all that lives." עֵת אֶפְתַּח פִּי בְּנִשְׁמַת כָּל חָי.

My soul is thirsting for the living God. צָמְאָה נַפְשִׁי לֵאלֹהִים לְאֵל חָי.

My heart, my flesh sing to the living God. לִבִּי וּבְשָׂרִי יְרַנְּנוּ אֶל אֵל־חָי.

בָּרוּךְ אֵל עֶלְיוֹן אֲשֶׁר נָתַן מְנוּחָה, ● לְנַפְשֵׁנוּ פִדְיוֹן מִשֵּׁאת וַאֲנָחָה.

וְהוּא יִדְרֹשׁ לְצִיּוֹן, עִיר הַנִּדָּחָה, ● עַד אָנָה תּוּגְיוֹן נֶפֶשׁ נֶאֱנָחָה.

הַשּׁוֹמֵר שַׁבָּת, ● הַבֵּן עִם הַבַּת, ● לָאֵל יֵרָצוּ כְּמִנְחָה עַל מַחֲבַת.

רוֹכֵב בָּעֲרָבוֹת, מֶלֶךְ עוֹלָמִים ● אֶת עַמּוֹ לִשְׁבֹּת אִזֵּן בַּנְּעִימִים

בְּמַאֲכָלוֹת עֲרֵבוֹת בְּמִינֵי מַטְעַמִּים, ● בְּמַלְבּוּשֵׁי כָבוֹד זֶבַח מִשְׁפָּחָה.

הַשּׁוֹמֵר שַׁבָּת, ● הַבֵּן עִם הַבַּת, ● לָאֵל יֵרָצוּ כְּמִנְחָה עַל מַחֲבַת

וְאַשְׁרֵי כָל חוֹכֶה לְתַשְׁלוּמֵי כֵפֶל, ● מֵאֵת כֹּל סוֹכֶה, שׁוֹכֵן בָּעֲרָפֶל

נַחֲלָה לוֹ יִזְכֶּה בָּהָר וּבַשָּׁפֶל, ● נַחֲלָה וּמְנוּחָה כַּשֶּׁמֶשׁ לוֹ זָרְחָה.

הַשּׁוֹמֵר שַׁבָּת, ● הַבֵּן עִם הַבַּת, ● לָאֵל יֵרָצוּ כְּמִנְחָה עַל מַחֲבַת.

כָּל שׁוֹמֵר שַׁבָּת כַּדָּת מֵחַלְּלוֹ, ● הֵן הֶכְשֵׁר חִבַּת קֹדֶשׁ גּוֹרָלוֹ

וְאִם יֵצֵא חוֹבַת הַיּוֹם, אַשְׁרֵי לוֹ, ● אֶל אֵל אָדוֹן מְחוֹלְלוֹ מִנְחָה הִיא שְׁלוּחָה.

הַשּׁוֹמֵר שַׁבָּת, ● הַבֵּן עִם הַבַּת, ● לָאֵל יֵרָצוּ כְּמִנְחָה עַל מַחֲבַת.

חֶמְדַּת הַיָּמִים קְרָאוֹ אֵלִי צוּר ● וְאַשְׁרֵי לִתְמִימִים אִם יִהְיֶה נָצוּר

כֶּתֶר הִלּוּמִים עַל רֹאשָׁם יָצוּר, ● צוּר הָעוֹלָמִים, רוּחוֹ בָּם נָחָה.

הַשּׁוֹמֵר שַׁבָּת, ● הַבֵּן עִם הַבַּת, ● לָאֵל יֵרָצוּ כְּמִנְחָה עַל מַחֲבַת.

זָכוֹר אֶת יוֹם הַשַּׁבָּת לְקַדְּשׁוֹ, ● קַרְנוֹ כִּי גָבְהָה נֵזֶר עַל רֹאשׁוֹ

עַל כֵּן יִתֵּן הָאָדָם לְנַפְשׁוֹ, ● עֹנֶג וְגַם שִׂמְחָה בָּהֶם לְמָשְׁחָה.

הַשּׁוֹמֵר שַׁבָּת, ● הַבֵּן עִם הַבַּת, ● לָאֵל יֵרָצוּ כְּמִנְחָה עַל מַחֲבַת.

קֹדֶשׁ הִיא לָכֶם שַׁבָּת הַמַּלְכָּה ● אֶל תּוֹךְ בָּתֵּיכֶם לְהָנִיחַ בְּרָכָה

בְּכָל מוֹשְׁבוֹתֵיכֶם לֹא תַעֲשׂוּ מְלָאכָה, ● בְּנֵיכֶם וּבְנוֹתֵיכֶם עֶבֶד וְגַם שִׁפְחָה.

הַשּׁוֹמֵר שַׁבָּת, ● הַבֵּן עִם הַבַּת, ● לָאֵל יֵרָצוּ כְּמִנְחָה עַל מַחֲבַת.

94

Blessed is God the Highest, He who gave us rest, • Who gave our souls relief from suffering and sorrow.
He will care for Zion, the city so neglected. • How much longer must that soul so doleful go on grieving?
Those who keep the sabbath, • men and women both,
delight the Lord, as if they brought • an offering on the altar.

He who rides upon the clouds, the king who lives forever, • Bade His people rest, and bade them do so with all pleasure
To eat full-flavored dishes, tasty food of every kind, • And dressed in festive clothes, to make a family celebration.
Those keep the sabbath, • men and women both,
delight the Lord, as if they brought • an offering on the altar.

Happy all who can expect to see rewards redoubled • From One who oversees all things from His dark-cloud dwelling.
To such, He grants a heritage in mountain and in plain— • A place where they can rest, as did our father Jacob.
Those who keep the sabbath, • men and women both,
delight the Lord, as if they brought • an offering on the altar.

Whoe—ver guards the sabbath and keeps it from profanation • Has proved worthy, having shown his love for sacred things.
And if one fulfills the duties of the day, happy is that person— • For he has brought a true gift to the Lord, his maker.
Those who keep the sabbath, • men and women both,
delight the Lord, as if they brought • an offering on the altar.

My God, my Rock, has called the sabbath His beloved day. • And happiness is theirs, the good folk who observe it.
He will place a crown well-fitting on their heads, • The spirit of the Rock Eternal rests upon them.
Those who keep the sabbath, • men and women both,
delight the Lord, as if they brought • an offering on the altar.

"Remember the sabbath day to keep it holy." • When it is held up high, it becomes a crown upon His head.
Therefore every person should bestow upon himself • Pleasure, jollity and royal dignity.
Those who keep the sabbath, • men and women both,
delight the Lord, as if they brought • an offering on the altar.

The sabbath queen is holy, to be revered by you, • bringing all prosperity and blessings to your homes.
So do no work of any kind within your habitations. • You, your daughter or your sons, your servants male and female—
Those who keep the sabbath, • men and women both,
delight the Lord, as if they brought • an offering on the altar.

This day / יוֹם זֶה

is most honored among all days,
For on it, the Rock of Ages took rest.

Six days you may do your work,
But the seventh belongs to the Lord.
It is the Sabbath: no work thereon
For in six days He made all things.
This day is most honored among all days
For on it, the Rock of Ages took rest.

It is the first of all Holy days,
A day of cessation, the Holy Sabbath.
So let each person recite Kiddush
over wine, and break two perfect loaves.
This day is most honored among all days
For on it, the Rock of Ages took rest.

מְכֻבָּד מִכָּל יָמִים
כִּי בוֹ שָׁבַת צוּר עוֹלָמִים.

שֵׁשֶׁת יָמִים תַּעֲשֶׂה מְלַאכְתֶּךָ
וְיוֹם הַשְּׁבִיעִי לֵאלֹהֶיךָ.
שַׁבָּת לֹא תַעֲשֶׂה בוֹ מְלָאכָה
כִּי כֹל עָשָׂה שֵׁשֶׁת יָמִים.
יוֹם זֶה מְכֻבָּד מִכָּל יָמִים
כִּי בוֹ שָׁבַת צוּר עוֹלָמִים.

רִאשׁוֹן הוּא לְמִקְרָאֵי קֹדֶשׁ
יוֹם שַׁבָּתוֹן יוֹם שַׁבַּת קֹדֶשׁ.
עַל כֵּן כָּל אִישׁ בְּיֵינוֹ יְקַדֵּשׁ
עַל שְׁתֵּי לֶחֶם יִבְצְעוּ תְמִימִים.
יוֹם זֶה מְכֻבָּד מִכָּל יָמִים
כִּי בוֹ שָׁבַת צוּר עוֹלָמִים.

Dine on rich food, drink sweet wine— אֱכֹל מַשְׁמַנִּים, שְׁתֵה מַמְתַּקִּים

For God will grant to His adherents כִּי אֵל יִתֵּן לְכֹל בּוֹ דְבֵקִים

Clothing to wear and daily rations, בֶּגֶד לִלְבֹּשׁ, לֶחֶם חֻקִּים

Meat and fish and delicacies. בָּשָׂר וְדָגִים וְכָל מַטְעַמִּים.

This day is most honored among all days יוֹם זֶה מְכֻבָּד מִכָּל יָמִים

For on it, the Rock of Ages took rest. כִּי בוֹ שָׁבַת צוּר עוֹלָמִים.

Deny yourself nothing on the Sabbath: לֹא תֶחְסַר כֹּל בּוֹ, וְאָכַלְתָּ

Eat your fill and then say grace— וְשָׂבַעְתָּ וּבֵרַכְתָּ

To the Lord, the God you love— אֶת יהוה אֱלֹהֶיךָ אֲשֶׁר אָהַבְתָּ

For blessing you above all nations. כִּי בֵרַכְךָ מִכָּל הָעַמִּים.

This day is most honored among all days יוֹם זֶה מְכֻבָּד מִכָּל יָמִים

For on it the Rock of Ages took rest. כִּי בוֹ שָׁבַת צוּר עוֹלָמִים.

The heavens speak of His glory, הַשָּׁמַיִם מְסַפְּרִים כְּבוֹדוֹ

The earth is full of His kindness. וְגַם הָאָרֶץ מָלְאָה חַסְדּוֹ

See: His hand made all these things. רְאוּ כָל אֵלֶּה עָשְׂתָה יָדוֹ

He, the Rock, Whose work is perfect. כִּי הוּא הַצּוּר פָּעֳלוֹ תָמִים.

This day is most honored among all days יוֹם זֶה מְכֻבָּד מִכָּל יָמִים

For on it the Rock of Ages took rest. כִּי בוֹ שָׁבַת צוּר עוֹלָמִים.

Do not neglect the sabbath day. • The thought of it is sweet as incense.

On that day the dove found rest. • And on it all the weary rest.

The day is honored by the faithful. • Fathers and sons keep it with care.

The day inscribed on two tablets of stone • By One of might and awful power.

On that day, the dove found rest. • And on it, all the weary rest.

They all embraced the covenant, • As one they swore: "We hear and obey!"

They cried aloud, "The Lord is One! • Bless Him Who gives the weary strength."

On that day, the dove found rest, • And on it, all the weary rest.

He bade them at the mountain of myrrh: • "Remember and keep the seventh day.

And gird yourselves with will and strength • To master its laws in every detail.

On that day, the dove found rest. • And on it, all the weary rest.

Remember the oath and the covenant • You made with the nation that strayed like sheep.

And care for them that they come to no harm, • as You swore at Noah's flood.

On that day, the dove found rest. • And on it all the weary rest.

שַׁבָּת

הַיּוֹם לַיהוה, בְּאֹד צַהֲלִי בְּרִנּוּנֵי,

וְגַם הַרְבּוּ מַעֲדָנֵי, אֹתוֹ לִשְׁמֹר כְּמִצְוַת יהוה.

שַׁבָּת הַיּוֹם לַיהוה.

מֵעֲבֹד דֶּרֶךְ וּגְבוּלִים, מֵעֲשׂוֹת הַיּוֹם פְּעָלִים,

לֶאֱכֹל וְלִשְׁתּוֹת בְּהִלּוּלִים, זֶה הַיּוֹם עָשָׂה יהוה.

שַׁבָּת הַיּוֹם לַיהוה.

וְאִם תִּשְׁמְרֶנּוּ, יָהּ יִנְצָרְךָ כְּבָבַת, אַתָּה וּבִנְךָ וְגַם הַבַּת,

וְקָרָאתָ עֹנֶג לַשַּׁבָּת, אָז תִּתְעַנַּג עַל יהוה.

שַׁבָּת הַיּוֹם לַיהוה

אֱכֹל מַשְׁמַנִּים וּמַעֲדַנִּים, וּמַטְעַמִּים הַרְבֵּה מִינִים,

אֱגוֹזֵי פֶרֶךְ וְרִמּוֹנִים, וְאָכַלְתָּ וְשָׂבָעְתָּ וּבֵרַכְתָּ אֶת יהוה.

שַׁבָּת הַיּוֹם לַיהוה.

לַעֲרֹךְ בְּשֻׁלְחָן לֶחֶם חֲמוּדוֹת לַעֲשׂוֹת הַיּוֹם שָׁלֹשׁ סְעוּדוֹת

אֶת הַשֵּׁם הַנִּכְבָּד לְבָרֵךְ וּלְהוֹדוֹת, שִׁקְדוּ וְשִׁמְרוּ וַעֲשׂוּ בָנַי

שַׁבָּת הַיּוֹם לַיהוה.

Today

is the Sabbath of the— Lord Rejoice greatly with my songs.
Bring me many delicious treats. Keep it as the Lord commands.
Today is the Sabbath of the Lord

No traveling across boundaries Or doing any work today.
This is the— day the— Lord has made— For eating, drinking, and songs of praise.
Today is the Sabbath of the Lord.

Keep it and God will keep you like His own eye, With your son and daughter, too.
Call the sabbath a delight, And God take delight in you.
Today is the Sabbath of the Lord.

Eat rich foods and dainties Tasty food of every kind—
Pomegranates, soft shelled nuts— Eat your fill and bless the Lord.
Today is the Sabbath of the Lord.

Set the table with good bread, Dine three times upon this day.
Be sure to bless and thank God's name. Do it, keep it, O my sons.
Today is the Sabbath of the Lord.

שִׁמְרוּ שַׁבְּתוֹתַי, • לְמַעַן תִּינְקוּ וּשְׂבַעְתֶּם

מִזִּיו בִּרְכוֹתַי, • אֶל הַמְּנוּחָה כִּי בָאתֶם,

וִלְווּ עָלַי בָּנַי, וְעֶדְנוּ מַעֲדַנַי • שַׁבָּת הַיּוֹם לַיהוה.

לֶעָמֵל קִרְאוּ דְרוֹר, • וְנָתַתִּי אֶת בִּרְכָתִי,

אִשָּׁה אֶל אֲחוֹתָהּ לִצְרֹר • לִגְלוֹת עַל יוֹם שִׂמְחָתִי,

בִּגְדֵי שֵׁשׁ עִם שָׁנִי, וְהִתְבּוֹנְנוּ מִזְּקֵנַי, • שַׁבָּת הַיּוֹם לַיהוה.

וִלְווּ עָלַי בָּנַי, וְעֶדְנוּ מַעֲדַנַי • שַׁבָּת הַיּוֹם לַיהוה.

מַהֲרוּ אֶת הַמָּנֶה, • לַעֲשׂוֹת אֶת דְּבַר אֶסְתֵּר,

וְחִשְׁבוּ עִם הַקּוֹנֶה • לְשַׁלֵּם אָכוֹל וְהוֹתֵר,

בִּטְחוּ בִּי אֱמוּנַי • וּשְׁתוּ יַיִן מִשְׁמַנַּי • שַׁבָּת הַיּוֹם לַיהוה.

וִלְווּ עָלַי בָּנַי וְעֶדְנוּ מַעֲדַנַי • שַׁבָּת הַיּוֹם לַיהוה.

הִנֵּה יוֹם גְּאֻלָּה, • יוֹם שַׁבָּת אִם תִּשְׁמֹרוּ,

וִהְיִיתֶם לִי סְגֻלָּה, • לִינוּ וְאַחַר תַּעֲבֹרוּ,

וְאָז תִּהְיוּ לְפָנַי, • וּתְמַלְאוּ צְפוּנַי • שַׁבָּת הַיּוֹם לַיהוה.

וִלְווּ עָלַי בָּנַי, וְעֶדְנוּ מַעֲדַנַי • שַׁבָּת הַיּוֹם לַיהוה.

חִזְקוּ קִרְיָתַי, • אֵל אֱלֹהִים עֶלְיוֹן,

וְהָשֵׁב אֶת נְוָתַי • בְּשִׂמְחָה וּבְהִגָּיוֹן,

יְשׁוֹרְרוּ שָׁם רְנָנַי, לֵוִיַּי וְכֹהֲנַי, • וְאָז תִּתְעַנַּג עַל יהוה, • שַׁבָּת הַיּוֹם לַיהוה.

וִלְווּ עָלַי בָּנַי, וְעֶדְנוּ מַעֲדַנַי • שַׁבָּת הַיּוֹם לַיהוה.

Keep My sabbaths ❧ and you will be nourished and filled
with my luminous blessings ❧ when you come to my rest. Today is the sabbath of the Lord.
For my sake, borrow, my children, ❧ so as to enjoy My delights! ❧ Today is the sabbath of the Lord.

Proclaim freedom from labor, ❧ And I will grant you My blessings,
One after the other and altogether. ❧ On my day of joy, show
Your linen and scarlet finery. ❧ And pay attention to the sages. Today is the sabbath of the Lord.
For My sake, borrow, My children, ❧ so as to enjoy My delights! ❧ Today is the sabbath of the Lord.

Hurry, lay out your money ❧ To make a feast like Esther's
Reckon with the buyer and pay ❧ For the food that you need and more.
Have trust in Me, faithful friends, ❧ and drink wine with My rich foods. Today is the sabbath of the Lord.
For My sake, borrow, My children, so as to enjoy My delights! ❧ Today is the sabbath of the Lord.

Redemption is just at hand ❧ If you only keep the sabbath,
And serve as My treasured people. ❧ Stay tonight, and then move on;
Then you will live before Me ❧ And fill My treasury. Today is the sabbath of the Lord.
For My sake, borrow, My children, ❧ So as to enjoy My delights! ❧ Today is the sabbath of the Lord.

Fortify My city ❧ O God, highest Lord!
Restore My Temple ❧ In joy and song.
There My Levites and My Priests will sing my hymns; Then you will have delight in God. ❧ Today is the sabbath of the Lord.
For My sake, borrow, My children ❧ So as to enjoy My delights! ❧ Today is the sabbath of the Lord.

If I keep the Sabbath God will keep me. כִּי אֶשְׁמְרָה שַׁבָּת אֵל יִשְׁמְרֵנִי.

It is a sign forever between the Lord and me. אוֹת הִיא לְעוֹלְמֵי עַד בֵּינוֹ וּבֵינִי.

No transactions and no traveling, אָסוּר מְצֹא חֵפֶץ, עֲשׂוֹת דְּרָכִים,

No discussing worldly deeds, גַּם מִלְּדַבֵּר בּוֹ דִּבְרֵי צְרָכִים,

business or government. דִּבְרֵי סְחוֹרָה אַף דִּבְרֵי מְלָכִים,

But I study Torah, for it makes me wise. אֶהְגֶּה בְּתוֹרַת אֵל וּתְחַכְּמֵנִי.

It is a sign forever between the Lord and me. אוֹת הִיא לְעוֹלְמֵי עַד בֵּינוֹ וּבֵינִי.

That is when my soul finds its tranquility. בּוֹ אֶמְצָא תָמִיד נֹפֶשׁ לְנַפְשִׁי;

God gave me a sign of this to the first generation, הִנֵּה לְדוֹר רִאשׁוֹן נָתַן קְדוֹשִׁי

sending double manna on the sixth day; מוֹפֵת בְּתֵת לֶחֶם מִשְׁנֶה בַּשִּׁשִּׁי,

Likewise, every Friday He gives me a double portion. כָּכָה בְּכָל שִׁשִּׁי יַכְפִּיל מְזוֹנִי.

It is a sign forever between the Lord and me. אוֹת הִיא לְעוֹלְמֵי עַד בֵּינוֹ וּבֵינִי.

In His Law, God ordained that the priests | רָשַׁם בְּדַת הָאֵל חֹק אֶל סְגָנָיו,

Should set show-bread before Him every sabbath. | בּוֹ לַעֲרֹךְ לֶחֶם פָּנִים בְּפָנָיו,

That is why the sages say, there is no fasting then, | עַל כֵּן לְהִתְעַנּוֹת בּוֹ עַל פִּי נְבוֹנָיו,

Unless Yom Kippur and the sabbath chance to coincide. | אָסוּר לְבַד מִיּוֹם כִּפּוּר עֲוֹנִי.

It is a sign forever between the Lord and me. | אוֹת הִיא לְעוֹלְמֵי עַד בֵּינוֹ וּבֵינִי:

It is an honored day, a day of delight, | הוּא יוֹם מְכֻבָּד הוּא יוֹם הַתַּעֲנוּגִים,

A day of bread and fragrant wine, a day of flesh and fish. | לֶחֶם וְיַיִן טוֹב, בָּשָׂר וְדָגִים

To spend the sabbath mourning would be perverse, | הַמִּתְאַבְּלִים בּוֹ אָחוֹר נְסוֹגִים,

For it is a happy day and it should bring me joy. | כִּי יוֹם שְׂמָחוֹת הוּא וּתְשַׂמְּחֵנִי.

It is a sign forever between the Lord and me. | אוֹת הִיא לְעוֹלְמֵי עַד בֵּינוֹ וּבֵינִי:

Who desecrates it with work will meet an early end. | מְחַל מְלָאכָה בּוֹ סוֹפוֹ לְהַכְרִית,

So I will cleanse my heart of all impurities, | עַל כֵּן אֲכַבֵּס בּוֹ לִבִּי כְּבוֹרִית,

recite the prayers of evening and the morning prayers, | וְאֶתְפַּלְלָה אֶל אֵל עַרְבִית וְשַׁחֲרִית,

Musaf and then Minha, and God will answer me. | מוּסָף וְגַם מִנְחָה הוּא יַעֲנֵנִי.

It is a sign forever between the Lord and me. | אוֹת הִיא לְעוֹלְמֵי עַד בֵּינוֹ וּבֵינִי:

דְּרוֹר יִקְרָא

He calls to freedom

לְבֶן עִם בַּת,

וְיִנְצָרְכֶם כְּמוֹ בָבַת

נְעִים שִׁמְכֶם וְלֹא יֻשְׁבַּת,

שְׁבוּ נוּחוּ בְּיוֹם שַׁבָּת

every man and woman.

He guards you like the pupil of His eye

Your lovely name will never be forgotten

If you sit quietly at rest on the Sabbath day.

דְּרֹשׁ נָוִי וְאוּלַמִּי,

וְאוֹת יֶשַׁע עֲשֵׂה עִמִּי

נְטַע שׂוֹרֵק בְּתוֹךְ כַּרְמִי,

שְׁעֵה שַׁוְעַת בְּנֵי עַמִּי.

O seek the welfare of my Temple, of my palace,

And let me see a sign of my salvation.

Plant a splendid vine within my vineyard,

And hear my cry, when I call out to You.

דְּרֹךְ פּוּרָה בְּתוֹךְ בָּצְרָה,

וְגַם בָּבֶל אֲשֶׁר גָּבְרָה

נְתֹץ צָרַי בְּאַף עֶבְרָה,

שְׁמַע קוֹלִי בְּיוֹם אֶקְרָא.

Trample out the vineyard in Bozrah,

And Babylon, the overpowering.

In rage and fury, overturn my foes.

Hear me when I call upon Your name.

אֱלֹהִים תֵּן בְּמִדְבַּר הָה,
הֲדַס שִׁטָּה בְּרוֹשׁ תִּדְהָר,
וְלַמַּזְהִיר וְלַנִּזְהָר,
שְׁלוֹמִים תֵּן כְּמֵי נָהָר.

הֲדֹךְ קָמַי אֵל קַנָּא,
בְּמוֹג לֵבָב וּבְמִגְנָּה,
וְנַרְחִיב פֶּה וּנְמַלְאֶנָּה,
לְשׁוֹנֵנוּ לְךָ רִנָּה.

דְּעֶה חָכְמָה לְנַפְשֶׁךָ,
וְהִיא כֶתֶר לְרֹאשֶׁךָ,
נְצֹר מִצְוֹת קְדוֹשֶׁךָ,
שְׁמֹר שַׁבַּת קָדְשֶׁךָ.

O God, put on that hill, now desolate,
Acacia, myrtle, box and cypress trees.
And both to those who teach and those who heed,
Grant peace-abundant as the flowing streams.

Crush all who would attack me, God of rage,
And give them melting hearts and sorrow.
Then we will open wide our mouths to sing,
Filling them with songs of praise to You.

Know the way of wisdom for your soul,
And let it be a crown upon your head.
Obey the bidding of your Holy One,
Observe the Sabbath as a holy day.

צִיּוֹן נְמַשְּׁלוֹ אֲכַלְנוּ בָּרְכִי אֲמוֹנִי
שָׂבַעְנוּ וְהוֹתַרְנוּ כִּדְבַר יְהוָה

הַזָּן אֶת עוֹלָמוֹ רוֹעֵנוּ אָבִינוּ
אָכַלְנוּ אֶת לַחְמוֹ וְיֵינוֹ שָׁתִינוּ
עַל כֵּן נוֹדֶה לִשְׁמוֹ וּנְהַלְלוֹ בְּפִינוּ
אָמַרְנוּ וְעָנִינוּ אֵין קָדוֹשׁ כַּיהוָה.

בְּשִׁיר וְקוֹל תּוֹדָה נְבָרֵךְ אֱלֹהֵינוּ
עַל אֶרֶץ חֶמְדָּה טוֹבָה שֶׁהִנְחִיל לַאֲבוֹתֵינוּ
מָזוֹן וְצֵדָה הִשְׂבִּיעַ לְנַפְשֵׁנוּ
חַסְדּוֹ גָּבַר עָלֵינוּ וֶאֱמֶת יְהוָה.

רַחֵם בְּחַסְדֶּךָ עַל עַמְּךָ צוּרֵנוּ
עַל צִיּוֹן מִשְׁכַּן כְּבוֹדֶךָ זְבוּל בֵּית תִּפְאַרְתֵּנוּ
בֶּן דָּוִד עַבְדֶּךָ יָבוֹא וְיִגְאָלֵנוּ
רוּחַ אַפֵּינוּ מְשִׁיחַ יְהוָה.

יִבָּנֶה הַמִּקְדָּשׁ עִיר צִיּוֹן תְּמַלֵּא.
וְשָׁם נָשִׁיר שִׁיר חָדָשׁ וּבִרְנָנָה נַעֲלֶה.
הָרַחֲמָן הַנִּקְדָּשׁ יִתְבָּרַךְ וְיִתְעַלֶּה.
עַל כּוֹס יַיִן מָלֵא כְּבִרְכַּת יְהוָה.

108

Bless the Rock faithful friends, Whose bounty we have eaten.
We ate our fill, and found yet more. As promised by the Lord.

He who feeds the world, our Shepherd and our Father:
His bread we have eaten, His wine we have drunk.
So let us give Him thanks and praise Him with our voices.
We say, we sing that there is none as holy as the Lord.

With song and with thanksgiving, let us bless our God
For the land so lovely that He granted to our fathers.
He gave us food aplenty, He gave us sustenance—
He overwhelmed us with His love; faithful is the Lord.

Have mercy in Your kindness on your folk, our Rock!
On Zion where Your glory dwells, the splendid Holy Temple.
May Your servant David's scion come soon to redeem us,
He who is our breath of life, the anointed of the Lord.

Rebuild the Temple as before, fill Zion once again.
We will go up joyfully and sing new songs to You.
The Merciful, the Holy One be blessed and be exalted.
Over a full cup of wine, the blessed of the Lord.

שִׁיר הַמַּעֲלוֹת

בְּשׁוּב יהוה אֶת־שִׁיבַת צִיּוֹן, הָיִינוּ כְּחֹלְמִים.

אָז יִמָּלֵא שְׂחוֹק פִּינוּ וּלְשׁוֹנֵנוּ רִנָּה.

אָז יֹאמְרוּ בַגּוֹיִם,"הִגְדִּיל יהוה לַעֲשׂוֹת עִם־אֵלֶּה!"

הִגְדִּיל יהוה לַעֲשׂוֹת עִמָּנוּ, הָיִינוּ שְׂמֵחִים.

שׁוּבָה יהוה אֶת־שְׁבִיתֵנוּ, כַּאֲפִיקִים בַּנֶּגֶב.

הַזֹּרְעִים בְּדִמְעָה בְּרִנָּה יִקְצֹרוּ.

הָלוֹךְ יֵלֵךְ וּבָכֹה נֹשֵׂא מֶשֶׁךְ־הַזָּרַע,

בֹּא־יָבֹא בְרִנָּה נֹשֵׂא אֲלֻמֹּתָיו.

תְּהִלַּת יהוה יְדַבֶּר פִּי,

וִיבָרֵךְ כָּל־בָּשָׂר שֵׁם קָדְשׁוֹ לְעוֹלָם וָעֶד.

וַאֲנַחְנוּ נְבָרֵךְ יָהּ, מֵעַתָּה וְעַד־עוֹלָם, הַלְלוּיָהּ.

הוֹדוּ לַיהוה כִּי־טוֹב, כִּי לְעוֹלָם חַסְדּוֹ.

מִי יְמַלֵּל גְּבוּרוֹת יהוה, יַשְׁמִיעַ כָּל־תְּהִלָּתוֹ.

A song for the steps of the Temple

When the Lord restored Zion's exiles we felt we were dreaming.

Then our mouths were filled with laughter and our tongues with song.

Then they said among the nations: "The Lord has done great things with this people!"

The Lord has done great things for us. We rejoiced.

O Lord, restore our exiles like seasonal streams in the desert.

Those who sow in tears will reap in joy.

Though one goes out weeping as he carries his bag of seed,

he returns singing, as he carries in his sheaves.

My mouth will speak the praise of the Lord,

and all flesh will bless His holy name forever.

We will bless the Lord now and forever. Amen.

Praise the Lord for He is good, for His kindness is eternal.

Who can express the Lord's mighty acts or proclaim all His praise?

בִּרְכַּת הַמָּזוֹן

When three or more men say Birkat HaMazon together
the following zimmun is said:

When three or more women say Birkat HaMazon, substitute "friends" חֲבֵרוֹתַי for "Gentlemen" יְרְבּוֹתַי

The Leader should ask permission from those with precedence to lead the Birkat HaMazon.

Leader: רַבּוֹתַי / חֲבֵרֵי / נְבָרֵךְ:

Gentlemen Friends, let us say grace—:

Others: יְהִי שֵׁם יהוה מְבֹרָךְ מֵעַתָּה וְעַד־עוֹלָם:

May the name of the Lord be blessed from now and forever.

Leader יְהִי שֵׁם יהוה מְבֹרָךְ מֵעַתָּה וְעַד־עוֹלָם:

May the name of the Lord be blessed from now and for ever.

בִּרְשׁוּת (אָבִי מוֹרִי / אִמִּי מוֹרָתִי / כֹּהֲנִים / מוֹרֵינוּ הָרַב / בַּעַל הַבַּיִת הַזֶּה / בַּעֲלַת

הַבַּיִת הַזֶּה) מָרָנָן וְרַבָּנָן וְרַבּוֹתַי / וְחַבֵּ—־־י נְבָרֵךְ (in a minyan אֱלֹהֵינוּ) שֶׁאָכַלְנוּ מִשֶּׁלּוֹ.

With your permission, (my father and teacher / my mother and teacher / the Kohanim present / our
teacher our Rabbi / the master of this house / the mistress of this house /
my masters and teachers, let us bless the One (in a minyan, our God)
from whose food we have eaten,

Others בָּרוּךְ (in a minyan אֱלֹהֵינוּ) שֶׁאָכַלְנוּ מִשֶּׁלּוֹ וּבְטוּבוֹ חָיִינוּ.

Blessed be the One— (in a minyan: our God) from whose food we have eaten
and by whose goodness we live.

People present who have not taken part in the meal say:

בָּרוּךְ (in a minyan אֱלֹהֵינוּ) וּמְבֹרָךְ שְׁמוֹ תָּמִיד לְעוֹלָם וָעֶד.

Blessed be the One— (in a minyan: our God) from whose food we have eaten,
and by whose goodness we live—

Leader בָּרוּךְ (in a minyan אֱלֹהֵינוּ) שֶׁאָכַלְנוּ מִשֶּׁלּוֹ וּבְטוּבוֹ חָיִינוּ. בָּרוּךְ הוּא וּבָרוּךְ שְׁמוֹ.

Blessed be the One (in a minyan: our God) from whose food we have eaten,
and by whose goodness we live. Blessed be He, and blessed be His name—

בָּרוּך: אַתָּה יהוה, אֱלֹהֵינוּ מֶלֶךְ הָעוֹלָם, הַזָּן אֶת הָעוֹלָם כֻּלּוֹ בְּטוּבוֹ בְּחֵן בְּחֶסֶד וּבְרַחֲמִים הוּא נוֹתֵן לֶחֶם לְכָל בָּשָׂר כִּי לְעוֹלָם חַסְדּוֹ. וּבְטוּבוֹ הַגָּדוֹל תָּמִיד לֹא חָסַר לָנוּ וְאַל יֶחְסַר לָנוּ מָזוֹן לְעוֹלָם וָעֶד בַּעֲבוּר שְׁמוֹ הַגָּדוֹל. כִּי הוּא אֵל זָן וּמְפַרְנֵס לַכֹּל וּמֵטִיב לַכֹּל וּמֵכִין מָזוֹן לְכָל בְּרִיּוֹתָיו אֲשֶׁר בָּרָא. בָּרוּךְ אַתָּה יהוה, הַזָּן אֶת הַכֹּל.

מוֹדֶה לְךָ יהוה אֱלֹהֵינוּ, עַל שֶׁהִנְחַלְתָּ לַאֲבוֹתֵינוּ אֶרֶץ חֶמְדָּה טוֹבָה וּרְחָבָה וְעַל שֶׁהוֹצֵאתָנוּ יהוה אֱלֹהֵינוּ מֵאֶרֶץ מִצְרַיִם וּפְדִיתָנוּ מִבֵּית עֲבָדִים וְעַל בְּרִיתְךָ שֶׁחָתַמְתָּ בִּבְשָׂרֵנוּ וְעַל תּוֹרָתְךָ שֶׁלִּמַּדְתָּנוּ וְעַל חֻקֶּיךָ שֶׁהוֹדַעְתָּנוּ וְעַל חַיִּים חֵן וָחֶסֶד שֶׁחוֹנַנְתָּנוּ וְעַל אֲכִילַת מָזוֹן שָׁאַתָּה זָן וּמְפַרְנֵס אוֹתָנוּ תָּמִיד בְּכָל יוֹם וּבְכָל עֵת וּבְכָל שָׁעָה.

On Hanukka, Purim and Yom Ha'Atzmaut:

עַל הַנִּסִּים וְעַל הַפֻּרְקָן, וְעַל הַגְּבוּרוֹת וְעַל הַתְּשׁוּעוֹת וְעַל הַמִּלְחָמוֹת שֶׁעָשִׂיתָ לַאֲבוֹתֵינוּ בַּיָּמִים הָהֵם בַּזְּמַן הַזֶּה.

On Hanukka:

בִּימֵי מַתִּתְיָהוּ בֶּן יוֹחָנָן כֹּהֵן גָּדוֹל חַשְׁמוֹנַאי וּבָנָיו, כְּשֶׁעָמְדָה מַלְכוּת יָוָן הָרְשָׁעָה עַל עַמְּךָ יִשְׂרָאֵל לְהַשְׁכִּיחָם תּוֹרָתֶךָ וּלְהַעֲבִירָם מֵחֻקֵּי רְצוֹנֶךָ וְאַתָּה בְּרַחֲמֶיךָ הָרַבִּים עָמַדְתָּ לָהֶם בְּעֵת צָרָתָם, רַבְתָּ אֶת רִיבָם, דַּנְתָּ אֶת דִּינָם, נָקַמְתָּ אֶת נִקְמָתָם, מָסַרְתָּ גִבּוֹרִים בְּיַד חַלָּשִׁים, וְרַבִּים בְּיַד מְעַטִּים, וּטְמֵאִים בְּיַד טְהוֹרִים, וּרְשָׁעִים בְּיַד צַדִּיקִים, וְזֵדִים בְּיַד עוֹסְקֵי תוֹרָתֶךָ, וּלְךָ עָשִׂיתָ שֵׁם גָּדוֹל וְקָדוֹשׁ בְּעוֹלָמֶךָ, וּלְעַמְּךָ יִשְׂרָאֵל עָשִׂיתָ תְּשׁוּעָה גְדוֹלָה וּפֻרְקָן כְּהַיּוֹם הַזֶּה. וְאַחַר כֵּן בָּאוּ בָנֶיךָ לִדְבִיר בֵּיתֶךָ, וּפִנּוּ אֶת הֵיכָלֶךָ, וְטִהֲרוּ אֶת מִקְדָּשֶׁךָ, וְהִדְלִיקוּ נֵרוֹת בְּחַצְרוֹת קָדְשֶׁךָ, וְקָבְעוּ שְׁמוֹנַת יְמֵי חֲנֻכָּה אֵלּוּ, לְהוֹדוֹת וּלְהַלֵּל לְשִׁמְךָ הַגָּדוֹל.

On Purim:

בִּימֵי מָרְדְּכַי וְאֶסְתֵּר בְּשׁוּשַׁן הַבִּירָה, כְּשֶׁעָמַד עֲלֵיהֶם הָמָן הָרָשָׁע, בִּקֵּשׁ לְהַשְׁמִיד לַהֲרֹג וּלְאַבֵּד אֶת-כָּל הַיְּהוּדִים, מִנַּעַר וְעַד-זָקֵן טַף וְנָשִׁים בְּיוֹם אֶחָד, בִּשְׁלוֹשָׁה עָשָׂר לְחֹדֶשׁ שְׁנֵים-

114

Blessed are You, Lord our God, King of the Universe, who in His goodness feeds the whole world with grace, kindness and compassion. He gives food to all living things for His kindness is forever. Because of His continual great goodness, we have never lacked food, nor may we ever lack it, for the sake of His great name. For He is God who feeds and sustains all, does good to all, and prepares food for all creatures He has created. Blessed are You, Lord, who feeds all.

We thank You, Lord our God, for having granted as a heritage to our ancestors a desirable, good and spacious land; for bringing us out, Lord our God, from the land of Egypt, freeing us from the house of slavery; for Your covenant which You sealed in our flesh; for Your Torah which you taught us; for Your laws which You made known to us; for the life, grace and kindness You have bestowed on us; and for the food by which You continually feed and sustain us, eve—ry day, every season, every hour.

On Hanuka, Purim and Yom Ha'Atzmaut:

We thank You also for the miracles, the redemption, the mighty deeds and the victorie—s in battle which You performed for our ancestors in those days at this time.

On Hanukka:

In the days of Mattityahu, son of Yohanan, the High Priest, the Hasmonean, and his sons, the wicked Greek kingdom rose up against Your people Israel to make them forget Your Torah and force them to transgress the statutes of Your will. It was then that You in your gre—at compassion stood by them in the time of their distress. You championed their cause, judged their claim, and avenged their wrong. You delivered the strong into the hands of the weak, the many into the hands of the few, the impure into the hands of the pure, the wicked into the hands of the righteous, and the arrogant into the hands of those who were engaged in the study of Your Torah. You made for Yourself great and holy renown in Your world, and for Your people Israel You performed a great salvation and redemption as of this very day. Your children then entered the holiest part of Your House, cleansed Your Temple, purified Your sanctuary, kindled lights in Your holy courts, and designated these eight days of Hanukka for giving thanks and praise to Your great name.

On Purim:

In the days of Mordekhai and Esther, in Shushan the capital, the wicked Haman rose up against them and sought to destroy, slay and exterminate all the Jews, young and old, children and women, on one day, the thirteenth day of the twelfth month, which is the month of Adar, and to plunder their

115

עֶשֶׂר, הוּא חֹדֶשׁ אֲדָר, וּשְׁלָלָם לָבוֹז: וְאַתָּה בְּרַחֲמֶיךָ הָרַבִּים הֵפַרְתָּ אֶת עֲצָתוֹ, וְקִלְקַלְתָּ אֶת מַחֲשַׁבְתּוֹ, וַהֲשֵׁבוֹתָ לּוֹ גְּמוּלוֹ בְּרֹאשׁוֹ, וְתָלוּ אוֹתוֹ וְאֶת בָּנָיו עַל הָעֵץ.

On Yom Ha'Atzmaut:

בִּימֵי שִׁיבַת בָּנִים לִגְבוּלָם, בְּעֵת תְּקוּמַת עַם בְּאַרְצוֹ כִּימֵי קֶדֶם, נִסְגְּרוּ שַׁעֲרֵי אֶרֶץ אֲבוֹת בִּפְנֵי אַחֵינוּ פְּלִיטֵי חֶרֶב, וְאוֹיְבִים בָּאָרֶץ וּמִסָּבִיב קָמוּ לְהַכְחִית עַמְּךָ יִשְׂרָאֵל. וְאַתָּה בְּרַחֲמֶיךָ הָרַבִּים עָמַדְתָּ לָהֶם בְּעֵת צָרָתָם, רַבְתָּ אֶת רִיבָם, דַּנְתָּ אֶת דִּינָם, חִזַּקְתָּ אֶת לִבָּם לַעֲמוֹד בַּשַּׁעַר וְלִפְתֹּחַ שְׁעָרִים לַנִּרְדָּפִים וּלְגָרֵשׁ אֶת צִבְאוֹת הָאוֹיֵב מִן הָאָרֶץ. מָסַרְתָּ רַבִּים בְּיַד מְעַטִּים, וּרְשָׁעִים בְּיַד צַדִּיקִים, וּלְךָ עָשִׂיתָ שֵׁם גָּדוֹל וְקָדוֹשׁ בְּעוֹלָמֶךָ, וּלְעַמְּךָ יִשְׂרָאֵל עָשִׂיתָ תְּשׁוּעָה גְדוֹלָה וּפֻרְקָן כְּהַיּוֹם הַזֶּה.

Continue:

וְעַל הַכֹּל, יהוה אֱלֹהֵינוּ, אֲנַחְנוּ מוֹדִים לָךְ וּמְבָרְכִים אוֹתָךְ יִתְבָּרַךְ שִׁמְךָ בְּפִי כָּל חַי תָּמִיד לְעוֹלָם וָעֶד כַּכָּתוּב: וְאָכַלְתָּ וְשָׂבָעְתָּ, וּבֵרַכְתָּ אֶת־יהוה אֱלֹהֶיךָ עַל־הָאָרֶץ הַטֹּבָה אֲשֶׁר נָתַן־לָךְ: בָּרוּךְ אַתָּה יהוה, עַל הָאָרֶץ וְעַל הַמָּזוֹן.

רַחֵם נָא, יהוה אֱלֹהֵינוּ עַל יִשְׂרָאֵל עַמֶּךָ וְעַל יְרוּשָׁלַיִם עִירֶךָ וְעַל צִיּוֹן מִשְׁכַּן כְּבוֹדֶךָ וְעַל מַלְכוּת בֵּית דָּוִד מְשִׁיחֶךָ וְעַל הַבַּיִת הַגָּדוֹל וְהַקָּדוֹשׁ שֶׁנִּקְרָא שִׁמְךָ עָלָיו. אֱלֹהֵינוּ, אָבִינוּ, רְעֵנוּ, זוּנֵנוּ, פַּרְנְסֵנוּ וְכַלְכְּלֵנוּ וְהַרְוִיחֵנוּ, וְהַרְוַח לָנוּ יהוה אֱלֹהֵינוּ מְהֵרָה מִכָּל צָרוֹתֵינוּ. וְנָא אַל תַּצְרִיכֵנוּ, יהוה אֱלֹהֵינוּ לֹא לִידֵי מַתְּנַת בָּשָׂר וָדָם, וְלֹא לִידֵי הַלְוָאָתָם כִּי אִם לְיָדְךָ הַמְּלֵאָה, הַפְּתוּחָה, הַקְּדוֹשָׁה וְהָרְחָבָה שֶׁלֹּא נֵבוֹשׁ וְלֹא נִכָּלֵם לְעוֹלָם וָעֶד.

On Shabbat:

רְצֵה וְהַחֲלִיצֵנוּ, יהוה אֱלֹהֵינוּ, בְּמִצְוֹתֶיךָ וּבְמִצְוַת יוֹם הַשְּׁבִיעִי הַשַּׁבָּת הַגָּדוֹל וְהַקָּדוֹשׁ הַזֶּה כִּי יוֹם זֶה גָּדוֹל וְקָדוֹשׁ הוּא לְפָנֶיךָ לִשְׁבָּת בּוֹ, וְלָנוּחַ בּוֹ בְּאַהֲבָה כְּמִצְוַת רְצוֹנֶךָ וּבִרְצוֹנְךָ הָנִיחַ לָנוּ, יהוה אֱלֹהֵינוּ, שֶׁלֹּא תְהֵא צָרָה וְיָגוֹן וַאֲנָחָה בְּיוֹם מְנוּחָתֵנוּ. וְהַרְאֵנוּ, יהוה אֱלֹהֵינוּ, בְּנֶחָמַת צִיּוֹן עִירֶךָ וּבְבִנְיַן יְרוּשָׁלַיִם עִיר קָדְשֶׁךָ כִּי אַתָּה הוּא בַּעַל הַיְשׁוּעוֹת וּבַעַל הַנֶּחָמוֹת.

possessions. Then You in Your great compassion thwarted his counsel, frustrated his plans, and caused his scheme to recoil on his own head, so that they hanged him and his sons on the gallows.

On Yom Ha'Atzmaut:

In the days when Your children were returning to their borders, at the time of a people revived in its land as in days of old, the gates to the land of our ancestors were closed before those who were fleeing the sword. When enemies from within the land together with surrounding nations sought to annihilate Your people, You, in Your great mercy, stood by them in time of trouble. You defended them and vindicated them. You gave them courage to meet their foes, to open the gates to those seeking refuge, and to free the land of its armed invaders. You delivered the many into the hands of the few, the guilty into the hands of the innocent. You have revealed Your glory and Your holiness to all the world, acheiving great victories and miraculous deliverance for Your people Israel to this day.

Continue—:

For all this, Lord our God, we thank and bless You. May Your name be blessed continually by the mouth of all that lives, for ever and all time – for so it is written: "You will eat and be satisfied, then you shall bless the Lord your God for the good land He has given you." Blessed are You, Lord, for the land and for the food.

Have compassion, please, Lord our God, on Israel Your people, on Jerusalem Your city, on Zion, the dwelling place of Your glory, on the royal house of David, Your anointed, and on the great and holy House that bears Your name. Our God, our Father, tend us, feed us, sustain us and support us, relieve us and send us relief, Lord our God, do not make us dependent on the gifts or loans of other people, but only on Your full, open, holy and generous hand so that we may suffer neither shame nor humiliation for ever and all time.

On Shabbat:

Favor and strengthen us, Lord our God, through Your commandments, especially through the commandment of the seventh day, this great and holy Sabbath. For it is, for You, a great and holy day. On it we cease work and rest in love in accord with Your will's commandment. May it be Your will, Lord our God, to grant us rest without distress, grief or lament on our day of rest. May You show us the consolation of Zion Your city, and the rebuilding of Jerusalem Your holy city, for You are the Master of salvation and consolation.

On Rosh Ḥodesh and Festivals, say:

אֱלֹהֵינוּ וֵאלֹהֵי אֲבוֹתֵינוּ יַעֲלֶה וְיָבֹא וְיַגִּיעַ, וְיֵרָאֶה וְיֵרָצֶה וְיִשָּׁמַע, וְיִפָּקֵד וְיִזָּכֵר זִכְרוֹנֵנוּ

וּפִקְדוֹנֵנוּ, וְזִכְרוֹן אֲבוֹתֵינוּ, וְזִכְרוֹן מָשִׁיחַ בֶּן דָּוִד עַבְדֶּךָ, וְזִכְרוֹן יְרוּשָׁלַיִם עִיר קָדְשֶׁךָ, וְזִכְרוֹן

כָּל עַמְּךָ בֵּית יִשְׂרָאֵל לְפָנֶיךָ, לִפְלֵיטָה לְטוֹבָה, לְחֵן וּלְחֶסֶד וּלְרַחֲמִים לְחַיִּים וּלְשָׁלוֹם בְּיוֹם

On Rosh Ḥodesh: רֹאשׁ הַחֹדֶשׁ הַזֶּה.

On Rosh Hashanah: הַזִּכָּרוֹן הַזֶּה.

On Pesach: חַג הַמַּצּוֹת הַזֶּה.

On Shavuot: חַג הַשָּׁבֻעוֹת הַזֶּה.

On Succot: חַג הַסֻּכּוֹת הַזֶּה.

On Shemini Atzeret and Simchat Torah: הַשְּׁמִינִי חַג הָעֲצֶרֶת הַזֶּה.

זָכְרֵנוּ יהוה אֱלֹהֵינוּ בּוֹ לְטוֹבָה וּפָקְדֵנוּ בוֹ לִבְרָכָה וְהוֹשִׁיעֵנוּ בוֹ לְחַיִּים וּבִדְבַר יְשׁוּעָה

וְרַחֲמִים, חוּס וְחָנֵּנוּ וְרַחֵם עָלֵינוּ, וְהוֹשִׁיעֵנוּ כִּי אֵלֶיךָ עֵינֵינוּ כִּי אֵל (*On Rosh Hashanah* מֶלֶךְ)

חַנּוּן וְרַחוּם אָתָּה.

וּבְנֵה יְרוּשָׁלַיִם עִיר הַקֹּדֶשׁ בִּמְהֵרָה בְיָמֵינוּ. בָּרוּךְ אַתָּה יהוה בּוֹנֵה בְרַחֲמָיו יְרוּשָׁלַיִם, אָמֵן.

בָּרוּךְ אַתָּה יהוה אֱלֹהֵינוּ מֶלֶךְ הָעוֹלָם, הָאֵל אָבִינוּ, מַלְכֵּנוּ, אַדִּירֵנוּ, בּוֹרְאֵנוּ, גּוֹאֲלֵנוּ, יוֹצְרֵנוּ,

קְדוֹשֵׁנוּ, קְדוֹשׁ יַעֲקֹב רוֹעֵנוּ, רוֹעֵה יִשְׂרָאֵל, הַמֶּלֶךְ הַטּוֹב וְהַמֵּטִיב לַכֹּל שֶׁבְּכָל יוֹם וָיוֹם הוּא

הֵיטִיב, הוּא מֵטִיב, הוּא יֵיטִיב לָנוּ הוּא גְמָלָנוּ, הוּא גוֹמְלֵנוּ, הוּא יִגְמְלֵנוּ לָעַד

לְחֵן וּלְחֶסֶד וּלְרַחֲמִים, וּלְרֶוַח הַצָּלָה וְהַצְלָחָה, בְּרָכָה וִישׁוּעָה, נֶחָמָה, פַּרְנָסָה וְכַלְכָּלָה

וְרַחֲמִים וְחַיִּים וְשָׁלוֹם וְכָל טוֹב, וּמִכָּל טוּב לְעוֹלָם אַל יְחַסְּרֵנוּ.

הָרַחֲמָן הוּא יִמְלֹךְ עָלֵינוּ לְעוֹלָם וָעֶד.

הָרַחֲמָן הוּא יִתְבָּרַךְ בַּשָּׁמַיִם וּבָאָרֶץ.

On Rosh Hodesh and Festivals, say:

Our God and God of our ancestors, may there rise, come, reach, appear, be favored, heard, regarded and remembered before You, our recollection and remembrance, as well as the remembrance of our ancestors, and of the Messiah son of David Your servant, and of Jerusalem Your holy city, and of all Your people the house of Israel—for deliverance and well-being, grace, lovingkindness and compassion, life and peace, on this day of:

On Rosh Hodesh: Rosh Hodesh.
On Rosh Hashanah: the Day of Memorial.
On Pesah: the Festival of Matzot.
On Shavuot: the Festival of Shavuot.
On Sukkot: the Festival of Sukkot.
On Shemini Atzeret and Simhat Torah: the Festival of Shemini Atzeret.

On it remember us, Lord our God, for good; recollect us for blessing, and deliver us for life. In accord with Your promise of salvation and compassion, spare us and be gracious to us; have compassion on us and deliver us, for our eyes are turned to You because You are God, gracious and compassionate. (on Rosh Hashana: King).

And may Jerusalem the holy city be rebuilt soon, in our time. Blessed are You, Lord, who in His compassion will rebuild Jerusalem. Amen.

Blessed are You, Lord our God, King of the Universe — God our Father, our King, our Sovereign, our Creator, our Redeemer, our Maker, our Holy One, the Holy One of Jacob. He is our Shepherd, Israel's Shepherd, the good King who does good to all. Every day He has done, is doing, and will do good to us. He has acted, is acting, and will always act kindly toward us forever, granting us grace, kindness and compassion, relief and rescue, prosperity, blessing, redemption and comfort, sustenance and support, compassion, life, peace and all good things, and of all good things may He never let us lack.

May the Compassionate One reign over us forever and all time.
May the Compassionate One be blessed in heaven and on earth.

הָרַחֲמָן, הוּא יִשְׁתַּבַּח לְדוֹר דּוֹרִים, וְיִתְפָּאַר בָּנוּ לָעַד וּלְנֵצַח נְצָחִים וְיִתְהַדַּר בָּנוּ לָעַד וּלְעוֹלְמֵי עוֹלָמִים.

הָרַחֲמָן, הוּא יְפַרְנְסֵנוּ בְּכָבוֹד.

הרחמן, הוּא יִשְׁבֹּר עֻלֵנוּ מֵעַל צַוָּארֵנוּ וְהוּא יוֹלִיכֵנוּ קוֹמְמִיּוּת לְאַרְצֵנוּ.

הָרַחֲמָן, הוּא יִשְׁלַח לָנוּ בְּרָכָה מְרֻבָּה בַּבַּיִת הַזֶּה וְעַל שֻׁלְחָן זֶה שֶׁאָכַלְנוּ עָלָיו.

הָרַחֲמָן, הוּא יִשְׁלַח לָנוּ אֶת אֵלִיָּהוּ הַנָּבִיא זָכוּר לַטּוֹב וִיבַשֶּׂר לָנוּ בְּשׂוֹרוֹת טוֹבוֹת יְשׁוּעוֹת וְנֶחָמוֹת.

הָרַחֲמָן, הוּא יְבָרֵךְ אֶת מְדִינַת יִשְׂרָאֵל, רֵאשִׁית צְמִיחַת גְּאֻלָּתֵנוּ.

הָרַחֲמָן, הוּא יְבָרֵךְ אֶת חַיָּלֵי צְבָא הַהֲגָנָה לְיִשְׂרָאֵל הָעוֹמְדִים עַל מִשְׁמַר אַרְצֵנוּ.

When eating at one's own table say (include the words in parentheses that apply):

הָרַחֲמָן הוּא יְבָרֵךְ אוֹתִי וְאֶת (אִשְׁתִּי\ בַּעֲלִי\ אָבִי מוֹרִי\ אִמִּי מוֹרָתִי\ זַרְעִי\) וְאֶת כָּל אֲשֶׁר לִי.

A guest at someone else's table says (include the words in parentheses that apply):

הָרַחֲמָן הוּא יְבָרֵךְ אֶת בַּעַל הַבַּיִת הַזֶּה, אוֹתוֹ וְאֶת (אִשְׁתּוֹ בַּעֲלַת הַבַּיִת הַזֶּה\ זַרְעוֹ) וְאֶת כָּל אֲשֶׁר לוֹ.

Children at their parents' table say (include the words in parentheses that apply):

הָרַחֲמָן, הוּא יְבָרֵךְ אֶת אָבִי מוֹרִי (בַּעַל הַבַּיִת הַזֶּה), וְאֶת אִמִּי מוֹרָתִי, (בַּעֲלַת הַבַּיִת הַזֶּה), אוֹתָם וְאֶת בֵּיתָם וְאֶת זַרְעָם וְאֶת כָּל אֲשֶׁר לָהֶם

For all other guests, add:

וְאֶת כָּל הַמְּסֻבִּין כַּאן

אוֹתָנוּ וְאֶת כָּל אֲשֶׁר לָנוּ כְּמוֹ שֶׁנִּתְבָּרְכוּ אֲבוֹתֵינוּ אַבְרָהָם יִצְחָק וְיַעֲקֹב, בַּכֹּל, מִכֹּל, כֹּל, כֵּן יְבָרֵךְ אוֹתָנוּ כֻּלָּנוּ יַחַד בִּבְרָכָה שְׁלֵמָה, וְנֹאמַר אָמֵן.

May the Compassionate One be praised from generation to generation, be glorified by us to all eternity, and honored among us for ever and all time.

May the Compassionate One grant us an honorable livelihood

May the Compassionate One break the yoke from our neck and lead us upright to our land.

May the Compassionate One send us many blessings to this house and this table at which we have eaten.

May the Compassionate One send us Elijah the prophet — may he be remembered for good — to bring us good tidings of salvation and consolation.

May the Compassionate One bless the state of Israel, first flowering of our redemption.

May the Compassionate One bless the members of Israel's Defense Forces who stand guard over our land.

May the Compassionate One bless—

> When eating at one's own table, say (include the words in parentheses that apply):

Me, (my wife / husband / my father, my teacher / my mother, my teacher / my children,) and all that is mine;

> A guest at someone else's table says (include the words in parentheses that apply):

The master of this house, him (and his wife, the mistress of this house / and his children) and all that is his,

> children at their parents' table say (include the words in parentheses that apply):

My father, my teacher (master of this house,) and my mother, my teacher, (mistress of this house,) them, their household, their children and all that is his,

> for all other guests, add:

And all the diners here,

together with us and all that is ours. Just as our forefathers Abraham, Isaac and Jacob were blessed in all, from all, with all, so may He bless all of us together with a complete blessing, and let us say: Amen.

בַּמָּרוֹם יְלַמְּדוּ עֲלֵיהֶם וְעָלֵינוּ זְכוּת, שֶׁתְּהֵא לְמִשְׁמֶרֶת שָׁלוֹם, וְנִשָּׂא בְרָכָה מֵאֵת יהוה, וּצְדָקָה

מֵאֱלֹהֵי יִשְׁעֵנוּ וְנִמְצָא חֵן וְשֵׂכֶל טוֹב בְּעֵינֵי אֱלֹהִים וְאָדָם.

On Shabbat:

הָרַחֲמָן, הוּא יַנְחִילֵנוּ יוֹם שֶׁכֻּלּוֹ שַׁבָּת וּמְנוּחָה לְחַיֵּי הָעוֹלָמִים.

On Rosh Hodesh:

הָרַחֲמָן, הוּא יְחַדֵּשׁ עָלֵינוּ אֶת הַחֹדֶשׁ הַזֶּה לְטוֹב וְלִבְרָכָה.

On Yom Tov:

הָרַחֲמָן, הוּא יַנְחִילֵנוּ יוֹם שֶׁכֻּלּוֹ טוֹב.

On Sukkot:

הָרַחֲמָן, הוּא יָקִים לָנוּ אֶת סֻכַּת דָּוִד הַנּוֹפָלֶת.

הָרַחֲמָן, הוּא יְזַכֵּנוּ לִימוֹת הַמָּשִׁיחַ וּלְחַיֵּי הָעוֹלָם הַבָּא

מַגְדִּיל (*On Shabbat, Festivals and Rosh Hodesh*: מִגְדּוֹל) יְשׁוּעוֹת מַלְכּוֹ וְעֹשֶׂה-חֶסֶד לִמְשִׁיחוֹ,

לְדָוִד וּלְזַרְעוֹ עַד - עוֹלָם: עֹשֶׂה שָׁלוֹם בִּמְרוֹמָיו

הוּא יַעֲשֶׂה שָׁלוֹם עָלֵינוּ וְעַל כָּל יִשְׂרָאֵל וְאִמְרוּ אָמֵן.

יְראוּ אֶת-יהוה קְדֹשָׁיו כִּי-אֵין מַחְסוֹר לִירֵאָיו: כְּפִירִים רָשׁוּ וְרָעֵבוּ וְדֹרְשֵׁי יהוה לֹא-יַחְסְרוּ

כָל-טוֹב: הוֹדוּ לַיהוה כִּי-טוֹב כִּי לְעוֹלָם חַסְדּוֹ: פּוֹתֵחַ אֶת-יָדֶךָ וּמַשְׂבִּיעַ לְכָל-חַי רָצוֹן:

בָּרוּךְ הַגֶּבֶר אֲשֶׁר יִבְטַח בַּיהוה וְהָיָה יהוה מִבְטַחוֹ: נַעַר הָיִיתִי גַּם-זָקַנְתִּי וְלֹא-רָאִיתִי

צַדִּיק נֶעֱזָב וְזַרְעוֹ מְבַקֶּשׁ-לָחֶם: יהוה עֹז לְעַמּוֹ יִתֵּן יהוה יְבָרֵךְ אֶת-עַמּוֹ בַשָּׁלוֹם:

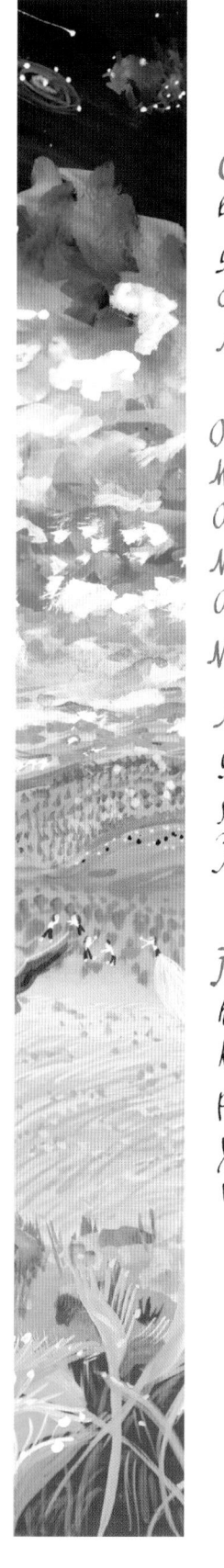

On high, may grace be invoked for them and for us, as a safeguard of peace. May we receive a blessing from the Lord and a just reward from the God of our salvation, and may we find grace and good favor in the eyes of God and man.

On Shabbat:

May the Compassionate One let us inherit the time, that will be entirely Shabbat
 and rest for life everlasting.

On Rosh Hodesh:

May the Compassionate One renew this month for us, for good and blessing.

On Yom Tov:

May the Compassionate One let us inherit the day, that is all good.

On Sukkot:

May the Compassionate One restore for us, the fallen Tabernacle of David.

May the Compassionate One make us worthy of the Messianic Age and life in the World to Come. He gives great (On Shabbat, Festivals and Rosh Hodesh: He is a tower of) salvation to His king, showing kindness to His anointed, to David and his descendants for ever. He who makes peace in His high places, may He make peace for us and all Israel, and let us say: Amen.

Fear the Lord, you His holy ones; those who fear Him lack nothing. Young lions may grow weak and hungry, but those who seek the Lord lack no good thing. Thank the Lord for He is good: His loving-kindness is for ever. You open Your hand and satisfy the desire of every living thing. Blessed is the person who trusts in the Lord, whose trust is in the Lord alone. Once I was young and now I am old, yet I have never watched a righteous man forsaken or his children begging for bread. The Lord will give His people strength. The Lord will bless His people with peace.—

מַעֲרִיב

The service below is appropriate for a regular Shabbat, Shabbat Rosh Ḥodesh, and Shabbat Ḥol HaMo'ed.

Blessings of the Shema
The leader says the following, bowing at "Bless," standing straight at "the Lord." The congregation, followed by the leader, responds, bowing at "Bless," standing straight at "the Lord."

Leader:

בָּרְכוּ
אֶת יהוה הַמְבֹרָךְ

Congregation:

בָּרוּךְ יהוה הַמְבֹרָךְ לְעוֹלָם וָעֶד.

Leader:

בָּרוּךְ יהוה הַמְבֹרָךְ לְעוֹלָם וָעֶד.

בָּרוּךְ יהוה הַמְבֹרָךְ לְעוֹלָם וָעֶד. בָּרוּךְ אַתָּה יהוה, אֱלֹהֵינוּ מֶלֶךְ הָעוֹלָם,
אֲשֶׁר בִּדְבָרוֹ מַעֲרִיב עֲרָבִים, בְּחָכְמָה פּוֹתֵחַ שְׁעָרִים, וּבִתְבוּנָה מְשַׁנֶּה
עִתִּים, וּמַחֲלִיף אֶת הַזְּמַנִּים וּמְסַדֵּר אֶת הַכּוֹכָבִים בְּמִשְׁמְרוֹתֵיהֶם בָּרָקִיעַ
כִּרְצוֹנוֹ. בּוֹרֵא יוֹם וָלַיְלָה, גּוֹלֵל אוֹר מִפְּנֵי חֹשֶׁךְ, וְחֹשֶׁךְ מִפְּנֵי אוֹר וּמַעֲבִיר
יוֹם וּמֵבִיא לַיְלָה וּמַבְדִּיל בֵּין יוֹם וּבֵין לַיְלָה יהוה צְבָאוֹת שְׁמוֹ. אֵל חַי וְקַיָּם
תָּמִיד, יִמְלוֹךְ עָלֵינוּ לְעוֹלָם וָעֶד. בָּרוּךְ אַתָּה יהוה, הַמַּעֲרִיב עֲרָבִים.

אַהֲבַת עוֹלָם בֵּית יִשְׂרָאֵל עַמְּךָ אָהַבְתָּ תּוֹרָה וּמִצְוֹת, חֻקִּים וּמִשְׁפָּטִים
אוֹתָנוּ לִמַּדְתָּ עַל כֵּן יהוה אֱלֹהֵינוּ, בְּשָׁכְבֵנוּ וּבְקוּמֵנוּ נָשִׂיחַ בְּחֻקֶּיךָ וְנִשְׂמַח
בְּדִבְרֵי תוֹרָתֶךָ וּבְמִצְוֹתֶיךָ לְעוֹלָם וָעֶד כִּי הֵם חַיֵּינוּ וְאֹרֶךְ יָמֵינוּ, וּבָהֶם נֶהְגֶּה
יוֹמָם וָלָיְלָה. וְאַהֲבָתְךָ אַל תָּסִיר מִמֶּנּוּ לְעוֹלָמִים. בָּרוּךְ אַתָּה יהוה, אוֹהֵב
עַמּוֹ יִשְׂרָאֵל.

Ma'ariv for Shabbat

The service below is appropriate for a regular Shabbat, Shabbat Rosh Ḥodesh, and Shabbat Ḥol HaMo'ed.

Blessings of the Shema
The leader says the following, bowing at "Bless," standing straight at "the Lord." The congregation, followed by the leader, responds, bowing at "Bless," standing straight at "the Lord."

Leader:

BLESS

the Lord, the blessed One.

Congregation:

Bless the Lord, the blessed One, for ever and all time.

Leader:

Bless the Lord, the blessed One, for ever and all time.

Blessed are You, Lord our God, King of the Universe, Who by His word brings on evenings, by His wisdom opens the gates of heaven, with understanding makes time change and the seasons rotate, and by His will orders the stars in their constellations in the sky. He creates day and night, rolling away the light before the darkness, and darkness before the light. He makes the day pass and brings on night, distinguishing day from night: the Lord of hosts is His name. May the living and forever enduring God rule over us for all time. Blessed are You, Lord, who brings on evenings.

With everlasting love have You loved Your people, the House of Israel. You have taught us Torah and commandments, decrees and laws of justice. Therefore, Lord our God, when we lie down and when we rise up we will speak of Your decrees, rejoicing in the words of Your Torah and Your commandments for ever. For they are our life and the length of our days; on them will we meditate day and night. May You never take away Your love from us. Blessed are You, Lord, Who loves His people Israel.

שמע

When not with a minyan, say:

אֵל מֶלֶךְ נֶאֱמָן

שְׁמַע יִשְׂרָאֵל, יהוה אֱלֹהֵינוּ, יהוה אֶחָד.
בָּרוּךְ שֵׁם כְּבוֹד מַלְכוּתוֹ לְעוֹלָם וָעֶד.

וְאָהַבְתָּ אֵת יהוה אֱלֹהֶיךָ, בְּכָל לְבָבְךָ, וּבְכָל נַפְשְׁךָ, וּבְכָל מְאֹדֶךָ. וְהָיוּ
הַדְּבָרִים הָאֵלֶּה, אֲשֶׁר אָנֹכִי מְצַוְּךָ הַיּוֹם, עַל לְבָבֶךָ. וְשִׁנַּנְתָּם לְבָנֶיךָ,
וְדִבַּרְתָּ בָּם, בְּשִׁבְתְּךָ בְּבֵיתֶךָ, וּבְלֶכְתְּךָ בַדֶּרֶךְ, וּבְשָׁכְבְּךָ, וּבְקוּמֶךָ.
וּקְשַׁרְתָּם לְאוֹת עַל יָדֶךָ, וְהָיוּ לְטֹטָפֹת בֵּין עֵינֶיךָ. וּכְתַבְתָּם עַל מְזֻזוֹת
בֵּיתֶךָ וּבִשְׁעָרֶיךָ.

וְהָיָה אִם שָׁמֹעַ תִּשְׁמְעוּ אֶל מִצְוֹתַי, אֲשֶׁר אָנֹכִי מְצַוֶּה אֶתְכֶם הַיּוֹם,
לְאַהֲבָה אֶת יהוה אֱלֹהֵיכֶם וּלְעָבְדוֹ, בְּכָל לְבַבְכֶם וּבְכָל נַפְשְׁכֶם. וְנָתַתִּי
מְטַר אַרְצְכֶם בְּעִתּוֹ, יוֹרֶה וּמַלְקוֹשׁ, וְאָסַפְתָּ דְגָנֶךָ וְתִירֹשְׁךָ וְיִצְהָרֶךָ. וְנָתַתִּי
עֵשֶׂב בְּשָׂדְךָ לִבְהֶמְתֶּךָ, וְאָכַלְתָּ וְשָׂבָעְתָּ. הִשָּׁמְרוּ לָכֶם פֶּן יִפְתֶּה לְבַבְכֶם,
וְסַרְתֶּם וַעֲבַדְתֶּם אֱלֹהִים אֲחֵרִים וְהִשְׁתַּחֲוִיתֶם לָהֶם. וְחָרָה אַף יהוה בָּכֶם,
וְעָצַר אֶת הַשָּׁמַיִם וְלֹא יִהְיֶה מָטָר, וְהָאֲדָמָה לֹא תִתֵּן אֶת יְבוּלָהּ,
וַאֲבַדְתֶּם מְהֵרָה מֵעַל הָאָרֶץ הַטֹּבָה אֲשֶׁר יהוה נֹתֵן לָכֶם. וְשַׂמְתֶּם אֶת
דְּבָרַי אֵלֶּה עַל | לְבַבְכֶם וְעַל נַפְשְׁכֶם, וּקְשַׁרְתֶּם אֹתָם לְאוֹת עַל יֶדְכֶם,
וְהָיוּ לְטוֹטָפֹת בֵּין עֵינֵיכֶם. וְלִמַּדְתֶּם אֹתָם אֶת בְּנֵיכֶם לְדַבֵּר בָּם, בְּשִׁבְתְּךָ
בְּבֵיתֶךָ, וּבְלֶכְתְּךָ בַדֶּרֶךְ, וּבְשָׁכְבְּךָ, וּבְקוּמֶךָ. וּכְתַבְתָּם עַל מְזוּזוֹת בֵּיתֶךָ
וּבִשְׁעָרֶיךָ. לְמַעַן יִרְבּוּ יְמֵיכֶם וִימֵי בְנֵיכֶם עַל הָאֲדָמָה אֲשֶׁר נִשְׁבַּע יהוה
לַאֲבֹתֵיכֶם לָתֵת לָהֶם, כִּימֵי הַשָּׁמַיִם עַל הָאָרֶץ.

Shema

When not with a minyan, say:
God, faithful King!

Listen, Israel: the Lord is our God, the Lord is One.
Blessed be the name of His glorious kingdom for ever and all time.

Love the Lord your God with all your heart, with all your soul, and with all your might. These words that I command you today shall be on your heart. Teach them repeatedly to your children, speaking of them when you sit at home and when you travel on the way, when you lie down and when you rise. Bind them as a sign on your hand, and they shall be an emblem between your eyes. Write them on the doorposts of your house and gates.

If you indeed heed My commandments with which I charge you today, to love the Lord your God and worship Him with all your heart and with all your soul, I will give rain in your land in its season, the early and late rain; and you shall gather in your grain, wine, and oil. I will give grass in your field for your cattle, and you shall eat and be satisfied. Be careful lest your heart be tempted and you go astray and worship other gods, bowing down to them. Then the Lord's anger will flare against you and He will close the heavens so that there will be no rain. The land will not yield its crops, and you will perish swiftly from the good land that the Lord is giving you. Therefore, set these, My words, on your heart and soul. Bind them as a sign on your hand, and they shall be an emblem between your eyes. Teach them to your children, speaking of them when you sit at home and when you travel on the way, when you lie down and when you rise. Write them on the doorposts of your house and gates, so that you and your children may live long in the land that the Lord swore to your ancestors to give them, for as long as the heavens are above the earth.

וַיֹּאמֶר יהוה אֶל מֹשֶׁה לֵּאמֹר. דַּבֵּר אֶל בְּנֵי יִשְׂרָאֵל וְאָמַרְתָּ אֲלֵהֶם, וְעָשׂוּ לָהֶם צִיצִת עַל כַּנְפֵי בִגְדֵיהֶם לְדֹרֹתָם, וְנָתְנוּ עַל צִיצִת הַכָּנָף פְּתִיל תְּכֵלֶת. וְהָיָה לָכֶם לְצִיצִת, וּרְאִיתֶם אֹתוֹ וּזְכַרְתֶּם אֶת כָּל מִצְוֹת יהוה, וַעֲשִׂיתֶם אֹתָם, וְלֹא תָתוּרוּ אַחֲרֵי לְבַבְכֶם וְאַחֲרֵי עֵינֵיכֶם, אֲשֶׁר אַתֶּם זֹנִים אַחֲרֵיהֶם. לְמַעַן תִּזְכְּרוּ וַעֲשִׂיתֶם אֶת כָּל מִצְוֹתָי, וִהְיִיתֶם קְדֹשִׁים לֵאלֹהֵיכֶם. אֲנִי יהוה אֱלֹהֵיכֶם, אֲשֶׁר הוֹצֵאתִי אֶתְכֶם מֵאֶרֶץ מִצְרַיִם, לִהְיוֹת לָכֶם לֵאלֹהִים, אֲנִי יהוה אֱלֹהֵיכֶם. אֱמֶת

The leader repeats:

יהוה אֱלֹהֵיכֶם אֱמֶת

וֶאֱמוּנָה כָּל זֹאת, וְקַיָּם עָלֵינוּ, כִּי הוּא יהוה אֱלֹהֵינוּ וְאֵין זוּלָתוֹ, וַאֲנַחְנוּ יִשְׂרָאֵל עַמּוֹ. הַפּוֹדֵנוּ מִיַּד מְלָכִים מַלְכֵּנוּ הַגּוֹאֲלֵנוּ מִכַּף כָּל הֶעָרִיצִים. הָאֵל הַנִּפְרָע לָנוּ מִצָּרֵינוּ, וְהַמְשַׁלֵּם גְּמוּל לְכָל אֹיְבֵי נַפְשֵׁנוּ. הָעֹשֶׂה גְדוֹלוֹת עַד אֵין חֵקֶר, וְנִפְלָאוֹת עַד אֵין מִסְפָּר הַשָּׂם נַפְשֵׁנוּ בַּחַיִּים, וְלֹא נָתַן לַמּוֹט רַגְלֵנוּ הַמַּדְרִיכֵנוּ עַל בָּמוֹת אוֹיְבֵינוּ, וַיָּרֶם קַרְנֵנוּ עַל כָּל שׂוֹנְאֵינוּ. הָעֹשֶׂה לָנוּ נִסִּים וּנְקָמָה בְּפַרְעֹה, אוֹתוֹת וּמוֹפְתִים בְּאַדְמַת בְּנֵי חָם. הַמַּכֶּה בְעֶבְרָתוֹ כָּל בְּכוֹרֵי מִצְרָיִם וַיּוֹצֵא אֶת עַמּוֹ יִשְׂרָאֵל מִתּוֹכָם לְחֵרוּת עוֹלָם. הַמַּעֲבִיר בָּנָיו בֵּין גִּזְרֵי יַם סוּף אֶת רוֹדְפֵיהֶם וְאֶת שׂוֹנְאֵיהֶם בִּתְהוֹמוֹת טִבַּע. וְרָאוּ בָנָיו גְּבוּרָתוֹ, שִׁבְּחוּ וְהוֹדוּ לִשְׁמוֹ וּמַלְכוּתוֹ בְּרָצוֹן קִבְּלוּ עֲלֵיהֶם. מֹשֶׁה וּבְנֵי יִשְׂרָאֵל לְךָ עָנוּ שִׁירָה בְּשִׂמְחָה רַבָּה וְאָמְרוּ כֻלָּם

מִי כָמֹכָה בָּאֵלִם יהוה,
מִי כָּמֹכָה נֶאְדָּר בַּקֹּדֶשׁ
נוֹרָא תְהִלֹּת, עֹשֵׂה פֶלֶא.

The Lord spoke to Moses, saying: Speak to the Israelites and tell them to make tassels on the corners of their garments for all generations. They shall attach to the tassel at each corner a thread of blue. This shall be your tassel, and you shall see it and remember all of the Lord's commandments and keep them, not straying after your heart and after your eyes, following your own sinful desires. Thus you will be reminded to keep all My commandments, and be holy to your God. I am the Lord your God, who brought you out of the land of Egypt to be your God. I am the Lord your God. **True**

The leader repeats:
The Lord your God is true

and faithful is all this, and firmly established for us that He is the Lord our God, and there is none besides Him, and that we, Israel, are His people. He is our King, Who redeems us from the hand of kings and delivers us from the grasp of all tyrants. He is our God, Who on our behalf repays our foes and brings just retribution on our mortal enemies; Who performs great deeds beyond understanding and wonders beyond number; Who kept us alive, not letting our foot slip; Who led us on the high places of our enemies, raising our pride above all our foes; Who did miracles for us and brought vengeance against Pharaoh; Who performed signs and wonders in the land of Ham's children; Who smote in His wrath all the firstborn of Egypt, and brought out His people Israel from their midst into everlasting freedom; Who led His children through the divided Reed Sea, plunging their pursuers and enemies into the depths. When His children saw His might, they gave praise and thanks to His name, and willingly accepted His Sovereignty. Moses and the children of Israel then sang a song to You with great joy, and they all exclaimed:

"Who is like You, Lord, among the mighty?
Who is like You, majestic in holiness,
awesome in praises, doing wonders?"

מַלְכוּתְךָ רָאוּ בָנֶיךָ, בּוֹקֵעַ יָם לִפְנֵי מֹשֶׁה זֶה אֵלִי עָנוּ וְאָמְרוּ:
יהוה יִמְלֹךְ לְעֹלָם וָעֶד.
וְנֶאֱמַר:
כִּי פָדָה יהוה אֶת יַעֲקֹב, וּגְאָלוֹ מִיַּד חָזָק מִמֶּנּוּ.
בָּרוּךְ אַתָּה יהוה, גָּאַל יִשְׂרָאֵל.

הַשְׁכִּיבֵנוּ יהוה אֱלֹהֵינוּ לְשָׁלוֹם, וְהַעֲמִידֵנוּ מַלְכֵּנוּ לְחַיִּים,
וּפְרוֹשׂ עָלֵינוּ סֻכַּת שְׁלוֹמֶךָ, וְתַקְּנֵנוּ בְּעֵצָה טוֹבָה מִלְּפָנֶיךָ וְהוֹשִׁיעֵנוּ לְמַעַן
שְׁמֶךָ. וְהָגֵן בַּעֲדֵנוּ, וְהָסֵר מֵעָלֵינוּ אוֹיֵב, דֶּבֶר, וְחֶרֶב, וְרָעָב, וְיָגוֹן וְהָסֵר שָׂטָן
מִלְּפָנֵינוּ וּמֵאַחֲרֵינוּ, וּבְצֵל כְּנָפֶיךָ תַּסְתִּירֵנוּ כִּי אֵל שׁוֹמְרֵנוּ וּמַצִּילֵנוּ אָתָּה
כִּי אֵל מֶלֶךְ חַנּוּן וְרַחוּם אָתָּה. וּשְׁמוֹר צֵאתֵנוּ וּבוֹאֵנוּ, לְחַיִּים וּלְשָׁלוֹם,
מֵעַתָּה וְעַד עוֹלָם. וּפְרוֹשׂ עָלֵינוּ סֻכַּת שְׁלוֹמֶךָ. בָּרוּךְ אַתָּה יהוה
הַפּוֹרֵשׂ סֻכַּת שָׁלוֹם עָלֵינוּ וְעַל כָּל עַמּוֹ יִשְׂרָאֵל וְעַל יְרוּשָׁלָיִם.

The congregation stands and together with the leader says:
וְשָׁמְרוּ בְנֵי יִשְׂרָאֵל אֶת הַשַּׁבָּת לַעֲשׂוֹת אֶת הַשַּׁבָּת לְדֹרֹתָם בְּרִית עוֹלָם:
בֵּינִי וּבֵין בְּנֵי יִשְׂרָאֵל אוֹת הִיא לְעוֹלָם כִּי שֵׁשֶׁת יָמִים עָשָׂה יהוה אֶת
הַשָּׁמַיִם וְאֶת הָאָרֶץ וּבַיּוֹם הַשְּׁבִיעִי שָׁבַת וַיִּנָּפַשׁ:

חצי קדיש

Leader:
יִתְגַּדַּל וְיִתְקַדַּשׁ שְׁמֵהּ רַבָּא.
בְּעָלְמָא דִּי בְרָא כִרְעוּתֵהּ, וְיַמְלִיךְ מַלְכוּתֵהּ
בְּחַיֵּיכוֹן וּבְיוֹמֵיכוֹן וּבְחַיֵּי דְכָל בֵּית יִשְׂרָאֵל,
בַּעֲגָלָא וּבִזְמַן קָרִיב, וְאִמְרוּ אָמֵן.

Congregation:
אָמֵן

Your children beheld Your majesty as You parted the sea before Moses. "This is my God!" they responded, and then said: "The Lord shall reign for ever and ever." And it is said, "For the Lord has redeemed Jacob and rescued him from a power stronger than his own." Blessed are You, Lord, who redeemed Israel.

Help us lie down, O Lord our God, in peace, and rise up, O our King, to life. Spread over us Your canopy of peace. Direct us with Your good counsel, and save us for the sake of Your name. Shield us and remove from us every enemy, plague, sword, famine, and sorrow. Remove the adversary from before and behind us. Shelter us in the shadow of Your wings, for You, God, are our Guardian and Deliverer; You, God, are a gracious and compassionate King. Guard our going out and our coming in, for life and peace, from now and for ever. Spread over us Your canopy of peace. Blessed are You, Lord, who spreads a canopy of peace over us, over all His people Israel, and over Jerusalem.

The congregation stands and together with the leader says:

The children of Israel must keep the Sabbath, observing the Sabbath in every generation as an everlasting covenant. It is a sign between Me and the children of Israel for ever, for in six days God made the heavens and the earth, but on the seventh day He ceased work and refreshed Himself. Thus Moses announced the Lord's appointed seasons to the children of Israel.

Half-Kaddish

Leader:

Magnified and sanctified may His Great Name be, in the world He created by His will. May He establish His kingdom in your lifetime and in your days, and in the lifetime of all the House of Israel, swiftly and soon—and say: Amen.

Congregation:

Amen.

יְהֵא שְׁמֵהּ רַבָּא מְבָרַךְ לְעָלַם וּלְעָלְמֵי עָלְמַיָּא.

Leader:

יִתְבָּרַךְ וְיִשְׁתַּבַּח וְיִתְפָּאַר וְיִתְרוֹמַם וְיִתְנַשֵּׂא
וְיִתְהַדָּר וְיִתְעַלֶּה וְיִתְהַלָּל שְׁמֵהּ דְּקֻדְשָׁא בְּרִיךְ הוּא

Congregation:

בְּרִיךְ הוּא
לְעֵלָּא מִן כָּל בִּרְכָתָא
(*On Shabbat Shuva:* לְעֵלָּא וּלְעֵלָּא מִכָּל בִּרְכָתָא)
וְשִׁירָתָא תֻּשְׁבְּחָתָא וְנֶחֱמָתָא, דַּאֲמִירָן בְּעָלְמָא,
וְאִמְרוּ אָמֵן.

Congregation:

אָמֵן

עמידה

*The following prayer, until "in former times," is said silently, standing with feet together. Take three steps forward and at the points indicated with an *, bend the knees at the first word, bow at the second, and stand straight before saying God's name.*

אֲדֹנָי שְׂפָתַי תִּפְתָּח וּפִי יַגִּיד תְּהִלָּתֶךָ.

*בָּרוּךְ אַתָּה יהוה אֱלֹהֵינוּ וֵאלֹהֵי אֲבוֹתֵינוּ, אֱלֹהֵי אַבְרָהָם, אֱלֹהֵי יִצְחָק,
וֵאלֹהֵי יַעֲקֹב הָאֵל הַגָּדוֹל הַגִּבּוֹר וְהַנּוֹרָא, אֵל עֶלְיוֹן גּוֹמֵל חֲסָדִים טוֹבִים,
וְקֹנֵה הַכֹּל וְזוֹכֵר חַסְדֵי אָבוֹת וּמֵבִיא גוֹאֵל לִבְנֵי בְנֵיהֶם, לְמַעַן שְׁמוֹ
בְּאַהֲבָה.

On Shabbat Shuva:

זָכְרֵנוּ לְחַיִּים, מֶלֶךְ חָפֵץ בַּחַיִּים וְכָתְבֵנוּ בְּסֵפֶר הַחַיִּים, לְמַעַנְךָ אֱלֹהִים חַיִּים.

All:

May His Great Name be blessed for ever and all time.

Leader:

Blessed and praised, glorified and exalted, raised and honored, uplifted and lauded be the name of the Holy One, blessed be He,

Congregation:

blessed be He

Leader:

beyond any blessing, song, praise, and consolation uttered in the world—and say: Amen.

Congregation:

Amen.

The Amidah

*The following prayer, until "in former times," is said silently, standing with feet together. Take three steps forward and at the points indicated with an *, bend the knees at the first word, bow at the second, and stand straight before saying God's name.*

O Lord, open my lips, so that my mouth may declare Your praise.

*Blessed are You, Lord our God and God of our fathers, God of Abraham, God of Isaac and God of Jacob; the great, mighty, and awesome God, God Most High, who bestows acts of loving-kindness and creates all, who remembers the loving-kindness of the fathers and will bring a Redeemer to their children's children for the sake of His name, in love.

On Shabbat Shuva:

Remember us for life, O King who desires life, and write us in the book of life—for Your sake, O God of life.

מֶלֶךְ עוֹזֵר וּמוֹשִׁיעַ וּמָגֵן. *בָּרוּךְ אַתָּה יהוה, מָגֵן אַבְרָהָם.

אַתָּה גִּבּוֹר לְעוֹלָם אֲדֹנָי, מְחַיֵּה מֵתִים אַתָּה, רַב לְהוֹשִׁיעַ.

This phrase is added from Simḥat Torah until Pesaḥ:
מַשִּׁיב הָרוּחַ וּמוֹרִיד הַגֶּשֶׁם.
In Israel, the phrase below is added from Pesaḥ until Shemini Atzeret:
מוֹרִיד הַטָּל.

מְכַלְכֵּל חַיִּים בְּחֶסֶד, מְחַיֵּה מֵתִים בְּרַחֲמִים רַבִּים, סוֹמֵךְ נוֹפְלִים, וְרוֹפֵא
חוֹלִים, וּמַתִּיר אֲסוּרִים, וּמְקַיֵּם אֱמוּנָתוֹ לִישֵׁנֵי עָפָר. מִי כָמוֹךָ בַּעַל גְּבוּרוֹת
וּמִי דּוֹמֶה לָּךְ מֶלֶךְ מֵמִית וּמְחַיֶּה וּמַצְמִיחַ יְשׁוּעָה.

On Shabbat Shuva:
מִי כָמוֹךָ אַב הָרַחֲמִים, זוֹכֵר יְצוּרָיו לְחַיִּים בְּרַחֲמִים.

וְנֶאֱמָן אַתָּה לְהַחֲיוֹת מֵתִים. בָּרוּךְ אַתָּה יהוה, מְחַיֵּה הַמֵּתִים.

אַתָּה קָדוֹשׁ וְשִׁמְךָ קָדוֹשׁ, וּקְדוֹשִׁים בְּכָל יוֹם יְהַלְלוּךָ סֶּלָה.
בָּרוּךְ אַתָּה יהוה, הָאֵל הַקָּדוֹשׁ. *On Shabbat Shuva:* הַמֶּלֶךְ הַקָּדוֹשׁ

אַתָּה קִדַּשְׁתָּ אֶת יוֹם הַשְּׁבִיעִי לִשְׁמֶךָ תַּכְלִית מַעֲשֵׂה שָׁמַיִם וָאָרֶץ
וּבֵרַכְתּוֹ מִכָּל הַיָּמִים, וְקִדַּשְׁתּוֹ מִכָּל הַזְּמַנִּים וְכֵן כָּתוּב בְּתוֹרָתֶךָ:

וַיְכֻלּוּ הַשָּׁמַיִם וְהָאָרֶץ וְכָל צְבָאָם: וַיְכַל אֱלֹהִים בַּיּוֹם הַשְּׁבִיעִי מְלַאכְתּוֹ
אֲשֶׁר עָשָׂה וַיִּשְׁבֹּת בַּיּוֹם הַשְּׁבִיעִי, מִכָּל מְלַאכְתּוֹ אֲשֶׁר עָשָׂה: וַיְבָרֶךְ
אֱלֹהִים אֶת יוֹם הַשְּׁבִיעִי, וַיְקַדֵּשׁ אֹתוֹ כִּי בוֹ שָׁבַת מִכָּל מְלַאכְתּוֹ,
אֲשֶׁר–בָּרָא אֱלֹהִים לַעֲשׂוֹת:

King, Helper, Savior, Shield: *Blessed** are You, Lord, Shield of Abraham.

You are eternally mighty, Lord. You give life to the dead and have great power to save.

This phrase is added from Simḥat Torah until Pesaḥ:
He makes the wind blow and the rain fall.

In Israel, the phrase below is added from Pesaḥ until Shemini Atzeret:
He causes the dew to fall.

He sustains the living with loving-kindness, and with great compassion revives the dead. He supports the fallen, heals the sick, sets captives free, and keeps His faith with those who sleep in the dust. Who is like You, Master of might, and to whom can You be compared, O King who brings death and gives life, and makes salvation grow?

On Shabbat Shuva:
Who is like You, compassionate Father, Who remembers His creatures in compassion, for life?

Faithful are You to revive the dead. Blessed are You, Lord, Who revives the dead.

You are holy and Your name is holy, and holy ones praise You daily, Selah! Blessed are You, Lord, the holy God. *On Shabbat Shuva:* the holy King.

You sanctified the seventh day for Your name's sake, as the culmination of the creation of heaven and earth. Of all days, You blessed it; of all seasons, You sanctified it—and so it is written in Your Torah:

Then the heavens and the earth were completed, and all their array. With the seventh day, God completed the work He had done. He ceased on the seventh day from all the work He had done. God blessed the seventh day and declared it holy because on it, He ceased from all His work He had created to do.

אֱלֹהֵינוּ וֵאלֹהֵי אֲבוֹתֵינוּ, רְצֵה בִמְנוּחָתֵנוּ. קַדְּשֵׁנוּ בְּמִצְוֹתֶיךָ, וְתֵן חֶלְקֵנוּ
בְּתוֹרָתֶךָ שַׂבְּעֵנוּ מִטּוּבֶךָ, וְשַׂמְּחֵנוּ בִּישׁוּעָתֶךָ. וְטַהֵר לִבֵּנוּ לְעָבְדְּךָ בֶּאֱמֶת.
וְהַנְחִילֵנוּ, יְהוָה אֱלֹהֵינוּ, בְּאַהֲבָה וּבְרָצוֹן שַׁבַּת קָדְשֶׁךָ וְיָנוּחוּ בָהּ יִשְׂרָאֵל
מְקַדְּשֵׁי שְׁמֶךָ. בָּרוּךְ אַתָּה יְהוָה, מְקַדֵּשׁ הַשַּׁבָּת.

רְצֵה יְהוָה אֱלֹהֵינוּ בְּעַמְּךָ יִשְׂרָאֵל וּבִתְפִלָּתָם וְהָשֵׁב אֶת הָעֲבוֹדָה לִדְבִיר
בֵּיתֶךָ וְאִשֵּׁי יִשְׂרָאֵל וּתְפִלָּתָם בְּאַהֲבָה תְקַבֵּל בְּרָצוֹן וּתְהִי לְרָצוֹן תָּמִיד
עֲבוֹדַת יִשְׂרָאֵל עַמֶּךָ.

On Rosh Ḥodesh and Ḥol HaMo'ed:

אֱלֹהֵינוּ וֵאלֹהֵי אֲבוֹתֵינוּ, יַעֲלֶה וְיָבֹא, וְיַגִּיעַ, וְיֵרָאֶה, וְיֵרָצֶה, וְיִשָּׁמַע,
וְיִפָּקֵד, וְיִזָּכֵר זִכְרוֹנֵנוּ וּפִקְדּוֹנֵנוּ, וְזִכְרוֹן אֲבוֹתֵינוּ, וְזִכְרוֹן מָשִׁיחַ בֶּן דָּוִד
עַבְדֶּךָ, וְזִכְרוֹן יְרוּשָׁלַיִם עִיר קָדְשֶׁךָ, וְזִכְרוֹן כָּל עַמְּךָ בֵּית יִשְׂרָאֵל,
לְפָנֶיךָ, לִפְלֵיטָה, לְטוֹבָה, לְחֵן וּלְחֶסֶד וּלְרַחֲמִים, לְחַיִּים וּלְשָׁלוֹם, בְּיוֹם
On Rosh Ḥodesh: רֹאשׁ הַחֹדֶשׁ

On Pesaḥ: חַג הַמַּצּוֹת

On Sukkot: חַג הַסֻּכּוֹת

הַזֶּה. זָכְרֵנוּ, יְהוָה אֱלֹהֵינוּ, בּוֹ לְטוֹבָה, וּפָקְדֵנוּ בוֹ לִבְרָכָה, וְהוֹשִׁיעֵנוּ
בוֹ לְחַיִּים. וּבִדְבַר יְשׁוּעָה וְרַחֲמִים, חוּס וְחָנֵּנוּ, וְרַחֵם עָלֵינוּ וְהוֹשִׁיעֵנוּ,
כִּי אֵלֶיךָ עֵינֵינוּ, כִּי אֵל מֶלֶךְ חַנּוּן וְרַחוּם אָתָּה.

וְתֶחֱזֶינָה עֵינֵינוּ בְּשׁוּבְךָ לְצִיּוֹן בְּרַחֲמִים. בָּרוּךְ אַתָּה יְהוָה,
הַמַּחֲזִיר שְׁכִינָתוֹ לְצִיּוֹן.

Our God and God of our ancestors, may You find favor in our rest. Make us holy through Your commandments and grant us our share in Your Torah. Satisfy us with Your goodness, grant us joy in Your salvation, and purify our hearts to serve You in truth. In love and favor, O Lord our God, grant us as our heritage Your holy Shabbat, so that Israel, who sanctify Your name, may find rest on it. Blessed are You, Lord, who sanctifies the Sabbath.

Find favor, Lord our God, in Your people Israel and their prayer. Restore the service to Your most holy House, and accept in love and favor the fire-offerings of Israel and their prayer. May the service of Your people Israel always find favor with You.

On Rosh Ḥodesh and Ḥol HaMo'ed:
Our God and God of our ancestors, may there rise, come, reach, appear, be favored, heard, regarded, and remembered before You, our recollection and remembrance, as well as the remembrance of our ancestors, and of the Messiah son of David Your servant, and of Jerusalem Your holy city, and of all Your people the House of Israel—for deliverance and well-being, grace, loving-kindness and compassion, life and peace, on this day of:

> Rosh Ḥodesh.
> *or* the Festival of Matzot.
> *or* the Festival of Sukkot.

On it remember us, Lord our God, for good; recollect us for blessing, and deliver us for life. In accord with Your promise of salvation and compassion, spare us and be gracious to us; have compassion on us and deliver us, for our eyes are turned to You because You, God, are a gracious and compassionate King.

And may our eyes witness Your return to Zion in compassion.
Blessed are You, Lord, who restores His Presence to Zion.

*מוֹדִים אֲנַחְנוּ לָךְ שָׁאַתָּה הוּא יהוה אֱלֹהֵינוּ וֵאלֹהֵי אֲבוֹתֵינוּ, לְעוֹלָם וָעֶד.
צוּר חַיֵּינוּ, מָגֵן יִשְׁעֵנוּ, אַתָּה הוּא לְדוֹר וָדוֹר. נוֹדֶה לְךָ וּנְסַפֵּר תְּהִלָּתֶךָ עַל
חַיֵּינוּ הַמְּסוּרִים בְּיָדֶךָ וְעַל נִשְׁמוֹתֵינוּ הַפְּקוּדוֹת לָךְ וְעַל נִסֶּיךָ שֶׁבְּכָל יוֹם
עִמָּנוּ וְעַל נִפְלְאוֹתֶיךָ וְטוֹבוֹתֶיךָ שֶׁבְּכָל עֵת, עֶרֶב וָבֹקֶר וְצָהֳרָיִם. הַטּוֹב, כִּי
לֹא כָלוּ רַחֲמֶיךָ, וְהַמְרַחֵם, כִּי לֹא תַמּוּ חֲסָדֶיךָ מֵעוֹלָם קִוִּינוּ לָךְ.

On Shabbat Ḥanukka:

עַל הַנִּסִּים, וְעַל הַפֻּרְקָן, וְעַל הַגְּבוּרוֹת, וְעַל הַתְּשׁוּעוֹת, וְעַל הַמִּלְחָמוֹת
שֶׁעָשִׂיתָ לַאֲבוֹתֵינוּ בַּיָּמִים הָהֵם בַּזְּמַן הַזֶּה.

בִּימֵי מַתִּתְיָהוּ בֶּן יוֹחָנָן כֹּהֵן גָּדוֹל, חַשְׁמוֹנַאי וּבָנָיו, כְּשֶׁעָמְדָה מַלְכוּת יָוָן
הָרְשָׁעָה עַל עַמְּךָ יִשְׂרָאֵל לְהַשְׁכִּיחָם תּוֹרָתֶךָ, וּלְהַעֲבִירָם מֵחֻקֵּי רְצוֹנֶךָ,
וְאַתָּה בְּרַחֲמֶיךָ הָרַבִּים עָמַדְתָּ לָהֶם בְּעֵת צָרָתָם, רַבְתָּ אֶת רִיבָם, דַּנְתָּ אֶת
דִּינָם, נָקַמְתָּ אֶת נִקְמָתָם, מָסַרְתָּ גִבּוֹרִים בְּיַד חַלָּשִׁים, וְרַבִּים בְּיַד מְעַטִּים,
וּטְמֵאִים בְּיַד טְהוֹרִים, וּרְשָׁעִים בְּיַד צַדִּיקִים, וְזֵדִים בְּיַד עוֹסְקֵי תוֹרָתֶךָ. וּלְךָ
עָשִׂיתָ שֵׁם גָּדוֹל וְקָדוֹשׁ בְּעוֹלָמֶךָ, וּלְעַמְּךָ יִשְׂרָאֵל עָשִׂיתָ תְּשׁוּעָה גְדוֹלָה
וּפֻרְקָן כְּהַיּוֹם הַזֶּה. וְאַחַר כֵּן בָּאוּ בָנֶיךָ לִדְבִיר בֵּיתֶךָ, וּפִנּוּ אֶת הֵיכָלֶךָ,
וְטִהֲרוּ אֶת מִקְדָּשֶׁךָ, וְהִדְלִיקוּ נֵרוֹת בְּחַצְרוֹת קָדְשֶׁךָ, וְקָבְעוּ שְׁמוֹנַת יְמֵי
חֲנֻכָּה אֵלּוּ, לְהוֹדוֹת וּלְהַלֵּל לְשִׁמְךָ הַגָּדוֹל. וְעַל כֻּלָּם

On Shushan Purim in Jerusalem:

עַל הַנִּסִּים, וְעַל הַפֻּרְקָן, וְעַל הַגְּבוּרוֹת, וְעַל הַתְּשׁוּעוֹת, וְעַל הַמִּלְחָמוֹת
שֶׁעָשִׂיתָ לַאֲבוֹתֵינוּ בַּיָּמִים הָהֵם בַּזְּמַן הַזֶּה.

138

*We give thanks to You, for You are the Lord our God and God of our ancestors for ever and all time. You are the Rock of our lives, Shield of our salvation from generation to generation. We will thank You and declare Your praise for our lives, which are entrusted into Your hand; for our souls, which are placed in Your charge; for Your miracles that are with us every day; and for Your wonders and favors at all times, evening, morning, and midday. You are good—for Your compassion never fails. You are compassionate—for Your loving-kindnesses never cease. We have always placed our hope in You.

On Shabbat Ḥanukka:

[We thank You also] for the miracles, the redemption, the mighty deeds, the salvations, and the victories in battle that You performed for our ancestors in those days, at this time.

In the days of Mattityahu, son of Yoḥanan, the High Priest, the Hasmonean, and his sons, the wicked Greek kingdom rose up against Your people Israel to make them forget Your Torah and to force them to transgress the statutes of Your will. It was then that You in Your great compassion stood by them in the time of their distress. You championed their cause, judged their claim, and avenged their wrong. You delivered the strong into the hands of the weak, the many into the hands of the few, the impure into the hands of the pure, the wicked into the hands of the righteous, and the arrogant into the hands of those who were engaged in the study of Your Torah. You made for Yourself great and holy renown in Your world, and for Your people Israel You performed a great salvation and redemption as of this very day. Your children then entered the holiest part of Your House, cleansed Your Temple, purified Your Sanctuary, kindled lights in Your holy courts, and designated these eight days of Ḥanukka for giving thanks and praise to Your Great Name.

Continue with "For all these things."

On Shushan Purim in Jerusalem:

[We thank You also] for the miracles, the redemption, the mighty deeds, the salvations, and the victories in battle that You performed for our ancestors in those days, at this time.

בִּימֵי מָרְדְּכַי וְאֶסְתֵּר בְּשׁוּשַׁן הַבִּירָה, כְּשֶׁעָמַד עֲלֵיהֶם הָמָן הָרָשָׁע, בִּקֵּשׁ
לְהַשְׁמִיד לַהֲרֹג וּלְאַבֵּד אֶת כָּל הַיְּהוּדִים, מִנַּעַר וְעַד זָקֵן, טַף וְנָשִׁים, בְּיוֹם
אֶחָד, בִּשְׁלוֹשָׁה עָשָׂר לְחֹדֶשׁ שְׁנֵים עָשָׂר, הוּא חֹדֶשׁ אֲדָר, וּשְׁלָלָם לָבוֹז.
וְאַתָּה בְּרַחֲמֶיךָ הָרַבִּים הֵפַרְתָּ אֶת עֲצָתוֹ, וְקִלְקַלְתָּ אֶת מַחֲשַׁבְתּוֹ, וַהֲשֵׁבוֹתָ
לּוֹ גְּמוּלוֹ בְּרֹאשׁוֹ, וְתָלוּ אוֹתוֹ וְאֶת בָּנָיו עַל הָעֵץ.
וְעַל כֻּלָּם
Continue with

וְעַל כֻּלָּם יִתְבָּרַךְ וְיִתְרוֹמַם שִׁמְךָ מַלְכֵּנוּ תָּמִיד לְעוֹלָם וָעֶד.

On Shabbat Shuva:
וּכְתוֹב לְחַיִּים טוֹבִים כָּל בְּנֵי בְרִיתֶךָ.

וְכֹל הַחַיִּים יוֹדוּךָ סֶּלָה, וִיהַלְלוּ אֶת שִׁמְךָ בֶּאֱמֶת, הָאֵל יְשׁוּעָתֵנוּ וְעֶזְרָתֵנוּ
סֶלָה. בָּרוּךְ אַתָּה יהוה, הַטּוֹב שִׁמְךָ וּלְךָ נָאֶה לְהוֹדוֹת.

שָׁלוֹם רָב עַל יִשְׂרָאֵל עַמְּךָ תָּשִׂים לְעוֹלָם, כִּי אַתָּה הוּא מֶלֶךְ אָדוֹן לְכָל
הַשָּׁלוֹם. וְטוֹב בְּעֵינֶיךָ לְבָרֵךְ אֶת עַמְּךָ יִשְׂרָאֵל בְּכָל עֵת וּבְכָל שָׁעָה
בִּשְׁלוֹמֶךָ.

On Shabbat Shuva:
בְּסֵפֶר חַיִּים, בְּרָכָה, וְשָׁלוֹם, וּפַרְנָסָה טוֹבָה, נִזָּכֵר וְנִכָּתֵב לְפָנֶיךָ, אֲנַחְנוּ וְכָל
עַמְּךָ בֵּית יִשְׂרָאֵל, לְחַיִּים טוֹבִים וּלְשָׁלוֹם.

בָּרוּךְ אַתָּה יהוה, הַמְבָרֵךְ אֶת עַמּוֹ יִשְׂרָאֵל בַּשָּׁלוֹם.

On Shabbat Shuva outside Israel, many end with the blessing:
בָּרוּךְ אַתָּה הוּא עוֹשֶׂה הַשָּׁלוֹם.

In the days of Mordekhai and Esther, in Shushan the capital, the wicked Haman rose up against them and sought to destroy, slay, and exterminate all the Jews, young and old, children and women, on one day, the thirteenth day of the twelfth month, which is the month of Adar, and to plunder their possessions. Then You in Your great compassion thwarted his counsel, frustrated his plans, and caused his scheme to recoil on his own head, so that they hanged him and his sons on the gallows.

Continue with "For all these things."

For all these things may Your name be blessed and exalted, our King, continually, for ever and all time.

On Shabbat Shuva:

And write, for a good life, all the children of Your covenant.

Let all that lives thank You, Selah! and praise Your name in truth, God, our Savior and Help, Selah! Blessed are You, Lord, whose name is "the Good" and to whom thanks are due.

Grant great peace to Your people Israel for ever, for You are the sovereign Lord of all peace; and may it be good in Your eyes to bless Your people Israel at every time, at every hour, with Your peace.

On Shabbat Shuva:

In the book of life, blessing, peace, and prosperity, may we and all Your people the House of Israel be remembered and written before You for a good life, and for peace.

Blessed are You, Lord, Who blesses His people Israel with peace.

On Shabbat Shuva outside Israel, many end with the blessing:

Blessed are You, Lord, Who makes peace.

Some say the following verse:

יִהְיוּ לְרָצוֹן אִמְרֵי פִי וְהֶגְיוֹן לִבִּי לְפָנֶיךָ, יהוה צוּרִי וְגוֹאֲלִי.

אֱלֹהַי, נְצֹר לְשׁוֹנִי מֵרָע, וּשְׂפָתַי מִדַּבֵּר מִרְמָה, וְלִמְקַלְלַי נַפְשִׁי תִדֹּם, וְנַפְשִׁי כֶּעָפָר לַכֹּל תִּהְיֶה. פְּתַח לִבִּי בְּתוֹרָתֶךָ, וּבְמִצְוֹתֶיךָ תִּרְדּוֹף נַפְשִׁי. וְכָל הַחוֹשְׁבִים עָלַי רָעָה, מְהֵרָה הָפֵר עֲצָתָם וְקַלְקֵל מַחֲשַׁבְתָּם. עֲשֵׂה לְמַעַן שְׁמֶךָ, עֲשֵׂה לְמַעַן יְמִינֶךָ, עֲשֵׂה לְמַעַן קְדֻשָּׁתֶךָ, עֲשֵׂה לְמַעַן תּוֹרָתֶךָ. לְמַעַן יֵחָלְצוּן יְדִידֶיךָ, הוֹשִׁיעָה יְמִינְךָ וַעֲנֵנִי. יִהְיוּ לְרָצוֹן אִמְרֵי פִי וְהֶגְיוֹן לִבִּי לְפָנֶיךָ, יהוה צוּרִי וְגוֹאֲלִי.

Bow, take three steps back, then bow, first left, then right, then center, while saying:

עֹשֶׂה שָׁלוֹם (הַשָּׁלוֹם *On Shabbat Shuva say:*) בִּמְרוֹמָיו, הוּא יַעֲשֶׂה שָׁלוֹם עָלֵינוּ, וְעַל כָּל יִשְׂרָאֵל, וְאִמְרוּ אָמֵן.

יְהִי רָצוֹן מִלְּפָנֶיךָ, יהוה אֱלֹהֵינוּ וֵאלֹהֵי אֲבוֹתֵינוּ, שֶׁיִּבָּנֶה בֵּית הַמִּקְדָּשׁ בִּמְהֵרָה בְיָמֵינוּ, וְתֵן חֶלְקֵנוּ בְּתוֹרָתֶךָ, וְשָׁם נַעֲבָדְךָ בְּיִרְאָה כִּימֵי עוֹלָם וּכְשָׁנִים קַדְמוֹנִיּוֹת. וְעָרְבָה לַיהוה מִנְחַת יְהוּדָה וִירוּשָׁלָיִם, כִּימֵי עוֹלָם וּכְשָׁנִים קַדְמוֹנִיּוֹת.

All stand and say:

וַיְכֻלּוּ הַשָּׁמַיִם וְהָאָרֶץ וְכָל צְבָאָם. וַיְכַל אֱלֹהִים בַּיּוֹם הַשְּׁבִיעִי מְלַאכְתּוֹ אֲשֶׁר עָשָׂה, וַיִּשְׁבֹּת בַּיּוֹם הַשְּׁבִיעִי, מִכָּל מְלַאכְתּוֹ אֲשֶׁר עָשָׂה. וַיְבָרֶךְ אֱלֹהִים אֶת יוֹם הַשְּׁבִיעִי וַיְקַדֵּשׁ אֹתוֹ, כִּי בוֹ שָׁבַת מִכָּל מְלַאכְתּוֹ, אֲשֶׁר בָּרָא אֱלֹהִים לַעֲשׂוֹת.

Leader:

בָּרוּךְ אַתָּה יהוה, אֱלֹהֵינוּ וֵאלֹהֵי אֲבוֹתֵינוּ, אֱלֹהֵי אַבְרָהָם, אֱלֹהֵי יִצְחָק, וֵאלֹהֵי יַעֲקֹב, הָאֵל הַגָּדוֹל הַגִּבּוֹר וְהַנּוֹרָא, אֵל עֶלְיוֹן, קוֹנֵה שָׁמַיִם וָאָרֶץ.

Some say the following verse:

May the words of my mouth and the meditation of my heart find favor before You, Lord, my Rock and Redeemer.

My God, guard my tongue from evil and my lips from deceitful speech. To those who curse me, let my soul be silent; may my soul be to all like the dust. Open my heart to Your Torah and let my soul pursue Your commandments. As for all who plan evil against me, swiftly thwart their counsel and frustrate their plans. Act for the sake of Your name; act for the sake of Your right hand; act for the sake of Your holiness; act for the sake of Your Torah. That Your beloved ones may be delivered, save with Your right hand and answer me. May the words of my mouth and the meditation of my heart find favor before You, Lord, my Rock and Redeemer.

Bow, take three steps back, then bow, first left, then right, then center, while saying:

May He who makes peace in His high places, make peace for us and all Israel—and say: Amen.

May it be Your will, Lord our God and God of our ancestors, that the Temple be rebuilt speedily in our days, and grant us a share in Your Torah. And there we will serve You with reverence, as in the days of old and as in former years. Then the offering of Judah and Jerusalem will be pleasing to the Lord as in the days of old and as in former years.

All stand and say:

Then the heavens and the earth were completed, and all their array. With the seventh day, God completed the work He had done. He ceased on the seventh day from all the work He had done. God blessed the seventh day and declared it holy because on it, He ceased from all His work He had created to do.

Leader:

Blessed are You, Lord our God and God of our fathers, God of Abraham, God of Isaac and God of Jacob, the great, mighty, and awesome God, God Most High, Creator of heaven and earth.

Congregation, then the leader:

מָגֵן אָבוֹת בִּדְבָרוֹ, מְחַיֶּה מֵתִים בְּמַאֲמָרוֹ, הָאֵל
הַמֶּלֶךְ

On Shabbat Shuva:

הַקָּדוֹשׁ שֶׁאֵין כָּמוֹהוּ, הַמֵּנִיחַ לְעַמּוֹ בְּיוֹם שַׁבַּת קָדְשׁוֹ, כִּי בָם רָצָה לְהָנִיחַ
לָהֶם. לְפָנָיו נַעֲבוֹד בְּיִרְאָה וָפַחַד, וְנוֹדֶה לִשְׁמוֹ בְּכָל יוֹם תָּמִיד, מֵעֵין
הַבְּרָכוֹת. אֵל הַהוֹדָאוֹת, אֲדוֹן הַשָּׁלוֹם, מְקַדֵּשׁ הַשַּׁבָּת וּמְבָרֵךְ שְׁבִיעִי,
וּמֵנִיחַ בִּקְדֻשָּׁה לְעַם מְדֻשְּׁנֵי עֹנֶג, זֵכֶר לְמַעֲשֵׂה בְרֵאשִׁית.

Leader:

אֱלֹהֵינוּ וֵאלֹהֵי אֲבוֹתֵינוּ, רְצֵה בִמְנוּחָתֵנוּ, קַדְּשֵׁנוּ בְּמִצְוֹתֶיךָ, וְתֵן חֶלְקֵנוּ
בְּתוֹרָתֶךָ, שַׂבְּעֵנוּ מִטּוּבֶךָ, וְשַׂמְּחֵנוּ בִּישׁוּעָתֶךָ, וְטַהֵר לִבֵּנוּ לְעָבְדְּךָ בֶּאֱמֶת,
וְהַנְחִילֵנוּ יהוה אֱלֹהֵינוּ בְּאַהֲבָה וּבְרָצוֹן שַׁבַּת קָדְשֶׁךָ, וְיָנוּחוּ בָהּ יִשְׂרָאֵל
מְקַדְּשֵׁי שְׁמֶךָ. בָּרוּךְ אַתָּה יהוה, מְקַדֵּשׁ הַשַּׁבָּת.

קדיש

Leader:

יִתְגַּדַּל וְיִתְקַדַּשׁ שְׁמֵהּ רַבָּא *Congregation:* אָמֵן
בְּעָלְמָא דִּי בְרָא כִרְעוּתֵהּ, וְיַמְלִיךְ מַלְכוּתֵהּ בְּחַיֵּיכוֹן וּבְיוֹמֵיכוֹן וּבְחַיֵּי דְכָל
בֵּית יִשְׂרָאֵל, בַּעֲגָלָא וּבִזְמַן קָרִיב, וְאִמְרוּ אָמֵן.
Congregation: אָמֵן

All:

יְהֵא שְׁמֵהּ רַבָּא מְבָרַךְ לְעָלַם וּלְעָלְמֵי עָלְמַיָּא.

144

Congregation, then the leader:

By His word, He was the Shield of our ancestors. By His promise, He will revive the dead. There is none like the holy God (*On Shabbat Shuva:* the holy King) Who gives rest to His people on His holy Sabbath day, for He found them worthy of His favor to give them rest. Before Him we will come in worship with reverence and awe, giving thanks to His name daily, continually, with due blessings. He is God to Whom thanks are due, the Lord of peace Who sanctifies the Sabbath and blesses the seventh day, and in holiness gives rest to a people filled with delight, in remembrance of the work of creation.

Leader:

Our God and God of our ancestors, may You find favor in our rest. Make us holy through Your commandments and grant us our share in Your Torah. Satisfy us with Your goodness, grant us joy in Your salvation, and purify our hearts to serve You in truth. In love and favor, Lord our God, grant us as our heritage Your holy Sabbath, so that Israel who sanctify Your name may find rest on it. Blessed are You, Lord, Who sanctifies the Sabbath.

Full Kaddish

Leader:

Magnified and sanctified may His Great Name be, in the world He created by His will. May He establish His kingdom in your lifetime and in your days, and in the lifetime of all the House of Israel, swiftly and soon—and say: Amen.

Congregation:

Amen.

All:

May His Great Name be blessed for ever and all time.

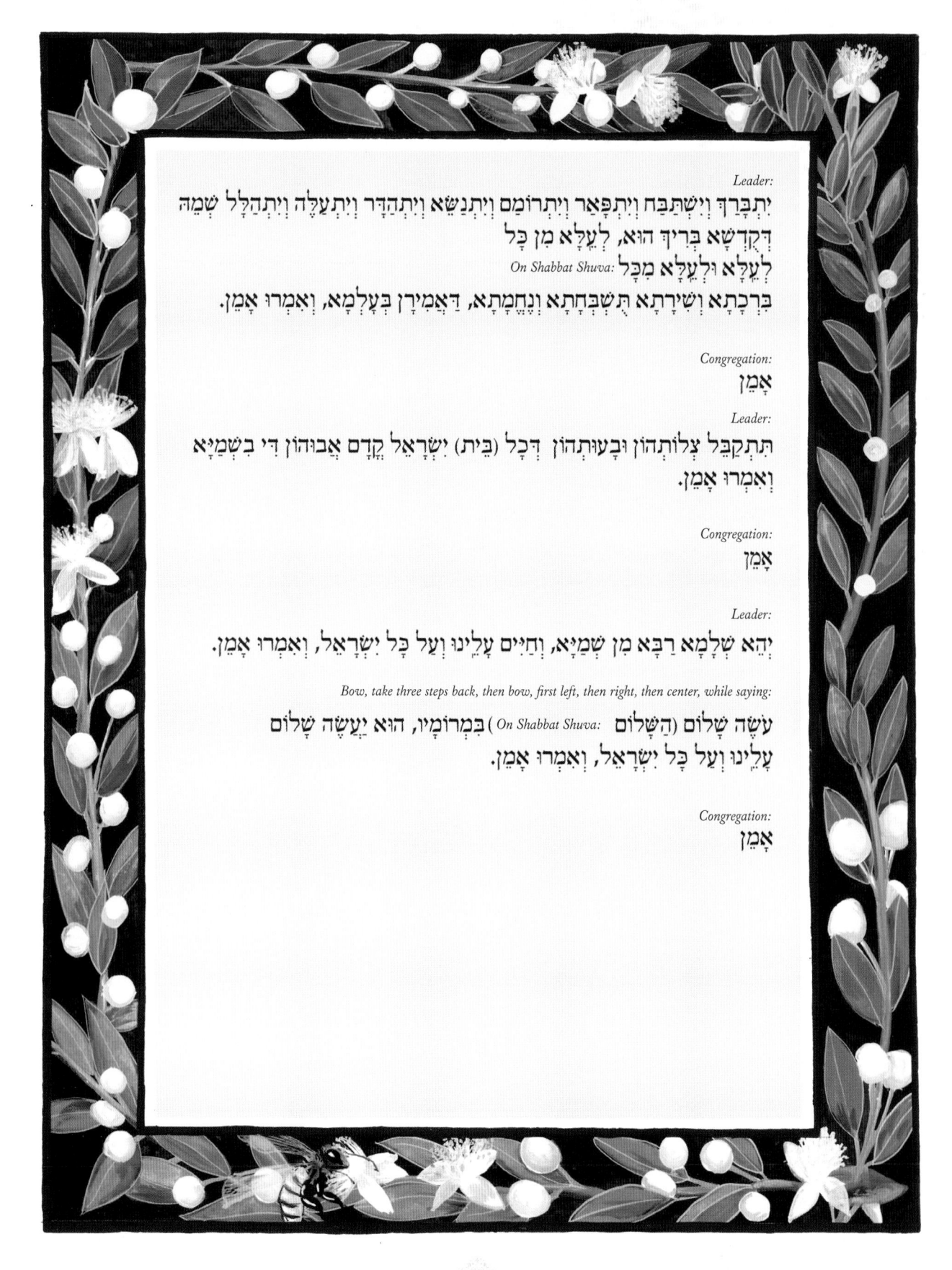

Leader:

יִתְבָּרַךְ וְיִשְׁתַּבַּח וְיִתְפָּאַר וְיִתְרוֹמַם וְיִתְנַשֵּׂא וְיִתְהַדָּר וְיִתְעַלֶּה וְיִתְהַלָּל שְׁמֵהּ
דְּקֻדְשָׁא בְּרִיךְ הוּא, לְעֵלָּא מִן כָּל
On Shabbat Shuva: לְעֵלָּא וּלְעֵלָּא מִכָּל

בִּרְכָתָא וְשִׁירָתָא תֻּשְׁבְּחָתָא וְנֶחֱמָתָא, דַּאֲמִירָן בְּעָלְמָא, וְאִמְרוּ אָמֵן.

Congregation:

אָמֵן

Leader:

תִּתְקַבֵּל צְלוֹתְהוֹן וּבָעוּתְהוֹן דְּכָל (בֵּית) יִשְׂרָאֵל קֳדָם אֲבוּהוֹן דִּי בִשְׁמַיָּא
וְאִמְרוּ אָמֵן.

Congregation:

אָמֵן

Leader:

יְהֵא שְׁלָמָא רַבָּא מִן שְׁמַיָּא, וְחַיִּים עָלֵינוּ וְעַל כָּל יִשְׂרָאֵל, וְאִמְרוּ אָמֵן.

Bow, take three steps back, then bow, first left, then right, then center, while saying:

עֹשֶׂה שָׁלוֹם (הַשָּׁלוֹם *On Shabbat Shuva:*) בִּמְרוֹמָיו, הוּא יַעֲשֶׂה שָׁלוֹם
עָלֵינוּ וְעַל כָּל יִשְׂרָאֵל, וְאִמְרוּ אָמֵן.

Congregation:

אָמֵן

Leader:

Blessed and praised, glorified and exalted, raised and honored, uplifted and lauded be the name of the Holy One, blessed be He, beyond any blessing, song, praise, and consolation uttered in the world—and say: Amen.

Congregation:

Amen.

Leader:

May the prayers and pleas of all Israel be accepted by their Father in heaven—and say: Amen.

Congregation:

Amen.

Leader:

May there be great peace from heaven, and life for us and all Israel—and say: Amen.

Congregation:

Amen.

Bow, take three steps back, then bow, first left, then right, then center, while saying:

May He who makes peace in His high places, make peace for us and all Israel—and say: Amen.

Congregation:

Amen.

קידוש בבית הכנסת

Leader raises a cup of wine and says:

סַבְרִי מָרָנָן

בָּרוּךְ אַתָּה יהוה אֱלֹהֵינוּ מֶלֶךְ הָעוֹלָם, בּוֹרֵא פְּרִי הַגָּפֶן.

בָּרוּךְ אַתָּה יהוה אֱלֹהֵינוּ מֶלֶךְ הָעוֹלָם, אֲשֶׁר קִדְּשָׁנוּ בְּמִצְוֹתָיו וְרָצָה בָנוּ, וְשַׁבַּת קָדְשׁוֹ בְּאַהֲבָה וּבְרָצוֹן הִנְחִילָנוּ זִכָּרוֹן לְמַעֲשֵׂה בְרֵאשִׁית, כִּי הוּא יוֹם תְּחִלָּה לְמִקְרָאֵי קֹדֶשׁ, זֵכֶר לִיצִיאַת מִצְרָיִם, כִּי בָנוּ בָחַרְתָּ וְאוֹתָנוּ קִדַּשְׁתָּ מִכָּל הָעַמִּים, וְשַׁבַּת קָדְשְׁךָ בְּאַהֲבָה וּבְרָצוֹן הִנְחַלְתָּנוּ. בָּרוּךְ אַתָּה יהוה, מְקַדֵּשׁ הַשַּׁבָּת.

The wine should be drunk by children under the age of bar/bat mitzvah or, if there are none, by the leader.

From the second night of Pesaḥ until the night before Shavuot, the Omer is counted (see page 244).

עלינו

*Stand while singing Aleinu. Bow at *.*

עָלֵינוּ לְשַׁבֵּחַ לַאֲדוֹן הַכֹּל, לָתֵת גְּדֻלָּה לְיוֹצֵר בְּרֵאשִׁית, שֶׁלֹּא עָשָׂנוּ כְּגוֹיֵי הָאֲרָצוֹת, וְלֹא שָׂמָנוּ כְּמִשְׁפְּחוֹת הָאֲדָמָה, שֶׁלֹּא שָׂם חֶלְקֵנוּ כָּהֶם, וְגֹרָלֵנוּ כְּכָל הֲמוֹנָם, (שֶׁהֵם מִשְׁתַּחֲוִים לְהֶבֶל וָרִיק, וּמִתְפַּלְלִים אֶל אֵל לֹא יוֹשִׁיעַ,) *וַאֲנַחְנוּ כּוֹרְעִים וּמִשְׁתַּחֲוִים וּמוֹדִים, לִפְנֵי מֶלֶךְ מַלְכֵי הַמְּלָכִים, הַקָּדוֹשׁ בָּרוּךְ הוּא. שֶׁהוּא נוֹטֶה שָׁמַיִם וְיֹסֵד אָרֶץ, וּמוֹשַׁב יְקָרוֹ בַּשָּׁמַיִם מִמַּעַל, וּשְׁכִינַת עֻזּוֹ בְּגָבְהֵי מְרוֹמִים, הוּא אֱלֹהֵינוּ אֵין עוֹד. אֱמֶת מַלְכֵּנוּ, אֶפֶס זוּלָתוֹ, כַּכָּתוּב בְּתוֹרָתוֹ: וְיָדַעְתָּ הַיּוֹם וַהֲשֵׁבֹתָ אֶל לְבָבֶךָ, כִּי יהוה הוּא הָאֱלֹהִים בַּשָּׁמַיִם מִמַּעַל, וְעַל הָאָרֶץ מִתָּחַת, אֵין עוֹד.

עַל כֵּן נְקַוֶּה לְּךָ יהוה אֱלֹהֵינוּ, לִרְאוֹת מְהֵרָה בְּתִפְאֶרֶת עֻזֶּךָ, לְהַעֲבִיר גִּלּוּלִים מִן הָאָרֶץ, וְהָאֱלִילִים כָּרוֹת יִכָּרֵתוּן, לְתַקֵּן עוֹלָם בְּמַלְכוּת שַׁדַּי, וְכָל בְּנֵי בָשָׂר יִקְרְאוּ בִשְׁמֶךָ, לְהַפְנוֹת אֵלֶיךָ כָּל רִשְׁעֵי אָרֶץ. יַכִּירוּ וְיֵדְעוּ

Leader raises a cup of wine and says:

Please pay attention, my masters.

Blessed are You, Lord our God, King of the Universe, Who creates the fruit of the vine.

Blessed are You, Lord our God, King of the Universe, Who has made us holy with His commandments, has favored us, and in love and favor given us His holy Sabbath as a heritage, a remembrance of the work of Creation. It is the first among the holy days of assembly, a remembrance of the Exodus from Egypt. For You chose us and sanctified us from all the peoples, and in love and favor gave us Your holy Sabbath as a heritage. Blessed are You, Lord, Who sanctifies the Sabbath.

The wine should be drunk by children under the age of bar/bat mitzvah or, if there are none, by the leader.

From the second night of Pesaḥ until the night before Shavuot, the Omer is counted (see page 244).

Aleinu

*Stand while singing Aleinu. Bow at *.*

It is our duty to praise the Master of all, and ascribe greatness to the Author of creation, Who has not made us like the nations of the lands nor placed us like the families of the earth; Who has not made our portion like theirs, nor our destiny like all their multitudes. (For they worship vanity and emptiness, and pray to a god who cannot save.) *But we bow in worship and thank the Supreme King of kings, the Holy One, blessed be He, Who extends the heavens and establishes the earth, Whose throne of glory is in the heavens above, and Whose power's Presence is in the highest of heights. He is our God; there is no other. Truly He is our King, there is none else, as it is written in His Torah: "You shall know and take to heart this day that the Lord is God, in heaven above and on earth below. There is no other."

Therefore, we place our hope in You, Lord our God, that we may soon see the glory of Your power, when You will remove abominations from the earth, and idols will be utterly destroyed, when the world will be perfected under the sovereignty of the

כָּל יוֹשְׁבֵי תֵבֵל, כִּי לְךָ תִּכְרַע כָּל בֶּרֶךָ, תִּשָּׁבַע כָּל לָשׁוֹן. לְפָנֶיךָ יהוה אֱלֹהֵינוּ יִכְרְעוּ וְיִפֹּלוּ, וְלִכְבוֹד שִׁמְךָ יְקָר יִתֵּנוּ, וִיקַבְּלוּ כֻלָּם אֶת עוֹל מַלְכוּתֶךָ, וְתִמְלֹךְ עֲלֵיהֶם מְהֵרָה לְעוֹלָם וָעֶד. כִּי הַמַּלְכוּת שֶׁלְּךָ הִיא, וּלְעוֹלְמֵי עַד תִּמְלוֹךְ בְּכָבוֹד, כַּכָּתוּב בְּתוֹרָתֶךָ, יהוה יִמְלֹךְ לְעוֹלָם וָעֶד. וְנֶאֱמַר, וְהָיָה יְיָ לְמֶלֶךְ עַל כָּל הָאָרֶץ, בַּיוֹם הַהוּא יִהְיֶה יהוה אֶחָד, וּשְׁמוֹ אֶחָד.

אַל תִּירָא מִפַּחַד פִּתְאֹם, וּמִשֹּׁאַת רְשָׁעִים כִּי תָבֹא. עֻצוּ עֵצָה וְתֻפָר, דַּבְּרוּ דָבָר וְלֹא יָקוּם, כִּי עִמָּנוּ אֵל. וְעַד זִקְנָה אֲנִי הוּא, וְעַד שֵׂיבָה אֲנִי אֶסְבֹּל, אֲנִי עָשִׂיתִי וַאֲנִי אֶשָּׂא, וַאֲנִי אֶסְבֹּל וַאֲמַלֵּט.

קדיש יתום

The following prayer said by mourners requires the presence of a minyan.

יִתְגַּדַּל וְיִתְקַדַּשׁ שְׁמֵהּ רַבָּא.

Congregation:

אָמֵן

Mourners:

בְּעָלְמָא דִּי בְרָא כִרְעוּתֵהּ, וְיַמְלִיךְ מַלְכוּתֵהּ בְּחַיֵּיכוֹן וּבְיוֹמֵיכוֹן וּבְחַיֵּי דְכָל בֵּית יִשְׂרָאֵל, בַּעֲגָלָא וּבִזְמַן קָרִיב, וְאִמְרוּ אָמֵן.

Congregation:

אָמֵן. יְהֵא שְׁמֵהּ רַבָּא מְבָרַךְ לְעָלַם וּלְעָלְמֵי עָלְמַיָּא.

Almighty, when all humanity will call on Your name, to turn all the earth's wicked toward You. All the world's inhabitants will realize and know that to You every knee must bow and every tongue swear loyalty. Before You, Lord our God, they will kneel and bow down and give honor to Your glorious name. They will all accept the yoke of Your kingdom, and You will reign over them soon and for ever. For the kingdom is Yours, and to all eternity You will reign in glory, as it is written in Your Torah: "The Lord will reign for ever and ever." And it is said: "Then the Lord shall be King over all the earth; on that day the Lord shall be One and His name One."

Have no fear of sudden terror or of the ruin when it overtakes the wicked. Devise your strategy, but it will be thwarted; propose your plan, but it will not stand, for God is with us. When you grow old, I will still be the same. When your hair turns gray, I will still carry you. I made you, I will bear you, I will carry you, and I will rescue you.

Mourners' Kaddish

The following prayer said by mourners requires the presence of a minyan.

Magnified and sanctified may His Great Name be,

Congregation:

Amen.

Mourners:

in the world He created by His will. May He establish His kingdom in your lifetime and in your days, and in the lifetime of all the House of Israel, swiftly and soon—and say: Amen.

Congregation:

Amen. May His Great Name be blessed for ever and all time.

Mourners:

יִתְבָּרַךְ וְיִשְׁתַּבַּח וְיִתְפָּאַר וְיִתְרוֹמַם וְיִתְנַשֵּׂא וְיִתְהַדָּר וְיִתְעַלֶּה וְיִתְהַלָּל שְׁמֵהּ דְּקֻדְשָׁא בְּרִיךְ הוּא,

Congregation:

בְּרִיךְ הוּא

לְעֵלָּא מִן כָּל (לְעֵלָּא וּלְעֵלָּא מִכָּל) *On Shabbat Shuva add:* בִּרְכָתָא וְשִׁירָתָא תֻּשְׁבְּחָתָא וְנֶחֱמָתָא, דַּאֲמִירָן בְּעָלְמָא, וְאִמְרוּ אָמֵן.

Congregation:

אָמֵן

יְהֵא שְׁלָמָא רַבָּא מִן שְׁמַיָּא, וְחַיִּים (טוֹבִים) עָלֵינוּ וְעַל כָּל יִשְׂרָאֵל, וְאִמְרוּ אָמֵן.

Congregation:

אָמֵן

Bow, take three steps back, then bow, first left, then right, then center, while saying:

עֹשֶׂה שָׁלוֹם (הַשָּׁלוֹם) *On Shabbat Shuva add:* בִּמְרוֹמָיו, הוּא יַעֲשֶׂה שָׁלוֹם עָלֵינוּ וְעַל כָּל יִשְׂרָאֵל, וְאִמְרוּ אָמֵן.

Congregation:

אָמֵן

From the second day of Rosh Ḥodesh Elul until and including Shemini Atzeret

(in Israel until and including Hoshana Raba), the following psalm is said:

לְדָוִד, יהוה אוֹרִי וְיִשְׁעִי מִמִּי אִירָא, יהוה מָעוֹז חַיַּי מִמִּי אֶפְחָד. בִּקְרֹב עָלַי מְרֵעִים לֶאֱכֹל אֶת בְּשָׂרִי, צָרַי וְאֹיְבַי לִי, הֵמָּה כָּשְׁלוּ וְנָפָלוּ. אִם תַּחֲנֶה עָלַי מַחֲנֶה לֹא יִירָא לִבִּי, אִם תָּקוּם עָלַי מִלְחָמָה בְּזֹאת אֲנִי בוֹטֵחַ. אַחַת

Mourners:

Blessed and praised, glorified and exalted, raised and honored, uplifted and lauded be the name of the Holy One, blessed be He,

Congregation:

Blessed be He

beyond any blessing, song, praise, and consolation uttered in the world—and say: Amen.

Congregation:

Amen.

May there be great peace from heaven, and good life for us and all Israel—and say: Amen.

Congregation:

Amen.

Bow, take three steps back, then bow, first left, then right, then center, while saying:

May He who makes peace in His high places, make peace for us and all Israel— and say: Amen.

Congregation:

Amen.

From the second day of Rosh Ḥodesh Elul until and including Shemini Atzeret

(in Israel until and including Hoshana Raba), the following psalm is said:

A psalm of David. The Lord is my light and my salvation—whom then shall I fear? The Lord is the stronghold of my life—of whom shall I be afraid? When evil men close in on me to devour my flesh, it is they, my enemies and foes, who stumble and

שָׁאַלְתִּי מֵאֵת יהוה, אוֹתָהּ אֲבַקֵּשׁ, שִׁבְתִּי בְּבֵית יהוה כָּל יְמֵי חַיַּי, לַחֲזוֹת בְּנֹעַם יהוה וּלְבַקֵּר בְּהֵיכָלוֹ. כִּי יִצְפְּנֵנִי בְּסֻכֹּה בְּיוֹם רָעָה, יַסְתִּרֵנִי בְּסֵתֶר אָהֳלוֹ, בְּצוּר יְרוֹמְמֵנִי. וְעַתָּה יָרוּם רֹאשִׁי עַל אֹיְבַי סְבִיבוֹתַי, וְאֶזְבְּחָה בְּאָהֳלוֹ זִבְחֵי תְרוּעָה, אָשִׁירָה וַאֲזַמְּרָה לַיהוה. שְׁמַע יהוה קוֹלִי אֶקְרָא, וְחָנֵּנִי וַעֲנֵנִי. לְךָ אָמַר לִבִּי, בַּקְּשׁוּ פָנָי, אֶת פָּנֶיךָ יהוה אֲבַקֵּשׁ. אַל תַּסְתֵּר פָּנֶיךָ מִמֶּנִּי, אַל תַּט בְּאַף עַבְדֶּךָ, עֶזְרָתִי הָיִיתָ, אַל תִּטְּשֵׁנִי וְאַל תַּעַזְבֵנִי אֱלֹהֵי יִשְׁעִי. כִּי אָבִי וְאִמִּי עֲזָבוּנִי, וַיהוה יַאַסְפֵנִי. הוֹרֵנִי יהוה דַּרְכֶּךָ, וּנְחֵנִי בְּאֹרַח מִישׁוֹר, לְמַעַן שׁוֹרְרָי. אַל תִּתְּנֵנִי בְּנֶפֶשׁ צָרָי, כִּי קָמוּ בִי עֵדֵי שֶׁקֶר וִיפֵחַ חָמָס. לוּלֵא הֶאֱמַנְתִּי, לִרְאוֹת בְּטוּב יהוה, בְּאֶרֶץ חַיִּים. קַוֵּה אֶל יהוה, חֲזַק וְיַאֲמֵץ לִבֶּךָ, וְקַוֵּה אֶל יהוה.

קדיש יתום

The following prayer said by mourners requires the presence of a minyan.

יִתְגַּדַּל וְיִתְקַדַּשׁ שְׁמֵהּ רַבָּא.

Congregation:

אָמֵן

Mourners:

בְּעָלְמָא דִּי בְרָא כִרְעוּתֵהּ, וְיַמְלִיךְ מַלְכוּתֵהּ בְּחַיֵּיכוֹן וּבְיוֹמֵיכוֹן וּבְחַיֵּי דְכָל בֵּית יִשְׂרָאֵל, בַּעֲגָלָא וּבִזְמַן קָרִיב, וְאִמְרוּ אָמֵן.

Congregation:

אָמֵן. יְהֵא שְׁמֵהּ רַבָּא מְבָרַךְ לְעָלַם וּלְעָלְמֵי עָלְמַיָּא.

fall. Should an army besiege me, my heart would not fear. Should war break out against me, still I would be confident. One thing I ask of the Lord, only this do I seek: to live in the House of the Lord all the days of my life, to gaze on the beauty of the Lord and worship in His Temple. For He will keep me safe in His pavilion on the day of trouble. He will hide me under the cover of His tent. He will set me high upon a rock. Now my head is high above my enemies who surround me. I will sacrifice in His tent with shouts of joy. I will sing and chant praises to the Lord. Lord, hear my voice when I call. Be gracious to me and answer me. On Your behalf my heart says, "Seek My face." Your face, Lord, will I seek. Do not hide Your face from me. Do not turn Your servant away in anger. You have been my help. Do not reject or forsake me, God, my Savior. Were my father and my mother to forsake me, the Lord would take me in. Teach me Your way, Lord, and lead me on a level path, because of my oppressors. Do not abandon me to the will of my foes, for false witnesses have risen against me, breathing violence. Were it not for my faith that I shall see the Lord's goodness in the land of the living. Hope in the Lord. Be strong and of good courage, and hope in the Lord!

Mourners' Kaddish

The following prayer said by mourners requires the presence of a minyan.

Magnified and sanctified may His Great Name be,

Congregation:

Amen.

Mourners:

in the world He created by His will. May He establish His kingdom in your lifetime and in your days, and in the lifetime of all the House of Israel, swiftly and soon—and say: Amen.

Congregation:

Amen. May His Great Name be blessed for ever and all time.

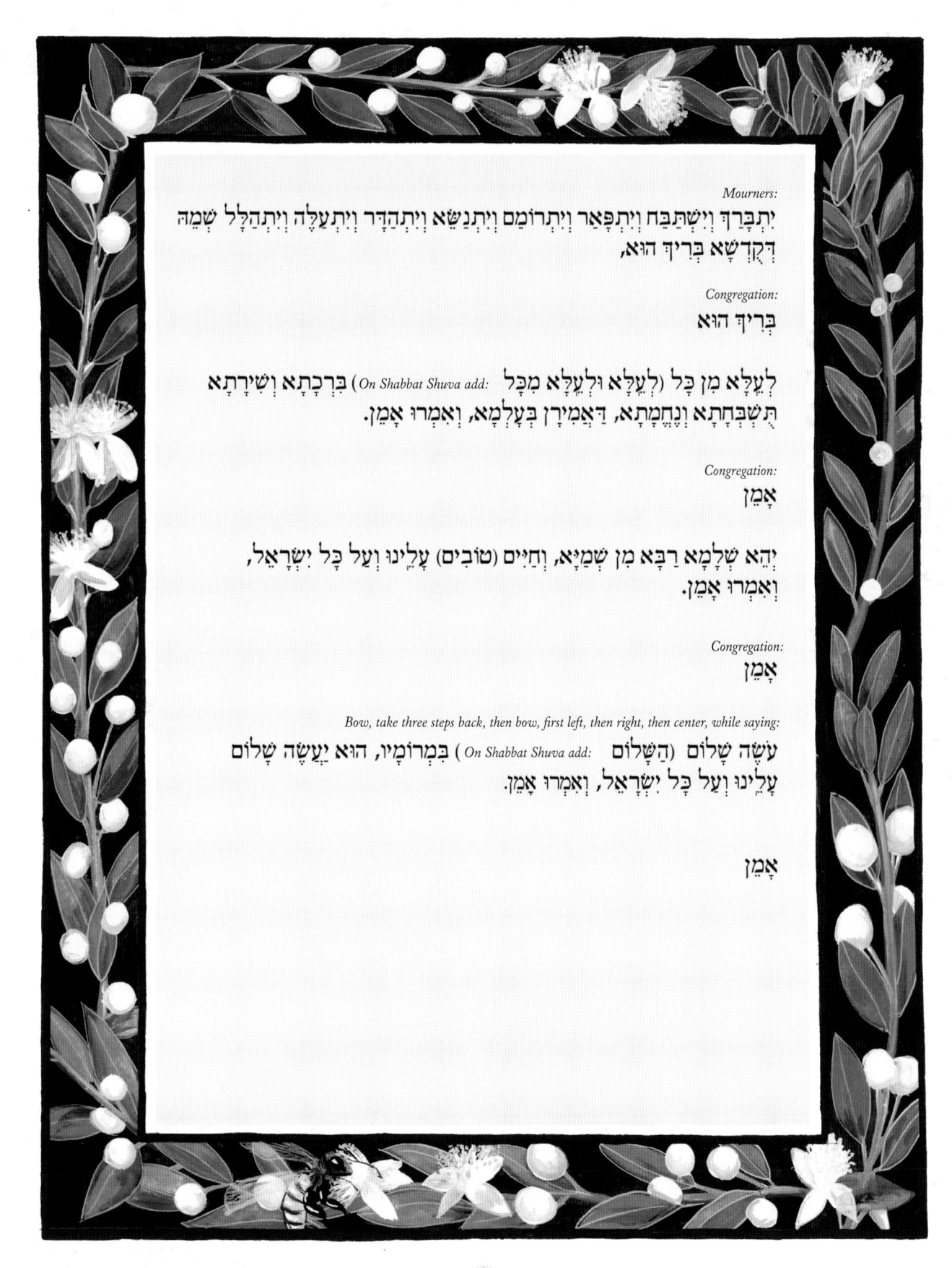

Mourners:

יִתְבָּרַךְ וְיִשְׁתַּבַּח וְיִתְפָּאַר וְיִתְרוֹמַם וְיִתְנַשֵּׂא וְיִתְהַדָּר וְיִתְעַלֶּה וְיִתְהַלָּל שְׁמֵהּ
דְּקֻדְשָׁא בְּרִיךְ הוּא,

Congregation:

בְּרִיךְ הוּא

לְעֵלָּא מִן כָּל (לְעֵלָּא וּלְעֵלָּא מִכָּל) *On Shabbat Shuva add:* בִּרְכָתָא וְשִׁירָתָא
תֻּשְׁבְּחָתָא וְנֶחֱמָתָא, דַּאֲמִירָן בְּעָלְמָא, וְאִמְרוּ אָמֵן.

Congregation:

אָמֵן

יְהֵא שְׁלָמָא רַבָּא מִן שְׁמַיָּא, וְחַיִּים (טוֹבִים) עָלֵינוּ וְעַל כָּל יִשְׂרָאֵל,
וְאִמְרוּ אָמֵן.

Congregation:

אָמֵן

Bow, take three steps back, then bow, first left, then right, then center, while saying:

עֹשֶׂה שָׁלוֹם (הַשָּׁלוֹם) *On Shabbat Shuva add:* בִּמְרוֹמָיו, הוּא יַעֲשֶׂה שָׁלוֹם
עָלֵינוּ וְעַל כָּל יִשְׂרָאֵל, וְאִמְרוּ אָמֵן.

אָמֵן

Mourners:

Blessed and praised, glorified and exalted, raised and honored, uplifted and lauded be the name of the Holy One, blessed be He,

Congregation:

Blessed be He

beyond any blessing, song, praise, and consolation uttered in the world—and say: Amen.

Congregation:

Amen.

May there be great peace from heaven, and good life for us and all Israel—and say: Amen.

Congregation:

Amen.

Bow, take three steps back, then bow, first left, then right, then center, while saying:

May He who makes peace in His high places, make peace for us and all Israel— and say: Amen.

Congregation:

Amen.

יִגְדַּל

Most congregations sing Yigdal at this point. In Israel, most congregations sing Adon Olam.

יִגְדַּל אֱלֹהִים חַי וְיִשְׁתַּבַּח, נִמְצָא, וְאֵין עֵת אֶל מְצִיאוּתוֹ.

אֶחָד וְאֵין יָחִיד כְּיִחוּדוֹ, נֶעְלָם, וְגַם אֵין סוֹף לְאַחְדּוּתוֹ.

אֵין לוֹ דְמוּת הַגּוּף וְאֵינוֹ גוּף, לֹא נַעֲרוֹךְ אֵלָיו קְדֻשָּׁתוֹ.

קַדְמוֹן לְכָל דָּבָר אֲשֶׁר נִבְרָא, רִאשׁוֹן וְאֵין רֵאשִׁית לְרֵאשִׁיתוֹ.

הִנּוֹ אֲדוֹן עוֹלָם לְכָל נוֹצָר, יוֹרֶה גְדֻלָּתוֹ וּמַלְכוּתוֹ.

שֶׁפַע נְבוּאָתוֹ נְתָנוֹ, אֶל אַנְשֵׁי סְגֻלָּתוֹ וְתִפְאַרְתּוֹ.

לֹא קָם בְּיִשְׂרָאֵל כְּמֹשֶׁה עוֹד, נָבִיא וּמַבִּיט אֶת תְּמוּנָתוֹ.

תּוֹרַת אֱמֶת נָתַן לְעַמּוֹ אֵל,

עַל יַד נְבִיאוֹ נֶאֱמַן בֵּיתוֹ.

לֹא יַחֲלִיף הָאֵל וְלֹא יָמִיר דָּתוֹ, לְעוֹלָמִים, לְזוּלָתוֹ.

צוֹפֶה וְיוֹדֵעַ סְתָרֵינוּ,

מַבִּיט לְסוֹף דָּבָר בְּקַדְמָתוֹ.

גּוֹמֵל לְאִישׁ חֶסֶד כְּמִפְעָלוֹ,

נוֹתֵן לְרָשָׁע רָע כְּרִשְׁעָתוֹ.

יִשְׁלַח לְקֵץ הַיָּמִין מְשִׁיחֵנוּ,

לִפְדּוֹת מְחַכֵּי קֵץ יְשׁוּעָתוֹ.

מֵתִים יְחַיֶּה אֵל בְּרֹב חַסְדּוֹ,

בָּרוּךְ עֲדֵי עַד שֵׁם תְּהִלָּתוֹ.

אֲדוֹן עוֹלָם

אֲדוֹן עוֹלָם אֲשֶׁר מָלַךְ, בְּטֶרֶם כָּל יְצִיר נִבְרָא. לְעֵת נַעֲשָׂה בְחֶפְצוֹ כֹּל, אֲזַי מֶלֶךְ שְׁמוֹ נִקְרָא. וְאַחֲרֵי כִּכְלוֹת הַכֹּל, לְבַדּוֹ יִמְלוֹךְ נוֹרָא. וְהוּא הָיָה, וְהוּא הֹוֶה, וְהוּא יִהְיֶה, בְּתִפְאָרָה. וְהוּא אֶחָד וְאֵין שֵׁנִי, לְהַמְשִׁיל לוֹ לְהַחְבִּירָה. בְּלִי רֵאשִׁית בְּלִי תַכְלִית, וְלוֹ הָעֹז וְהַמִּשְׂרָה. וְהוּא אֵלִי וְחַי גֹּאֲלִי, וְצוּר חֶבְלִי בְּעֵת צָרָה. וְהוּא נִסִּי וּמָנוֹס לִי, מְנָת כּוֹסִי בְּיוֹם אֶקְרָא. בְּיָדוֹ אַפְקִיד רוּחִי, בְּעֵת אִישַׁן וְאָעִירָה. וְעִם רוּחִי גְּוִיָּתִי, יְהֹוָה לִי וְלֹא אִירָא.

158

Yigdal

Most congregations sing Yigdal at this point. In Israel, most congregations sing Adon Olam.

Great is the living God and praised. He exists, and His existence is beyond time.

He is One, and there is no unity like His. Unfathomable, His oneness is infinite.

He has neither bodily form nor substance; His holiness is beyond compare.

He preceded all that was created. He was first: there was no beginning to His beginning.

Behold He is Master of the Universe; every creature shows His greatness and majesty.

The rich flow of His prophecy He gave to His treasured people in whom He gloried.

Never in Israel has there arisen another like Moses, a prophet who beheld God's image.

God gave His people a Torah of truth by the hand of His prophet,
> most faithful of His House.

God will not alter or change His law for any other, for eternity.

He sees and knows our secret thoughts; as soon as something is begun,
> He foresees its end.

He rewards people with loving-kindness according to their deeds;
> He punishes the wicked according to his wickedness.

At the end of days He will send our Messiah,
> to redeem those who await His final salvation.

God will revive the dead in His great loving-kindness.
> Blessed for evermore is His glorious name!

Adon Olam

When by His will all things were made, then was His name proclaimed King.

And when all things shall cease to be, He alone will reign in awe.

He was, He is, and He shall be glorious for evermore.

His is One, there is none else, alone, unique, beyond compare;

Without beginning, without end, His might, His rule are everywhere.

He is my God; my Redeemer lives. His is the Rock on whom I rely—

My banner and my safe retreat, my cup, my portion when I cry.

Into His hand my soul I place, when I awake and when I sleep.

God is with me, I shall not fear; body and soul from harm will He keep.

TAKING CHALLAH

אָבִינוּ שֶׁבַּשָּׁמַיִם!
בְּמִצְוָתֶיךָ הַקְּדוֹשָׁה אֲנִי מַפְרִישָׁה שִׁעוּר מִן הַחַלָּה.
עוֹד אֶזְכְּרָה שָׁנִים קַדְמוֹנִיּוֹת שֶׁבָּהֶן, בְּלֵב חָפֵץ,
הֶעֱלוּ אֲבוֹתֵינוּ עַל מִזְבַּחֲךָ אֶת בִּכּוּרֵיהֶם. גַּם
הַיּוֹם, אֱלֹהֵינוּ, אָנוּ מַעֲלִים לְפָנֶיךָ קָרְבָּנוֹת אַהֲבָה
שֶׁיֵּרָצוּ לְפָנֶיךָ. בְּשָׁעָה שֶׁאָנוּ מַשְׂבִּיעִים אֶת
רְעָבוֹנוֹ שֶׁל הַנִּצְרָךְ, מְקִלִּים עַל מְצוּקָתוֹ וְחֶסְרוֹנוֹ,
וּמְסַלְּקִים אֶת דַּאֲגוֹת פַּרְנָסָתוֹ, אָנוּ מַעֲלִים קָרְבָּן
לְפָנֶיךָ, אֲבִי דַלִּים וַעֲנִיִּים. אָבִינוּ שֶׁבַּשָּׁמַיִם, קַבֵּל
בְּרַחֲמִים וּבְרָצוֹן אֶת תְּרוּמָתִי וְתֵן לִי לֵב חָזָק
וְנֶאֱמָן, וְגַם אִם תִּדְרֹשׁ מִמֶּנִּי קָרְבָּנוֹת גְּדוֹלִים
וַעֲצוּמִים, אַעֲלֶה אוֹתָם וְאֶשְׂמַח בֶּאֱמוּנָתִי.

תֵּן לָנוּ לְהַרְוִיחַ אֶת לֶחֶם יוֹמֵנוּ בְּכָבוֹד וְלֹא
בְמוֹרָה, וְתֵן שֶׁנֹּאכַל מִמֶּנּוּ וְשֶׁיַּשְׁפִּיעַ עָלֵינוּ בְּרָכָה
וְשִׂגְשׂוּג. וּבְרֹב בְּרִיאוּת וְכֹחַ נִשְׂמַח בַּחַיִּים
וּבְחַסְדָּם, וּבְלֵב שָׂמֵחַ וּבְרוּחַ טוֹבָה נְהַלֶּלְךָ, הַטּוֹב
וְהַמֵּטִיב. וּשְׁלַח בְּרָכָה וְהַצְלָחָה בְּמַעֲשֵׂי יָדֵינוּ.

בָּרוּךְ אַתָּה יהוה אֱלֹהֵינוּ מֶלֶךְ הָעוֹלָם
אֲשֶׁר קִדְּשָׁנוּ בְּמִצְוֹתָיו וְצִוָּנוּ
לְהַפְרִישׁ חַלָּה.

By your holy command, I am separating a measure of challah. At the same time, I recall ancient times when, with a willing heart, our forefathers would offer the first of their produce upon Your altar. Today, too, our God, we offer up offerings of love—may they find favor before You. Whenever we satisfy the hunger of those in need, easing their distress and their deprivation and relieving their concerns for their sustenance, we are offering a sacrifice before You, Father of the poor and the destitute. Our Father in heaven—accept my gift with mercy and favor and grant me a strong and loyal heart; then even if You demand great and difficult sacrifices of me, I shall offer them up and rejoice in my faith.

Allow us to earn our daily bread with dignity and not in dread. May we eat of it and may it bring us an abundance of blessing and prosperity. With good health and vigor may we rejoice in life and its face, and with joyful heart and a good spirit, we shall praise You Who are good and Who performs good, and may You send blessing and success to our endeavors.[20]

Blessed are You, Lord our God, King of the universe, Who has sanctified us with His commandments and commanded us to separate challah.

COMBINED LITERARY AND ILLUMINATION COMMENTARIES

Jewish tradition ascribes three particular mitzvot to women: lighting Shabbat and holiday candles, "taking challah," and the laws of family purity. "Taking challah" symbolizes the Shabbat sacrifice in the Temple and, since the Temple's destruction, has been ascribed specifically to women. A small ball of dough taken from dough being prepared for the Shabbat meals—the precise amount is debated but is generally considered to be about "an olive's worth"—is placed on the oven floor to burn in lieu of offering it to the Temple's priests (nowadays, priestly lineage is questionable enough that offering the dough to a Cohen is not considered fulfillment of the mitzvah). Following the

placement of the dough, the woman recites the blessing at the bottom of the text above. The prayer shown above is a *tehina* (in Hebrew and in English; the *tehine* itself was originally composed in German) by Fanny Neuda—a liberally educated daughter of a nineteenth-century German rabbi; she was also a rabbi's wife as well as a writer—that emphasizes the love of God and the dignity inherent in preparing food.

he illuminations highlight the symbolic relationship between the modern woman's offering of dough (here symbolized in grain) and the Temple-era grain offering on the four-horned altars used in Israelite sacrifice since our earliest days. The modern woman's hands offer up not only grain but private prayer and the required blessing to the providential God who enjoined Sabbath rest, just as in Temple times when the fragrant smoke of sacrifices wafted up from the stone altar to the heavens to please Him. Her bracelets are inlaid with the ancient Israelite palmette design that, as we will see elsewhere, brings to mind Solomon's Temple (see Commentary on "Yedid nefesh" below).

THE SABBATH QUEEN

Hebrew	English
הַחַמָּה מֵרֹאשׁ הָאִילָנוֹת נִסְתַּלְּקָה–	The sun has sunk below the trees.
בֹּאוּ וְנֵצֵא לִקְרַאת שַׁבָּת הַמַּלְכָּה.	Come, let us welcome the Sabbath, the queen.
הִנֵּה הִיא יוֹרֶדֶת הַקְּדוֹשָׁה, הַבְּרוּכָה,	Come, watch her descending, holy and blessed,
וְעִמָּהּ מַלְאָכִים צְבָא שָׁלוֹם וּמְנוּחָה.	and with her, angels of peace and of rest.
בּוֹאִי בּוֹאִי הַמַּלְכָּה!	Come, come, Sabbath queen!
בּוֹאִי בּוֹאִי הַמַּלְכָּה!	Come, come, Sabbath bride!
שָׁלוֹם עֲלֵיכֶם מַלְאֲכֵי הַשָּׁלוֹם!	Welcome, welcome, angels of peace!
קִבַּלְנוּ פְּנֵי שַׁבָּת בִּרְנָנָה וּתְפִלָּה,	We've greeted the Sabbath with prayer and with song.
הַבַּיְתָה נָשׁוּבָה בְּלֵב מָלֵא גִילָה.	We go from the synagogue, back to our home.
שָׁם עָרוּךְ הַשֻּׁלְחָן הַנֵּרוֹת יָאִירוּ,	The table is set, the candles are gleaming,
כָּל פִּנּוֹת הַבַּיִת יִזְרְחוּ, יַזְהִירוּ.	and every part of the household is beaming.
שַׁבָּת שָׁלוֹם וּמְבֹרָךְ!	A Sabbath of blessing, a Sabbath of peace!
שַׁבָּת שָׁלוֹם וּמְבֹרָךְ!	A Sabbath of blessing, a Sabbath of peace!
בּוֹאֲכֶם לְשָׁלוֹם, מַלְאֲכֵי הַשָּׁלוֹם!	Come in peace, angels of peace!

Hebrew	English
שְׁבִי, זַכָּה, עִמָּנוּ וּבְזִיוֵךְ נָא אוֹרִי	Stay with us, Pure One. For a night and a day,
לַיְלָה וָיוֹם, אַחַר תַּעֲבֹרִי.	grant us Your light, and then go Your way.
וַאֲנַחְנוּ נְכַבְּדֵךְ בְּבִגְדֵי חֲמוּדוֹת,	We will honor You, wearing our best,
בִּזְמִרוֹת וּתְפִלּוֹת וּבְשָׁלוֹשׁ סְעוּדוֹת,	with hymns and with prayers and with three solemn feasts,
וּבִמְנוּחָה שְׁלֵמָה,	and perfect rest,
וּבִמְנוּחָה נְעֵמָה–	delightful rest.
בָּרְכוּנוּ לְשָׁלוֹם מַלְאֲכֵי הַשָּׁלוֹם!	Bless us with peace, angels of peace!
הַחַמָּה מֵרֹאשׁ הָאִילָנוֹת נִסְתַּלְּקָה–	The sun has again sunk below the trees.
בֹּאוּ וְנִלְוֶה אֶת שַׁבָּת הַמַּלְכָּה.	Let's go and bid the Sabbath farewell.
צֵאתֵךְ לְשָׁלוֹם, הַקְּדוֹשָׁה, הַזַּכָּה–	Farewell, holy Sabbath, at the last rays.
דְּעִי, שֵׁשֶׁת יָמִים אֶל שׁוּבֵךְ נְחַכֶּה...	We will await your return in six days.
כֵּן לַשַּׁבָּת הַבָּאָה!	May the next Sabbath be like the last!
כֵּן לַשַּׁבָּת הַבָּאָה!	May the next Sabbath be like the last!
צֵאתְכֶם לְשָׁלוֹם מַלְאֲכֵי הַשָּׁלוֹם!	Go in peace, angels of peace.

LITERARY COMMENTARY

This poem, first published in 1903, was composed by Ḥayyim Naḥman Bialik (1873–1934), the outstanding Hebrew poet of the late nineteenth and early twentieth century. Intended for children, the poem was composed in the style of a folk song, as part of Bialik's project of creating folk poetry in Hebrew, which, until its revival as a spoken language toward the end of the nineteenth century, had only a learned literature. The poem's four stanzas offer four vignettes of the Sabbath, from sunset on Friday to nightfall on Saturday, as it is traditionally observed and as it might be experienced by a child. The four stanzas are modeled on the four lines of "Shalom aleikhem," each one ending with the opening words of the latter's four stanzas in turn. The poem's lovely simplicity found a perfect complement in the melody composed by the great cantor Pinḥas Minkovsky (1859–1924), through which it has become so widely known that today it fits seamlessly into the more deeply rooted traditions of the Sabbath.

COMMENTARY ON THE ILLUMINATIONS

Ḥayyim Naḥman Bialik echoes the traditional "Shalom aleikhem" in this beloved ode to the calm beauty of Shabbat. In the illuminations, I present Bialik's home in Tel Aviv, a Shabbat table laid on a terrace. Two trees flank the scene. The palm brings to mind the Psalmist's comparison of the righteous person to the tall palm; the olive, with new shoots rising from its roots, suggests the children clustered around parents at the family dinner table.[21] The fresh green leaves gently drifting from the trees reflect the health of the Shekhinah[22] as Israel begins its Shabbat rest.

CANDLE-LIGHTING

בָּרוּךְ אַתָּה יהוה אֱלֹהֵינוּ מֶלֶךְ הָעוֹלָם,
אֲשֶׁר קִדְּשָׁנוּ בְּמִצְוֹתָיו,
וְצִוָּנוּ לְהַדְלִיק נֵר שֶׁל שַׁבָּת.

Blessed are You, Lord our God, King of the world,
Who set us apart with His commandments
and commanded us to light the Sabbath lamp.

LITERARY COMMENTARY

The practice of lighting lamps or candles at the beginning of the Sabbath has its origin in the nearly universal practice of marking festive occasions by illumination. At a time when people would go to bed at nightfall and when only the well-off could afford the expenditure of oil that would permit them to stay up later, the rabbis enjoined all Jews to light lamps at the onset of the Sabbath and festivals. This practice is not mentioned in the Bible; but the rabbis decreed that, on lighting the lamps, a benediction be recited declaring it a divine command, under the general principle that the ancient rabbis' decisions and decrees were divinely authorized. (The same reasoning applies to the benediction of the Ḥanukka lamps.) When the Sabbath coincides with a festival, the benediction is expanded accordingly, and an additional benediction is recited, thanking God for enabling us to live to see this day. In most places, wax candles long ago replaced the oil lamps of antiquity.

Note on chanting: The festival and the festive Shabbat variations on candle-lighting are included in the section "Additions for Special Sabbaths."

COMMENTARY ON THE ILLUMINATIONS

hile Shabbat candle-lighting began simply to illuminate the Shabbat table so that the family could enjoy their festive meal together, the light from the candles has come to express values far beyond simple pragmatism. In the illuminations, I express the exchange of prayer and light between the heavens above and the human world below, as we begin Shabbat by illuminating our tables.

The author of the seventeenth-century mystical tract *Ḥemdat yamim* suggests that the light from the Shabbat candles adds to the *neshama yetera*, the additional soul that flowers within the soul of every Jew during Shabbat. Because the *neshama yetera* descends from the feminine Shekhinah, the woman of the house enjoys the privilege of lighting the candles. She thus reenacts the unification of the human and divine spheres, of the *sefirot* themselves. The pleasure of the candlelight extends to all who celebrate Shabbat within it; the author of *Ḥemdat yamim* compares the candlelight that reaches toward heaven to Jacob's Ladder (Gen. 28:12), suggesting that the light gladdens and blesses the hearts of those it illuminates.[23]

At right, the Hebrew illumination presents the silver candlesticks passed from my grandmother to my mother within a design depicting sources of light and human understandings of the cosmos. A blue and gold motif representing the *shefa*, the divine energy flowing throughout the universe, becomes the candle flames. We view the candles against the dusk sky lit by the setting sun, while the ever-evolving deep sky, presenting the history of the heavens back to the early universe, wheels far above our heads and homes.[24] The geometric painting surrounding the words of the blessing is a classical Moorish pattern that was part of the visual surroundings of the Sephardic world. The pattern expresses the flow of all geometric form from a single central point,[25] symbolizing the origin of the entire universe in the Creator whose work we celebrate on Shabbat.

The illumination is edged by two borders of decorative calligraphy. The outer band in blue offers a Yemenite *teḥine* for women to say while enjoying the light of the candles:

O, my Master; save us and deliver us and have mercy upon us, and have mercy upon my children and their father. Imbue them with wisdom, elevate their path, and smooth their life's trails. Grant them favor and acceptance, endow them with complete health, and fulfill their wishes. Keep troubled times from them, and allow no tormentor or enemy to prevail over them. Guide them in Your way, to observe the Torah.[26]

The inner band, in green, presents a famous medieval view of how the human soul reflects divine radiance. In his poetic philosophical treatise, *The Royal Crown,* the eleventh-century Spanish poet and philosopher Solomon ibn Gabirol attempts to reconcile Torah with the Neoplatonic thought of his day, exploring ideas about the flow of divine energy through the cosmos and how divine energy flows from God, through the stars and planets, and inward toward the earth.

> You are the light of the upper regions,
> and the eye of every soul that's pure
> will take You in—
> and the clouds of sin
> in the sinner's soul will obscure You.
> Your invisible light in the world
> will be seen in the World-to-Come
> on the mountain of God.[27]

The illumination at left surrounds the English translation of the blessing with similar geometric and astronomical imagery. The green band of decorative text presents the English translation of Ibn Gabirol's description of divine light, while the blue band presents a passage from a *teḥine* to be recited after candle-lighting, composed by Fanny Neuda:

> Shabbat is the crown and the glorious ornament of the week.
> It ennobles our aspirations, consecrates our enjoyment,
> Pours soft, heavenly light
> Across our pilgrim path on earth,
> And carries us back to You
> Whenever weekday aspirations remove us from You.
> We look up to You, O God,
> With pure confidence, in love and humility.
> Every thought of You lifts the veil from our eyes,
> The light increases within our souls.[28]

YEDID NEFESH

יְדִיד נֶפֶשׁ אָב הָרַחֲמָן,

מְשֹׁךְ עַבְדְּךָ אֶל רְצוֹנָךְ.

יָרוּץ עַבְדְּךָ כְּמוֹ אַיָּל,

יִשְׁתַּחֲוֶה אֶל מוּל הֲדָרָךְ.

כִּי יֶעֱרַב לוֹ יְדִידוּתָךְ,

מִנֹּפֶת צוּף וְכָל טָעַם.

Soul's beloved, kindly father,

 draw Your servant to Your pleasure.

He will hasten on swift deer-feet,

 will bow in homage to Your splendor,

for to him Your love is sweeter

 than honeycomb or any dainty.

הָדוּר, נָאֶה זִיו הָעוֹלָם,

נַפְשִׁי חוֹלַת אַהֲבָתָךְ.

אָנָּא, אֵל נָא רְפָא נָא לָהּ,

בְּהַרְאוֹת לָהּ נֹעַם זִיוָךְ.

אָז תִּתְחַזֵּק וְתִתְרַפֵּא,

וְהָיְתָה לָךְ שִׂמְחַת עוֹלָם.

Splendid, lovely, Universal Light,

 my soul is faint with love of You.

Heal, O heal her, God of grace,

 reveal to her Your lovely light.

Then she will be strong and well,

 and ever be Your serving-girl.

וָתִיק, יֶהֱמוּ נָא רַחֲמֶיךָ,

וְחוּס נָא עַל בֵּן אֲהוּבָךְ.

כִּי זֶה כַּמֶּה נִכְסֹף נִכְסַף,

לִרְאוֹת בְּתִפְאֶרֶת עֻזָּךְ.

אָנָּא, אֵלִי מַחְמַד לִבִּי,

חוּשָׁה נָּא, וְאַל תִּתְעַלָּם.

Steadfast One, arouse Your love.

 Take pity on Your loving son,

How long it is that he has yearned

 to live to see Your mighty splendor.

O my God, my heart's desire,

 hurry, do not keep concealed.

הִגָּלֵה נָא וּפְרֹשׂ, חֲבִיב,

עָלַי אֶת סֻכַּת שְׁלוֹמָךְ.

תָּאִיר אֶרֶץ מִכְּבוֹדֶךְ,

נָגִילָה וְנִשְׂמְחָה בָךְ.

מַהֵר אֱהוֹב כִּי בָא מוֹעֵד,

וְחָנֵּנוּ כִּימֵי עוֹלָם.

Reveal Yourself, my dear, and spread

 Your tent of peace above my head.

Make the world gleam with Your glory;

 we will rejoice in You with glee.

Hurry, love, for the time has come.

 Show me grace, as You did of old.

LITERARY COMMENTARY

The kabbalist Eleazar Azikri (1533–1600) composed this poem for his Safed circle of mystics, who used to rise early each morning to recite hymns and mystical prayers. It consists of four three-line stanzas, each line containing sixteen syllables; the first two lines of each stanza rhyme with each other, and the last line of each stanza rhymes with the last lines of the other stanzas. The text has become corrupted through repeated reprintings and has entered many prayer books in this corrupt form. Fortunately, the author's autograph manuscript has been preserved, permitting the restoration of the original text, as reproduced in this book.

The poem is unusual in having as its acrostic the four-letter name of God. It reads much like a love poem in which the speaker represents himself as masculine in the first and third stanzas; and as feminine in the second and fourth stanzas. This separation of a single speaker into male and female voices could well reflect the kabbalistic idea that within the unitary Godhead exist male and female elements, namely, the *sefira* of *tiferet* and the *sefira* of *malkhut* (identified with the Shekhinah). The mystic strives to effect the union of these by means of rituals and prayers, which would result in the perfection of God's unity. The poet may have tried to imagine the kind of love poem that might be sung by *malkhut* and *tiferet* to each other. There is no certainty that Azikri intended the poem for the Sabbath, but it has found its way into the Kabbalat Shabbat service on account of the association of the Sabbath with these themes in the kabbalah and especially because the Zohar associates the Sabbath with the Tetragrammaton, which forms the acrostic of this poem.

COMMENTARY ON THE ILLUMINATIONS

he human "soul's beloved," soul's father, soul's light, soul's protector, soul's glory; the song suggests several facets of the human relationship to God, as God-fearing humans reenact the love of the *sefirot*. In each verse, however, the poet returns to the language that we associated with "beloved," the intimate language of romantic love rather than to idioms of parenthood, royal fealty, or awe to express the depth of human emotion to God. In this human sphere, whether father, healing light, or protective king, God is the intimate eternal beloved of the soul. The illuminations express the emotion of this *piyyut* of human love for the divine. The micrography winding through both paintings presents the text of the Song of Songs, the biblical love poetry that became a fundamental inspiration for the themes of erotic love and union that pervade Jewish mysticism. The imagery suggests the other forms of love that Azikri raises.

Drawing upon the manner in which the young lovers of the Song of Songs compare each other to deer or gazelles, the Jewish poets of medieval Spain, such as Judah Halevi, used the gazelle as a metaphor for their divine as well as human loves. This tradition is reflected in the Hebrew illumination, depicting the human lover of God as a gazelle, nestled in the bountiful natural world whose creation we celebrate as Shabbat arrives. In an image inspired by the passage "their soul shall be as a watered garden" (Jer. 31:12),[30] the gazelle thus rests safely and serenely within the embrace of the natural world, whose physical evolution and biology our God-given wisdom enables us to understand and protect.

The English illumination focuses on the parental quality of divine love. The image of a father holding his new baby at the Shabbat table suggests our love of our children, our ambition to raise them within Jewish tradition, and the notion of God as the supreme parent. The tiny painting of the text of "A Powerful Woman,"[31] to the father's left, suggests the role of the mother; classically seen as homemaker and nurturer, she corresponds to Proverbs' personification of wisdom as wife and mother. The two palm trees allude to a passage in Psalm 92, the special psalm for Shabbat, comparing the righteous person to a tall, straight palm tree, not simply planted in the natural world but transplanted into and flourishing within the very courts of the Temple.[32] The pink lilies suggest not only the beauty and color appropriate to any well-dressed Shabbat table but also the value of the Ten Commandments in the imperfect human world.[33]

In both the Hebrew and English illuminations of "Yedid nefesh," the text is surrounded by a palmette border. This ancient motif—employed across the early Mediterranean basin, from Persia and Babylonia to the east, through Egypt and North Africa to the west—takes on a special meaning in the context of ancient Israel. 1 Kings and Chronicles describe the decoration of Solomon's Temple and palace, mentioning palmette decorations throughout. The pattern that I present here is modeled on an ivory furniture plaque found in Samaria and contemporary with Solomon's Temple.[34] This pattern, found throughout this work, suggests the transference of the sanctity of the now-destroyed Temple to the Sabbath home, suffused with love, human and divine.

PSALM 95

לְכוּ נְרַנְּנָה לַיהוה	Come, let us shout to the Lord!
נָרִיעָה לְצוּר יִשְׁעֵנוּ:	Let us cry aloud to the Rock Who saves us!
נְקַדְּמָה פָנָיו בְּתוֹדָה,	Let us greet Him with an offering of thanks!
בִּזְמִרוֹת נָרִיעַ לוֹ:	With hymns let cry to Him aloud!
כִּי אֵל גָּדוֹל יהוה,	Indeed, the Lord is a great God,
וּמֶלֶךְ גָּדוֹל עַל־כָּל־אֱלֹהִים:	a king greater than all powers,
אֲשֶׁר בְּיָדוֹ מֶחְקְרֵי־אָרֶץ,	in Whose hands are the earth's depths,
וְתוֹעֲפוֹת הָרִים לוֹ:	Who owns the mountaintops,
אֲשֶׁר־לוֹ הַיָּם וְהוּא עָשָׂהוּ	Who owns the sea, for He made it,
וְיַבֶּשֶׁת יָדָיו יָצָרוּ:	and the dry land, shaped by His own hands.
בֹּאוּ נִשְׁתַּחֲוֶה וְנִכְרָעָה,	Come, let us bow and prostrate ourselves,
נִבְרְכָה לִפְנֵי־יהוה עֹשֵׂנוּ:	bend the knee before the Lord, our Maker.
כִּי הוּא אֱלֹהֵינוּ	For He is our God;
וַאֲנַחְנוּ עַם מַרְעִיתוֹ	we are the nation He pastures,
וְצֹאן יָדוֹ,	the sheep His hand tends.
הַיּוֹם אִם־בְּקֹלוֹ תִשְׁמָעוּ:	If only you would heed His voice this day!
אַל־תַּקְשׁוּ לְבַבְכֶם כִּמְרִיבָה,	Do not harden your hearts as at Meribah,

כְּיוֹם מַסָּה בַּמִּדְבָּר:	as on the day of Massah in the wilderness,
אֲשֶׁר נִסּוּנִי אֲבוֹתֵיכֶם, בְּחָנוּנִי גַּם רָאוּ פָעֳלִי:	tested me, though they had seen my deeds.
אַרְבָּעִים שָׁנָה אָקוּט בְּדוֹר,	Forty years I was in disgust with that generation,
וָאֹמַר עַם תֹּעֵי לֵבָב הֵם,	and I said, "They are a people of fickle heart;
וְהֵם לֹא־יָדְעוּ דְרָכָי:	They do not know My ways";
אֲשֶׁר־נִשְׁבַּעְתִּי בְאַפִּי,	when in My anger I vowed
אִם־יְבֹאוּן אֶל־מְנוּחָתִי:	that they would never come into My rest.

LITERARY COMMENTARY

The psalm falls into two parts: first is an ecstatic summons to praise the Lord, author of all Creation; second is an admonition, reminding the people that God bestows special care on His people Israel and that His care is conditional on their obedience. The poet has shrewdly carried the ecstatic tone of the first part into the beginning of the exhortatory second part, so that his new, more ominous, tone creeps up on the reader unexpectedly.

The last lines of the psalm back up the admonition by recalling an episode in Israel's sacred history when the people failed in their obedience. Meribah and Massah are places in the wilderness where the Israelites offended the Lord by demanding water instead of trusting Him to provide it. The two places are mentioned together at the beginning of Israel's forty-year period of wandering (Exod. 17:2, 7). Meribah is named alone at the end of the forty years (Num. 20:13). It is at the former place that the Israelites are said to have "tried" the Lord.

When God, speaking at the end of the psalm, recalls His vow that the rebellious Israelites will never come into His rest, he is referring to the Land of Israel, which is called "the rest and the inheritance" (Deut. 12:9). But here, it must have been understood as referring to the Sabbath rest.

COMMENTARY ON THE ILLUMINATIONS

salm 95 begins the cycle of psalms within the Kabbalat Shabbat liturgy in which we are led to experience God's power in the material world—and whose fullness and variety the illuminations celebrate. The Psalmist evokes the magnificent breadth of Creation, its heights and its depths, urging us to respect the limitless power of its Creator.

Why should we shout and sing to God, as the Psalmist urges? The midrash on Psalms opens its discussion of Psalm 95 by asking the same question. Calling upon Zeph. 3:14 and Isa. 14:5–6, the rabbis answer: Israel should exult in God because God extends royal mercy to Israel by abandoning judgments against us at the same time that He renders Edom [read: Rome] and other wicked rulers impotent. Since God is so great that He can rescue Israel from its enemies this way, He thus demonstrably not only surpasses every ordinary king but rules even over all other supposed gods. Indeed, Israel's God created and controls even the sea and the land. Thus Israel must worship God and, above all, as the psalm ends, trust in God and never doubt God's care even in the face of fear and doubt.[35]

The illuminations employ imagery of the powers that God, "greater than all powers," exerts in the natural world to express the Psalmist's exuberance. The Hebrew illumination offers a landscape border of the sea and sky, with a dove carrying an olive branch prominent in the foreground, flying from the English side. The dove reminds us not only of Noah's dove, who signaled God's restoration of life on the land after the Flood, but also of Israel's gentleness and compliance with divine will. The English painting depicts a microcosm of the whole variety of our planet's terrains, showing land rising from the sea, to desert, planted plains, forests, plateaus, Jerusalem rising in the highlands, and snowcapped mountains beyond, with an eagle—symbolic of God's parenting of Israel—soaring among the mountains. The dancing letters of the Hebrew and English initial words bear patterns of cosmic spectral emission lines of the most common chemical elements composing our universe, the building blocks of our material world created in the aftermath of the Big Bang: hydrogen, helium, lithium, oxygen, carbon, nitrogen, neon, magnesium, silicon, sulfur, iron, aluminum, calcium, argon, sodium, krypton, strontium, xenon, and barium.[36]

Psalm 96

שִׁירוּ לַיהוה שִׁיר חָדָשׁ,
 Sing a new song to the Lord,

שִׁירוּ לַיהוה כָּל־הָאָרֶץ:
 Sing to the Lord, all the earth!

שִׁירוּ לַיהוה בָּרֲכוּ שְׁמוֹ,
 Sing to the Lord, bless His name,

בַּשְּׂרוּ מִיּוֹם־לְיוֹם יְשׁוּעָתוֹ:
 Proclaim His victory's tidings daily.

סַפְּרוּ בַגּוֹיִם כְּבוֹדוֹ,
 Speak of His glory among the nations,

בְּכָל־הָעַמִּים נִפְלְאוֹתָיו:
 His marvels among all peoples.

כִּי גָדוֹל יהוה וּמְהֻלָּל מְאֹד,
 For the Lord is great and greatly praised,

נוֹרָא הוּא עַל־כָּל־אֱלֹהִים:
 More fearsome than all other gods.

כִּי | כָּל־אֱלֹהֵי הָעַמִּים אֱלִילִים,
 For all the nations' gods are godlets,

וַיהוה שָׁמַיִם עָשָׂה:
 But the Lord made the heavens!

הוֹד־וְהָדָר לְפָנָיו,
 Splendor and beauty are in His presence,

עֹז וְתִפְאֶרֶת בְּמִקְדָּשׁוֹ:
 Might and glory in His holy place.

הָבוּ לַיהוה מִשְׁפְּחוֹת עַמִּים,
 Attribute to the Lord, O families of the nations,

הָבוּ לַיהוה כָּבוֹד וָעֹז:
 Attribute to the Lord glorious might.

הָבוּ לַיהוה כְּבוֹד שְׁמוֹ,
 Attribute to the Lord the glory due His name;

שְׂאוּ־מִנְחָה וּבֹאוּ לְחַצְרוֹתָיו:
 Bring Him tribute as you come into His courts.

הִשְׁתַּחֲווּ לַיהוה בְּהַדְרַת־קֹדֶשׁ,
 Bow to the Lord in His splendid sanctuary.

חִילוּ מִפָּנָיו כָּל־הָאָרֶץ:
 Tremble before Him, all the earth.

אִמְרוּ בַגּוֹיִם יהוה מָלָךְ,
 Say to the nations, "The Lord is now king!

אַף־תִּכּוֹן תֵּבֵל בַּל־תִּמּוֹט,
 The earth is fixed, it cannot be moved.

יָדִין עַמִּים בְּמֵישָׁרִים:
 He judges the nations in equity."

יִשְׂמְחוּ הַשָּׁמַיִם וְתָגֵל הָאָרֶץ,
 Let the heavens rejoice and the earth be glad,

יִרְעַם הַיָּם וּמְלֹאוֹ׃

יַעֲלֹז שָׂדַי וְכָל־אֲשֶׁר־בּוֹ,

אָז יְרַנְּנוּ כָּל־עֲצֵי־יָעַר׃

לִפְנֵי יהוה כִּי בָא,

כִּי בָא לִשְׁפֹּט הָאָרֶץ׃

יִשְׁפֹּט־תֵּבֵל בְּצֶדֶק,

וְעַמִּים בֶּאֱמוּנָתוֹ׃

Let the sea and all that is in it thunder.
Let the fields rejoice and all they contain,
Then will all the forests' trees sing
Before the Lord, for He comes!
He comes to judge the earth.
He judges the world in justice,
And the nations with His truth.

LITERARY COMMENTARY

Psalms 96–99 are similar to one another in theme, though they vary in the aspects of the theme that they choose to emphasize. They also share certain turns of phrase. These four psalms all proclaim the God of Israel as the king of Creation and summon the nations of the world to hail Him as their king by attending Him in the Holy Temple. They depict the moment as a second act in universal history in which God has taken, or is about to take, control of the nations of the world as He took charge of the cosmos in the original act of Creation. The acclamation of the Lord as universal king is a joyous event, and the song to be sung to the Lord is called a "new song," suitable to His new and expanded dominion. Because of these themes, scholars refer to these four psalms and a few others as the "Throne Ascension" psalms.

To the kabbalists who designed the Kabbalat Shabbat service, these psalms must have seemed a most appropriate way of stimulating the worshipers to meditate on the meaning of the Sabbath as a "remembrance of the work of Creation." For them, the Sabbath was more than a mere act of remembrance; it was a reenactment and a prefiguration. By properly observing the Sabbath, the worshiper participates in renewing the original act of Creation, thereby helping guarantee the fecundity of the world for the coming week. Nor did the "remembrance of the work of Creation" only look backward to the original act of Creation; it also looked forward, to the new world that would be created in the messianic era. By properly observing the Sabbath, the worshiper joins with God in bringing about the redemption of Israel and the creation of that new world. Thus, the Throne Ascension psalms served well as an expression of the kabbalists' theology.

Psalm 96. The Psalmist calls upon all the world to sing to the Lord, to acknowledge that He is the only God, and to acclaim Him in His sanctuary. A shift from duple to triple meter in verse 10, followed by a return to duple meter, calls attention to the meaning of the Lord's renewed sovereignty: just as the original act of Creation established the earth on an eternally stable foundation, the new act of creation establishes society on the stable foundation of justice. The earth and its peoples can well rejoice in this assurance.

ho among us, standing at the seashore amid the clamor of thundering waves and rustling palms, has not been overcome by the grandeur of Creation, struck with awe at the power that created such drama? The power evident in the divine wind, the *ruah hakodesh*, the wind or spirit of God, has caught the Psalmist's attention in Psalm 96. In the illuminations, the singing of the trees, the roaring of the waves, and energy rushing through the ever-evolving heavens announce the presence of God in the physical world. The spectral emission lines for the gases most prevalent in air appear in the border separating the deep sky imagery from the biosphere.

The imagery of the double curtains blowing in the wind, the weighty blue outer curtain, and the more delicate white fabric beneath symbolize the human soul's ability to accept God's presence and judgment. Midrash on the Song of Songs compares the human soul to a curtain; the workaday world may seem to darken the soul with grime, but our ability to repent and accept divine law on Yom Kippur leaves our souls pure and light like fresh white linen curtains. Thus even in its impure state—the colored curtain—the human soul, capable of repentance, *teshuva*, remains a thing of beauty to its Creator, whose omnipresent power the Psalmist celebrates in Psalm 96.

PSALM 97

יהוה מָלַךְ תָּגֵל הָאָרֶץ,	The Lord rules! Let the earth rejoice,
יִשְׂמְחוּ אִיִּים רַבִּים:	May the multitudinous regions be glad.
עָנָן וַעֲרָפֶל סְבִיבָיו,	Cloud and darkness surround Him;
צֶדֶק וּמִשְׁפָּט מְכוֹן כִּסְאוֹ:	Justice and judgment are His throne's foundation.
אֵשׁ לְפָנָיו תֵּלֵךְ,	Fire goes before Him,
וּתְלַהֵט סָבִיב צָרָיו:	Burning around His foes.
הֵאִירוּ בְרָקָיו תֵּבֵל,	His flashes illumine the world;
רָאֲתָה וַתָּחֵל הָאָרֶץ:	The earth sees and trembles.
הָרִים כַּדּוֹנַג נָמַסּוּ מִלִּפְנֵי יהוה,	Mountains melt like wax before the Lord,
מִלִּפְנֵי אֲדוֹן כָּל־הָאָרֶץ:	Before the Lord of all the world.
הִגִּידוּ הַשָּׁמַיִם צִדְקוֹ,	The heavens declare His righteousness,
וְרָאוּ כָל־הָעַמִּים כְּבוֹדוֹ:	And all the nations see His glory.
יֵבֹשׁוּ ǀ כָּל־עֹבְדֵי פֶסֶל	Shamed are all the idolaters,
הַמִּתְהַלְלִים בָּאֱלִילִים,	Who boast of their godlets;
הִשְׁתַּחֲווּ־לוֹ כָּל־אֱלֹהִים:	All gods bow down to Him.
שָׁמְעָה וַתִּשְׂמַח צִיּוֹן,	Zion rejoices to hear,
וַתָּגֵלְנָה בְּנוֹת יְהוּדָה...	Judaea's daughters are happy...

<div dir="rtl">

לְמַעַן מִשְׁפְּטֶיךָ יהוה:

כִּי־אַתָּה יהוה עֶלְיוֹן עַל־כָּל־הָאָרֶץ,

מְאֹד נַעֲלֵיתָ עַל־כָּל־אֱלֹהִים:

אֹהֲבֵי יהוה שִׂנְאוּ רָע,

שֹׁמֵר נַפְשׁוֹת חֲסִידָיו,

מִיַּד רְשָׁעִים יַצִּילֵם:

אוֹר זָרֻעַ לַצַּדִּיק,

וּלְיִשְׁרֵי־לֵב שִׂמְחָה:

שִׂמְחוּ צַדִּיקִים בַּיהוה,

וְהוֹדוּ לְזֵכֶר קָדְשׁוֹ:

</div>

Because of Your judgments, O Lord.

For You, O Lord, are exalted above all the earth;
 You have risen high above all the gods.

O you who love the Lord: Despise evil!
 He protects the lives of His adherents,
 Saves them from the wicked.

Light is strewn upon the righteous,
 Joy to those who are good at heart.

Rejoice, O righteous, in the Lord,
 And praise His holy name.

LITERARY COMMENTARY

The ecstatic tone of Psalm 96 is replaced by a more vehement tone. The Lord who comes to reign anew reveals Himself in natural upheavals: storm clouds, lightning, and earthquakes; the very earth that He created trembles at His approach. Thus, His renewed reign promises, along with joy and justice for the righteous who acclaim Him, danger for the wicked idolaters who resist His claim.

COMMENTARY ON THE ILLUMINATIONS

torms cloud the sky and shocking white lightning may flash, yet through the clouds, "light is strewn upon the righteous, joy to those who are good at heart." The psalm focuses on the human sense of sight, our ability to perceive light—as brilliant and fearsome as it may be—enabling us to perceive and celebrate the glory of the Creator. The illuminations present an image of light streaming through sunset-lit storm clouds at sea, the birthplace of all life on earth. Throughout the verses, the barred blue cartouches suggest the light signatures of the most common elements of the cosmos, while clouds of gold reflect light into the reader's eyes, reminding us of the physical and divine energy that suffuses the universe, enabling and illuminating all life.

מִזְמוֹר:
שִׁירוּ לַיהוה שִׁיר חָדָשׁ, כִּי־נִפְלָאוֹת עָשָׂה,
הוֹשִׁיעָה־לּוֹ יְמִינוֹ
וּזְרוֹעַ קָדְשׁוֹ:
הוֹדִיעַ יהוה יְשׁוּעָתוֹ,
לְעֵינֵי הַגּוֹיִם גִּלָּה צִדְקָתוֹ:
זָכַר חַסְדּוֹ
וֶאֱמוּנָתוֹ לְבֵית יִשְׂרָאֵל,
רָאוּ כָל־אַפְסֵי־אָרֶץ
אֵת יְשׁוּעַת אֱלֹהֵינוּ:
הָרִיעוּ לַיהוה כָּל־הָאָרֶץ!
פִּצְחוּ וְרַנְּנוּ וְזַמֵּרוּ:
זַמְּרוּ לַיהוה בְּכִנּוֹר,
בְּכִנּוֹר וְקוֹל זִמְרָה:
בַּחֲצֹצְרוֹת וְקוֹל שׁוֹפָר,
הָרִיעוּ לִפְנֵי | הַמֶּלֶךְ יהוה:
יִרְעַם הַיָּם וּמְלֹאוֹ,
תֵּבֵל וְיֹשְׁבֵי בָהּ:
נְהָרוֹת יִמְחֲאוּ־כָף,
יַחַד הָרִים יְרַנֵּנוּ:
לִפְנֵי־יהוה כִּי בָא לִשְׁפֹּט הָאָרֶץ,
יִשְׁפֹּט־תֵּבֵל בְּצֶדֶק
וְעַמִּים בְּמֵישָׁרִים:

A psalm.

Sing a new song to the Lord, for He has done wonders.

His right hand and His holy arm
Have given Him victory.

The Lord has proclaimed His saving help.

He has revealed His victory to the nations.

He remembered to do acts of kindness

and loyalty to the House of Israel.

All the ends of the earth have observed

the victory of our God.

Shout to the Lord, all the earth!

Open your mouths, shout, and sing!

Sing to the Lord with the lyre,

With the lyre and the sound of singing.

To the sound of trumpets and horn blasts,

Shout in acclaim of the Lord, the King.

Let the sea and all that is in it thunder,

The earth and those who dwell on it.

Let the rivers clap their hands,

The mountains shout together,

Before the Lord, for He comes to judge the earth.

He judges the world with justice

and the nations in equity.

LITERARY COMMENTARY

In this psalm, the ecstatic voice of Psalm 96 returns, as if to soften the vehemence of Psalm 97. Again, the Psalmist calls upon the world to sing to the Lord; again, the elements of Creation are called upon to celebrate their Creator; and again, the Lord is celebrated as establishing justice. But the predominant reason for praising the Lord in this psalm is His special care of Israel.

ing! Just as the powers of the natural world praise their Creator with their noise, the people of Israel should use their mouths and musical instruments to praise God for the wonders of His Creation of the world and victorious protection of Israel. The illuminations evoke music-making and the great songs of humanity. Signaling the special exhortation to sing to the Lord, the lettering of this psalm includes the traditional trope marks.

The "mosaic" panels flanking the poetry present biblical-era and modern instruments—a shofar, lyres, flute, and horns—those of our own day emerging from the mosaic memory into a vision of their physical actuality. The mosaics are edged with bands of the spectral emission lines for chemical elements prominent in making the instruments—from right to left: silver, iron, carbon, and calcium. The musical notation floating from the mosaics is suggested by the beginning bars of J. S. Bach's "Prelude No. 1," from *The Well-Tempered Clavier*.

The micrographic borders surrounding the mosaic panels contain the initial verses of the biblical poems considered to be the ten great songs to be sung prior to the coming of the Messiah.[37] These include: (1) Psalm 92, sung by Adam upon his first Sabbath; (2) Song of the Sea, sung by Moses and the children of Israel following the parting of the Red Sea; (3) Num. 21:17, sung by the children of Israel when the well of water was given them; (4) *Ha'azinu*, in Deuteronomy 32, sung by Moses as he prepared to finally leave the people; (5) Josh. 10:12–13, sung by Joshua, calling upon God to cease the motion of the sun during the battle with Gibeon; (6) the triumphant Song of Deborah in Judges 5; (7) Hannah's hymn of thanks to God, in 1 Samuel 1; (8) David's song of gratitude for the miracles that God had performed for him, recorded in 2 Samuel 22; (9) Solomon's Song of Songs; and (10) the song sung by the redeemed and returning exiles written by Isaiah, recorded in Isa. 30:29.

PSALM 99

יהוה מָלָךְ! יִרְגְּזוּ עַמִּים,	The Lord reigns! Let the nations tremble.
יֹשֵׁב כְּרוּבִים תָּנוּט הָאָרֶץ!	He in enthroned on the Cherubim. Let the earth shake!
יהוה בְּצִיּוֹן גָּדוֹל,	The Lord is great in Zion,
וְרָם הוּא עַל־כָּל־הָעַמִּים:	Exalted over all the nations.
יוֹדוּ שְׁמְךָ	Let them acknowledge Your name,
גָּדוֹל וְנוֹרָא	Great and terrible One.
קָדוֹשׁ הוּא!	Holy is He!
וְעֹז מֶלֶךְ מִשְׁפָּט אָהֵב,	And this mighty king loves justice:
אַתָּה כּוֹנַנְתָּ מֵישָׁרִים,	You established righteousness,
מִשְׁפָּט וּצְדָקָה	Performed justice and fairness

בְּיַעֲקֹב אַתָּה עָשִׂיתָ:	In the House of Jacob.
רוֹמְמוּ יהוה אֱלֹהֵינוּ,	Exalt the Lord our God,
וְהִשְׁתַּחֲווּ לַהֲדֹם רַגְלָיו,	Prostrate yourselves at His footstool.
קָדוֹשׁ הוּא!	Holy is He!
מֹשֶׁה וְאַהֲרֹן בְּכֹהֲנָיו,	Moses and Aaron were among His priests,
וּשְׁמוּאֵל בְּקֹרְאֵי שְׁמוֹ,	Samuel among those who called upon His name:
קֹרְאִים אֶל־יהוה וְהוּא יַעֲנֵם:	They called upon the Lord, and He would answer them.
בְּעַמּוּד עָנָן יְדַבֵּר אֲלֵיהֶם,	He spoke to them in a pillar of cloud.
שָׁמְרוּ עֵדֹתָיו,	They observed His testimonies,
וְחֹק נָתַן־לָמוֹ:	And the law that He gave to them.
יהוה אֱלֹהֵינוּ אַתָּה עֲנִיתָם:	O Lord, God: You answered them.
אֵל נֹשֵׂא הָיִיתָ לָהֶם,	You were a forgiving God to them,
וְנֹקֵם עַל־עֲלִילוֹתָם:	But took revenge for their misdeeds.
רוֹמְמוּ יהוה אֱלֹהֵינוּ,	Exalt the Lord our God
וְהִשְׁתַּחֲווּ לְהַר קָדְשׁוֹ,	Prostrate yourselves at His holy mountain,
כִּי־קָדוֹשׁ יהוה אֱלֹהֵינוּ:	For holy is the Lord our God.

LITERARY COMMENTARY

The tone of this psalm is quite different from that of the preceding psalms: it is less ecstatic and universalistic and more historically oriented. It stresses the special relationship between God and Israel in the new world that He is creating. The nearly identical verses 5 and 9 serve as a kind of refrain, dividing the psalm into two parts. The first part speaks of the renewed reign of the Lord over the nations and His imposing a realm of justice. The second recalls the ancient Israelite leaders Moses, Aaron, and Samuel, whose relationship with the Lord was so intimate that they could call upon Him and be assured of an answer. Moses called upon the Lord several times in the Torah. Aaron, as high priest, is associated with Him. Samuel called upon the Lord and was answered in 1 Sam. 11:18.

COMMENTARY ON THE ILLUMINATIONS

he last of this set of psalms leads us to experience the Creator through our senses of righteousness, justice, and fairness and brings us to worship at His footstool, the holy mountain, Jerusalem. The imagery I offer you here conjures up ideas of the perseverance of our love for Jerusalem throughout Jewish history. Whether gazing at the glistening heights of the Second Temple—its beauty considered a marvel of its age—or worshiping at its last surviving section of retaining wall (the Western Wall), Jews have revered the sacred energy suffusing its earth and stone. Caper branches spring from the Western Wall, symbolizing Israel's perseverance, while a dove, a midrashic symbol of Israel's trust in God and compliance with divine law, flies

before its stones.[38] The pattern of blue, purple, and crimson pomegranates interspersed with golden bells draws upon the divine prescription for the decoration of Aaron's priestly vestments related in Exod. 28:34–35. The imagery is bound together with the words of Judah Halevi's famous poem "Ode to Jerusalem,"[39] worked in a micrographic pattern of caper blossoms, symbolizing Israel's ability to flourish and persevere even through adversity, with the support of our invisible God.[40]

The three black triangular cartouches present the spectral lines emitted by the three elements that compose the minerals in Jerusalem limestone: oxygen on the first page; and calcium and carbon on the second, reminding us that the physical world mediates our experience of the divine.

PSALM 29

מִזְמוֹר לְדָוִד,
הָבוּ לַיהוה בְּנֵי אֵלִים,
הָבוּ לַיהוה כָּבוֹד וָעֹז:
הָבוּ לַיהוה כְּבוֹד שְׁמוֹ,
הִשְׁתַּחֲווּ לַיהוה בְּהַדְרַת־קֹדֶשׁ:

קוֹל יהוה עַל־הַמָּיִם,
אֵל־הַכָּבוֹד הִרְעִים,
יהוה עַל־מַיִם רַבִּים:
קוֹל־יהוה בַּכֹּחַ,
קוֹל יהוה בֶּהָדָר:
קוֹל יהוה שֹׁבֵר אֲרָזִים,
וַיְשַׁבֵּר יהוה אֶת־אַרְזֵי הַלְּבָנוֹן:
וַיַּרְקִידֵם כְּמוֹ־עֵגֶל,
לְבָנוֹן וְשִׂרְיֹן כְּמוֹ בֶן־רְאֵמִים:
קוֹל יהוה חֹצֵב לַהֲבוֹת אֵשׁ:
קוֹל יהוה יָחִיל מִדְבָּר,
יָחִיל יהוה מִדְבַּר קָדֵשׁ:
קוֹל יהוה יְחוֹלֵל אַיָּלוֹת
וַיֶּחֱשֹׂף יְעָרוֹת,
וּבְהֵיכָלוֹ כֻּלּוֹ אֹמֵר כָּבוֹד:

A psalm of David.

Acclaim the Lord, O sons of gods,
 Acclaim the Lord in His glory and might!
Acclaim the Lord in His glorious name,
 Bow to the Lord in his glorious sanctuary.

The voice of the Lord was over the waters;
 The God of Glory thundered—
 The Lord over the endless waters.
The voice of the Lord came in power.
 The voice of the Lord came in splendor.
The voice of the Lord split the cedars;
 The Lord cracked the cedars of Lebanon,
Made them dance like calves;
 Lebanon and Sirion like wild oxen.
The voice of the Lord, splitting flames of fire—
 The voice of the Lord made the desert quake;
 The Lord made the desert of Kadesh quake
The voice of the Lord made gazelles drop their young,
 Stripped the forests.
Meanwhile, all in His palace were telling of His glory.

יהוה לַמַּבּוּל יָשָׁב
וַיֵּשֶׁב יהוה מֶלֶךְ לְעוֹלָם:
יהוה עֹז לְעַמּוֹ יִתֵּן,
יהוה יְבָרֵךְ אֶת־עַמּוֹ בַשָּׁלוֹם:

The Lord presided over the Flood,
 The Lord presides as King forever.
May the Lord give strength to His folk,
 May the Lord bless His folk forever.

LITERARY COMMENTARY

This psalm reverts to the theme of God as Lord of all and all-powerful Creator. The Psalmist summons the pagan gods, now reduced to mere subjects of the Lord of the Universe, to acclaim Him as He takes His place amid the raging storms and earthquakes in which He is manifest. Over and over, the Psalmist evokes the terrifying voice of the Lord, the thunder and earth tremors, cracking the ancient trees of the forest, striking flame, and shaking the desert. He ends by recalling Noah's Flood—when the Lord definitively demonstrated His control of nature—but also by assuring Israel that it will come to no harm under His eternal reign.

COMMENTARY ON THE ILLUMINATIONS

s its opening words exhort us to praise the Almighty God in His Temple, Psalm 29 completes the cycle of psalms that evoke the divine power manifest in the physical Creation, whose completion we celebrate as Shabbat arrives. Here, the Psalmist leads us to experience the divine power of Creation through sound, whether the earsplitting crashing of earthquakes, storms, and cracking trees, or the birth sounds of the gentlest and loveliest of creatures.

In the illuminations, sound waves reverberate through the text. Below, in a mighty forest, a gazelle nurses its fragile newborn in the wake of thunder and earthquake. Strong cedar trees break, and new shoots spring from their roots; delicate almond blossoms[41] bloom from broken trunks, signaling divine leadership. The caper shrubs growing from dry rock bloom and fruit, symbolizing Israel's ability to persevere through adversity, supported only by God's unseen but nonetheless outstretched arm. The view of the deep sky through the storm clouds witnesses the presence of the eternal divine suffusing all the universe. Flowering myrrh bushes, shaken along with the earth under their roots, have cast their fragrant blossoms across the land.

The eagle flying overhead suggests qualities of both divine protection and the soul of the nation of Israel. Midrash compares the splitting of the Red Sea to the eagle's protection of its chicks; an eagle supports its young safely on its back even while fighting off aggressors, just as God protected Israel from the pursuing Egyptian army.[42] The thirteenth-century Spanish kabbalist Joseph Gikatilla builds on this traditional midrashic metaphor about divine protection by comparing the eagle's strength to Israel's soul, refreshed and strengthened when the mystical channels of blessing are in good repair.[43]

Arthur Green suggests that the kabbalists positioned Psalm 29 at this point in the Kabbalat Shabbat liturgy mostly because of its eighteen mentions of YHWH, the divine name associated with love, picked out here in celestial light blue. He suggests "shouting out" the name "eighteen times as you recite the psalm. In this moment, both intimate and powerful, you are calling on the Lover by name."[44]

אָנָּא, בְּכְחַ גְּדֻלַּת יְמִינְךָ, תַּתִּיר
צְרוּרָה. קַבֵּל רִנַּת עַמְּךָ, שַׂגְּבֵנוּ,
טַהֲרֵנוּ, נוֹרָא. נָא גִבּוֹר, דּוֹרְשֵׁי
יִחוּדְךָ, כְּבָבַת שָׁמְרֵם. בָּרְכֵם, טַהֲרֵם,
רַחֲמֵם, צִדְקָתְךָ תָּמִיד גָּמְלֵם. חֲסִין
קָדוֹשׁ, בְּרוֹב טוּבְךָ, נַהֵל עֲדָתֶךָ.
יָחִיד גֵּאֶה, לְעַמְּךָ פְּנֵה, זוֹכְרֵי
קְדֻשָּׁתֶךָ. שַׁוְעָתֵנוּ קַבֵּל, וּשְׁמַע
צַעֲקָתֵנוּ, יוֹדֵעַ תַּעֲלוּמוֹת. בָּרוּךְ שֵׁם
כְּבוֹד מַלְכוּתוֹ לְעוֹלָם וָעֶד.

O, with the might of Your great right hand, release the captive one. Accept Your people's prayer. Lift us up, purify us, fearsome One. O mighty One, protect those who promote Your unity like the pupil of Your eye. Bless them, purify them, have mercy on them, grant them Your righteousness ever. Mighty, Holy One, in Your great kindness lead Your community. Proud, unique One, turn to Your people, who speak of Your holiness. Accept our prayer and hear our cry, O You Who know the mysteries. Blessed is the name of His glorious majesty forever and ever.

LITERARY COMMENTARY

This little prayer was composed in the Middle Ages, using as its acrostic the forty-two letters that some mystics believed made up one of the names of God. It first appeared in prayer books in the seventeenth century. It consists of three rhymed couplets and one additional line, followed by the response that was used in antiquity after the name of God was pronounced and that is still found as an insertion after the first line of the Shema.

COMMENTARY ON THE ILLUMINATION

mid all the ecstatic celebration of divine power in Creation in this liturgy, "Ana bekho'aḥ" introduces a note of courtly pleading that God free the captive souls of all Israel so that we might express ourselves in prayer. As Arthur Green suggests, the poem begins with "a plea for God to release the captive. She is our soul, imprisoned by the rush of life during the week, now about to be set free, to be allowed to sing with full voice."[45] The illumination expresses the soul's longing through the imagery of a gazelle. Building upon a metaphor in the Song of Songs (e.g., Song 2:17), the medieval Sephardic poets see in the gazelle an embodiment of the love between Israel and God. "Beautiful gazelle, so far from camp—Her love is angry with her, why her smile?" as Judah Halevi wrote.[46] Here, at the outset of the poem, the gazelle sits awkwardly, weighed down by chains of daily care and national exile. Finally freed, she leaps away into a future of joy and fulfillment.

The initial letters of each Hebrew word, here highlighted in light blue, spell out the hidden forty-two-letter name of God and become—even more than the actual words—the focus of the text. Green observes that

> although the letters rather than the words are the heart of the matter here, the text itself is, in fact, very touching. The first line is a plea for God to release the captive. She is our soul, imprisoned by the rush of life during the week, now about to be set free, to be allowed to sing with full voice. The last line, "Accept our pleas, hear our outcry, You who know all our secrets," is one of those moments where the text of the prayer book transcends itself. "How much more am I praying for than all these words can say! From how much deeper within me does my prayer come than the authors of these words could ever know!" But *You* know all my secrets. You who know me fully—hear the cry that comes from all those hidden places.[47]

The letters of the mysterious divine name embedded in this text contain *all* the letters of the Hebrew alphabet except the letter *mem*. We might wonder whether the missing *mem* suggests the Messiah. In anticipation of redemption, however, the border imagines all the Hebrew letters scattered through the night sky, lighter in the upper reaches nearest the *ein sof*, darker closest to the material realm, all suffused with the astronomical imagery that suggests the unity of all matter in its common divine origin.

Lekha dodi

לְכָה דוֹדִי לִקְרַאת כַּלָּה.	Come, my friend, to greet the bride.
פְּנֵי שַׁבָּת נְקַבְּלָה.	Let us welcome the Sabbath.
שָׁמוֹר וְזָכוֹר בְּדִבּוּר אֶחָד	"Observe" and "Remember": In a single word
הִשְׁמִיעָנוּ אֵל הַמְיֻחָד.	the one God gave us the command.
יהוה אֶחָד וּשְׁמוֹ אֶחָד	The Lord is One, and His name is One
לְשֵׁם וּלְתִפְאֶרֶת וְלִתְהִלָּה.	in honor and splendor and praise.
לְכָה דוֹדִי לִקְרַאת כַּלָּה.	Come, my friend, to greet the bride.
פְּנֵי שַׁבָּת נְקַבְּלָה.	Let us welcome the Sabbath.
לִקְרַאת שַׁבָּת לְכוּ וְנֵלְכָה,	Come, let us all go to welcome the Sabbath,
כִּי הִיא מְקוֹר הַבְּרָכָה.	for she is the source of blessing.
מֵרֹאשׁ מִקֶּדֶם נְסוּכָה,	Crowned from the first, from of old,
סוֹף מַעֲשֶׂה בְּמַחֲשָׁבָה תְּחִלָּה.	the last of God's deeds, the first in His plan.
לְכָה דוֹדִי לִקְרַאת כַּלָּה.	Come, my friend, to greet the bride.
פְּנֵי שַׁבָּת נְקַבְּלָה.	Let us welcome the Sabbath.

מִקְדַּשׁ מֶלֶךְ עִיר מְלוּכָה !

קוּמִי צְאִי מִתּוֹךְ הַהֲפֵכָה,

רַב לָךְ שֶׁבֶת בְּעֵמֶק הַבָּכָא,

וְהוּא יַחֲמֹל עָלַיִךְ חֶמְלָה.

לְכָה דוֹדִי לִקְרַאת כַּלָּה.

פְּנֵי שַׁבָּת נְקַבְּלָה.

O Royal Temple, O Royal City!
Rise up! Come forth out of your ruins!
Long enough have you dwelt in the valley of tears.
He will take pity on you, He will take pity.
 Come, my friend, to greet the bride.
 Let us welcome the Sabbath.

הִתְנַעֲרִי, מֵעָפָר קוּמִי!

לִבְשִׁי בִּגְדֵי תִפְאַרְתֵּךְ עַמִּי.

עַל יַד בֶּן יִשַׁי בֵּית הַלַּחְמִי,

קָרְבָה אֶל נַפְשִׁי, גְאָלָהּ.

לְכָה דוֹדִי לִקְרַאת כַּלָּה.

פְּנֵי שַׁבָּת נְקַבְּלָה.

Shake yourself off from the dust, and arise!
Put on your splendid robes, O my people.
Through Jesse's son, the man of Bethlehem,
come near to my soul and save it.
 Come, my friend, to greet the bride.
 Let us welcome the Sabbath.

הִתְעוֹרְרִי ! הִתְעוֹרְרִי!

כִּי בָא אוֹרֵךְ! קוּמִי אוֹרִי!

עוּרִי עוּרִי, שִׁיר דַּבֵּרִי,

כְּבוֹד יהוה עָלַיִךְ נִגְלָה.

לְכָה דוֹדִי לִקְרַאת כַּלָּה.

פְּנֵי שַׁבָּת נְקַבְּלָה.

Wake up! Wake up!
Your light has come! Get up and shine!
Wake! Wake! Utter song!
God's glory is revealed upon you.
 Come, my friend, to greet the bride.
 Let us welcome the Sabbath.

לֹא תֵבֹשִׁי, וְלֹא תִכָּלְמִי,

מַה תִּשְׁתּוֹחֲחִי וּמַה תֶּהֱמִי?

בָּךְ יֶחֱסוּ עֲנִיֵּי עַמִּי,

וְנִבְנְתָה עִיר עַל תִּלָּהּ.

לְכָה דוֹדִי לִקְרַאת כַּלָּה.

פְּנֵי שַׁבָּת נְקַבְּלָה.

Do not be ashamed, do not be abashed.
Why are you downcast, why upset?
My people's poor will take refuge in you,
and the city will be built on the mound of its ruins.
 Come, my friend, to greet the bride.
 Let us welcome the Sabbath.

וְהָיוּ לִמְשִׁסָּה שֹׁאסָיִךְ,

וְרָחֲקוּ כָּל מְבַלְּעָיִךְ,

יָשִׂישׂ עָלַיִךְ אֱלֹהָיִךְ,

כִּמְשׂוֹשׂ חָתָן עַל כַּלָּה.

לְכָה דוֹדִי לִקְרַאת כַּלָּה.

פְּנֵי שַׁבָּת נְקַבְּלָה.

Despoiled will be those who took your spoils,
and those who devoured you will be removed afar.
Your God will rejoice in you
as a new husband rejoices in his bride.
 Come, my friend, to greet the bride.
 Let us welcome the Sabbath.

יָמִין וּשְׂמֹאל תִּפְרֹוצִי,
וְאֶת יהוה תַּעֲרִיצִי
עַל יַד אִישׁ בֶּן פַּרְצִי,
וְנִשְׂמְחָה וְנָגִילָה.
לְכָה דוֹדִי לִקְרַאת כַּלָּה.
פְּנֵי שַׁבָּת נְקַבְּלָה.

Rightward, leftward you will spread,

offering praises to the Lord

through the man descended from Peretz,

and we will rejoice, and we will be glad.

 Come, my friend, to greet the bride.

 Let us welcome the Sabbath.

בּוֹאִי בְשָׁלוֹם עֲטֶרֶת בַּעְלָהּ,
גַּם בְּשִׂמְחָה וּבְצָהֳלָה,
תּוֹךְ אֱמוּנֵי עַם סְגֻלָּה,
בּוֹאִי כַלָּה, בּוֹאִי כַלָּה.
לְכָה דוֹדִי לִקְרַאת כַּלָּה.
פְּנֵי שַׁבָּת נְקַבְּלָה.

Enter in peace, O crown of your husband,

both in jubilation and in joy

among the treasured people's faithful.

Enter, O bride! Enter, O bride!

 Come, my friend, to greet the bride.

 Let us welcome the Sabbath.

LITERARY COMMENTARY

Possibly the most famous Hebrew poem ever written, "Lekha dodi" was composed by Solomon Halevi Alkabetz, a kabbalist rabbi who was born in Salonika, ca. 1500, and died in Safed, ca. 1580. The poem consists of a leading stanza (a kind of heading that is also used as a refrain and provides the rhyme common to all the stanzas) and nine four-line stanzas. The author's name, Shelomo Halevi, is formed by the acrostic in the first eight stanzas. Stanzas 3–8 are apparently devoted not to the Sabbath but to the restoration of the exiled people of Israel, much of their language deriving from the prophecies of consolation to the exiled Israelites found in the latter part of the book of Isaiah. This shift in the subject matter might seem to be a puzzle but is easily resolved by considering the author's kabbalistic intent: the poem, so simple and transparent-seeming in its wording, is actually an esoteric composition celebrating the marriage of the two *sefirot* of *tiferet* and *malkhut*; the former represents the male aspect of God, and the latter represents the Shekhinah, understood as God in His female aspect. To the kabbalists, these two *sefirot* also correspond to God and Israel, respectively, so that by welcoming the Sabbath as bride, the Jewish people is uniting in marriage with God, and the two aspects of God are uniting with each other, bringing joy and abundance into the world as well as the redemption of Israel and of the world at large. Thus, the attention paid at such length to the redemption of Jerusalem is actually intended to describe the restoration of the divine unity.

The poem's kabbalistic intentions are invisible to a reader not steeped in the linguistic usages of the kabbalah. A few examples will provide a taste of the poet's method of composition. The leading stanza comprises two

lines rhyming in *lamed-hay*: the first line has fifteen letters, and the second has eleven. Fifteen and eleven are the numerical value of the two halves of the Tetragrammaton, *yud-hay* and *vav-hay*. The leading stanza thus unites the two parts of the Tetragrammaton, which, for the kabbalists, is another way of expressing the union of *tiferet* and *malkhut*, which is the goal of much kabbalistic ritual, including Kabbalat Shabbat itself. Furthermore, the rhyme syllables of the leading stanza add up to thirty-five each, for a total of seventy, like the two parts of kiddush, which contain thirty-five words each (in the Sephardic version used by the kabbalists), for a total of seventy. This number is probably meant to represent the seventy crowns that the Zohar says are worn by the Shekhinah when she appears at the onset of Shabbat.

The esoteric elements in this poem go far beyond these mere numerological features. The first two words of the first stanza, *shamor* and *zakhor*, are in reverse order, as compared with their order in the Torah (Exod. 20:8; Deut. 5:12) because, according to the kabbalists, the former word represents the female element in God; and the latter, the male. The former therefore represents the Shekhinah and the Sabbath bride, whom we welcome on Friday night, while the male element is honored on the Sabbath day. A kabbalistic adept can see some such consideration behind nearly every word in the poem. Even the book-length academic treatment of the poem by Reuven Kimelman, from which most of the above information has been drawn, analyzes only a few stanzas in close detail.[48]

COMMENTARY ON THE ILLUMINATIONS

This elegant, multilayered song urges us to welcome the arrival of the Shekhinah, the Shabbat bride, into our midst at the cusp of the supernal and material worlds. In the illuminations, we watch, as though we were wedding guests, as she floats toward her *ḥuppa* and enriches the human world with divine wisdom.

The full-page painting that accompanies the initial verses presents the scene of the wedding as the bride approaches. Wisdom, ushered into the human realm through the Shekhinah, speaks in the border text, drawn from Proverbs 8:

> The Lord created me at the beginning of His course
> As the first of His works of old.
> In the distant past I was fashioned,
> At the beginning, at the origin of earth…
> Before [the foundation of] the mountains were sunk,
> Before the hills I was born…
> When He made the heavens above firm,
> And the fountains of the deep gushed forth…
> When He fixed the foundations of the earth
> I was with Him as a confidant,
> A source of delight every day,
> Rejoicing before Him at all times,
> Rejoicing in His inhabited world,
> Finding delight with mankind.

The *ḥuppa* billows in a breeze that suggests the *ruaḥ Adonai*, the wind, or the spirit of God that hovered over the waters at the moment of Creation. The canopy's edges are embroidered with a repeated pattern of the Hebrew letters *daled vav daled yud / yud daled vav daled / yud hay vav hay*. In kabbalah, this pattern suggests

the transformation of the human groom (the beloved, *dodi*), into the *sefira* of *tiferet* (associated with the divine name YHVH), fulfilling the human role in bringing about the unification of the divine emanations.[49]

Clouds, alluding to God's guidance of Israel through the desert, give way to the deep sky symbolizing the all-suffusing divine presence. Shekhinah's groom, *tiferet*, has not yet—so far as we can perceive—appeared; yet he surrounds her, evident in the intense greens—his ascribed color—of the fertile field through which she approaches the marriage canopy.

In the foreground, we see a fountain, a symbol of Torah throughout Jewish lore. The tiles show the atomic spectral lines of carbon, the element common to all forms of life on earth. The four streams of water flowing from it allude to the notion about the nature of matter, suggested by the mystic Ezra of Gerona: "'A river goes forth from Eden to water the garden' [Gen. 2:10]. The garden constitutes the beginning of the differentiated universe. As it says: 'from there it divides and becomes four branches' [ibid.]. The verse is in present tense, the process is eternal."[50]

Myrtle and myrrh bushes grow at the base of each of the ḥuppa poles. The myrrh alludes to the fragrant incense in the Temple. Myrtle branches, shown more closely in the border of the painting, represent the Shekhinah throughout kabbalah; the eighteenth-century work recounting Sabbath observance in Isaac Luria's community, *Ḥemdat yamim*, suggests decorating the Sabbath table with the fragrant branches. The walls of Jerusalem rise in the background.

Alkabetz's poem includes a refrain and nine stanzas, yielding ten separate passages—corresponding to the number of *sefirot*. Within the body of the text, the refrain and the first word of the stanza begin with colors associated with the successive *sefirot*. The refrain is presented in black and white; *keter* (crown), at the top of the sefirotic tree, relates to both those shades. Thereafter, gold is substituted for the white, while the colors green, red, and blue also appear (see the commentary on kiddush on pages 206–7).

The second pair of pages presenting the later verses of "Lekha dodi" present miniature images relating to the national rebirth and redemption that the poem describes at the literal level. At right, the Shekhinah raises a man from the ground covered in shards of skeletons, referring to Ezekiel's vision of the Valley of Dry Bones (Ezekiel 37). At left, a gazelle springs away from the viewer toward the hills, suggesting the final verse of the Song of Songs: "Flee, my love, and be like a deer or a young gazelle on the mountain of spice."[51]

In the Targum on Song of Songs, this verse anticipates the unification of God and Israel at the time of the Messiah. Exploring the mystical significance of this verse, Ezra of Gerona suggested: "Souls will be bound up in the bond of life, and they will be a throne for the Lord. Then the river, which is the life and existence of the world, flowing forth from the Eden of Wisdom, will cease its flow. This is the meaning of 'Flee, my beloved': pointing to the rising of the Glory, its ascent into the upper light."[52] As friends rise to greet the Shekhinah, the Sabbath queen, human souls thus become a throne for the Lord.

מִזְמוֹר שִׁיר לְיוֹם הַשַּׁבָּת:

טוֹב לְהֹדוֹת לַיהוה,

וּלְזַמֵּר לְשִׁמְךָ עֶלְיוֹן:

לְהַגִּיד בַּבֹּקֶר חַסְדֶּךָ

וֶאֱמוּנָתְךָ בַּלֵּילוֹת:

עֲלֵי־עָשׂוֹר

וַעֲלֵי־נָבֶל

עֲלֵי הִגָּיוֹן בְּכִנּוֹר:

כִּי שִׂמַּחְתַּנִי יְהוָה בְּפָעֳלֶךָ,

בְּמַעֲשֵׂי יָדֶיךָ אֲרַנֵּן:

מַה־גָּדְלוּ מַעֲשֶׂיךָ יהוה,

מְאֹד עָמְקוּ מַחְשְׁבֹתֶיךָ:

אִישׁ בַּעַר לֹא יֵדָע,

וּכְסִיל לֹא־יָבִין אֶת־זֹאת:

בִּפְרֹחַ רְשָׁעִים כְּמוֹ עֵשֶׂב,

וַיָּצִיצוּ כָּל־פֹּעֲלֵי אָוֶן,

לְהִשָּׁמְדָם עֲדֵי־עַד:

וְאַתָּה מָרוֹם לְעֹלָם יְהוָה:

כִּי הִנֵּה אֹיְבֶיךָ יהוה

כִּי־הִנֵּה אֹיְבֶיךָ יֹאבֵדוּ יִתְפָּרְדוּ

כָּל־פֹּעֲלֵי אָוֶן:

וַתָּרֶם כִּרְאֵים קַרְנִי,

בַּלֹּתִי בְּשֶׁמֶן רַעֲנָן:

וַתַּבֵּט עֵינִי בְּשׁוּרָי,

בַּקָּמִים עָלַי מְרֵעִים

תִּשְׁמַעְנָה אָזְנָי:

צַדִּיק כַּתָּמָר יִפְרָח,

כְּאֶרֶז בַּלְּבָנוֹן יִשְׂגֶּה:

שְׁתוּלִים בְּבֵית יהוה,

בְּחַצְרוֹת אֱלֹהֵינוּ יַפְרִיחוּ:

עוֹד יְנוּבוּן בְּשֵׂיבָה,

דְּשֵׁנִים וְרַעֲנַנִּים יִהְיוּ:

לְהַגִּיד כִּי־יָשָׁר יהוה,

צוּרִי, וְלֹא־עַוְלָתָה בּוֹ:

A psalm. A song for the Sabbath day.

It is to give thanks to the Lord,

 To sing to Your name, O Most High!

To speak of Your favors at morning

 And Your steadfastness at night

On a ten-string lyre,

 Upon the lute,

 Humming with a harp.

For You have gladdened me with Your deeds,

 I sing of what Your hands have wrought.

How great are Your deeds, O Lord,

 How profound Your thoughts.

A brutish man cannot know,

 A fool cannot grasp this:

When the wicked flourish like grass,

 When wrongdoers blossom,

It is only for their eternal ruin.

 But You are forever on high, O Lord.

For lo, Your enemies, O Lord,

 For lo, Your enemies will perish,

 All evildoers will be undone.

But You have raised my horn like a wild bull,

 I am anointed with refreshing oil.

My eyes observed my enemies;

 When the wicked rose against me,

 My ears were informed.

The righteous will flourish like a palm tree,

 Grow lofty as a cedar in Lebanon,

Planted in the house of the Lord,

 Blooming in the courts of our God.

Giving fruit into old age,

 Luxuriant and verdant will they be,

Telling that God is good—

 My Rock, with no wickedness in Him.

LITERARY COMMENTARY

This is the only psalm (besides Psalm 30) with a heading that stipulates the liturgical occasion for which it was used in antiquity, the Sabbath; yet it contains no explicit reference to the Sabbath. It may have been selected because of its beginning and its end. It opens by depicting the worshiper's satisfaction on contemplating God's creative activity, a mood that one might imagine as corresponding to the mood of God Himself contemplating His own completed work on the first Sabbath day. It closes by describing the rewards of the righteous, which were understood by rabbinic thinkers as being in the World-to-Come, of which the Sabbath is a prefiguring. From an exegetical point of view, the psalm thus looks backward to Creation and forward to the World-to-Come, a stance in line with the understanding of Psalms 95–99. The middle verses of the psalm (For lo, Your enemies, O Lord / For lo, Your enemies will perish), dealing with the downfall of the wicked, bear a remarkable similarity in form and rhythm to a passage in a pagan creation text from Ugarit dating from about the thirteenth century BCE, which may have been an inspiration to the poet of the Psalms.

COMMENTARY ON THE ILLUMINATIONS

salm 92, the special psalm for Shabbat, recounts how, during the sacred Shabbat, the righteous Jewish soul is transplanted into the Temple's sacred space to praise God's eternal goodness. The illuminations present a mystical allegory of the Shekhinah and the soul planted in the sacred place and time. The mystical tradition compares the glory of the Shekhinah, the Shabbat bride, to the fragrance and beauty of the Field of Holy Apples, within which the verses rest. On the eve of Shabbat, the tradition holds, God unites with the Sabbath bride in the holy field, and the souls of the righteous spring from their union.[53] The branches of these apple trees grow in a branching fractal pattern, such as may be found throughout the natural world; the fractal here has tree branches branching in the shape of the Hebrew letter *shin*, as in the divine name *Shaddai*, found on every mezuzah scroll. The potted cedar and palm draw upon the psalm's comparison of the two trees to the righteous person. Growing not outside but instead transplanted to the sacred precincts of the Temple, they flourish—their height, strength, and sweet fruit praising the Creator.

יהוה מָלָךְ! גֵּאוּת לָבֵשׁ:
לָבֵשׁ יהוה עֹז הִתְאַזָּר!
אַף־תִּכּוֹן תֵּבֵל,
בַּל־תִּמּוֹט:
נָכוֹן כִּסְאֲךָ מֵאָז,
מֵעוֹלָם אָתָּה:

נָשְׂאוּ נְהָרוֹת יהוה,
נָשְׂאוּ נְהָרוֹת קוֹלָם
יִשְׂאוּ נְהָרוֹת דָּכְיָם:
מִקֹּלוֹת מַיִם רַבִּים אַדִּירִים
מִשְׁבְּרֵי־יָם,
אַדִּיר בַּמָּרוֹם יהוה:
עֵדֹתֶיךָ נֶאֶמְנוּ מְאֹד,
לְבֵיתְךָ נָאֲוָה־קֹדֶשׁ,

The Lord reigns! He is robed in majesty.
The Lord is robed, girded in might!
The world, too, is set firm.
It does not totter.
Your throne has been firmly set from of old,
You are eternal.

The rivers raise, O Lord,
The rivers raise their voice,
The rivers raise their surge.
Mightier than the voices of multitudinous waters,
Than the mighty breakers of the sea,
Lord is mighty on high.
Your covenants are surely steadfast
For Your house, the Holy Sanctuary,
O Lord, for ever more.

Literary Commentary

Another Throne Ascension psalm, Psalm 93 foregrounds the oceans' submission and homage to God as He takes His throne on the newly established earth. The same ancient rhythm as that commented on in connection with Psalm 92 appears in Psalm 93: "The rivers raise, O Lord,/The rivers raise their voice,/The rivers raise their surge," pointing to a similar origin.

Commentary on the Illuminations

he Mishnah records that during the Second Temple period, the Levites recited Psalm 93 as Sabbath arrived,[54] hailing God's royal dominion over the world, observed through the power of His created seas and the sanctity of His glorious Temple.

The illuminations express God's royalty through images of divine dominion surfacing through the ocean waves. In the Hebrew illumination, we see a crown, modeled upon a Torah crown from the destroyed Jewish community of Danzig, rising through the thunderous waves; in the English, the golden menorah of the Temple shimmers through the water. As elsewhere in these illuminations, the palmette border recalls the decorations of Solomon's Temple.[55]

MOURNERS' KADDISH

The following prayer, said by mourners, requires the presence of a minyan.

(אבל:) יִתְגַּדַּל וְיִתְקַדַּשׁ שְׁמֵהּ רַבָּא.
(קהל: אָמֵן)
בְּעָלְמָא דִּי בְרָא כִרְעוּתֵהּ
וְיַמְלִיךְ מַלְכוּתֵהּ
בְּחַיֵּיכוֹן וּבְיוֹמֵיכוֹן
וּבְחַיֵּי דְכָל בֵּית יִשְׂרָאֵל,
בַּעֲגָלָא וּבִזְמַן קָרִיב,
וְאִמְרוּ אָמֵן. (קהל: אָמֵן)
(קהל ואבל:) יְהֵא שְׁמֵהּ רַבָּא מְבָרַךְ לְעָלַם
וּלְעָלְמֵי עָלְמַיָּא.

(Mourner:) Magnified and sanctified be the Great Name

(Congregation:) Amen,

In accordance with His will, in the world that He created,

May His kingdom be established

In your lives and in your days

and in the lifetime of all Israel,

Speedily and soon.

Say: Amen,

(All:) may the Great Name be blessed

forever and ever.

(אבל:) יִתְבָּרַךְ וְיִשְׁתַּבַּח וְיִתְפָּאַר
וְיִתְרוֹמַם וְיִתְנַשֵּׂא וְיִתְהַדָּר
וְיִתְעַלֶּה וְיִתְהַלָּל שְׁמֵהּ דְּקֻדְשָׁא
בְּרִיךְ הוּא, (קהל: בְּרִיךְ הוּא)
לְעֵלָּא מִן כָּל בִּרְכָתָא וְשִׁירָתָא,
(בשבת שובה:) לְעֵלָּא לְעֵלָּא מִן כָּל בִּרְכָתָא
וְשִׁירָתָא, תֻּשְׁבְּחָתָא וְנֶחֱמָתָא
דַּאֲמִירָן בְּעָלְמָא,
וְאִמְרוּ אָמֵן. (קהל: אָמֵן)

(Mourner:) Blessed, praised, extolled,

elevated, raised up,

glorified, lauded, and exalted

be the name of the Holy One, blessed is He,

(Congregation:) Blessed is He,

high above all songs and blessings, praises,

and hymns that are spoken in the world.

Say: Amen.

יְהֵא שְׁלָמָא רַבָּא מִן שְׁמַיָּא,
וְחַיִּים עָלֵינוּ וְעַל כָּל יִשְׂרָאֵל,
וְאִמְרוּ אָמֵן. (קהל: אָמֵן)

May great peace and life from heaven be upon us

and all Israel.

Say: Amen.

Bow, take three steps back, as if taking leave of the Divine Presence, then bow, first left, then right, then center, while saying:

Bow, take three steps back, as if taking leave of the Divine Presence; then bow, first left, then right, then center, while saying:

עֹשֶׂה שָׁלוֹם בִּמְרוֹמָיו, הוּא יַעֲשֶׂה שָׁלוֹם עָלֵינוּ וְעַל
כָּל יִשְׂרָאֵל,
וְאִמְרוּ אָמֵן. (קהל: אָמֵן)

May He who makes peace in His heaven make peace for us

and all Israel.

Say: Amen.

Note on chanting: Congregational responses are indicated in blue in the illuminations.

Literary Commentary

Kaddish had its origin as a benediction upon the students, offered by a teacher at the end of a lesson. This can be seen from the fact that it is addressed to the congregation in the second person and refers to God in the third person, whereas true prayers address God in the second person and refer to the congregation, if at all, in the third person. Kaddish was transferred to the synagogue service in its function as a concluding prayer, but its use was extended so that it now concludes units within the prayer service. Over the centuries, additional petitions were added to it, with the result that there are now several versions with different functions in the service, all of them longer than the original benediction (the basis of what is now called "Half-Kaddish"). In the Middle Ages, it became customary for mourners and people observing the anniversary of the death of a close relative to recite the final Kaddish at the end of a service. But there is no reference to the dead in any version of Kaddish except the one recited at a cemetery. The person reciting Kaddish is actually wishing the congregation that they live to see the messianic era, when God's name will be truly magnified and sanctified, in accordance with the prophecy of Ezek. 38:23. I have translated the word *neḥemata* as "hymns" rather than "consolations," in accordance with the best recent scholarship on the etymology of this puzzling word.

Commentary on the Illuminations

he gravity of the verses of the Mourners' Kaddish, as well as the solemn emotions of those chanting it during *yahrzeit* observances, calls for simplicity. The illuminations focus on the words themselves, accompanied only by the blue-and-gold arabesque pattern symbolizing the *shefa*, the celestial everflow that suffuses the conjoined material and supernal worlds.

א) בַּמֶּה מַדְלִיקִין וּבַמֶּה אֵין מַדְלִיקִין, אֵין מַדְלִיקִין לֹא בְלֶכֶשׁ וְלֹא בְחֹסֶן, וְלֹא בְכַלָּךְ, וְלֹא בִפְתִילַת הָאִידָן, וְלֹא בִפְתִילַת הַמִּדְבָּר, וְלֹא בִירוֹקָה שֶׁעַל פְּנֵי הַמַּיִם. לֹא בְזֶפֶת, וְלֹא בְשַׁעֲוָה, וְלֹא בְשֶׁמֶן קִיק, וְלֹא בְשֶׁמֶן שְׂרֵפָה, וְלֹא בְאַלְיָה, וְלֹא בְחֵלֶב. נַחוּם הַמָּדִי אוֹמֵר, מַדְלִיקִין בְּחֵלֶב מְבֻשָּׁל. וַחֲכָמִים אוֹמְרִים, אֶחָד מְבֻשָּׁל וְאֶחָד שֶׁאֵינוֹ מְבֻשָּׁל אֵין מַדְלִיקִין בּוֹ.

ב) אֵין מַדְלִיקִין בְּשֶׁמֶן שְׂרֵפָה בְּיוֹם טוֹב. רַבִּי יִשְׁמָעֵאל אוֹמֵר, אֵין מַדְלִיקִין בְּעִטְרָן, מִפְּנֵי כְּבוֹד הַשַּׁבָּת. וַחֲכָמִים מַתִּירִין בְּכָל הַשְּׁמָנִים, בְּשֶׁמֶן שֻׁמְשְׁמִין, בְּשֶׁמֶן אֱגוֹזִים, בְּשֶׁמֶן צְנוֹנוֹת, בְּשֶׁמֶן דָּגִים, בְּשֶׁמֶן פַּקּוּעוֹת, בְּעִטְרָן וּבְנֵפְט. רַבִּי טַרְפוֹן אוֹמֵר, אֵין מַדְלִיקִין אֶלָּא בְשֶׁמֶן זַיִת בִּלְבָד.

ג) כָּל הַיּוֹצֵא מִן הָעֵץ אֵין מַדְלִיקִין בּוֹ, אֶלָּא פִשְׁתָּן. וְכָל הַיּוֹצֵא מִן הָעֵץ אֵינוֹ מִטַּמֵּא טֻמְאַת אֹהָלִים, אֶלָּא פִשְׁתָּן. פְּתִילַת הַבֶּגֶד שֶׁקִּפְּלָהּ וְלֹא הִבְהֲבָהּ, רַבִּי אֱלִיעֶזֶר אוֹמֵר, טְמֵאָה הִיא, וְאֵין מַדְלִיקִין בָּהּ. רַבִּי עֲקִיבָא אוֹמֵר, טְהוֹרָה הִיא, וּמַדְלִיקִין בָּהּ.

ד) לֹא יִקֹּב אָדָם שְׁפוֹפֶרֶת שֶׁל בֵּיצָה וִימַלְאֶנָּה שֶׁמֶן וְיִתְּנֶנָּה עַל פִּי הַנֵּר בִּשְׁבִיל שֶׁתְּהֵא מְנַטֶּפֶת, וַאֲפִלּוּ הִיא שֶׁל חֶרֶס. וְרַבִּי יְהוּדָה מַתִּיר. אֲבָל אִם חִבְּרָהּ הַיּוֹצֵר מִתְּחִלָּה מֻתָּר, מִפְּנֵי שֶׁהוּא כְּלִי אֶחָד. לֹא יְמַלֵּא אָדָם קְעָרָה שֶׁמֶן וְיִתְּנֶנָּה בְּצַד הַנֵּר וְיִתֵּן רֹאשׁ הַפְּתִילָה בְּתוֹכָהּ בִּשְׁבִיל שֶׁתְּהֵא שׁוֹאֶבֶת. וְרַבִּי יְהוּדָה מַתִּיר.

ה) הַמְכַבֶּה אֶת הַנֵּר מִפְּנֵי שֶׁהוּא מִתְיָרֵא מִפְּנֵי גוֹיִם, מִפְּנֵי לִסְטִים, מִפְּנֵי רוּחַ רָעָה, אוֹ בִּשְׁבִיל הַחוֹלֶה שֶׁיִּישָׁן, פָּטוּר. כְּחָס עַל הַנֵּר, כְּחָס עַל הַשֶּׁמֶן, כְּחָס עַל הַפְּתִילָה, חַיָּב. רַבִּי יוֹסֵי פּוֹטֵר בְּכֻלָּן, חוּץ מִן הַפְּתִילָה, מִפְּנֵי שֶׁהוּא עוֹשָׂה פֶּחָם.

1) With what wicks may we light the Sabbath lamp and with what may we not light? We may not use a wick of cedar bast, or uncombed flax, or raw silk, or a wick made of willow bast or desert weed, or seaweed. [For oil] we may not use pitch, or wax, or cottonseed oil or [contaminated consecrated] oil that must be destroyed by burning, or fate from sheeps' tail or tallow. Naḥum the Mede says: We may use boiled tallow. But the Sages say: Whether boiled or not boiled, we may not use it.

2) [Contaminated consecrated] oil that must be destroyed by burning may not be used for a festival lamp. Rabbi Ishma'el says: We may not use tar, out of respect for the honor due to the Sabbath. But the Sages permit all these oils: sesame oil, nut oil, radish oil, fish oil, gourd oil, tar, or naphtha. Rabbi Tarfon, however, says: We may use only olive oil.

3) No product from a tree may be used as a wick for the Sabbath lamp, except flax. Also no product of a tree can contract "tent" uncleanness, except flax. If a wick was made from a cloth that has been twisted but not singed, Rabbi Eliezer declares, it is susceptible to contamination and may not be used for the Sabbath lamp.

4) One may not pierce an eggshell, fill it with oil, and put it over the mouth of a lamp so that the oil may drip from it into the lamp, even if the vessel is of earthenware, but Rabbi Judah permits it. If, however, the potter had originally attached it to the lamp, it is permitted because it constitutes a single vessel. One may not fill a bowl with oil, put it beside a lamp, and put the end of the wick in it so that it draws oil from the bowl, but Rabbi Judah permits this.

5) One who extinguishes a lamp because he is afraid of heathens, robbers, or depression, or to enable a sick person to sleep, is not liable [for violating the Sabbath]. If he did it to spare the lamp, or the oil, or the wick, he is liable. Rabbi Yose absolves him in all these cases except that of sparing the wick because he thereby turns it into charcoal.

ו) עַל שָׁלֹשׁ עֲבֵרוֹת נָשִׁים מֵתוֹת בִּשְׁעַת לֵדָתָן, עַל שֶׁאֵינָן זְהִירוֹת בְּנִדָּה, בְּחַלָּה, וּבְהַדְלָקַת הַנֵּר.

ז) שְׁלֹשָׁה דְבָרִים צָרִיךְ אָדָם לוֹמַר בְּתוֹךְ בֵּיתוֹ עֶרֶב שַׁבָּת עִם חֲשֵׁכָה, עִשַּׂרְתֶּם, עֵרַבְתֶּם, הַדְלִיקוּ אֶת הַנֵּר. סָפֵק חֲשֵׁכָה סָפֵק אֵינָהּ חֲשֵׁכָה, אֵין מְעַשְּׂרִין אֶת הַוַּדַּאי, וְאֵין מַטְבִּילִין אֶת הַכֵּלִים, וְאֵין מַדְלִיקִין אֶת הַנֵּרוֹת, אֲבָל מְעַשְּׂרִין אֶת הַדְּמַאי, וּמְעָרְבִין, וְטוֹמְנִין אֶת הַחַמִּין.

תַּנְיָא, אָמַר רַבִּי חֲנִינָא: חַיָּב אָדָם לְמַשְׁמֵשׁ בְּבִגְדָיו בְּעֶרֶב שַׁבָּת עִם חֲשֵׁכָה, שֶׁמָּא יִשְׁכַּח וְיֵצֵא. אָמַר רַב יוֹסֵף: הִלְכְתָא רַבְּתָא לְשַׁבַּתָּא.

אָמַר רַבִּי אֶלְעָזָר אָמַר רַבִּי חֲנִינָא: תַּלְמִידֵי חֲכָמִים מַרְבִּים שָׁלוֹם בָּעוֹלָם, שֶׁנֶּאֱמַר: וְכָל בָּנַיִךְ לִמּוּדֵי יְהוָה, וְרַב שְׁלוֹם בָּנָיִךְ. אַל תִּקְרֵי בָּנָיִךְ, אֶלָּא בּוֹנָיִךְ. שָׁלוֹם רָב לְאֹהֲבֵי תוֹרָתֶךָ, וְאֵין לָמוֹ מִכְשׁוֹל. יְהִי שָׁלוֹם בְּחֵילֵךְ, שַׁלְוָה בְּאַרְמְנוֹתָיִךְ. לְמַעַן אַחַי וְרֵעָי, אֲדַבְּרָה נָּא שָׁלוֹם בָּךְ. לְמַעַן בֵּית יְהוָה אֱלֹהֵינוּ, אֲבַקְשָׁה טוֹב לָךְ. יְהוָה עֹז לְעַמּוֹ יִתֵּן, יְהוָה יְבָרֵךְ אֶת עַמּוֹ בַשָּׁלוֹם.

6) For three transgressions, women may die in childbirth: for being careless in observing the laws of menstruation, separating challah [dough-offering], and lighting the Sabbath light.

7) One should say three things at home on the eve of the Sabbath just before dark: Have you tithed? Have you prepared the *eruv*? Light the Sabbath lamp. If there is doubt whether darkness has fallen, we may not tithe definitely untithed produce, nor immerse [unclean] vessels, nor light the Sabbath lamp. We may tithe produce about which there is doubt whether it has been tithed, we may prepare an *eruv*, and we may insulate hot food.

It was taught, Rabbi Ḥanina said: One should examine his clothing on the eve of the Sabbath before nightfall [to ensure that one is not carrying anything], for one may forget and go out. Rav Yosef said: This is an important law about the Sabbath [for it is easy to forget and thus inadvertently violate the holiness of the day].

Rabbi Eliezer said in the name of Rabbi Ḥanina: The disciples of the Sages increase peace in the world, as it is said, "And all your children shall be taught of the Lord, and great shall be the peace of your children [*banayikh*]. Read not *banayikh*, "your children," but *bonayikh*, "your builders." Those who love Your Torah have great peace; there is no stumbling block for them. May there be peace within your ramparts, prosperity in your palaces. For the sake of my brothers and friends, I shall say, "Peace be within you." For the sake of the House of the Lord our God, I will seek your good. May the Lord grant strength to His people; may the Lord bless His people with peace.

COMMENTARY ON THE ILLUMINATIONS

This passage from the Mishnah introduces a moment during which we may celebrate Shabbat through the act of learning. At the same time, we connect our present and past as we study upon the substances permissible for the Sabbath lights and review the mitzvot essential for the women who kindle them. The texts are flanked by paintings of cosmic light sources, as well as sources of the Shabbat lights that we bless, stretching from the early universe to the biblical period and our present.

On the first spread, the border of the English page presents the night falling in the natural world; the brilliant sunset glows beneath the deep sky, showing us the early universe; a double-wicked ancient Israelite oil lamp sends light to the heavens from the human world. On the Hebrew side, we see the seeds and plants from which appropriate oils might be pressed.

By the time we reach the second spread, time has moved on. The plants have begun to sprout, promising a new generation to supply the oil for Sabbath lights, while the starry sky now presents the constellations visible over Jerusalem on the night of Israel's Independence Day: Camelopardalis, Cepheus, Rukba, and Ursa Minor.

RABBIS' KADDISH

The following prayer, said by mourners, requires the presence of a minyan.

(אבל:) יִתְגַּדַּל וְיִתְקַדַּשׁ שְׁמֵהּ רַבָּא.

Magnified and sanctified be the Great Name

(קהל: אָמֵן)

(Congregation:) Amen.

בְּעָלְמָא דִּי בְרָא כִרְעוּתֵהּ

In accordance with His will, in the world that He created,

וְיַמְלִיךְ מַלְכוּתֵהּ

May His kingdom be established

בְּחַיֵּיכוֹן וּבְיוֹמֵיכוֹן

In your lives and in your days

וּבְחַיֵּי דְכָל בֵּית יִשְׂרָאֵל,

and in the lifetime of all Israel,

בַּעֲגָלָא וּבִזְמַן קָרִיב,

Speedily and soon.

וְאִמְרוּ אָמֵן. (קהל: אָמֵן)

Say: Amen.

(Congregation:) Amen.

(קהל ואבל:) יְהֵא שְׁמֵהּ רַבָּא מְבָרַךְ לְעָלַם וּלְעָלְמֵי עָלְמַיָּא.

May the Great Name be blessed

forever and ever.

(אבל:) יִתְבָּרַךְ וְיִשְׁתַּבַּח וְיִתְפָּאַר

Blessed, praised, extolled,

וְיִתְרוֹמַם וְיִתְנַשֵּׂא וְיִתְהַדָּר

elevated, raised up,

וְיִתְעַלֶּה וְיִתְהַלָּל שְׁמֵהּ דְּקֻדְשָׁא

glorified, lauded, and exalted

בְּרִיךְ הוּא, (קהל: בְּרִיךְ הוּא)

be the name of the Holy One, blessed is He,

(Congregation:) Blessed be He

לְעֵלָּא מִן כָּל בִּרְכָתָא וְשִׁירָתָא,

high above all songs and blessings, praises,

(בשבת שובה: לְעֵלָּא לְעֵלָּא מִן כָּל בִּרְכָתָא)

תֻּשְׁבְּחָתָא וְנֶחֱמָתָא, דַּאֲמִירָן בְּעָלְמָא,

and hymns that are spoken in the world.

וְאִמְרוּ אָמֵן. (קהל: אָמֵן)

Say: Amen. (Congregation:) Amen.

עַל יִשְׂרָאֵל וְעַל רַבָּנָן, וְעַל תַּלְמִידֵיהוֹן
וְעַל כָּל תַּלְמִידֵי תַלְמִידֵיהוֹן,
וְעַל כָּל מָאן דְּעָסְקִין בְּאוֹרַיְתָא,
דִּי בְאַתְרָא (בארץ ישראל: קַדִּישָׁה) הָדֵין,
וְדִי בְכָל אֲתַר וַאֲתַר.
יְהֵא לְהוֹן וּלְכוֹן שְׁלָמָא רַבָּא,
חִנָּא וְחִסְדָּא, וְרַחֲמֵי, וְחַיֵּי אֲרִיכֵי,
וּמְזוֹנֵי רְוִיחֵי, וּפֻרְקָנָא, מִן קֳדָם אֲבוּהוֹן
דִּי בִשְׁמַיָּא, וְאִמְרוּ אָמֵן. (קהל: אָמֵן)

Upon Israel and its rabbis,
Their disciples and their disciples' disciples,
And all who occupy themselves with the Torah,
In this place [in Israel, add: holy] and in every place—
upon them and upon you—
May there be much peace, favor, grace, and mercy,
Long life, abundant food, and salvation
from their Father in heaven.
Say: Amen.
(Congregation:) Amen.

יְהֵא שְׁלָמָא רַבָּא מִן שְׁמַיָּא,
וְחַיִּים (טוֹבִים) עָלֵינוּ וְעַל כָּל יִשְׂרָאֵל,
וְאִמְרוּ אָמֵן. (קהל: אָמֵן)

May great peace and (good) life from heaven
be upon us and all Israel.
Say: Amen. (Congregation:) Amen.

(Bow, take three steps back, as if taking leave of the divine presence;
then bow, first left, then right, then center, while saying:)

עֹשֶׂה שָׁלוֹם (בשבת שובה: הַשָּׁלוֹם) בִּמְרוֹמָיו, הוּא
יַעֲשֶׂה שָׁלוֹם עָלֵינוּ וְעַל כָּל יִשְׂרָאֵל,
וְאִמְרוּ אָמֵן. (קהל: אָמֵן)

(Bow, take three steps back, as if taking leave of the divine presence;
then bow, first left, then right, then center, while saying:)

May He who makes peace in His heaven make peace
for us and all Israel in his mercy.
Say: Amen. (Congregation:) Amen.

LITERARY COMMENTARY

Please see the literary commentary on the Mourners' Kaddish on page 188.

COMMENTARY ON THE ILLUMINATIONS

As in the Mourners' Kaddish, the solemnity of the moment calls for simple treatment. This Kaddish, however, draws down heaven's blessings for the generations of Israel's scholars, whose traditions of learning transmit Torah from earlier generations to the present and whose teaching and legal activities guide Jewish daily life. The micrographic borders create imagery of Jerusalem, using text from the beginning of Maimonides' *Mishneh Torah*,[56] that traces the chain of transmission of the Written Torah and the Oral Torah from Moses through the prophets to the rabbis.

BLESSING THE CHILDREN

יְשִׂמְךָ אֱלֹהִים כְּאֶפְרַיִם וְכִמְנַשֶּׁה:

May God make you like Ephraim and Menasseh.

or

יְשִׂמֵךְ אֱלֹהִים כְּשָׂרָה רִבְקָה רָחֵל וְלֵאָה:

May God make you like Sarah, Rebecca, Rachel, and Leah.

יְבָרֶכְךָ יהוה וְיִשְׁמְרֶךָ:

May the Lord bless you and protect you.

יָאֵר יהוה פָּנָיו אֵלֶיךָ וִיחֻנֶּךָּ:

May the Lord shine His face upon you and favor you.

יִשָּׂא יהוה פָּנָיו אֵלֶיךָ וְיָשֵׂם לְךָ שָׁלוֹם:

May the Lord lift His face toward you and grant you peace.

COMMENTARY ON THE ILLUMINATIONS

All of us blessed with children wish many things for them—a long and healthy life, love, learning and spiritual joy, success and prosperity, and many more blessings. Yet for parents, these all amount to wishing each child a serene soul—indeed, for all the nation of Israel, a serene soul. No text better captures the nature of the grace that I pray will be granted to my children than Jer. 31:12, prophesying that Israel's "soul shall be as a watered garden." The illuminations depict the luxuriant garden of the serene soul, held within the parent's two hands as they rise to call down divine blessing. In kabbalah, the ten fingers of the hands symbolize the ten *sefirot*, channeling God's creative energy into the material world.[57] Droplets of the divine everflow, the *shefa,* float beside the initial words of the Priestly Blessing (Num. 6:24–26).

At right, the *ḥamsa*—a traditional hand-shaped Sephardic and eastern Jewish amulet for divine protection—presents an apple tree laden with fruit, bringing to mind the kabbalistic likening of the Shekhinah, the Shabbat bride, to a field of holy apples. The single stalk of pink lilies in each painting suggests the value of Torah in the imperfect human world. As we have seen earlier, the Psalmist regarded the palm tree as a symbol of the righteous person. The trees and surrounding plants thrive next to a river, the flowing water that throughout Jewish lore symbolizes Torah and that the kabbalists associated with divine wisdom. As we see throughout this work, the eagle calls to mind God's power and ultimate protection of Israel. The geometric pattern painted within the palm of each hand is part of a classical Moorish pattern, part of the visual world of the medieval Sephardic Jews, expressing the notion that all matter flows from, and returns to, God. The paintings are bordered with the full verse of Jeremiah's prophecy (31:12): "They shall come and sing in the height of Zion and shall flow to the bounty of the Lord, for wheat and for wine, and for oil and for the young of the flock and of the herd and their soul shall be like a watered garden."

The first four verses are sung, often three times.

שָׁלוֹם עֲלֵיכֶם, מַלְאֲכֵי הַשָּׁרֵת, מַלְאֲכֵי עֶלְיוֹן,
מִמֶּלֶךְ מַלְכֵי הַמְּלָכִים, הַקָּדוֹשׁ בָּרוּךְ הוּא.

Welcome, servant-angels, messengers of the Highest
from the King, the King of Kings, the Blessed Holy One.

בּוֹאֲכֶם לְשָׁלוֹם, מַלְאֲכֵי הַשָּׁלוֹם, מַלְאֲכֵי עֶלְיוֹן,
מִמֶּלֶךְ מַלְכֵי הַמְּלָכִים, הַקָּדוֹשׁ בָּרוּךְ הוּא.

Come in peace, angels of peace, messengers of the Highest,
from the King, the King of Kings, the Blessed Holy One.

בָּרְכוּנִי לְשָׁלוֹם, מַלְאֲכֵי הַשָּׁלוֹם, מַלְאֲכֵי עֶלְיוֹן,
מִמֶּלֶךְ מַלְכֵי הַמְּלָכִים, הַקָּדוֹשׁ בָּרוּךְ הוּא.

Bless me with peace, angels of peace, messengers of the Highest,
from the King, the King of Kings, the Blessed Holy One.

צֵאתְכֶם לְשָׁלוֹם, מַלְאֲכֵי הַשָּׁלוֹם, מַלְאֲכֵי עֶלְיוֹן,
מִמֶּלֶךְ מַלְכֵי הַמְּלָכִים, הַקָּדוֹשׁ בָּרוּךְ הוּא.

Go in peace, angels of peace, messengers of the Highest,
from the King, the King of Kings, the Blessed Holy One.

כִּי מַלְאָכָיו יְצַוֶּה לָּךְ,
לִשְׁמָרְךָ בְּכָל דְּרָכֶיךָ.
יְיָ יִשְׁמָר צֵאתְךָ וּבוֹאֶךָ,
מֵעַתָּה וְעַד עוֹלָם.

For He will order his angels in your behalf
to protect you wherever you go.
The Lord will guard your coming and going
now and forever.

Literary Commentary

The custom of welcoming the angels to the Sabbath table by reciting this invocation was introduced in the seventeenth century by the kabbalists. It is related to the statement in the Talmud (Shabbat 119b) that each person is accompanied home from the synagogue on Friday night by a benevolent angel and a malevolent one; if he finds the lamp lit, the table set, and the bed made, the benevolent angel prays that he find the same on the following Sabbath, and the malevolent angel has no choice but to answer "amen." Otherwise, the malevolent angel prays that he find the same on the following Sabbath, and the benevolent angel has no choice but to answer "amen." This Talmudic statement is also the basis of the poem by Bialik in this volume.

"Shalom aleikhem" is more like an incantation than a poem, for each of its four lines repeats the identical address to the angels, with the only difference between the lines being the first pair of words. Petitions to angels were frowned upon by the Talmud and are therefore rare in the Jewish liturgy. Nevertheless, this text has been adopted by most Jewish communities worldwide.

amily and friends who are gathered around the Sabbath dinner table begin the Sabbath feast by singing "Shalom aleikhem." The song, with its four rhythmic verses, successively welcomes the angels, bids them enter, asks their blessing, and finally wishes them a peaceful departure; some traditions insert a penultimate verse, urging the angels to stay for a while. Mystical tradition holds that the readiness of the home for Shabbat is crucial to making the angels feel welcome and satisfied with their stay. The words of the poem are inscribed at the left in the crimson, blue, purple, and gold prescribed in Exodus 26 and 28 for the hangings of the Ark of the Covenant (and later described in the biblical accounts of Solomon's Temple) and the priestly vestments. The repeated sequence of colors in the verses echoes the rhythmic sequence of the phrases within each verse.

The eighteenth-century Turkish kabbalistic manual Ḥemdat yamim describes how preparation of the home should be carefully completed just before Shabbat begins so that the home is fresh and ready for the angels to accompany the family into the sacred time in their own sacred space. Here, the young family has prepared its home for Shabbat. Transformed from its workaday backdrop of work, school, child-rearing, and mundane activity, the home has become the family's sacred space. Now the angels accompany the family home from synagogue to enjoy their Shabbat together. The family's unity embodies the Shabbat unification of wisdom, life, and matter, blessed by the angels, the messengers of the divine.

The painting presents a visual allegory of the unity of all matter, of the divine blessings that the family enjoys as the nearly hidden angels accompany them home to celebrate Shabbat in their beloved home, illuminated by the light of the Shabbat candles. The scene, which emphasizes the dark and light contrast that separates the sacred hours of Shabbat from the workweek, infuses the material world of the family's environment with the same hues that not only enhance the lines of the poem but also decorated the ark and the Temple. Ahead of the accompanying angels whose arms stretch over them in blessing, the family enters its home as into a palace; the weedy paving stones outside give way to immaculate tile, and the blue doors swing wide to reveal the candlelit Shabbat table within. The two columns suggest the two pillars at the gates of the Temple, named Boaz and Yakhin, whose capitals were carved with networks of pomegranates, as recorded in 1 Kings.

Just beyond the column at right stands a potted palm; as we saw above, Psalm 92 likens the righteous person to a tall, straight, sweetly fruiting date palm. Just as the palm in those illuminations flourishes within the sacred walls of the Temple, here it grows within the family's home. The midrash on Psalm 92 describes the relationship of the graceful palm to the righteous of Israel: "Like the palm tree that sends out no fewer than three shoots, so the people of Israel are never without their complement of three righteous men, like Abraham, Isaac, and Jacob, or like Ḥanania, Mishael, and Azaria…. Or, like the palm tree, whose trunk goes straight up toward the sky, the heart of Israel is directed to their Father in heaven."[58]

Stretching over the doorway are branches of an olive tree. The olive produces the oil used both for anointing priests and kings and for illuminating homes. In Psalm 128, the Psalmist compares children clustered around the family table to the shoots that spring from the olive-tree roots. Behind the branches, the family glimpses the night sky; this view of the deep sky recorded by the Hubble Space Telescope includes imagery of some of the oldest galaxies in the universe, formed close to the moment of Creation.[59]

Two decorative borders surround the painting. The inner border presents a palmette motif adapted from a small ivory plaque found among a trove of artifacts from ninth–eighth-century BCE Samaria, contemporary with the First Temple. Similar palmette designs were ubiquitous across the ancient Mediterranean basin and are, in fact, described in 1 Kings 6:32 among the decorations for the Temple in nearby Jerusalem.[60] The vivid floral border not only calls to mind the fragrance and color that the roses and lilies add to the Shabbat table but also alludes to specific qualities of the family's Jewish home life. Midrash describes the thorny Burning Bush as a humble rosebush, teaching that "no place is devoid of God's presence, not even a thornbush."[61] The pink lilies allude to a famous midrash that compares a stalk of fragrant pink lilies growing in an otherwise ruined royal orchard to the value of the Ten Commandments in the corrupt human world.[62] The angels have accompanied this family into their home to celebrate a restful Shabbat infused with pleasure, tradition, and worship of the Creator.

Eᴉsʜᴇᴛ Ḥᴀʏɪʟ

אֵשֶׁת חַיִל מִי יִמְצָא	A powerful woman—who can find one?
וְרָחֹק מִפְּנִינִים מִכְרָהּ׃	Her worth would be far beyond pearls.
בָּטַח בָּהּ לֵב בַּעְלָהּ	Her husband's heart can count on her
וְשָׁלָל לֹא יֶחְסָר׃	And lack no gain.
גְּמָלַתְהוּ טוֹב וְלֹא־רָע	She does him good and never harm
כֹּל יְמֵי חַיֶּיהָ׃	All her life long.
דָּרְשָׁה צֶמֶר וּפִשְׁתִּים	She goes looking for wool and flax.
וַתַּעַשׂ בְּחֵפֶץ כַּפֶּיהָ׃	Her hands work with a will.
הָיְתָה כָּאֳנִיּוֹת סוֹחֵר	Like a merchant ship she is—
מִמֶּרְחָק תָּבִיא לַחְמָהּ׃	From afar she brings her bread.
וַתָּקָם ׀ בְּעוֹד לַיְלָה	She rises while it is still night
וַתִּתֵּן טֶרֶף לְבֵיתָהּ	To give food to her family
וְחֹק לְנַעֲרֹתֶיהָ׃	And their due to her maids.
זָמְמָה שָׂדֶה וַתִּקָּחֵהוּ	She considers a field and buys it,
מִפְּרִי כַפֶּיהָ נָטְעָה כָּרֶם׃	Plants a vineyard with her hands' yield.
חָגְרָה בְעוֹז מָתְנֶיהָ	She ties her belt on firmly,
וַתְּאַמֵּץ זְרוֹעֹתֶיהָ׃	Braces her arms.
טָעֲמָה כִּי־טוֹב סַחְרָהּ	She realizes that her business goes well.
לֹא־יִכְבֶּה בַלַּיִל נֵרָהּ׃	Her lamp does not go out at night.
יָדֶיהָ שִׁלְּחָה בַכִּישׁוֹר	She sets her hand to the distaff.
וְכַפֶּיהָ תָּמְכוּ פָלֶךְ׃	Her palms hold up the spindle.

<div dir="rtl">

כַּפָּהּ פָּרְשָׂה לֶעָנִי

וְיָדֶיהָ שִׁלְּחָה לָאֶבְיוֹן:

לֹא־תִירָא לְבֵיתָהּ מִשָּׁלֶג

כִּי כָל־בֵּיתָהּ לָבֻשׁ שָׁנִים:

מַרְבַדִּים עָשְׂתָה־לָּהּ

שֵׁשׁ וְאַרְגָּמָן לְבוּשָׁהּ:

נוֹדָע בַּשְּׁעָרִים בַּעְלָהּ

בְּשִׁבְתּוֹ עִם־זִקְנֵי־אָרֶץ:

סָדִין עָשְׂתָה וַתִּמְכֹּר

וַחֲגוֹר נָתְנָה לַכְּנַעֲנִי:

עוֹז־וְהָדָר לְבוּשָׁהּ

וַתִּשְׂחַק לְיוֹם אַחֲרוֹן:

פִּיהָ פָּתְחָה בְחָכְמָה

וְתוֹרַת־חֶסֶד עַל־לְשׁוֹנָהּ:

צוֹפִיָּה הֲלִיכוֹת בֵּיתָהּ

וְלֶחֶם עַצְלוּת לֹא תֹאכֵל:

קָמוּ בָנֶיהָ וַיְאַשְּׁרוּהָ

בַּעְלָהּ וַיְהַלְלָהּ:

רַבּוֹת בָּנוֹת עָשׂוּ חָיִל

וְאַתְּ עָלִית עַל־כֻּלָּנָה:

שֶׁקֶר הַחֵן וְהֶבֶל הַיֹּפִי

אִשָּׁה יִרְאַת־יְהֹוָה הִיא תִתְהַלָּל:

תְּנוּ־לָהּ מִפְּרִי יָדֶיהָ

וִיהַלְלוּהָ בַשְּׁעָרִים מַעֲשֶׂיהָ:

</div>

She opens her palm to the poor.
 She stretches her hand to the pauper.
She has no fear for her household in snow,
 For all her household wear scarlet wool.
She provides bedding for herself.
 Linen and crimson are her garments.
Her husband is distinguished in the city gates,
 Sitting among the elders of the land.
She makes wraps and sells them,
 Supplies sashes to merchants.
Her own clothing is strength and splendor.
 She can laugh at the future.
She opens her mouth with wisdom.
 On her tongue are kindly adages.
She keeps an eye on the doings of her household.
 She eats no idle bread.
Her children rise to bless her;
 Her husband, to praise her.
"Many women are powerful,
 But you excel them all!"
Charm is false, and beauty fleeting.
 A God-fearing woman alone deserves praise.
Celebrate the fruit of her two hands!
 Her accomplishments praise her in the city square.

LITERARY COMMENTARY

The poem on the excellent wife that comprises the last twenty-two verses of the book of Proverbs was introduced to the Shabbat home ritual by the Safed kabbalists. In the book of Proverbs, the passage is an encomium on the ideal wife and, in this sense, is understood by most observant Jews today, who recite it in gratitude for the wife's efforts in preparing the Shabbat meal. But to the kabbalists, the woman is the Shekhinah; the recitation of the chapter, like the recitation of the Song of Songs and so many other rituals, was part of the reinterpretation of Shabbat as the enactment of the sacred marriage between the *tiferet* and *malkhut*—between God or the Sabbath and Israel.

Like all biblical poetry, the passage is made up of verses that divide naturally into two parts such that the first half-verse makes a statement and the second half-verse adds a complementary statement; often the two statements mirror each other in some way, so that the second reinforces or contrasts with the first. Our

passage is arranged as an acrostic according to the twenty-two letters of the Hebrew alphabet. The poem begins by stating the woman's value to her husband, goes on to describe her multifarious activities and skills, and concludes with the praise that she enjoys from others. Tradition maintains that the author of the book of Proverbs, including our poem, was Solomon, but academic scholars have not reached a consensus about the date of the book or of this passage.

The wife depicted in this passage is an energetic, effective, and kindly manager of the household and its associated business affairs. We learn nothing of the husband except that he can count on her and that—presumably, thanks to her efforts—he is respected among the elders of his town.

It may be surprising to observe that among the activities for which the woman garners praise are her business acumen and her agricultural activities. Even in the purely domestic realm, she appears to be more a business manager than a traditional homemaker; we hear nothing, for example, of her cooking, cleaning, or doing the laundry, but a lot about her production of items that can be sold and about the uses to which she puts the profits. Of course, women in antiquity were under the control of men, but the scope for their enterprise was not as limited as we sometimes imagine.

In view of the fact that the virtues described in the poem are entirely of the domestic and mercantile type, the usual translation of the opening as "a woman of valor" seems to miss the point. The Hebrew word ḥayil usually has the same military connotations as the English word "valor" but is also used to connote strength in any sphere of activity or good personal character. Thus, "a woman of substance" would also be an acceptable translation.

COMMENTARY ON THE ILLUMINATIONS

he illuminations present a flourishing oak tree in an allegory of the wisdom and strength of the Shabbat bride, the Shekhinah, and the homemaker who embodies her as we sit down at the dinner table to begin our Shabbat feast. My maternal grandmother, Bessie Pakman Swift, was the oak from which all life in my family sprang. The very model of the rebbetsin (rabbi's wife), committed not only to her husband, children, and home but also to her London community through wartime and rebuilding, regal leader of countless Jewish and non-Jewish women's organizations throughout mid-twentieth-century England and South Africa—all paths in our extended family led back to her. I spent the night of her passing at my worktable, making an eishet ḥayil, depicting her as an oak for her youngest child, my mother. That same strength and wisdom has characterized Jewish homemakers throughout the ages and inspires these illuminations.

This ode to the Shekhinah focuses primarily on the woman's material accomplishments. Only a few lines explicitly describe her moral, spiritual, or emotional qualities. However, in many biblical contexts, skills in material matters embody wisdom. For instance, in directing Moses to appoint Bezalel to build the Tabernacle, God praises Bezalel: "I have endowed him with a divine spirit of wisdom, ability, and knowledge in every kind of work" (Exod. 31:3). As wisdom flows into the material world on Shabbat, it pervades and inspires the concrete mundane matters of the world.

Trees—oak trees, in particular—vividly evoke the idea of the powerful woman, the allegorical embodiment of the Shekhinah on earth. The Zohar compares her to the Tree of Life. Commenting on the verse "she does him good and never harm all her life long," the character of R. Yose interpreted:

"She provides good for the world, for the temple of the King and those who frequent it. When is this? When those 'days of heaven' shine upon her and unite with her fitly, these being then the 'days of her life' because the Tree of Life has sent to her life and shines upon her." Said R. Abba: "All this is well said, and all these verses can be applied to the Community of Israel."[63]

The double focus on the tree's roots and branches suggests the balanced strength of the wise person. *Pirkei avot*, or *Ethics of the Fathers*, an anthology of ethical statements attributed to the rabbis of the Mishnah (the first major codification of Jewish law, accomplished by the end of the second century BCE), compares the wise person to the tree whose strong roots can hold it. The tree's roots hold it firm in the face of harsh winds and nourish the tree in times of drought.[64] Isaiah prophesied that Israel would be reborn after conquest, "like the terebinth and the oak, of which stumps are left even when they are felled: its [the tree's] stump shall be a holy seed."[65] The canopy of trees presented here allows the light from the heavens to flicker through its leaves, yet it shelters the doves and squirrels nested within it. The tree's strong roots protect the grasses and lilies growing among them, and hide the acorns that will give rise to the tree's next generation. Roses and grapes twine around the oak's strong trunk.

These items sheltered by this oak embody the values that the powerful woman instills in her home and family. Noah's dove signaled the survival of life on earth as it returned home bearing its olive branch; in Jewish allegorical readings of the Song of Songs, the gentle dove embodies Israel's trust in God.[66] In a famous midrash, a stalk of fragrant pink lilies alone in a ruined orchard symbolizes the value of the Ten Commandments in an otherwise corrupt human world.[67] Throughout Jewish ritual and lore, grapes suggest joy and sanctification; in the illuminations of kiddush herein, we have already explored the metaphorical relationship between the wine from the grape and divine wisdom. During the Sephardic Golden Age, as Raymond Scheindlin points out, "in the secular poetry, 'gazelle' is a code word for the lover; in religious poetry, for God or the Messiah."[68] Roses symbolize many things in Jewish lore. In the Song of Songs, the rose symbolizes physical beauty; but midrash on the Burning Bush describes the miraculous plant, representing God's power over nature, as a rosebush.[69]

The initial letter *alef* of the text is illuminated in gold. A "great Hasidic saint" of the late eighteenth and early nineteenth centuries, R. Mendel Torum of Rymanov, suggested that at Sinai, the assembled Israelites heard not all the Ten Commandments, nor the whole Torah, but only the initial *alef* of the first word of the First Commandment, *anokhi*. Since the *alef* itself has no sound, Gershom Scholem understood that R. Torum "transformed the revelation on Mount Sinai into a mystical revelation, pregnant with infinite meaning, but without specific meaning. In order to become a foundation of religious authority, it had to be translated into human language, and that is what Moses did."[70] The enlarged initial *alef* of *Eishet ḥayil* similarly signals that divine wisdom animates the very worldly activities of the wise woman who embodies the qualities of the Shekhinah as Shabbat begins.

אַתְקִינוּ סְעוּדָתָא דִמְהֵימְנוּתָא שְׁלֵימָתָא,
חֶדְוָתָא דְמַלְכָּא קַדִּישָׁא.
אַתְקִינוּ סְעוּדָתָא דְמַלְכָּא,
דָּא הִיא סְעוּדָתָא דַחֲקַל תַּפּוּחִין קַדִּישִׁין,
וּזְעֵיר אַנְפִּין וְעַתִּיקָא קַדִּישָׁא אַתְיָן
לְסַעֲדָא בַּהֲדַהּ.

Prepare the feast of perfect faith,
the joy of the Holy King.
Prepare the feast of the King.
This is the feast of the Holy Apple Orchard,
and the Impatient One and the Ancient Holy One
come to dine with her.

אֲזַמֵּר בִּשְׁבָחִין
לְמֵיעַל גּוֹ פִתְחִין,
דִּבְחֲקַל תַּפּוּחִין,
דְּאִנּוּן קַדִּישִׁין.

I now sing songs of praise
to enter the gates
of the Field of Apple Trees
that are holy.

נְזַמֵּן לָהּ הַשְׁתָּא,
בִּפְתוֹרָא חַדְתָּא,
וּבִמְנַרְתָּא טַבְתָּא,
דְּנַהֲרָא עַל רֵישִׁין.

We herewith welcome her
with a new table
and a well-trimmed lamp
shining on every head,

יְמִינָא וּשְׂמָאלָא,
וּבֵינַיְהוּ כַלָּה,
בְּקִשּׁוּטִין אַזְלָא,
וּמָאנִין וּלְבוּשִׁין.

one on the right and one on the left,
and the bride walks between them,
with her ornaments,
fine clothes and raiment.

יְחַבֵּק לָהּ בַּעְלָהּ,
וּבִיסוֹדָא דִילָהּ,
דְּעָבֵיד נַיְחָא לָהּ,
יְהֵא כַּתִּישׁ כַּתִּישִׁין.

Her husband embraces her,
and into her foundation
he pours his pressings,
which give her pleasure.

צְוָחִין אַף עַקְתִין,
בְּטֵלִין וּשְׁבִיתִין,
בְּרַם אַנְפִּין חַדְתִּין,
וְרוּחִין עִם נַפְשִׁין.

Cries and suffering
are canceled and annulled,
but every face rejoices,
every soul and spirit.

חֲדוּ סַגִּי יֵיתֵי,
וְעַל חֲדָא תַּרְתֵּי,
נְהוֹרָא לָהּ יִמְטֵי,
וּבִרְכָאן דִּנְפִישִׁין.

Great joy comes,
in a double measure.
Light reaches her,
abundant blessings, too.

קְרִיבוּ שׁוֹשְׁבִינִין,	Groomsmen, come here
עֲבִידוּ תִקּוּנִין,	and make the preparations!
לְאַפָּשָׁא זִינִין,	Set out abundant food,
וְנוּנִין עִם רַחֲשִׁין.	fish and fowl,

לְמֶעְבַּד נִשְׁמָתִין,	making new
וְרוּחִין חַדְתִּין,	souls and spirits
בְּתַרְתִּין וּבִתְלָתִין,	by virtue of the Thirty-Two
וּבִתְלָתָא שְׁבְשִׁין.	and the Three Twigs.

וְעִטּוּרִין שַׁבְעִין לָהּ,	Seventy crowns she has,
וּמַלְכָּא דִלְעֵלָּא,	with the king above,
דְּיִתְעַטַּר כֹּלָּא,	that all may be crowned
בְּקַדִּישׁ קַדִּישִׁין.	by the holiest of the holy ones.

רְשִׁימִין וּסְתִימִין	Engraved and hidden
בְּגוֹ כָּל עַלְמִין,	in her are all the worlds,
בְּרַם עַתִּיק יוֹמִין,	but the Ancient of Days
הֲלָא בַטִישׁ בַּטִישִׁין.	treads them out with His treading.

יְהֵא רַעֲוָא קַמֵּיהּ,	May it be His will
דְּיִשְׁרֵי עַל עַמֵּיהּ	that she abide with His people
דְּיִתְעַנַּג לִשְׁמֵהּ,	who, for His name's sake,
בִּמְתִיקִין וְדֻבְשִׁין.	take pleasure in honey and sweets.

אֲסַדֵּר לִדְרוֹמָא,	On the south, I place
מְנַרְתָּא דִסְתִימָא,	the mystic lamp,
וְשֻׁלְחָן עִם נַהֲמָא,	and on the north, I set
בְּצִפּוֹנָא אַרְשִׁין.	a table with abundant bread,

בְּחַמְרָא גוֹ כַסָּא,	with wine in a goblet,
וּמְדָאנֵי אָסָא	and bunches of myrtle
לְאָרוּס וַאֲרוּסָה,	for the groom and bride,
לְהִתְקְפָּא חַלָּשִׁין.	to fortify the weak.

נַעֲבִיד לְהוֹן כִּתְרִין,	Let us make them crowns
בְּמִלִּין יַקִּירִין,	of precious words,
בְּשַׁבְעִין עִטּוּרִין,	with seventy ornaments
דְּעַל גַּבֵּי חַמְשִׁין.	and fifty more besides.

שְׁכִינְתָּא תִּתְעַטָּר
בְּשִׁית נַהֲמֵי לִסְטַר,
בְּוָוִין תִּתְקַטָּר,
וְזִינִין דְּכְנִישִׁין.

The Shekhinah is adorned
with six loaves on each side,
bound with two times six,
and all the articles assembled.

שְׁבִיתִין וּשְׁבִיקִין,
מְסָאֲבִין דִּרְחִיקִין,
חֲבִילִין דִּמְעִיקִין,
וְכָל זִינֵי חֲבוּשִׁין.

Voided and abandoned
are impure causes of affliction,
oppressive, destroying spirits,
and all kinds of witchcraft.

לְמִבְצַע עַל רִפְתָּא
כְּזֵיתָא וּכְבֵיעֲתָא,
תְּרֵין יוּדִין נָקְטָא:
סְתִימִין וּפְרִישִׁין.

The loaf is broken
into olive- and egg-size pieces,
a loaf that grasps two yods:
one manifest, one hidden.

מְשַׁח זֵיתָא דַכְיָא
דְּטָחֲנִין רֵיחַיָּא
וְנָגְדִין נַחֲלַיָּא
בְּגַוַּהּ בִּלְחִישִׁין.

Pure olive oil
is pressed by millstones
so that rivers of it flow
into her with a whisper.

הֲלָא נֵימָא רָזִין
וּמִלִּין דִּגְנִיזִין,
דְּלֵיתֵיהוֹן מִתְחַזִין
טְמִירִין וּכְבִישִׁין.

We speak of mysteries,
esoteric words,
things not clearly seen
but hidden and obscured,

אִתְעַטְּרַת כַּלָּה
בְּרָזִין דִּלְעֵלָּא
בְּגוֹ הַאי הִלּוּלָא
דְּעִירִין קַדִּישִׁין.

that we may crown the Bride
with supernal mysteries
in this wedding feast
of the Holy Watchers.

LITERARY COMMENTARY

This is the first of the Aramaic poems composed by Isaac Luria (1534–72), the great kabbalist of Safed, to introduce each of the three obligatory Sabbath meals. In the poems, each meal is dedicated to one of the three major manifestations of God envisioned by the kabbalah, and the other two manifestations are described as accompanying the primary one. The chief figure of the Friday night meal is the Field of Holy Apples, which, to the kabbalists, was

another way of referring to the Sabbath bride, or the Shekhinah. The other two manifestations are the "Ancient Holy One" (also called "Ancient of Days"), who is celebrated at the midday Sabbath meal, and the "Impatient One," celebrated at the late afternoon meal.

Like all three poems, this one is preceded by an Aramaic declaration that the meal is intended as a mystical communion. The poem itself consists of twenty stanzas, each made up of three segments that rhyme with one another, and a fourth segment that links all the stanzas in a common rhyme. As in the case of "Lekha dodi," but much more obviously, nearly every detail of this poem refers to a kabbalistic idea or scriptural interpretation put into the service of a kabbalistic idea, but commentators are not in complete agreement as to the meaning of some passages.[71]

- "one on the right and one on the left": The Sabbath is depicted in the kabbalah as walking amid the weekdays, with Wednesday, Thursday, and Friday on her right; and Sunday, Monday, and Tuesday on her left.

- "pressings": Luria is referring to the specially pressed oil used for the lamp stand in the Tabernacle, which, in the kabbalah, signifies the overflow of the upper *sefirot* into the Shekhinah (the consummation of the sacred marriage).

- "the Thirty-Two": the Marvelous Thirty-Two Paths of Wisdom, the source of the extra soul bestowed on those who observe the Sabbath, according to the Zohar.

- "the Three Twigs": The phrase, from Gen. 40:10, has a number of possible interpretations in the kabbalah. The poet may have in mind three of the *sefirot*.

- "Seventy crowns": the seventy words in kiddush (in the Sephardic version preferred by the kabbalists), the numerical value of the Hebrew word for wine, and the number of ornaments worn by the Sabbath bride, according to the Zohar.

- "holiest of the holy ones": probably refers to *keter*, the highest of the ten *sefirot*.

- "treads them out with His treading": According to the Zohar, *malkhut* contains all the worlds in potential; they emerge to reality because of the pressure upon her from the Ancient of Days.

- "On the south": in imitation of the arrangement of the inner chamber of the Tabernacle, where the table with the shewbread was placed to the north and the lamp stand to the south.

- "bunches of myrtle": This medieval custom of ordinary wedding ceremonies was attached to the Sabbath by the kabbalists.

- "fifty": may refer to the number of blessings granted the patriarchs in accordance with kabbalistic exegesis of the word *bakol* in Gen. 24:1.

- "six loaves on each side": i.e., twelve loaves—again, in imitation of the practice in the Tabernacle.

COMMENTARY ON THE ILLUMINATIONS

s we see repeatedly throughout the Kabbalat Shabbat liturgy, the mystical tradition treats Shabbat as the wedding of the bride/queen Shekhinah and her groom, *tiferet*. The illuminations accompany Isaac Luria's colorful and erotically charged poem with imagery traditionally associated with Jewish marriage. All five paintings are bound together by a continuous micrographic design of the Song of Songs. The great biblical love poem was considered by Akiva to be as essential as all Creation, and it became a fundamental source text for the medieval kabbalists, who found within it not only the highest expression of the love between God and Israel but indeed of powerful attraction among the ten *sefirot*.

As any young woman reveals herself and moves toward the *ḥuppa*, she fulfills the suspense of her guests, who stand amazed and delighted at her transformation into a lovely bride. In this depiction of the mystical wedding within the Godhead, the metaphorical, ethereal bride/queen slowly reveals herself within the Field of Holy Apples that is itself another symbol of the Shekhinah. Those trees create the wedding canopy over her head—and soon, that of her groom. The tree trunks divide into fractal branches shaped into the letter *shin*, the initial letter of the divine name inscribed on the back of mezuzah scrolls.

The next three pages transform the three legally required elements of a Jewish wedding into elements of the Shabbat wedding of Shekhinah and *tiferet*: the ring, the *ketuba* signed by two witnesses, and the *yiḥud* (the period of seclusion immediately following the ceremony that symbolizes the consummation of the marriage). This depiction of Shabbat as the divine wedding is founded upon Levi Yitsḥak of Berditchev's suggestion that proper Sabbath observance hangs upon human memory of the divine origin of Creation and the intentional linking of observance with faith in God. Referring to the biblical commandments to *shamor* (keep or observe) and *zakhor* (remember) the Sabbath day, he wrote:

> The Torah clearly spelled out what our thoughts must be when observing the Sabbath properly, i.e., the fact that it is a testimonial to God having created the universe in the six days preceding the first Sabbath. When a Jew refrains from activities forbidden on the Sabbath, but he fails to reflect on the fact that the sanctity of this day is due to [the commandment to remember that God] created the universe in the six days preceding the original Sabbath, such a Jew has not observed the commandment of *keeping* the Sabbath…. The Sabbath is the symbol of our faith that God preceded the universe and therefore is the only Being in the universe deserving to be worshiped as Deity.[72]

The second illumination presents the first of the required wedding elements, the ring. A golden ring hovers in the cosmos, representing the joining of the human and divine brides' lives with their groom's, against a backdrop of the deep sky coupling a current view with light streaming from the early universe,[73] alluding to the notion that all matter has a common beginning in the original moment of Creation.

The third illumination suggests the signing of a mystical *ketuba*, the marriage document that has been a required part of every Jewish wedding since the first century CE. The "document" begins with *bereishit* ("in the beginning"), the first word of the Torah, regarded in midrash and mysticism as the tie between the Jewish people and God. The body consists of the repeating Hebrew alphabet that the kabbalists view as a fundamental quality of the worldly and supernal spheres. Following Levi Yitsḥak's suggestion, the twin commandments of Shabbat, *shamor* and *zakhor*, stand as witnesses to the heavenly marriage.

Next, the heavenly bride and groom embrace in a symbolic *yiḥud*. Shekhinah, floating in her ethereal white gown, and her groom, *tiferet*, clad in the green color associated with this *sefira* in the Zohar and surrounded by the fragrant myrtle branches that the kabbalists associate with Shabbat,[74] clasp each other among the fruitful branches of the Field of Holy Apples, symbolizing their intimate union. The eighteen apples correspond to the numerical value of the Hebrew word *ḥai* ("life"), symbolizing the new souls and spirits mentioned in the poem, the creation of new lives from human love. The Zohar likens human children conceived in the course of Sabbath lovemaking to the souls created by the union of the King (*tiferet*) and the *Matronita* (Shekhinah):

> Come and see! It is written: *Six days you shall labor and do all ... your work, but on the seventh day is Sabbath to YHVH your God* (Exod. 20:9–10). *All your work*—on those six days, the work of all human beings: therefore the Companions couple only when human work is not to be found, but rather the work of the blessed Holy One. And what is His work? Coupling of *Matronita*. Consequently, the Companions sanctify themselves in the holiness of their Lord, concentrating their hearts, and fine children issue, children not straying to the right or to the left, children of the King and *Matronita*.[75]

In the last of the paintings, the micrography of the last three chapters of the Song of Songs winds into the arabesque design that symbolizes the *shefa*, the divine everflow, throughout these paintings.

KIDDUSH

וַיְהִי עֶרֶב וַיְהִי בֹקֶר	Evening came and morning came—
יוֹם הַשִּׁשִּׁי.	the sixth day.
וַיְכֻלּוּ	The sky, the earth, and all their vast contents
הַשָּׁמַיִם וְהָאָרֶץ וְכָל צְבָאָם,	were completed.
וַיְכַל אֱלֹהִים בַּיּוֹם הַשְּׁבִיעִי מְלַאכְתּוֹ	By the seventh day, God had finished all the work
אֲשֶׁר עָשָׂה,	that He had done,
וַיִּשְׁבֹּת בַּיּוֹם הַשְּׁבִיעִי, מִכָּל מְלַאכְתּוֹ	and so He rested on the seventh day from all His work
אֲשֶׁר עָשָׂה.	that He had done.

וַיְבָרֶךְ אֱלֹהִים אֶת יוֹם הַשְּׁבִיעִי וַיְקַדֵּשׁ אֹתוֹ,
כִּי בוֹ שָׁבַת מִכָּל מְלַאכְתּוֹ,
אֲשֶׁר בָּרָא אֱלֹהִים לַעֲשׂוֹת.

He blessed the seventh day and set it apart as holy,
for that was when He rested from making all the things
 that He created.

סַבְרִי מָרָנָן וְרַבָּנָן וְרַבּוֹתַי:

With the consent of all present:

בָּרוּךְ אַתָּה יהוה אֱלֹהֵינוּ מֶלֶךְ הָעוֹלָם,
בּוֹרֵא פְּרִי הַגָּפֶן.

Blessed are You, Lord our God,
 Who created the fruit of the vine.

בָּרוּךְ אַתָּה יהוה אֱלֹהֵינוּ מֶלֶךְ הָעוֹלָם,
אֲשֶׁר קִדְּשָׁנוּ בְּמִצְוֹתָיו
וְרָצָה בָנוּ,
וְשַׁבַּת קָדְשׁוֹ בְּאַהֲבָה וּבְרָצוֹן הִנְחִילָנוּ
זִכָּרוֹן לְמַעֲשֵׂה בְרֵאשִׁית,
כִּי הוּא יוֹם תְּחִלָּה לְמִקְרָאֵי קֹדֶשׁ,
זֵכֶר לִיצִיאַת מִצְרָיִם.

Blessed are You, Lord our God,
 Who set us apart by His commandments,
was pleased with us,
and made His holy Sabbath ours in love and pleasure,
a remembrance of the work of Creation.
Indeed, it is the first of all holy festivals,
a remembrance of the Exodus from Egypt.

כִּי בָנוּ בָחַרְתָּ וְאוֹתָנוּ קִדַּשְׁתָּ מִכָּל הָעַמִּים,
וְשַׁבַּת קָדְשְׁךָ בְּאַהֲבָה וּבְרָצוֹן הִנְחַלְתָּנוּ.
בָּרוּךְ אַתָּה יהוה, מְקַדֵּשׁ הַשַּׁבָּת.

Indeed, You chose us and set us apart among the nations
and made Your holy Sabbath ours in love and pleasure.
Blessed are You, Lord, Who makes the Sabbath holy.

LITERARY COMMENTARY

Kiddush, a declaration of sanctity of the Sabbath, has been known as a home ritual since the time of the Talmud; it is also recited in the synagogue at the end of the evening service for the sake of the homeless. Like many other rites performed outside the framework of the obligatory daily prayers, it is preceded by the drinking of wine, accompanied by its own benediction. The ritual is prefaced with the biblical account of the origin of the Sabbath, the verses of the Creation story relating that God rested on the seventh day of Creation (Gen. 2:1–3). The ritual thus falls into three parts: the biblical passage; the benediction over the wine; and the benediction of the sanctity of the Sabbath. Some recite the first part while standing; others stand for the entire ritual.

Kiddush follows Scripture in offering two explanations for the Sabbath, first saying that it is "a remembrance of the work of Creation," in accordance with Gen. 2:1–3 and the first version of the Ten Commandments (Exod. 20:11); and then saying that it is "a remembrance of the Exodus from Egypt," in accordance with the second version of the Ten Commandments (Deut. 5:15). It also calls the Sabbath "the first of all the holy festivals," referring to the fact that in the Torah's lists of sacred times (Leviticus 23; Num. 28:9 and 29), the Sabbath is mentioned first.

ewish tradition inaugurates almost all sacred times with blessings over wine. The illuminations of the Friday night kiddush express the mystical metaphor of the wine's translation of divine wisdom into the material world. The wine that the young woman in the Song of Songs compares to her lover's kisses symbolizes divine wisdom, according to the Castilian mystic Ezra of Gerona's twelfth-century commentary on that biblical love poetry.[76] Jewish mystical tradition suggests that Shabbat is the time of the week when the light of that wisdom flows most abundantly into our material realm. Jewish lore compares the Torah—the essential expression of divine wisdom—to water, the physical substance that, apart from its component oxygen, is most essential to sustaining life. The micrographic text bordering the two paintings presents Prov. 8:22–31, a seminal text in kabbalistic tradition, in which wisdom, anthropomorphized as a woman, describes how she was created by God as his companion since "the beginning of His course, as the first of His works of old." At right, the Hebrew illumination plays with the image of the wine fountains with which many of us share kiddush with family and friends at our tables. These cups, however, are not arrayed on the typical tiered trays that pipe wine from the uppermost to the lower cups, and this wine is more than the fermented juice of the grape. Instead, this wine overflows from one level to the next, following the kabbalistic metaphor that describes how divine wisdom flows from the highest, most hidden aspects of God, downward until it reaches the material world and finally appears as water. Ezra of Gerona likened divine wisdom to water:

> "See, fear of the Lord is Wisdom" [Job 28:28]. For Wisdom [*hokhma*] is the Holy One's quality of goodness, all existing, going forth and being emanated from the luminescence of Wisdom and continually blessed through it without cessation. Because their origin is from it, it provides the essence of their sustenance. The remaining *sefirot* possess but one request, toward which the entirety of their desire is directed. That is to ascend and enter into the sacred sanctuary, to draw water from the honored fonts of Wisdom.[77]

The cups symbolize the ten *sefirot*, or emanations of God. Each reflects the characteristic color that the mystical tradition assigns to its corresponding *sefira*. Thus, beginning at the top and moving from right to left, the painting presents: *keter*, white and black; *bina*, green; *hokhma*, blue; *gevura*, red; *hesed*, white; *tiferet*, white; *hod*, green; *netsah*, red; *yesod*, white; and, closest to the material world, *malkhut* (Shekhinah), white.[78]

The pyramid arrangement of the cups alludes to the human understanding of order in the universe. Just as the kabbalistic system ascribes to the number ten cosmic significance—for instance, the ten *sefirot*—Pythagorean philosophy regarded the number ten as holy. This classical Greek philosophy considered that the *tetractys*, the pyramid tracing the flow of all geometric form from a single point, symbolized the unity of the universe. The four levels of these cups' Pythagorean pyramid trace the development of geometric form as follows: level 1, the element establishing a single point; level 2, two points determining a line; level 3, three points determining a plane; and level 4, four points determining a tetrahedron, the simplest three-dimensional form.[79]

The water flows down into the material world, tumbling over boulders, perhaps into a mountain stream. Ezra also compared rough boulders to wisdom. Why does wisdom remind the mystic of rocks? The stony cracks and fissures symbolize the task of looking for wisdom in hidden, hard places.[80]

The English illumination at left offers a painting of a single brimming family kiddush cup, bearing not only the wine but also imagery suggesting another aspect of the Shabbat whose holiness we recognize with that wine. The Zohar compares the Shekhinah, the feminine emanation closest to the material realm, to a field of holy apples. On Friday night, "the King is joined with the Sabbath-Bride; the holy field is fertilized, and from their sacred union the souls of the righteous are produced."[81] Isaac Luria's disciple Ḥayyim Vital described the Shabbat queen—the Shekhinah descended to the earthly realm—as the Field of Holy Apples.[82] The eighteen apples growing on the two trees remind us of numerical equivalent of the word ḥai, "life."

WASHING THE HANDS

בָּרוּךְ אַתָּה יהוה אֱלֹהֵינוּ מֶלֶךְ הָעוֹלָם
אֲשֶׁר קִדְּשָׁנוּ בְּמִצְוֹתָיו
וְצִוָּנוּ עַל נְטִילַת יָדָיִם.

Blessed are You, Lord our God, Ruler of the Universe
Who has sanctified us with Your commandments
And commanded us about washing the hands.

COMMENTARY ON THE ILLUMINATIONS

Jewish tradition requires hand-washing accompanied by this blessing before every meal (defined as including bread). Hand-washing, of course, is ordinary before a meal in daily life; but as the completion of cleansing oneself in preparation for the Shabbat feast, hand-washing has a mystical role in rinsing away the stained garment of the pollution, guilt, and general evils of the world to prepare us to receive the *neshama yetera*, the special additional soul brought down by the Shekhinah on Shabbat.[83]

The illumination depicts both the human action of hand-washing before making the *motsi*, the blessing over the challah, and its supernal welcome of the Shekhinah. As a person pours water from a vessel over the hands, the water flows down to nourish the apple tree representing the Shekhinah. The droplets are lit with white, green, blue, and red light, reflecting all the *sefirot* as our special Shabbat souls draw us closer to the heavens. The papercut depicts parents saying "shhh!" to their child, teaching him to obey the rule not to speak between making the blessing for handwashing and *motsi*.

רִבּוֹנוֹ שֶׁל עוֹלָם, מְבַקֶּשֶׁת אֲנִי מִלְפָנֶיךָ—
אָנָּא עֲזָר לִי, שֶׁכְּשֶׁיְּהֵא לֵוִי יִצְחָק שֶׁלִּי מְבָרֵךְ
בְּשַׁבָּת עַל הַחַלּוֹת הָאֵלֶּה, יְכַוֵּן בְּלִבּוֹ אוֹתָן הַכַּוָּנוֹת
שֶׁאֲנִי מְכַוֶּנֶת בְּשָׁעָה זוֹ שֶׁאֲנִי לָשָׁה וְאוֹפָה.

Master of the world: I ask of You—please help me, such that when my Levi Yitsḥak recites the blessing over these loaves on Shabbat, he should have in his heart the same meditations that I have at this time, as I knead and bake.

בָּרוּךְ אַתָּה יהוה, אֱלֹהֵינוּ מֶלֶךְ הָעוֹלָם
הַמּוֹצִיא לֶחֶם מִן הָאָרֶץ:

Blessed are You, Lord our God, Ruler of the Universe, Who brings forth bread from the earth.

COMMENTARY ON THE ILLUMINATIONS

These pages present the *motsi*—the blessing over bread recited prior to eating bread at any meal, whether on Shabbat, festivals, or weekdays—and a woman's short meditation relating to it. All the baker's work at mixing, kneading, and rising develops the protein chains, activates the yeast, and ferments the sugars to create the gas bubbles that "rise" the dough. In Jewish tradition, all this biochemistry causes effects even loftier than feeding appreciative diners at the Shabbat table. We explore these loftier aspects of the challah in two paintings.

At right

This illumination presents one woman's private devotional prayer, a *teḥine*, which links the act of baking the bread to the blessing at the table and elevates the sacred but nonetheless quotidian blessing itself to a special Sabbath meditation. This *teḥine* is especially meaningful for me as I bake my family's weekly challah, since it carries the thoughts of my own ancestress, Perl, wife of the Hasidic master Levi Yitsḥak of Berditchev (1740–1809).[84] Perl's brief meditation surrounds a scene of a woman kneading the challah dough, the ball of dough surrounded by its bed of flour, an egg, and honey. At bottom right, a macroscopic view of budding yeast cells escapes the frame.

At left

At left, the Hebrew and English translation of the actual blessing surround an image conveying the mystical significance of the act of breaking the bread. The two loaves are set within a view of the deep cosmos, suggesting the all-suffusing divine, with the hills of Judaea burgeoning with the wheat harvest.

In simple Jewish practice, the custom of blessing not one but two loaves on Shabbat commemorates the double portion of manna that the Israelites collected for Shabbat during the desert wanderings: "double bread, two *omers* for each" (Exod. 16:22). The Zohar suggests that the two loaves instead symbolize *bina* and Shekhinah.[85] Two kabbalistic guides to Shabbat observance present different kinds of mystical import— and different numbers of loaves. In *Sod ha-Shabbat* (*The Mystery of the Sabbath*, 1507), the Spanish-Turkish kabbalist R. Meir ibn Gabbai suggests that the biblical custom of making the blessing over not one but two loaves of challah on Shabbat has a deeper mystical meaning. The additional loaf alludes to the greater

spirituality of Shabbat, as evidenced by the mystical arrival of the additional soul, the *neshama yetera*. The pair of loaves symbolizes the twin commandments, *shamor* (keep the Sabbath) and *zakhor* (remember the Sabbath); at the supernal level, they symbolize the union of *tiferet* and *malkhut* (Shekhinah). According to the later *Ḥemdat yamim*, Isaac Luria's community in Safed blessed not two but twelve loaves, representing the light streaming from the twelve letters of three names of God.[86]

The challah symbolizes the entire Sabbath meal, which, according to mystical tradition, is the earthly double of the heavenly celebration. Ibn Gabbai presents a vision of the celestial meal that descends from the early *Heikhalot* (Palaces) mysticism that originated during the First Temple period:

> The festive meal of Sabbath night. In the fourth palace, which is called *Zekhut* (Merit), there presides a certain *ḥayya*, or living creature, and under it are four seraphim who are appointed to watch over those who rejoice on the Sabbath. This *ḥayya* and the seraphim beneath it enter that station in the palace called *'oNeG*, Delight, because [each Shabbat] festive tables are arranged there for the children of the king's palace. Thousands upon thousands stand at their tables, and this *ḥayya* who is above the seraphim watches over each table, observing their celebration. When it sees that those present at a [certain] table are rejoicing in honor of the Sabbath, it blesses them. The [celebrants] answer, in turn, "Amen."[87]

The illuminations present an image of two challahs, leaning together as the bottom one is broken, together nourishing both the (human) family and, by extension, their friends and community. The bread is shown sprung from the fields that produced its grain, while the deep sky overhead reminds us of the Eternal's presence within which all the cosmos resides. The four winged seraphim[88] surround and guard this core of the human and heavenly feast.

KOL MEKADESH

כָּל מְקַדֵּשׁ שְׁבִיעִי כָּרָאוּי לוֹ,	All who sanctify the Sabbath as it deserves,
כָּל שׁוֹמֵר שַׁבָּת כַּדָּת, מֵחַלְּלוֹ,	All who keep the day from profanation
שְׂכָרוֹ הַרְבֵּה מְאֹד עַל פִּי פָעֳלוֹ	Will be rewarded in accordance with their deeds—
אִישׁ עַל מַחֲנֵהוּ וְאִישׁ עַל דִּגְלוֹ.	"Each one in his camp, each one by his standard."
אוֹהֲבֵי יהוה הַמְחַכִּים לְבִנְיַן אֲרִיאֵל	Friends of God who await the Temple's restoration:
בְּיוֹם הַשַּׁבָּת שִׂישׂוּ וְשִׂמְחוּ	Rejoice on the Sabbath like those
כִּמְקַבְּלֵי מַתַּן נַחֲלִיאֵל	who first received the Torah.
גַּם שְׂאוּ יְדֵיכֶם קֹדֶשׁ וְאִמְרוּ לָאֵל	Lift up your hands in holiness and say to God,
בָּרוּךְ יהוה אֲשֶׁר נָתַן מְנוּחָה לְעַמּוֹ יִשְׂרָאֵל.	"Blessed is the Lord, Who has given Israel rest."
דּוֹרְשֵׁי יהוה זֶרַע אַבְרָהָם אוֹהֲבוֹ	You who seek the Lord, the seed of Abraham, His friend,
הַמְאַחֲרִים לָצֵאת מִן הַשַּׁבָּת וּמְמַהֲרִים לָבוֹא	You who begin the Sabbath early, and keep it until late,
וּשְׂמֵחִים לְשָׁמְרוֹ וּלְעָרֵב עֵרוּבוֹ,	Who observe it gladly and gladly set its boundaries—

זֶה הַיּוֹם עָשָׂה יהוה
נָגִילָה וְנִשְׂמְחָה בוֹ.

זִכְרוּ תּוֹרַת מֹשֶׁה
בְּמִצְוַת שַׁבָּת גְּרוּסָה
חֲרוּתָה לַיּוֹם הַשְּׁבִיעִי
כְּכַלָּה בֵּין רֵעוֹתֶיהָ מְשֻׁבָּצָה
טְהוֹרִים יִירָשׁוּהָ וִיקַדְּשׁוּהָ
בְּמַאֲמַר כָּל אֲשֶׁר עָשָׂה
וַיְכַל אֱלֹהִים בַּיּוֹם הַשְּׁבִיעִי מְלַאכְתּוֹ
אֲשֶׁר עָשָׂה.

יוֹם קָדוֹשׁ הוּא, מִבּוֹאוֹ וְעַד צֵאתוֹ
כָּל זֶרַע יַעֲקֹב יְכַבְּדוּהוּ, כִּדְבַר הַמֶּלֶךְ וְדָתוֹ
לָנוּחַ בּוֹ וְלִשְׂמֹחַ בְּתַעֲנוּג אָכוֹל וְשָׁתֹה
כָּל עֲדַת יִשְׂרָאֵל יַעֲשׂוּ אֹתוֹ.

מְשֹׁךְ חַסְדְּךָ לְיֹדְעֶיךָ,
אֵל קַנּוֹא וְנוֹקֵם,
נוֹטְרֵי לַיּוֹם הַשְּׁבִיעִי זָכוֹר
וְשָׁמוֹר לְהָקֵם
שַׂמְּחֵם בְּבִנְיַן שָׁלֵם,
בְּאוֹר פָּנֶיךָ תַּבְהִיקֵם,
יִרְוְיֻן מִדֶּשֶׁן בֵּיתֶךָ,
וְנַחַל עֲדָנֶיךָ תַשְׁקֵם:

עֲזֹר לַשּׁוֹבְתִים בַּשְּׁבִיעִי,
בֶּחָרִישׁ וּבַקָּצִיר עוֹלָמִים
פּוֹסְעִים בּוֹ פְּסִיעָה קְטַנָּה, סוֹעֲדִים בּוֹ,
לְבָרֵךְ שָׁלֹשׁ פְּעָמִים
צִדְקָתָם תַּצְהִיר כְּאוֹר
שִׁבְעַת הַיָּמִים,
יהוה אֱלֹהֵי יִשְׂרָאֵל, הָבָה תָמִים.

"This is the day the Lord has made!
 On it, let us rejoice and be happy."

Remember my servant Moses's Law
with its Sabbath teaching,
The seventh day engraved therein,
like a bride amid her bridesmaids.
The pure will acquire it and sanctify it in obedience
to God Who made all things:
"And on the seventh day, God completed the work
 that He had done."

A holy day it is from its beginning until its end.
All Jacob's seed revere it as the royal word and law,
Resting on it and rejoicing with delight in food and drink.
"The whole congregation of Israel will observe it."

O God of zeal and vengeance,
draw Your favor over those who know You,
Those who keep the seventh day,
remembering and observing.
Give them joy of Jerusalem rebuilt,
make them gleam with Your face's light,
"May they eat their fill of Your house's fat;
 let them quaff Your rivers of delight."

Help those who ever rest on the seventh day in plow-
 and harvest-time,
Who walk gently on that day, who dine three times,
 each time reciting Grace.
Make their righteousness shine like the light
 of days of Creation.
"O Lord, God of Israel, grant a perfect outcome."

The author cannot be identified. The name Moses can be spelled with the initial letter of the second word of the first three lines, but this is probably a coincidence, as acrostics are virtually never buried in this manner only to be discontinued after a few lines. The poem consists of seven four-line monorhymed stanzas, each stanza ending with a verse from the Bible. The biblical verses are not always clearly linked with the content of the stanzas and are sometimes used to mean something quite different from their meaning in their biblical context. Thus, the biblical verse that ends the first stanza, which in the Bible (Num. 1:52) refers to the arrangement of the twelve tribes during the Israelites' forty-year march through the desert, is used here as if it meant "each person in his own home and with his own family." The biblical verse in the last stanza, in its biblical source (1 Sam. 14:21), refers to the oracle known as the Urim and Thummim but is used here as if it were a plea to God for a Sabbath perfectly observed and enjoyed. This procedure of using biblical phrases in unexpected ways is a ubiquitous device of medieval Hebrew rhetoric, so common that it would be impossible to comment on it at each occurrence in this book.

The opening stanzas elaborate on the commandment to observe the Sabbath, and the last two pray that God requite the people of Israel for observing the Sabbath by rebuilding the Temple and granting them eternal blessing. Some prayer books have two additional lines, which do not seem to be authentic.

COMMENTARY ON THE ILLUMINATIONS

he illuminations reflect the kabbalistic ideas of the exchange of benefit between the physical and the supernal realms embedded in the song's graceful lines. The author builds his song not only around the set of seven biblical verses but also around concepts basic in classical kabbalah. In *Sod ha-Shabbat*, ibn Gabbai lays out the mystical underpinnings of Shabbat preparations and customs. He suggests that we "add to the holy by taking from the profane [by beginning the Sabbath early]" so that we might "expand the boundaries of the sacred, the mystery of the Shekhinah," the bride who "unites on high with her beloved [*tiferet*], the one who lights up her eyes." R. Meir adds that not only do we contribute to the unification of the *sefirot* but that Shabbat observance leads to our own greater security and pleasure in this world: "One who scrupulously observes this mitzvah will be given ample reward by God in his hour of need; as he meted out, so will he be rewarded."[89]

The illuminations offer imagery drawn from the architecture of late-seventeenth-century Veneto (Italy) synagogues, expressing the joy and bounty promised to those who build their lives around the love of God. The grapevine-embellished columns presented on the first pages are inspired by the wooden columns fronting the ark of the Italian synagogue in Jerusalem; the pomegranate garlands on the second pages

are adapted from carvings in the Ashkenazi Scuola Grande Synagogue of Padua, now preserved in the Israel Museum in Jerusalem.[90] The Shabbat bride enters the scene behind the grand columns, receiving Israel's welcome beneath the lush garlands as she bears the lily stalk that reminds us of the value of the Commandments in the imperfect human world.

Menuḥa V'simḥa

מְנוּחָה וְשִׂמְחָה אוֹר לַיְּהוּדִים-
יוֹם שַׁבָּתוֹן!– יוֹם מַחֲמַדִּים.
שׁוֹמְרָיו וְזוֹכְרָיו
הֵמָּה מְעִידִים,
כִּי לְשִׁשָּׁה כֹּל בְּרוּאִים וְעוֹמְדִים-

Rest for the Jews and joy and light—
the Sabbath day!—light and delight.
By keeping it in mind and deed,
we testify that on the sixth,
all Creation stood complete—

שְׁמֵי שָׁמַיִם אֶרֶץ וְיַמִּים,
כָּל צְבָא מָרוֹם גְּבוֹהִים וְרָמִים,
תַּנִּין וְאָדָם וְחַיַּת רְאֵמִים-
כִּי בְּיָהּ יְיָ
צוּר עוֹלָמִים.

the highest heaven, land, and seas,
the high and lofty throngs above,
ocean creatures, man, and beast—
God shaped them from
the letters of His name.

הוּא אֲשֶׁר דִּבֶּר לְעַם סְגֻלָּתוֹ,
שָׁמוֹר לְקַדְּשׁוֹ מִבּוֹאוֹ וְעַד צֵאתוֹ-
שַׁבַּת קֹדֶשׁ יוֹם חֶמְדָּתוֹ,
כִּי בוֹ שָׁבַת אֵל
מִכָּל מְלַאכְתּוֹ.

He bade His treasured people keep
it holy from start to finish—
the Sabbath, day of His delight,
the day the Lord took rest
from making all His works.

בְּמִצְוַת שַׁבָּת אֵל יַחֲלִיצָךְ,
קוּם קְרָא אֵלָיו יָחִישׁ לְאַמְּצָךְ.
נִשְׁמַת כָּל חַי וְגַם נַעֲרִיצָךְ,
אֱכֹל בְּשִׂמְחָה
כִּי כְבָר רְצָךְ.

By the Sabbath law, God gives you rest.
Go pray to Him, and He will give you strength.
Recite *Nishmat* and *Qedusha*,
then go, eat your bread in joy,
for He is pleased with you.

בְּמִשְׁנֶה לֶחֶם וְקִדּוּשׁ רַבָּה,
בְּרֹב מַטְעַמִּים וְרוּחַ נְדִיבָה-
יִזְכּוּ לְרַב טוּב הַמִּתְעַנְּגִים בָּהּ,
בְּבִיאַת גּוֹאֵל:
לְחַיֵּי הָעוֹלָם הַבָּא.

Two loaves and kiddush of the day,
Food aplenty and a hearty spirit—
Those who enjoy it gain much reward
When the Messiah arrives:
life in the World-to-Come.

213

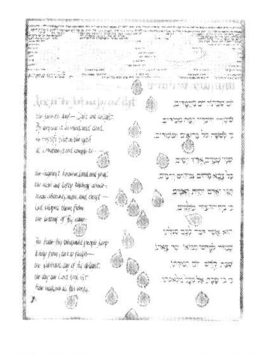

The authorship of this poem of five four-line monorhymed stanzas is unknown. The first letters of the first three stanzas spell the name Moses, but this might be merely a coincidence, since the remaining stanzas do not yield a continuation of the acrostic. The meter is mostly eight syllables to a line. The Hebrew is so compact that it seemed best to translate the four-line stanzas as five lines each. The first two stanzas speak of the Sabbath as a commemoration of the Creation of the world. The third speaks of God's command to observe the Sabbath. The last two stanzas promise that those who celebrate the Sabbath lavishly are rewarded with abundance in this world and in the World-to-Come.

The last line of the second stanza calls for explanation. The Hebrew text is a verbatim quotation of the second half of Isa. 26:4, which is translated in the JPS Bible, "For in Yah the Lord, you have an everlasting Rock." In quoting it, the poet had in mind the interpretation of the verse given by the midrash (Bereishit Raba 12:10, quoted by Rashi on Gen. 2:4) according to which God created the world out of His name Yah, using the letter *hay* to create this world and the letter *yod* to create the next. That is why the translation "God shaped them from the letters of His name" seems so different from the Hebrew.

The first line of stanza 4, "God gives you rest," has been translated in accordance with the meaning of the Hebrew word that seems most appropriate to the context. But other interpretations are possible, as this word is assigned four seemingly unrelated meanings by a midrashic text (Vayikra Raba 34:15). Later in this stanza appear the names of two prayers specific to the Sabbath and festivals: "The breath of every living thing" and the Sabbath version of the *Kedusha*, which begins with the word *na'aritsekha* ("We exalt you"). The last line of stanza 4, "eat your bread in joy," is a partial quotation from Eccles. 9:7. In Ecclesiastes, it is part of an admonition to a young reader to enjoy his youth; but here, it is used to refer to the midday Sabbath meal. This may be seen from the fact that it follows the lines describing the morning service and is followed by mention of kiddush of the day, recited at the midday meal.

COMMENTARY ON THE ILLUMINATIONS

ix days a week the spirit is alone, disregarded, forsaken, forgotten. Working under strain, beset with worries, enmeshed in anxieties, man has no mind for ethereal beauty. But the spirit is waiting for man to join it" (Abraham Joshua Heschel, *The Sabbath*).[91]

"Menuḥa vesimḥa" celebrates the Sabbath refreshment of the soul and unity of all nature—sky, land, and sea—created from the same Hebrew alphabet that embodies the divine name. The illuminations employ the sacred alphabet in micrography, adapting the Song of Songs' image of the walled garden to symbolize the love between young lovers, between husband and wife, between God and Israel, and among the *sefirot* longing for union. According to the mystical tradition, the Hebrew alphabet does far more than simply record the phonetics of words. As far back as the early kabbalistic work *Sefer Yetsira* (ca. 100–200 CE), Jewish mystics have found in the alphabet the very tools of Creation, evidence of the ongoing nature of Creation, and the names and the forms of the divine.[92] The letters composing this garden incorporate a series of Psalms (8, 45, 92, 103, 105, 147, and 148) rejoicing in the elegant harmony of

God's created world, of man's place in the cosmos, of Shabbat, and of song in praise of God.

The micrographic lines present a walled garden under the dusky sky; pomegranate and rosebushes blossom, the fountain purls its musical droplets. Within the intimacy of the garden, we experience the pleasure of fellowship at the table and the pleasure of the Shabbat rest.

The many-seeded pomegranate symbolizes not only fertility but also the 613 mitzvot. The fragrant rose, with its thorny stem, alludes to the Burning Bush of humility—and also of physical beauty. Throughout Jewish lore, fountains symbolize Torah and, in the mystical tradition, the flow of divine wisdom into the world. Flowing here, as throughout this work, the celestial droplets of sky-blue and gold remind us of the *shefa*, the divine everflow, suffusing the created world.

MA YEDIDUT

מַה יְּדִידוּת מְנוּחָתֵךְ,
How lovely is your rest,

אַתְּ שַׁבָּת הַמַּלְכָּה.
O Sabbath queen.

בְּכֵן נָרוּץ לִקְרָאתֵךְ—
We run to greet you—

בּוֹאִי כַלָּה נְסוּכָה—
Come, anointed bride!—

לְבוּשׁ בִּגְדֵי חֲמוּדוֹת,
We wear our festive clothing,

לְהַדְלִיק נֵר בִּבְרָכָה,
we light the lamp, recite the blessing,

וַתֵּכֶל כָּל הָעֲבוֹדוֹת,
finish all our chores, as bidden:

"לֹא תַעֲשׂוּ מְלָאכָה."
"Do no labor."

לְהִתְעַנֵּג בְּתַעֲנוּגִים:
What a pleasure, what delight:

בַּרְבּוּרִים וּשְׂלָו וְדָגִים.
swans and quail and fish!

מֵעֶרֶב מַזְמִינִים
On Friday, we assemble

כָּל מִינֵי מַטְעַמִּים.
food of every kind.

מִבְּעוֹד יוֹם מוּכָנִים,
Before sunset, we prepare,

תַּרְנְגוֹלִים מְפֻטָּמִים.
fattened fowl aplenty.

וְלַעֲרֹךְ בּוֹ כַּמָּה מִינִים,
Varied foods are set out there,

שְׁתוֹת יֵינוֹת מְבֻשָּׂמִים,
fragrant wines to drink,

וְתַפְנוּקֵי מַעֲדַנִּים
delicious delicacies

בְּכָל שָׁלֹשׁ פְּעָמִים.
for each of the three meals.

לְהִתְעַנֵּג בְּתַעֲנוּגִים:
What a pleasure, what delight:

בַּרְבּוּרִים וּשְׂלָו וְדָגִים.
swans and quail and fish!

215

נַחֲלַת יַעֲקֹב יִירַשׁ,
בְּלִי מְצָרִים נַחֲלָה:
וִיכַבְּדוּהוּ, עָשִׁיר וָרָשׁ,
וְתִזְכּוּ לִגְאֻלָּה.
יוֹם שַׁבָּת אִם תְּכַבְּדוּ,
וִהְיִיתֶם לִי סְגֻלָּה,
שֵׁשֶׁת יָמִים תַּעֲבֹדוּ,
וּבַשְּׁבִיעִי נָגִילָה.
לְהִתְעַנֵּג בְּתַעֲנוּגִים:
בַּרְבּוּרִים וּשְׂלָו וְדָגִים.

The estate of father Jacob,
a legacy unlimited:
Observe it, rich and poor,
and thus deserve redemption.
If you keep the Sabbath day,
if you are My treasured folk,
do your work on six weekdays
and pass the seventh day in joy.
 What a pleasure, what delight:
 swans and quail and fish!

חֲפָצֶיךָ אֲסוּרִים
וְגַם לַחֲשֹׁב חֶשְׁבּוֹנוֹת,
הִרְהוּרִים מֻתָּרִים,
וּלְשַׁדֵּךְ הַבָּנוֹת.
וְתִינוֹק לְלַמְּדוֹ סֵפֶר,
לַמְנַצֵּחַ בִּנְגִינוֹת,
וְלַהֲגוֹת בְּאִמְרֵי שֶׁפֶר
בְּכָל פִּנּוֹת וּמַחֲנוֹת.
לְהִתְעַנֵּג בְּתַעֲנוּגִים:
בַּרְבּוּרִים וּשְׂלָו וְדָגִים.

No tending to your business
or reckoning accounts,
but you may do your planning
or arrange a marriage.
Teach your child his lessons,
recite the Psalms in song,
think about the Torah's words
wherever you may dwell.
 What a pleasure, what delight:
 swans and quail and fish!

הִלּוּכְךָ יְהֵא בְנַחַת,
עֹנֶג קְרָא לַשַּׁבָּת!
וְהַשֵּׁנָה מְשֻׁבַּחַת,
כְּדָת נֶפֶשׁ מְשִׁיבַת.
בְּכֵן נַפְשִׁי לְךָ עָרְגָה,
וְלָנוּחַ בְּחִבַּת,
כַּשּׁוֹשַׁנִּים סוּגָה,
בּוֹ יָנוּחוּ בֵּן וּבַת.
לְהִתְעַנֵּג בְּתַעֲנוּגִים:
בַּרְבּוּרִים וּשְׂלָו וְדָגִים.

No bustling, no hurrying:
Make the Sabbath pleasant!
Sleep, too, is a good thing,
Sufficient to restore your strength.
And so my spirit longs for You,
when it can take its rest in love,
when every man and woman rests
as if within a rosy hedge,
 What a pleasure, what delight:
 swans and quail and fish!

מֵעֵין עוֹלָם הַבָּא
יוֹם שַׁבָּת מְנוּחָה.
כָּל הַמִּתְעַנְּגִים בָּהּ
יִזְכּוּ לְרֹב שִׂמְחָה.
מֵחֶבְלֵי מָשִׁיחַ,
יֻצְּלוּ לִרְוָחָה,.

The day of Sabbath rest
is like the World-to-Come.
All who take delight in it
will one day see great joy.
Saved from the turmoil of the messianic age,
they enter a realm of comfort.

פְּדוּתֵנוּ תַצְמִיחַ,
וְנָס יָגוֹן וַאֲנָחָה.
לְהִתְעַנֵּג בְּתַעֲנוּגִים:
בַּרְבּוּרִים וּשְׂלָו וְדָגִים.

Then our salvation will flourish,
and sighs and sorrow vanish.
What a pleasure, what delight:
swans and quail and fish.

LITERARY COMMENTARY

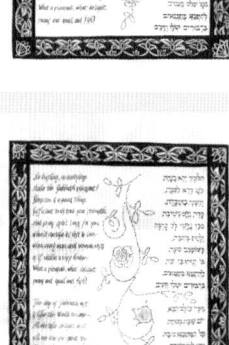

This song, by an unidentified author named Menaḥem, has an unusually complicated verse pattern, consisting of six monorhymed four-line stanzas, in which each line is subdivided into two parts, the first part having its own rhyme. There is also a refrain. There does not appear to be any regular meter. The poem offers an unusually detailed description of the observance of the Sabbath in what sounds like an affluent household. The meals alone are impressive: they consist of fattened fowl, mulled wine, and varied side dishes at every one of the three Sabbath meals; as if this weren't enough food, the refrain wraps up every verse with the mention of swans, quail, and fish. We also get a glimpse of the day's prohibitions and activities (based largely on Talmudic passages at Shabbat 113a–b, 117b, and 150a): no transactions are permitted, but the anxious businessman may do mental financial planning, consider potential husbands for his daughter, and make arrangements to engage a teacher of Torah for his child. (The Talmud also states that one may make arrangements for a son to learn a profession, but this is not mentioned in the poem; where it would be expected, we find only the phrase *lamenatse'aḥ bineginot*, which could mean to sing melodious hymns to God or which may refer to the additional psalms added to the Sabbath morning service.) The poem also speaks of lighting the Sabbath lamps, of not engaging in work, of eating three meals, of walking with a measured pace, and of studying the Torah, and one of the Sabbath's special delights—the afternoon nap. The last stanza sums up the matter by depicting the Sabbath as a foretaste of the World-to-Come.

COMMENTARY ON THE ILLUMINATIONS

s we sing together at Shabbat dinner, we not only revel in the chance to relax with family and friends. We continue to celebrate the Shekhinah's wedding feast. The artwork casts the poem as a wedding celebration. The border offers motifs from a silk velvet brocade wedding jacket from the Jewish community of early-twentieth-century Isfahan,[93] its intricate pattern and luxurious colors conjuring up the sensual pleasures of the grand feast. The micrographic flower vine introduces the text of the Creation stories from Genesis, as we honor the completion of the six days of Creation.

יוֹם זֶה לְיִשְׂרָאֵל אוֹרָה וְשִׂמְחָה, שַׁבַּת מְנוּחָה!

This day is Israel's light and joy: Sabbath rest!

צִוִּיתָ פִּקוּדִים בְּמַעֲמַד הַר סִינַי
שַׁבָּת וּמוֹעֲדִים לִשְׁמֹר בְּכָל שָׁנַי,
לַעֲרֹךְ לְפָנַי מַשְׂאֵת וַאֲרוּחָה.
שַׁבַּת מְנוּחָה!

At Sinai's assembly, You commanded me
To keep the Sabbath and festivals all my life,
To set before me goodly portions.
 Sabbath rest!

חֶמְדַּת הַלְּבָבוֹת, לְאֻמָּה שְׁבוּרָה,
לִנְפָשׁוֹת נִכְאָבוֹת, נְשָׁמָה יְתֵרָה.
לְנֶפֶשׁ מְצֵרָה תָּסִיר אֲנָחָה,
שַׁבַּת מְנוּחָה!

For a broken people, a delight to the heart.
For aching spirits, an extra soul.
Relief for suffering spirits from sorrow.
 Sabbath rest!

קִדַּשְׁתָּ בֵּרַכְתָּ אוֹתוֹ מִכָּל יָמִים.
בְּשֵׁשֶׁת כִּלִּיתָ מְלֶאכֶת עוֹלָמִים.
בּוֹ מָצְאוּ עֲגוּמִים הַשְׁקֵט וּבִטְחָה.
שַׁבַּת מְנוּחָה!

You hallowed it and blessed it above the other days.
In six days, You finished making all the worlds.
The sorrowing find calm and security then.
 Sabbath rest!

לֶאֱסוֹר מְלָאכָה צִוִּיתָנוּ נוֹרָא,
אֶזְכֶּה הוֹד מְלוּכָה אִם שַׁבָּת אֶשְׁמְרָה.
אַקְרִיב שַׁי לַמּוֹרָא מִנְחָה מֶרְקָחָה:
שַׁבַּת מְנוּחָה!

You forbade us labor, fearsome God,
Promised royal splendor if I keep the Sabbath.
So I bring a fragrant offering to the fearsome God:
 Sabbath rest!

חַדֵּשׁ מִקְדָּשֵׁנוּ זָכְרָה נֶחֱרֶבֶת,
טוּבְךָ, מוֹשִׁיעֵנוּ, תְּנָה לַנֶּעֱצֶבֶת,
בְּשַׁבָּת יוֹשֶׁבֶת בְּזֶמֶר וּשְׁבָחָה,
שַׁבַּת מְנוּחָה!

Restore our Temple, God; remember the ruined city!
Grant Your bounty, Savior, to the sorrowing one
Who passes every Sabbath in song and praise to You:
 Sabbath rest!

LITERARY COMMENTARY

This poem is one of the few by Isaac Luria (1534–72), the great kabbalist of Safed, written in Hebrew rather than Aramaic. It appears to have no kabbalistic content. It has a leading stanza, which serves as a refrain to the five three-line stanzas. The rhyme scheme is unusually complicated. The poem treats the Sabbath mostly from the national point of view: the law of the Sabbath was given when the people were assembled to receive the Ten Commandments, at Mount Sinai; it was to be a comfort to them in future suffering. God sanctified the Sabbath because on that day, He completed the work of Creation and promised the people redemption if they would abstain from work on that day. In the last lines, the poet calls

upon God to redeem this promise, using the touching image of Israel as a woman in mourning, who, despite her sorrows, spends the Sabbath in joyful song and praise. The original poem had fifteen stanzas with the acrostic Isaac Luria Hazaq, but only nine appear in prayer books used today.

COMMENTARY ON THE ILLUMINATIONS

heat and roses and grapes and pomegranates and olives and lilies—all these delights are ultimately one, whether seen as chemicals processed through the stars whose origins ignited at the Big Bang, or whether seen simply as the gifts of the providential God of the Creation whose completion we celebrate as Shabbat begins. Over the first verses of the song, branches of these plants spring from a blossom-shaped window into the deep sky, showing the cosmos that has processed all matter, stretching back to the early universe. The poem ends with an image of Jerusalem resting serenely under the sky, surrounded by the same bountiful fruits and flowers, expressing the poet's wish for the holy city's—his home's—restoration.

YAH RIBON

יָהּ, רִבּוֹן עָלַם וְעָלְמַיָּא–
Lord, master of the world, all worlds—

אַנְתְּ הוּא מַלְכָּא מֶלֶךְ מַלְכַיָּא.
You are the King, the King of Kings.

עוֹבַד גְּבוּרְתֵּךְ וְתִמְהַיָּא
To speak of Your mighty works and miracles

שְׁפַר קֳדָמָךְ לְהַחֲוָיָא.
is all my pleasure.

שְׁבָחִין אֲסַדֵּר צַפְרָא וְרַמְשָׁא,
Morning and evening, I set out praises

לָךְ, אֱלָהָא קַדִּישָׁא, דִּי בְרָא כָל נַפְשָׁא–
to You, holy God, who created all life—

עִירִין קַדִּישִׁין, וּבְנֵי אֱנָשָׁא,
holy angels, human beings,

חֵיוַת בָּרָא וְעוֹפֵי שְׁמַיָּא.
beasts of the field and birds that ply the sky.

רַבְרְבִין עוֹבְדֵיךְ וְתַקִּיפִין.
Multitudinous Your works and mighty.

מָכֵךְ רְמַיָּא, וְזַקֵּף כְּפִיפִין,
You bring down the proud, lift up the lowly.

לוּ יִחְיֵ גְבַר שְׁנִין אַלְפִין,
If a person should live a thousand years,

לָא יֵעַל גְּבוּרְתֵּךְ בְּחֻשְׁבְּנַיָּא.
he could not enumerate Your wonders.

אֱלָהָא דִּי לֵהּ יְקַר וּרְבוּתָא,
God of glory, God of power,

פְּרֹק יַת עָנָךְ מִפֻּם אַרְיָוָתָא,
save Your flocks from the lion's jaws

וְאַפֵּק יַת עַמֵּךְ מִגּוֹ גָלוּתָא,
and bring Your people out of exile,

עַמָּא דִּי בְחַרְתְּ מִכָּל אֻמַּיָּא.
the folk You chose from among the nations.

219

לְמִקְדָּשֵׁךְ תּוּב וּלְקֹדֶשׁ קֻדְשִׁין,
אֲתַר דִּי בֵהּ יֶחֱדוּן רוּחִין וְנַפְשִׁין,
וִיזַמְּרוּן לָךְ שִׁירִין וְרַחֲשִׁין
בִּירוּשְׁלֵם, קַרְתָּא דְשֻׁפְרַיָּא.

Come back to Your Temple and its holiest chamber,
where our spirits and our souls will take delight,
and all will sing hymns and praises to You
in Jerusalem, the city of all beauties.

LITERARY COMMENTARY

The author, Rabbi Israel Najara, lived (ca. 1555–ca. 1625) in Damascus and Gaza. He was a kabbalist and author of hundreds of poems, secular and sacred. He was much criticized in his own time for using secular tunes that he had picked up in Turkish coffee shops as the metrical model for his religious poems; but in his own mind, this was his way of exploiting the people's love for Turkish popular songs—Palestine had been incorporated into the Turkish Ottoman Empire early in the sixteenth century—in order to turn them toward religion. Such secular tunes were thought by Sufis to be conducive to religious ecstasy, and it is possible that this was another effect that Najara was hoping to achieve. "Yah ribon" is one of a number of poems that Najara composed in Aramaic, the language of the Zohar, but it does not appear to have any kabbalistic content; in fact, it probably was not written for the Sabbath, as it does not contain any overt reference to the Sabbath and was not included in his book of Sabbath hymns, *Olat shabbat*.

Speaking in the first-person singular, the poet expresses his delight in praising God, who is King of Kings and Creator of all living things, Whose deeds are actually too wide-ranging for man to praise adequately. In the last two stanzas, the speaker prays on behalf of his people that God redeem them from their exile and that God Himself return to Jerusalem, where He will be praised by all Israel.

COMMENTARY ON THE ILLUMINATIONS

The illuminations of "Yah ribon" express the song's theme of divine royalty. Israel's God alone created every element of heaven and earth; God alone has the power to make all humanity equal, raising the powerless and diminishing the powerful; God alone can rescue His chosen people from oppression. All exist, and all thrive within God's domain. Finally, the poet urges God to restore the divine presence to the Temple, enabling our whole beings, "our spirits and our souls," to unify in praise of God, brought together in sacred Jerusalem.

On the Hebrew page, the crown-shaped painting features a sunset landscape. The crown is adapted from the design of a late-nineteenth-century German Torah crown.[94] The sky presents a view of sun rays streaming through clouds at sunset.[95] In the foreground, a couple rises to meet the day near browsing gazelles, a symbol of love throughout Sephardic poetry. Two flowering plants—pink lilies, which allude to the value of the Ten Commandments in the imperfect human world; and the caper plant, which the rabbis of the Talmud suggested symbolizes Israel's ability to persevere through adversity protected by the unseen hand of God—rise in the foreground.

The rosette-shaped painting beneath presents a dawn landscape of sea and sky seen through a newly fruiting fig branch, which symbolizes humankind throughout Jewish lore. The micrographic designs forming Solomon's Knots present a poem in Yiddish and Hebrew, "A Dudele," by the Hasidic master Levi Yitshak of

Berditchev (1740–1809), singing in a more intimate, personal tone of the unity of all things within the Lord of the World:[96]

> Lord of the World.
> Lord of the World.
> Lord of the World,
> I'll sing You a little song of You.
>
> You-You-You
>
> Where will I find You?
> And where won't I find You?
>
> So—here I go—You,
> and—there I go—You,
> always You, however You,
> only You, and ever You.
>
> You—You—You
>
> East—You—West—You,
> North—You—South—You.
>
> You—You—You
>
> The heavens—You. Earth—You.
> On high—You, and below…
> In every direction, and every inflection.
> Still you. However You. Only You. Ever You.
>
> You—You—You

The English page offers an image of the heavens as a golden vessel holding the starry night sky that symbolizes God's all-pervading yet invisible presence. The Solomon's Knots flanking the vessel present a poem of the eleventh-century Spanish Jewish poet Solomon ibn Gabirol, which expresses a theme similar to that of "Yah ribon," God's inimitable royalty and splendor:

> With lowly spirit, lowered knee and head
> In fear I come; I offer Thee my dread.
> But once with Thee, I seem to have no worth
> More than a little worm upon the earth.
>
> O Fullness of the World, Infinity—
> What praise can come, if any can, from me?
> Thy splendor is not contained by the hosts on high,
> And how much less capacity have I!
> Infinite Thou, and infinite Thy ways;
> Therefore the soul expands to sing Thy praise.[97]

צָמְאָה נַפְשִׁי לֵאלֹהִים לְאֵל חָי.	My soul is thirsting for the living God.
לִבִּי וּבְשָׂרִי יְרַנְּנוּ אֶל אֵל־חָי.	My heart, my flesh sing to the living God.
אֵל אֶחָד בְּרָאָנִי,	God, Who is One, created me,
וְאָמַר חַי אָנִי	And said, "As I live,
כִּי לֹא יִרְאַנִי הָאָדָם	No man shall gaze upon Me
וָחָי.	And remain alive."
בָּרָא כֹל בְּחָכְמָה,	He made all things with wisdom,
בְּעֵצָה וּבִמְזִמָּה	Sagacity and counsel.
מְאֹד נֶעְלָמָה	He is altogether hidden
מֵעֵינֵי כָל חָי.	From the sight of all alive.
רָם עַל כֹּל כְּבוֹדוֹ,	His glory is above all.
כָּל פֶּה יְחַוֶּה הוֹדוֹ	Every mouth proclaims His glory.
בָּרוּךְ אֲשֶׁר בְּיָדוֹ	Blessed is He in Whose hand
נֶפֶשׁ כָּל חָי.	Is the soul of all that lives.
הִבְדִּיל נִינֵי תָם,	He set Jacob's seed apart
חֻקִּים לְהוֹרוֹתָם	To teach them His commandments,
אֲשֶׁר יַעֲשֶׂה אוֹתָם	Which a person should
הָאָדָם וָחָי.	Observe that he may live.
מִי זֶה יִצְטַדָּק,	How can one who is mere dust
נִמְשַׁל לְאָבָק דָּק	Claim that he is sinless?
אֱמֶת, כִּי לֹא יִצְדַּק	Truly, in Your sight, no one
לְפָנֶיךָ כָּל חָי.	Is righteous among the living.
בְּלֵב יֵצֶר	The impulses of the heart
חָשׁוּב כִּדְמוּת חֲמַת עַכְשׁוּב	Are like an adder's venom.
וְאֵיכָכָה יָשׁוּב הַבָּשָׂר	How, then, can the flesh
הֶחָי.	return again and live?

נְסוּגִים אִם אָבוּ,	If sinners have the will,
וּמִדַּרְכְּכֶם שָׁבוּ	They may repent their ways,
טֶרֶם יִשְׁכְּבוּ בֵּית מוֹעֵד	Before they take the place
לְכָל חָי.	Assigned to all who live.
עַל כָּל אֲהוֹדֶךָ.	For everything, I thank You.
כָּל פֶּה תִיחֲדֶךָ,	All mouths proclaim Your unity,
פּוֹתֵחַ אֶת־יָדֶךָ	You Whose hand is open
וּמַשְׂבִּיעַ לְכָל־חַי רָצוֹן:	To satisfy all who live.
זְכֹר אַהֲבַת קְדוּמִים,	Remember Your ancient love,
וְהַחֲיֵה נִרְדָּמִים,	Restore the sleeping folk,
וְקָרֵב הַיָּמִים	And bring about the day
אֲשֶׁר בֶּן יִשַׁי חָי.	When Jesse's son will live.
רְאֵה לִגְבֶרֶת אֱמֶת	See how the concubine
שִׁפְחָה נוֹאֶמֶת,	Says to the true wife,
לֹא כִי, בְּנֵךְ הַמֵּת	"Your son is the dead one;
וּבְנִי הֶחָי.	It is my son who lives."
אֶקֹּד עַל אַפִּי,	Down to the ground I bow,
וְאֶפְרֹשׂ לְךָ כַּפִּי,	And spread my hands toward You,
עֵת אֶפְתַּח פִּי	As now I open my mouth to recite
בְּנִשְׁמַת כָּל חָי.	"The breath of all that lives."

LITERARY COMMENTARY

Abraham Ibn Ezra (ca. 1089–ca. 1167) was a distinguished polymath born in Tudela, Spain; in 1140, he left Spain and resided in various places in western Europe until his death. He was the author of secular and abundant liturgical poetry, in addition to books on astronomy, mathematics, Hebrew grammar, and philosophy, as well as commentaries on most of the books of the Bible. It is for these commentaries that he is best known today.

The author's name is found in the poem's acrostic, Ezra being spelled with *hay*. The leading stanza has nine syllables per line and was intended to be used in whole or in part as a refrain. The remaining stanzas are of four lines each, with generally ten syllables per line. The fourth line of each stanza is a part of biblical verse ending in *hay*, except for the last line of the poem, which is not a biblical verse but the opening words of the prayer "The soul of every living thing" (*Nishmat kol ḥai*), from the morning service of Sabbath and festivals. This is a certain indication that the poem was originally intended as an introduction to that prayer and was

meant to be recited as part of the morning service. Two stanzas of the original poem are omitted in most modern prayer books.

- "My heart, my flesh": From Ibn Ezra's exegetical works, we know that in using these terms, he is referring to soul and body.

- "For everything ... Your unity": The wording was originally "You renew the testimony to all Your benefaction, opening Your hand and satisfying all who live." The thought was that God demonstrates His providence at all times by providing every creature with its sustenance. It is not clear why the text was altered.

- "the day ... will live": Referring to the messianic era; Jesse was the father of King David.

- "concubine ... lives": The rivalry between Sarah and Hagar (Abraham's concubine) was considered in the Middle Ages to be a foreshadowing of the rivalry between Judaism and Islam. The poet asks God to observe how the Muslims taunt the Jews, claiming that their religion has perished, while the Muslim religion has survived. The following stanza in the original poem dealt with the rivalry between Judaism and Christianity. Its omission is probably due to self-censorship on the part of Jewish printers in Christian Europe.

COMMENTARY ON THE ILLUMINATIONS

An early morning walk along the rapids of the Potomac River following days of rainstorms inspired these paintings of Ibn Ezra's poem. The illuminations present the divine wisdom for which Ibn Ezra longs revealed in the natural world. The rushing stream—a frequent biblical symbol of Torah; in kabbalah, a symbol of divine wisdom—emerges from an unseen source between the strong roots of an oak tree, another allusion to the wisdom and strength of men and women immersed in Jewish life.[98] A perfect spider's nest hung between blades of grass reveals the precision and elegance of even the smallest creature, while an eagle plunging down toward the water reminds us of God's providential care.[99] At bottom—while the waters fill a cup and transform into the wine that we bless on Shabbat—a gazelle, alluding to the love between God and Israel, satisfies its thirst with the waters of divine wisdom.

BARUKH EL ELYON

בָּרוּךְ אֵל עֶלְיוֹן אֲשֶׁר נָתַן מְנוּחָה, | Blessed is God the Highest, He who gave us rest,

לְנַפְשֵׁנוּ פִדְיוֹן מִשֵּׁאת וַאֲנָחָה, | Who gave our souls relief from suffering and sorrow.

וְהוּא יִדְרוֹשׁ לְצִיּוֹן עִיר הַנִּדָּחָה, | He will care for Zion, the city so neglected.

עַד אָנָה תּוּגְיוֹן נֶפֶשׁ נֶאֱנָחָה. | How much longer must that soul so doleful go on grieving?

הַשּׁוֹמֵר שַׁבָּת, | *Those who keep the Sabbath,*

הַבֵּן עִם הַבַּת, | *men and women both,*

לָאֵל יֵרָצוּ | *delight the Lord, as if they brought*

כְּמִנְחָה עַל מַחֲבַת.

| | an offering on the altar. |

רוֹכֵב בָּעֲרָבוֹת, מֶלֶךְ עוֹלָמִים,
אֶת עַמּוֹ לִשְׁבֹּת אִזֵּן
בַּנְּעִימִים–
בְּמַאֲכָלוֹת עֲרֵבוֹת, בְּמִינֵי מַטְעַמִּים,
בְּמַלְבּוּשֵׁי כָבוֹד, זֶבַח מִשְׁפָּחָה.
הַשּׁוֹמֵר שַׁבָּת,
הַבֵּן עִם הַבַּת,
לָאֵל יֵרָצוּ
כְּמִנְחָה עַל מַחֲבַת.

He who rides upon the clouds, the King Who lives forever,
Bade His people rest and bade them do so with all
 pleasures—
To eat full-flavored dishes, tasty food of every kind,
And dressed in festive clothes, to make a family celebration.
Those who keep the Sabbath,
men and women both,
delight the Lord, as if they brought
an offering on the altar.

וְאַשְׁרֵי כָּל חוֹכֶה לְתַשְׁלוּמֵי כֵפֶל,
מֵאֵת כָּל סוֹכֶה,
שׁוֹכֵן בָּעֲרָפֶל,
נַחֲלָה לוֹ יִזְכֶּה בָּהָר וּבַשֶּׁפֶל–
נַחֲלָה וּמְנוּחָה כַּשֶּׁמֶשׁ לוֹ זָרָחָה.
הַשּׁוֹמֵר שַׁבָּת,
הַבֵּן עִם הַבַּת,
לָאֵל יֵרָצוּ
כְּמִנְחָה עַל מַחֲבַת.

Happy all who can expect to see rewards redoubled
From One Who oversees all things from His dark-cloud
 dwelling.
To such, He grants a heritage in mountain and in plain—
A place where they can rest, as did our father Jacob.
Those who keep the Sabbath,
men and women both,
delight the Lord, as if they brought
an offering on the altar.

כָּל שׁוֹמֵר שַׁבָּת כַּדָּת מֵחַלְּלוֹ
הֵן הֻכְשַׁר חִבַּת קֹדֶשׁ גּוֹרָלוֹ.
וְאִם יֵצֵא חוֹבַת הַיּוֹם
אַשְׁרֵי לוֹ–
אֵל אֵל אָדוֹן מְחוֹלְלוֹ, מִנְחָה הִיא שְׁלוּחָה.
הַשּׁוֹמֵר שַׁבָּת,
הַבֵּן עִם הַבַּת,
לָאֵל יֵרָצוּ
כְּמִנְחָה עַל מַחֲבַת.

Whoever guards the Sabbath and keeps it from profanation
Has proved worthy, having shown his love for sacred things.
And if one fulfills the duties of the day, happy is that
 person!—
For he has brought a true gift to the Lord, his Maker.
Those who keep the Sabbath,
men and women both,
delight the Lord, as if they brought
an offering on the altar.

חֶמְדַּת הַיָּמִים קְרָאוֹ אֵלִי צוּר.
וְאַשְׁרֵי לִתְמִימִים אִם יִהְיֶה נָצוּר.
כֶּתֶר הִלּוּמִים עַל רֹאשָׁם יָצוּר,
צוּר הָעוֹלָמִים רוּחוֹ בָּם נָחָה.
הַשּׁוֹמֵר שַׁבָּת,
הַבֵּן עִם הַבַּת,
לָאֵל יֵרָצוּ
כְּמִנְחָה עַל מַחֲבַת.

My God, my Rock, has called the Sabbath His beloved day.
And happiness is theirs, the good folk who observe it.
He will place a crown well-fitting on their heads,
The spirit of the Rock Eternal rests upon them.
Those who keep the Sabbath,
men and women both,
delight the Lord, as if they brought
an offering on the altar.

זְכוֹר אֶת יוֹם הַשַּׁבָּת לְקַדְּשׁוֹ.

קַרְנוֹ כִּי גָבְהָה,

נֵזֶר עַל רֹאשׁוֹ,

עַל כֵּן יִתֵּן הָאָדָם לְנַפְשׁוֹ,

עֹנֶג וְגַם שִׂמְחָה בָּהֶם לְמָשְׁחָה.

הַשּׁוֹמֵר שַׁבָּת,

הַבֵּן עִם הַבַּת,

לָאֵל יֵרָצוּ

כְּמִנְחָה עַל מַחֲבַת.

קֹדֶשׁ הִיא לָכֶם, שַׁבַּת הַמַּלְכָּה,

אֶל תּוֹךְ בָּתֵּיכֶם לְהָנִיחַ בְּרָכָה,

בְּכָל מוֹשְׁבוֹתֵיכֶם לֹא תַעֲשׂוּ מְלָאכָה,

בְּנֵיכֶם וּבְנוֹתֵיכֶם,

עֶבֶד וְגַם שִׁפְחָה.

הַשּׁוֹמֵר שַׁבָּת,

הַבֵּן עִם הַבַּת,

לָאֵל יֵרָצוּ

כְּמִנְחָה עַל מַחֲבַת.

"Remember the Sabbath day to keep it holy."
When it is held up high,
it becomes a crown upon His head.
Therefore every person should bestow upon himself
Pleasure, jollity, and royal dignity.

Those who keep the Sabbath,
men and women both,
delight the Lord, as if they brought
an offering on the altar.

The Sabbath queen is holy, to be revered by you,
Bringing all prosperity and blessings to your homes.
So do no work of any kind within your habitations—
You, your daughters or your sons,
 your servants male and female.

Those who keep the Sabbath,
men and women both,
delight the Lord, as if they brought
an offering on the altar.

LITERARY COMMENTARY

This seven-stanza poem is by Barukh ben Samuel of Mainz, a prominent Talmudic scholar who died around 1221. There is no definite meter. The poem has four monorhymed four-line stanzas and a refrain, which says that the observance of the Sabbath is as pleasing to God as a sacrifice in the Temple. In making this point, the poet uses the term "an offering brought on a pan," this being one of many kinds of sacrifices detailed in the opening chapters of Leviticus. Since he uses this term merely as a metonymy for sacrifice in general, the phrase has been replaced in the translation with "an offering on the altar."

The "rewards redoubled" promised in stanza 3 refer to a midrash asserting that both the reward for observing the Sabbath and the punishment for breaking it are double. In the same stanza, Jacob is not named explicitly in the poem but by means of an epithet based on a biblical phrase, a very common technique in medieval Hebrew poetry; the association of Jacob with the sunrise comes from Gen. 32:32.

"Has proved worthy, having shown his love for sacred things": The Hebrew is an ingenious adaptation of a Talmudic phrase referring to something that has no intrinsic holiness but that may be treated as if it were holy, out of sheer delight in the ritual.

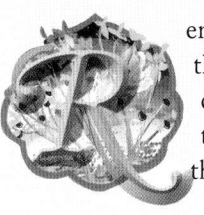

eminiscent of God's leadership of Israel through the desert by means of a pillar of cloud, the illuminations play upon the image of God's wisdom streaming forth from "His dark-cloud dwelling" toward the earth. The plains and mountains are forested with the trees that symbolize life and wisdom; they glint with the all-suffusing light that descends from the distant cosmos and streams through the ever-changing clouds into the human realm.

YOM ZEH MEKHUBAD

יוֹם זֶה מְכֻבָּד מִכָּל יָמִים,	This day is most honored among all days
כִּי בוֹ שָׁבַת צוּר עוֹלָמִים.	For on it, the Rock of Ages took rest.
שֵׁשֶׁת יָמִים תַּעֲשֶׂה מְלַאכְתֶּךָ,	Six days you may do your work,
וְיוֹם הַשְּׁבִיעִי לֵאלֹהֶיךָ,	But the seventh belongs to the Lord.
שַׁבָּת לֹא תַעֲשֶׂה בוֹ מְלָאכָה,	It is the Sabbath: no work thereon,
כִּי כֹל עָשָׂה שֵׁשֶׁת יָמִים.	For in six days He made all things.
יוֹם זֶה מְכֻבָּד מִכָּל יָמִים,	This day is most honored among all days
כִּי בוֹ שָׁבַת צוּר עוֹלָמִים.	For on it, the Rock of Ages took rest.
רִאשׁוֹן הוּא לְמִקְרָאֵי קֹדֶשׁ,	It is the first of all holy days,
יוֹם שַׁבָּתוֹן יוֹם שַׁבַּת קֹדֶשׁ,	A day of cessation, the holy Sabbath.
עַל כֵּן כָּל אִישׁ בְּיֵינוֹ יְקַדֵּשׁ,	So let each person recite kiddush
עַל שְׁתֵּי לֶחֶם יִבְצְעוּ תְמִימִים.	Over wine and break two perfect loaves.
יוֹם זֶה מְכֻבָּד מִכָּל יָמִים,	This day is most honored among all days
כִּי בוֹ שָׁבַת צוּר עוֹלָמִים.	For on it, the Rock of Ages took rest.
אֱכֹל מַשְׁמַנִּים שְׁתֵה מַמְתַּקִּים,	Dine on rich food, drink sweet wine,
כִּי אֵל יִתֵּן לְכָל בּוֹ דְבֵקִים,	For God will grant to His adherents
בֶּגֶד לִלְבּוֹשׁ לֶחֶם חֻקִּים,	Clothing to wear and daily rations:
בָּשָׂר וְדָגִים וְכָל מַטְעַמִּים.	Meat and fish and delicacies.
יוֹם זֶה מְכֻבָּד מִכָּל יָמִים,	This day is most honored among all days
כִּי בוֹ שָׁבַת צוּר עוֹלָמִים.	For on it, the Rock of Ages took rest.

לֹא תֶחְסַר כֹּל בּוֹ וְאָכַלְתָּ	Deny yourself nothing on the Sabbath;
וְשָׂבַעְתָּ וּבֵרַכְתָּ	Eat your fill, and then say grace
אֶת יהוה אֱלֹהֶיךָ אֲשֶׁר אָהַבְתָּ,	To the Lord, the God you love
כִּי בֵרַכְךָ מִכָּל הָעַמִּים.	For blessing you above all nations.
יוֹם זֶה מְכֻבָּד מִכָּל יָמִים,	This day is most honored among all days
כִּי בוֹ שָׁבַת צוּר עוֹלָמִים.	For on it, the Rock of Ages took rest.
הַשָּׁמַיִם מְסַפְּרִים כְּבוֹדוֹ,	The heavens speak of His glory,
וְגַם הָאָרֶץ מָלְאָה חַסְדּוֹ,	The earth is full of His kindness.
רְאוּ כִּי כָל אֵלֶּה עָשְׂתָה יָדוֹ,	See: His hand made all these things.
כִּי הוּא הַצּוּר פָּעֳלוֹ תָמִים.	He, the Rock, Whose work is perfect.
יוֹם זֶה מְכֻבָּד מִכָּל יָמִים,	This day is most honored among all days
כִּי בוֹ שָׁבַת צוּר עוֹלָמִים.	For on it, the Rock of Ages took rest.

LITERARY COMMENTARY

The author named in the acrostic is an unknown poet named Israel. The poem has five stanzas and a leading stanza, which serves as a refrain. The meter is eight syllables to a line. The first stanza speaks of the Sabbath as a day for abstaining from labor, and the last stanzas speak of God's praises. The middle three stanzas are mostly about the tradition of eating plentifully on the Sabbath.

COMMENTARY ON THE ILLUMINATIONS

The vibrant color and energy of these paintings create a visual allegory of the flowing bounty of Creation, culminating in Sabbath calm and satisfaction. Water, symbolizing divine wisdom, cascades from a rugged rock wall that suggests the Rock of Ages, this composer's metaphor for the Almighty. Apples, reminiscent of the Shekhinah's Field of Holy Apples, pomegranates symbolizing fertility, and the wheat and grapes that yield the sanctified bread and wine tumble through the waves. Fish jump, and fowl peck for seeds and insects amid the rocks and sparkling spray. From a rocky crevice atop the waterfall, a dove emerges into the light, suggesting the "dove in the cranny of the rocks" of the Song of Songs, which midrash associates with Israel's trust in divine love. At the base of the waterfall, the action slows and rests. The rugged rocks become smooth and rounded, and the water calms. The quiet pool reflects the stars of the deep sky, reminding us of the all-suffusing presence of the Creator Whose rest we reenact on Shabbat. A gazelle symbolizing Israel's love of God sips from the pool of water as the energy of Creation gives way for the Shabbat rest. This image of life, energy, and final calm offers a visual commemoration of the acts of Creation (*ma'aseh bereishit*), paralleling the purpose of the Sabbath and its feasts.

יוֹם שַׁבָּתוֹן אֵין לִשְׁכּוֹחַ.
זִכְרוֹ כְּרֵיחַ הַנִּיחֹחַ.
יוֹנָה מָצְאָה בוֹ מָנוֹחַ,
וְשָׁם יָנוּחוּ יְגִיעֵי כֹחַ.

Do not neglect the Sabbath day.
The thought of it is sweet as incense.
On that day, the dove found rest,
And on it, all the weary rest.

הַיּוֹם נִכְבָּד לִבְנֵי אֱמוּנִים,
זְהִירִים לְשָׁמְרוֹ אָבוֹת וּבָנִים.
חָקוּק בִּשְׁנֵי לֻחוֹת אֲבָנִים
מֵרֹב אוֹנִים וְאַמִּיץ כֹּחַ.
יוֹנָה מָצְאָה בוֹ מָנוֹחַ,
וְשָׁם יָנוּחוּ יְגִיעֵי כֹחַ.

The day is honored by the faithful.
Fathers and sons keep it with care.
The day inscribed on two tables of stone
By One of might and awful power.
On that day, the dove found rest,
And on it, all the weary rest.

וּבָאוּ כֻלָּם בִּבְרִית יַחַד,
"נַעֲשֶׂה וְנִשְׁמַע" אָמְרוּ כְּאֶחָד!
וּפָתְחוּ וְעָנוּ "יהוה אֶחָד!
בָּרוּךְ נֹתֵן לַיָּעֵף כֹּחַ."
יוֹנָה מָצְאָה בוֹ מָנוֹחַ,
וְשָׁם יָנוּחוּ יְגִיעֵי כֹחַ.

They all embraced the covenant,
As one, they swore: "We hear and obey!"
They cried aloud, "The Lord is One!
Bless Him Who gives the weary strength."
On that day, the dove found rest,
And on it, all the weary rest.

דִּבֶּר בְּקָדְשׁוֹ בְּהַר הַמֹּר:
"יוֹם הַשְּׁבִיעִי זָכוֹר וְשָׁמוֹר.
וְכָל פִּקּוּדָיו יַחַד לִגְמֹר,
חַזֵּק מָתְנַיִם וְאַמֵּץ כֹּחַ."
יוֹנָה מָצְאָה בוֹ מָנוֹחַ,
וְשָׁם יָנוּחוּ יְגִיעֵי כֹחַ.

He bade them at the mountain of myrrh:
"Remember and keep the seventh day.
And gird yourselves with will and strength
To master its laws in every detail."
On that day, the dove found rest,
And on it, all the weary rest.

הָעָם אֲשֶׁר נָע כַּצֹּאן תָּעָה,
יִזְכֹּר לְפָקְדוֹ בְּרִית וּשְׁבוּעָה,
לְבַל יַעֲבָר בָּם מִקְרֵה רָעָה,
כַּאֲשֶׁר נִשְׁבַּעְתָּ עַל מֵי נֹחַ.
יוֹנָה מָצְאָה בוֹ מָנוֹחַ,
וְשָׁם יָנוּחוּ יְגִיעֵי כֹחַ.

Remember the oath and the covenant
You made with the nation that strayed like sheep,
And care for them that they come to no harm,
As You swore at Noah's Flood.
On that day, the dove found rest,
And on it, all the weary rest.

The author, whose name appears in the acrostic, is Judah Halevi (ca. 1090–1141), one of the most admired and prolific Hebrew poets of the Judaeo-Arabic school of Hebrew poetry. The poem consists of a leading stanza and four ordinary stanzas. Each stanza, including the leading stanza, ends with a biblical quotation—in some cases, slightly modified. Originally, there were eight syllables to a line, but this meter is no longer consistent because of changes introduced by copyists and printers who were not aware of the prosody.

A more far-reaching deviation from the original poem is the replacement of the original versions of stanzas 3 and 4 with the present text. The reason seems to be that Halevi's stanzas included a prayer for the downfall of Israel's enemies that, at some point, must have seemed too dangerous to continue to use. The present text of both stanzas first appeared in print in 1544/45.[100] A few slight deviations from the Hebrew text in the translation reflect the original version.

The poem opens by invoking a dove that found rest on the Sabbath. "Dove" is commonly used by medieval Hebrew poets as a way of referring to Israel, a usage that has its roots in rabbinic interpretation of the doves in the Song of Songs. But as written, it is almost impossible to avoid thinking of Noah's dove, which returned to the ark after seven days of scouting for food. It is as if Halevi imagined Noah's dove laboring for its sustenance for six days and returning to the ark to rest on the Sabbath. If that was what Halevi had in mind, it was an original thought, as there is no known source for it in earlier rabbinic interpretations of Noah's dove. Yet this interpretation seems to be confirmed by the last line of the poem, with its reference to God's promise to Israel (Isa. 44:9) to protect them from future destruction as he promised Noah to protect his descendants from destruction by flood. "Mountain of myrrh" refers to Mount Sinai, so called because of the ancient interpretation of Song of Songs 4:6.

COMMENTARY ON THE ILLUMINATIONS

udah Halevi likened himself to a dove, longed for doves' and eagles' wings to carry him away to the land of his ancestral Levites:

I wish that I could wander
where the Lord appeared to visionaries, prophets;
wish that I had wings
to fly away to you—so far!—
and place the pieces of my broken heart
among your jagged mountains....

If I had dove's wings,
To fly and alight—
"I would go to the Mount of Myrrh, the Hill of Frankincense."

Celebrated as poet and philosopher not only in his native Spain, Halevi saw the luxuries of court life in Spain as a decorative shackles and longed instead to rest among the clods and rubble of his soul's home in Jerusalem:

My heart is in the East, and I in the West,
as far in the West as west can be!
... Easily I could leave behind
this Spain and all her luxuries!—
As easy to leave as dear the sight
of the Temple's rubble would be to me.[101]

The illuminations of this song in which the dove finds respite from the world in Shabbat draw upon Halevi's identification with the biblical doves. The kabbalist Ezra of Gerona, writing two centuries after Halevi, interpreted the dove in the Song of Songs as the Shekhinah, accompanying Israel throughout its exile. Commenting on Song 2:14, "O my dove in the cranny of the rocks," Ezra suggests: "Until now the Shekhinah has dwelt with Israel in exile.... The community of Israel said before the Holy One, blessed be He: 'My children have made me to dwell, like a weasel, in ruined houses.' "[102]

Here, the dove finds respite from the luxuries and trials of exile. Its refuge, however, is not hidden in a rocky hillside, as suggested in the Song of Songs, but instead is a niche hidden in a brick wall covered with a veneer of lavish carving, suggesting the superficiality of material luxury. She has carried with her an olive branch, with multiple meanings. In Genesis, the olive branch symbolizes God's promise to Noah to protect the world from destruction; in Psalm 128, the olive tree's sprouts remind the Psalmist of children gathered around the family table; and throughout the Bible, olive oil is used for royal and priestly anointment.

Shabbat hayom l'Adonai

שַׁבָּת הַיּוֹם לַיהוה:
מְאֹד צַהֲלוּ בְּרנּוּנִי.
וְגַם הַרבּוּ מַעֲדָנַי,
אוֹתוֹ לִשְׁמֹר כְּמִצְוַת יהוה.
שַׁבָּת הַיּוֹם לַיהוה.

Today is the Sabbath of the Lord:
Rejoice greatly with my songs.
Bring me many delicious treats.
Keep it as the Lord commands.
　　Today is the Sabbath of the Lord.

מֵעֲבֹר דֶּרֶךְ וּגְבוּלִים
מֵעֲשׂוֹת הַיּוֹם פְּעָלִים.
לֶאֱכֹל וְלִשְׁתּוֹת בְּהִלּוּלִים
זֶה הַיּוֹם עָשָׂה יהוה.
שַׁבָּת הַיּוֹם לַיהוה.

No traveling across boundaries
Or doing any work today.
This is the day the Lord has made
For eating, drinking, and songs of praise
　　Today is the Sabbath of the Lord.

231

וְאִם תִּשְׁמְרֶנּוּ יָהּ יִנְצָרְךָ כְּבָבַת,	Keep it, and God will keep you like His own eye,
אַתָּה וּבִנְךָ וְגַם הַבַּת.	With your son and daughter, too.
וְקָרֵאתָ עֹנֶג לַשַּׁבָּת,	Call the Sabbath a delight,
אָז תִּתְעַנַּג עַל יהוה.	And God will take delight in you.
שַׁבָּת הַיּוֹם לַיהוה.	Today is the Sabbath of the Lord.

אֱכֹל מַשְׁמַנִּים וּמַעֲדַנִּים,	Eat rich foods and dainties,
וּמַטְעַמִּים הַרְבֵּה מִינִים—	Tasty food of every kind—,
אֱגוֹזֵי פֶרֶךְ וְרִמּוֹנִים,	Pomegranates, soft-shelled nuts—
וְאָכַלְתָּ וְשָׂבַעְתָּ וּבֵרַכְתָּ אֶת יהוה.	Eat your fill and bless the Lord.
שַׁבָּת הַיּוֹם לַיהוה.	Today is the Sabbath of the Lord.

לַעֲרֹךְ בַּשֻּׁלְחָן לֶחֶם חֲמוּדוֹת,	Set the table with good bread,
לַעֲשׂוֹת הַיּוֹם שָׁלֹשׁ סְעוּדוֹת.	Dine three times upon this day.
אֶת הַשֵּׁם הַנִּכְבָּד לְבָרֵךְ וּלְהוֹדוֹת,	Be sure to bless and thank God's name.
שִׁקְדוּ וְשִׁמְרוּ וַעֲשׂוּ בָנַי.	Do it, keep it, O my sons.
שַׁבָּת הַיּוֹם לַיהוה.	Today is the Sabbath of the Lord.

LITERARY COMMENTARY

The acrostic indicates that the poet's name was Samuel, but we have no further information about his identity. There are five four-line stanzas with a refrain; the stanzas are composed of three lines that rhyme with one another and a fourth that rhymes with the refrain. This is another poem that dwells on the abundant food of the Sabbath.

COMMENTARY ON THE ILLUMINATIONS

he illuminations present a Shabbat table set for ten family members and guests, corresponding to the number of divine *sefirot*. The table laden with dishes and food stands before windows suggesting the time of day of each of the three prescribed Shabbat meals. The scene rests upon symbols representing the twin supports of Jewish life: spiritual and physical. The dining room is supported by a balustrade discovered in the ruins of a royal Judaean palace at Ramat Raḥel, between Jerusalem and Bethlehem,[103] symbolizing the historical Jewish community. Nested below, the insets show imagery of cell division, common to all life forms, suggesting the unity of all matter—ourselves, our food, our homes, and the sky above—through our common origin in the Creator.

שִׁמְרוּ שַׁבְּתוֹתַי
לְמַעַן תִּינְקוּ וּשְׂבַעְתֶּם
מִזִּיו בִּרְכוֹתַי
אֶל הַמְּנוּחָה כִּי בָאתֶם.
וּלְווּ עָלַי בָּנַי,
וְעֶדְנוּ מַעֲדָנַי!
שַׁבָּת הַיּוֹם לַיהוה.

Keep My Sabbaths
And you will be nourished and filled
With My luminous blessings
When you come to My rest.
For My sake, borrow, My children,
So as to enjoy My delights!
 Today is the Sabbath of the Lord.

לְעָמֵל קִרְאוּ דְרוֹר,
וְנָתַתִּי אֶת בִּרְכָתִי,
אִשָּׁה אֶל אֲחוֹתָהּ לִצְרֹר.
לְגַלּוֹת עַל יוֹם שִׂמְחָתִי
בִּגְדֵי שֵׁשׁ עִם שָׁנִי.
וְהִתְבּוֹנְנוּ מִזְּקֵנַי.
שַׁבָּת הַיּוֹם לַיהוה.

Proclaim freedom from labor,
And I will grant you My blessings,
One after the other and altogether.
On My day of joy, show
Your linen and scarlet finery.
And pay attention to the Sages.
 Today is the Sabbath of the Lord.

מַהֲרוּ אֶת הַמָּנֶה,
לַעֲשׂוֹת אֶת דְּבַר אֶסְתֵּר.
וְחִשְּׁבוּ עִם הַקּוֹנֶה
לְשַׁלֵּם אָכוֹל וְהוֹתֵר.
בִּטְחוּ בִי אֱמוּנַי,
וּשְׁתוּ יֵין מִשְׁמַנַּי,
שַׁבָּת הַיּוֹם לַיהוה.

Hurry, lay out your money
To make a feast like Esther's.
Reckon with the buyer and pay
For the food that you need and more.
Have trust in Me, faithful friends,
And drink wine with My rich foods.
 Today is the Sabbath of the Lord.

הִנֵּה יוֹם גְּאֻלָּה
יוֹם שַׁבָּת אִם תִּשְׁמֹרוּ,
וִהְיִיתֶם לִי סְגֻלָּה.
לִינוּ וְאַחַר תַּעֲבֹרוּ:
וְאָז תִּחְיוּ לְפָנַי,
וּתְמַלְּאוּ צְפוּנַי.
שַׁבָּת הַיּוֹם לַיהוה.

Redemption is just at hand
If you only keep the Sabbath,
And serve as My treasured people.
Stay tonight, and then move on;
Then you will live before Me
And fill My treasury.
 Today is the Sabbath of the Lord.

חַזֵּק קִרְיָתִי,	Fortify my city
אֵל אֱלֹהִים עֶלְיוֹן!	O God, highest Lord!
וְהָשֵׁב אֶת נְוָתִי	Restore my Temple
בְּשִׂמְחָה וּבְהִגָּיוֹן.	In joy and song.
יְשׁוֹרְרוּ שָׁם רְנָנַי	There my Levites and my priests
לְוִיַּי וְכֹהֲנַי:	Will sing my hymns;
וְאָז תִּתְעַנַּג עַל יהוה.	Then you will have delight in God.
שַׁבָּת הַיּוֹם לַיהוה.	Today is the Sabbath of the Lord.

LITERARY COMMENTARY

The acrostic indicates that the poet's name was Samuel, but we have no further information about his identity. There are five four-line stanzas with a refrain; the stanzas are composed of three lines that rhyme with one another and a fourth that rhymes with the refrain. This is another poem that dwells on the abundant food of the Sabbath.

COMMENTARY ON THE ILLUMINATIONS

 he illumination presents an allegory about Israel's faith in the restoration of Jerusalem. The table is laid for Shabbat in a dusky walled garden, a literal symbol of the private love between man and woman. In midrash, it is a symbol of the love between God and Israel; and, in kabbalah, of the Shekhinah. The table is modeled on the stone table preserved in the late Second Temple period "Burnt House," destroyed by the Romans in 70 CE; the candles present a design of our own time. The olive trees arcing over the table allude to Zechariah's vision of the restoration of Jerusalem (Zech. 4:1–4), their branches tracing a fractal pattern of the letter *shin*, the initial of the divine name *Shaddai*. The dusky sky arcing above the garden rises into the deep sky, showing us the brilliant universe in its earliest moments.

כִּי אֶשְׁמְרָה שַׁבָּת אֵל יִשְׁמְרֵנִי.	If I keep the Sabbath, God will keep me.
אוֹת הִיא לְעוֹלְמֵי עַד בֵּינוֹ וּבֵינִי.	It is sign forever between the Lord and me.
אָסוּר מְצֹא חֵפֶץ, עֲשׂוֹת דְּרָכִים,	No transactions and no traveling,
גַּם מִלְּדַבֵּר בּוֹ דִּבְרֵי צְרָכִים,	no discussing worldly needs,
דִּבְרֵי סְחוֹרָה אַף דִּבְרֵי מְלָכִים.	business or government.
אֶהְגֶּה בְּתוֹרַת אֵל וּתְחַכְּמֵנִי.	But I study Torah, for it makes me wise.
אוֹת הִיא לְעוֹלְמֵי עַד בֵּינוֹ וּבֵינִי.	It is sign forever between the Lord and me.
בּוֹ אֶמְצָא תָמִיד נֹפֶשׁ לְנַפְשִׁי.	That is when my soul finds its tranquility.
הִנֵּה לְדוֹר רִאשׁוֹן נָתַן קְדוֹשִׁי,	God gave a sign of this to the first generation,
מוֹפֵת בְּתֵת לֶחֶם מִשְׁנֶה בַּשִּׁשִּׁי:	sending double manna on the sixth day.
כָּכָה בְּכָל שִׁשִּׁי יַכְפִּיל מְזוֹנִי.	Likewise, every Friday He gives me a double portion.
אוֹת הִיא לְעוֹלְמֵי עַד בֵּינוֹ וּבֵינִי.	It is sign forever between the Lord and me.
רָשַׁם בְּדַת הָאֵל חֹק אֶל סְגָנָיו	In His Law, God ordained that the priests
בּוֹ לַעֲרֹךְ לֶחֶם פָּנִים בְּפָנָיו.	should set shewbread before Him every Sabbath.
עַל כֵּן לְהִתְעַנּוֹת בּוֹ עַל פִּי נְבוֹנָיו	That is why, the Sages say, there is no fasting then,
אָסוּר לְבַד מִיּוֹם כִּפּוּר עֲוֹנִי.	unless Yom Kippur and the Sabbath chance to coincide.
אוֹת הִיא לְעוֹלְמֵי עַד בֵּינוֹ וּבֵינִי..	It is sign forever between the Lord and me.
הוּא יוֹם מְכֻבָּד, הוּא יוֹם תַּעֲנוּגִים,	It is an honored day, a day of delight,
לֶחֶם וְיַיִן טוֹב, בָּשָׂר וְדָגִים,	a day of bread and fragrant wine, a day of flesh and fish.
הַמִּתְאַבְּלִים בּוֹ אָחוֹר נְסוֹגִים,	To spend the Sabbath mourning would be perverse,
כִּי יוֹם שְׂמָחוֹת הוּא וּתְשַׂמְּחֵנִי.	for it is a happy day, and it should bring me joy.
אוֹת הִיא לְעוֹלְמֵי עַד בֵּינוֹ וּבֵינִי.	It is sign forever between the Lord and me.
מֵחַל מְלָאכָה בּוֹ סוֹפוֹ לְהַכְרִית.	Who desecrates it with work will meet an early end.
עַל כֵּן אֲכַבֵּס בּוֹ לִבִּי כְּבֹרִית,	So I will cleanse my heart of all impurities,
וְאֶתְפַּלְּלָה אֶל אֵל עַרְבִית וְשַׁחֲרִית,	recite the prayers of evening and the morning prayers,
מוּסָף וְגַם מִנְחָה הוּא יַעֲנֵנִי.	Musaf and then Minḥa, and God will answer me.
אוֹת הִיא לְעוֹלְמֵי עַד בֵּינוֹ וּבֵינִי.	It is sign forever between the Lord and me.

LITERARY COMMENTARY

This poem, by Abraham Ibn Ezra (ca. 1089–ca. 1167), consists of a leading stanza and five ordinary stanzas; these latter contain the poet's name in acrostic. Much of the poem is devoted to the prohibitions associated with the Sabbath. The first stanza mentions the prohibition of speaking about business or public affairs and recommends instead using the Sabbath rest in order to study Torah. The third stanza mentions the biblical rule that on the Sabbath, the priests were to replace the shewbread in the Temple. The fourth speaks of the lavish meals of the Sabbath and the requirement to abstain from mourning. The fifth recalls the general prohibition of labor and the requirement of the four Sabbath liturgical services.

COMMENTARY ON THE ILLUMINATIONS

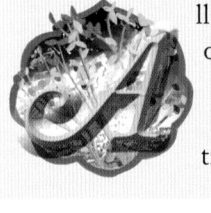

All is calm, and all worldly disturbances give way to the pleasures of rest, food, and learning on Shabbat, the composer tells us. The illuminations express the serene rhythm of the Sabbath rest. The crown atop the illuminations reminds us of the royalty of the sacred bride, the Shekhinah who joins us at the regal Shabbat table; the palmettes[104] allude to the transformation of the home into a virtual Temple during the sacred day.

DROR YIKRA

Hebrew	English
דְּרוֹר יִקְרָא לְבֵן עִם בַּת,	He calls to freedom every man and woman.
וְיִנְצָרְכֶם כְּמוֹ בָבַת.	He guards you like the pupil of His eye.
נְעִים שִׁמְכֶם וְלֹא יֻשְׁבַּת,	Your lovely name will never be forgotten,
שְׁבוּ נוּחוּ בְּיוֹם שַׁבָּת.	If you sit quietly at rest on the Sabbath day.
דְּרוֹשׁ נָוִי וְאוּלְמִי,	O seek the welfare of my Temple, of my palace,
וְאוֹת יֶשַׁע עֲשֵׂה עִמִּי,	And let me see a sign of my salvation.
נְטַע שׂוֹרֵק בְּתוֹךְ כַּרְמִי,	Plant a splendid vine within my vineyard,
שְׁעֵה שַׁוְעַת בְּנֵי עַמִּי.	And hear my cry, when I call out to You.
דְּרֹךְ פּוּרָה בְּתוֹךְ בָּצְרָה,	Trample out the vineyard in Bozrah
וְגַם בָּבֶל אֲשֶׁר גָּבְרָה,	And Babylon, the overpowering.
נְתוֹץ צָרַי בְּאַף וְעֶבְרָה,	In rage and fury, overturn my foes,
שְׁמַע קוֹלִי בְּיוֹם אֶקְרָא.	Hear me when I call upon Your name.

Hebrew	English
אֱלֹהִים תֵּן בַּמִּדְבָּר הַר,	O God, put on that hill, now desolate,
הֲדַס שִׁטָּה בְּרוֹשׁ תִּדְהָר.	Acacia, myrtle, box, and cypress trees.
וְלַמַּזְהִיר וְלַנִּזְהָר,	And both to those who teach and those who heed,
שְׁלוֹמִים תֵּן כְּמֵי נָהָר.	Grant peace abundant as the flowing streams.
הֲדֹךְ קָמַי אֵל קַנָּא,	Crush all who would attack me, God of rage,
בְּמוֹג לֵבָב וּבַמְּגִנָּה.	And give them melting hearts and sorrow.
וְנַרְחִיב פֶּה וּנְמַלְּאֶנָּה,	Then we will open wide our mouths to sing,
לְשׁוֹנֵנוּ לְךָ רִנָּה.	Filling them with songs of praise to You.
דְּעֵה חָכְמָה לְנַפְשֶׁךָ,	Know the way of wisdom for your soul,
וְהִיא כֶתֶר לְרֹאשֶׁךָ:	And let it be a crown upon your head:
נְצֹר מִצְוֹת קְדוֹשֶׁךָ,	Obey the bidding of your Holy One:
שְׁמֹר שַׁבַּת קָדְשֶׁךָ.	Observe the Sabbath as a holy day.

LITERARY COMMENTARY

This poem is among the earliest Hebrew poems employing the quantitative meters adopted by Hebrew poets from Arabic poetry. Its author was Dunash ben Labrat (ca. 920–ca. 990), who pioneered this practice, thereby establishing the prosodic scheme on which most of the poetry of the Hebrew Golden Age was based. Dunash's name appears in acrostic form in stanzas 1, 2, 3, and 6. Only stanzas 1 and 6, which are addressed to the people, refer to the Sabbath; stanzas 2 through 5, which are addressed to God, are concerned with the restoration of Israel and the punishment of her enemies.

"To those who teach and those who heed": This is the functionally correct meaning of words usually translated "the one who warns and the one who is warned." The Hebrew verb meaning "to warn" can mean "to call attention" to something (not necessarily something to be avoided) and, by extension, "to teach" or "to admonish." In the passive, it therefore is used to mean "to heed the admonition." Here, the reference is undoubtedly to religious teachers and those who adhere to their teachings.

Bozrah in stanza 3 is an Edomite town mentioned in the Bible, especially in Isa. 63:1–2, in a prophecy of the destruction of Edom. This ancient kingdom in the Transjordan was associated by the rabbis with Esau, and therefore with the Romans, who were thought to be descended from Esau. When the Roman Empire adopted Christianity in the fourth century, rabbinic invective against Rome was transferred to Christianity. As a result, medieval Hebrew poets regularly use Edom as an epithet for Christianity, as they usually used Ismael as an epithet for Islam. In this poem, however, Islam is represented by Babylon, which is mentioned in the same stanza.

 n "Dror yikra"—whose name calls to mind for Americans the famous biblical passage inscribed on the Liberty Bell, "proclaim liberty throughout the land" (Lev. 25:10)—we sing of how observing Shabbat helps bring about the coming of the Messiah. As Dunash urges God to redeem Israel from worldly oppressors, he also exhorts his fellow Jews to mind the laws of Sabbath rest. Sabbath observance, he sings, hastens salvation, anticipating the kabbalistic theme of the individual Jew's ability to heal the world and heal the divine, through performing mitzvot.

A sturdy vine wraps itself around wooden pillars. Dunash follows the later prophets—in particular, Isaiah and Jeremiah—in alluding to the House of David, from which the Messiah will descend, as a vine.[105] Here, the vine's roots twine through a harp, David's own instrument. The wooden pillars upon which the vine twines are balusters decorating the bimah of the Bevis Marks Synagogue in London, the first synagogue built in Great Britain (1701) following the return of Jews in the seventeenth century, and now the oldest continually operating synagogue in Europe, here reminding us of Israel's enduring ability to persevere and restore itself in the wake of oppression.

TSUR MISHELO

צוּר מִשֶּׁלּוֹ אָכַלְנוּ,
בָּרְכוּ אֱמוּנַי.
שָׂבַעְנוּ וְהוֹתַרְנוּ
כִּדְבַר יהוה.

Bless the Rock, faithful friends,
Whose bounty we have eaten.
We ate our fill, and found yet more,
As promised by the Lord.

הַזָּן אֶת עוֹלָמוֹ רוֹעֵנוּ אָבִינוּ:
אָכַלְנוּ אֶת לַחְמוֹ, וְיֵינוֹ שָׁתִינוּ.
עַל כֵּן נוֹדֶה לִשְׁמוֹ וּנְהַלְלוֹ בְּפִינוּ.
אָמַרְנוּ, וְעָנִינוּ אֵין קָדוֹשׁ כַּיהוה.

He who feeds the world, our Shepherd and our Father:
His bread we have eaten, His wine we have drunk.
So let us give Him thanks and praise Him with our voices.
We say, we sing that there is none as holy as the Lord.

בְּשִׁיר וְקוֹל תּוֹדָה, נְבָרֵךְ לֵאלֹהֵינוּ
עַל אֶרֶץ חֶמְדָּה טוֹבָה שֶׁהִנְחִיל לַאֲבוֹתֵינוּ.
מָזוֹן וְצֵדָה, הִשְׂבִּיעַ לְנַפְשֵׁנוּ.
חַסְדּוֹ גָּבַר עָלֵינוּ: וֶאֱמֶת יהוה.

With song and with thanksgiving, let us bless our God
For the land so lovely that He granted to our fathers.
He gave us food aplenty, He gave us sustenance.
He overwhelmed us with His love: faithful is the Lord.

רַחֵם בְּחַסְדֶּךָ עַל עַמְּךָ, צוּרֵנוּ!
עַל צִיּוֹן מִשְׁכַּן כְּבוֹדֶךָ,
זְבוּל בֵּית תִּפְאַרְתֵּנוּ,
בֶּן דָּוִד עַבְדֶּךָ יָבוֹא וְיִגְאָלֵנוּ,
רוּחַ אַפֵּינוּ, מְשִׁיחַ יהוה.

Have mercy in Your kindness on your folk, our Rock!
On Zion where Your glory dwells,
the splendid Holy Temple.
May Your servant David's scion come soon to redeem us,
He who is our breath of life, the anointed of the Lord.

יִבָּנֶה הַמִּקְדָּשׁ, עִיר צִיּוֹן תְּמַלֵּא.
וְשָׁם נָשִׁיר שִׁיר חָדָשׁ וּבִרְנָנָה נַעֲלֶה.
הָרַחֲמָן, הַנִּקְדָּשׁ יִתְבָּרַךְ וְיִתְעַלֶּה
עַל כּוֹס יַיִן מָלֵא, כְּבִרְכַּת יהוה.

Rebuild the Temple as before, fill Zion once again.
We will go up joyfully and sing new songs to You.
The Merciful, the Holy One be blessed and be exalted
Over a full cup of wine, the blessing of the Lord.

Note on singing: The refrain, in blue on the illuminations, begins the song and is repeated after each verse.

LITERARY COMMENTARY

This poem contains no references to the Sabbath but contains many allusions to Grace after Meals, and its stanzas parallel the benedictions of Grace after Meals. It is one of a large number of poems composed in the Middle Ages as an alternate version of Grace. It is therefore most appropriately sung as the last of the table-songs.

The poem consists of a leading stanza and four ordinary stanzas. Each stanza echoes the leading stanza in concluding with a biblical quotation that has God's name as its last word.

The leading stanza, which serves also as a refrain, incorporates the traditional summons to Grace, calling upon all at the table to participate. The first three stanzas represent the three canonical benedictions of which Grace after Meals is composed: the first thanks God for providing food to all the world; the second thanks God for giving Israel its land; the third asks God to restore Jerusalem and the Davidic kingdom. The fourth stanza does not, however, refer to the fourth benediction of Grace after Meals, in which God is thanked for His varied benefactions; this benediction, as pointed out in the Talmud, was not part of the original Grace after Meals. But the fourth stanza does refer to part of the Grace after Meals ceremony, the cup of wine over which Grace was (and, in many communities, still is) recited.

COMMENTARY ON THE ILLUMINATIONS

andering the narrow, shaded streets of Jerusalem's Jewish Quarter, one unexpectedly encounters sunlit keyhole views of the broader plazas and landscape beyond the close walls. The illuminations of this traditional last table-song sung before Grace after Meals celebrate and offer thanks for the joy of those sudden views of the sacred city and its environs.

At right, the Hebrew side presents an idyllic view of the Second Temple–period city, topped by the Temple itself, embedded in the vineyards, pastures, and fields of ripening grain that produce the food for which Grace thanks God. At left, in the modern Jewish Quarter, the viewer emerges from a narrow passageway into the light of a courtyard overlooking the Western Wall plaza, where children play, again reminding the viewer of Zechariah's prophecy (Zech. 8:5). Beneath the limitless, always evolving, heavens, an eagle soars, calling to mind God's parenting of Israel.

שִׁיר הַמַּעֲלוֹת	A Song for the Steps of the Temple.
בְּשׁוּב יהוה אֶת־שִׁיבַת צִיּוֹן	When the Lord restored Zion's exiles,
הָיִינוּ כְּחֹלְמִים.	we felt we were dreaming.
אָז יִמָּלֵא שְׂחוֹק פִּינוּ,	Then our mouths were filled with laughter
וּלְשׁוֹנֵנוּ רִנָּה.	and our tongues with song.
אָז יֹאמְרוּ בַגּוֹיִם,	Then they said among the nations:
"הִגְדִּיל יהוה לַעֲשׂוֹת עִם־אֵלֶּה!"	"The Lord has done great things with this people!"
הִגְדִּיל יהוה לַעֲשׂוֹת עִמָּנוּ. הָיִינוּ שְׂמֵחִים.	The Lord has done great things for us. We rejoiced.
שׁוּבָה יהוה אֶת־שְׁבִיתֵנוּ,	O Lord, restore our exiles
כַּאֲפִיקִים בַּנֶּגֶב.	like seasonal streams in the desert.
הַזֹּרְעִים בְּדִמְעָה בְּרִנָּה יִקְצֹרוּ.	Those who sow in tears will reap in joy.
הָלוֹךְ יֵלֵךְ וּבָכֹה נֹשֵׂא מֶשֶׁךְ־הַזָּרַע,	Though one goes out weeping as he carries his bag of seed,
בֹּא־יָבֹא בְרִנָּה, נֹשֵׂא אֲלֻמֹּתָיו.	he returns singing, as he carries in his sheaves.
תְּהִלַּת יהוה יְדַבֶּר פִּי,	My mouth will speak the praise of the Lord,
וִיבָרֵךְ כָּל בָּשָׂר שֵׁם קָדְשׁוֹ לְעוֹלָם וָעֶד.	and all flesh will bless His holy name forever.
וַאֲנַחְנוּ נְבָרֵךְ יָהּ מֵעַתָּה וְעַד עוֹלָם. הַלְלוּיָהּ.	We will bless the Lord now and forever. Amen.
הוֹדוּ לַיהוה כִּי טוֹב, כִּי לְעוֹלָם חַסְדּוֹ.	Praise the Lord, for He is good, for His kindness is eternal.
מִי יְמַלֵּל גְּבוּרוֹת יהוה	Who can express the Lord's mighty acts
יַשְׁמִיעַ כָּל תְּהִלָּתוֹ?	or proclaim all His praise?

LITERARY COMMENTARY

On the Sabbath and festivals, it is customary to sing Psalm 126 before Grace and to insert references to the Sabbath or festival at appropriate points within Grace.

Psalm 126 is one of fifteen consecutive psalms that begin with the enigmatic heading *shir hama'alot*. (*Ma'alot* means "steps.") Jewish tradition explains the terms as meaning that these psalms were sung in the Temple by the Levites, who were ranged on the fifteen steps that led from the women's court of the Temple to the Israelite court. However, the psalm's second part appears to pray for the restoration of the people from the exile, implying that the psalm was composed after the Temple was destroyed.

A further difficulty is that the first part of the psalm appears to describe the joy of the returning exiles after the restoration. Perhaps the first part is merely a fantasy of a redemption still in the future, despite its being couched in the past tense.

The expression "Those who sow in tears will reap in joy" has become proverbial. After enunciating it, the Psalmist concretizes it by imagining an actual person weeping as he sows, singing as he brings the harvest home—a touching image for Israel in exile and restoration.

COMMENTARY ON THE ILLUMINATIONS

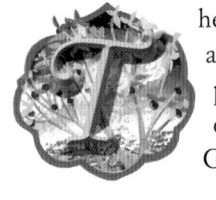 he illuminations treat "Shir hama'alot" as a reverie about the remembered exuberance of anticipating the return to Zion from exile. Its verses use agricultural metaphors—water, precious in an arid land, and seeding, often a matter of risky guesswork—to fuse the love of Zion, its people, and the land with faith in Israel's providential God, to introduce Grace after Meals on Sabbath and festivals.

The Hebrew and English illuminations contrast painful, but fertile, exile with joyful and fruitful redemption, inspired by the agricultural metaphors of Psalm 126. In the Hebrew illumination, the woman is not the glorious Sabbath bride or queen but—following Lamentations and Jeremiah—Jerusalem, mourning in the wake of exile, longing for restoration to her land. She listlessly drags the seed bag behind her through the sunset landscape; amid the barren landscape of stones and broken trees, the fallen seeds sprout with promises of rebirth that she does not see. The desert's vernal springs tumble down a hillside, feeding the dry land with water, feeding the human realm with wisdom. Brilliant day has arrived in the English illumination, a sparkling sky and clouds promising life-giving rain for the landscape of modern Israel. As the vernal springs again flow from the same hillside, young people drive tractors through burgeoning fields and date orchards, cultivating the bounty afforded by divine providence and human imagination and hard work. The divine everflow spreads throughout the land.

The columns flanking the texts present a rosette pattern adapted from a frieze from a fourth–fifth-century synagogue at Ḥorazin in the northern Galilee, now in the collection of the Israel Museum (my sketch, 2007). The columns are topped by proto-Aeolian capitals from Ramat Raḥel, near Jerusalem—dating to the late ninth century BCE, contemporary with the early Davidic dynasty—now in the collection of the Bible Lands Museum in Jerusalem (my sketch, 1997).

LITERARY COMMENTARY

Grace after Meals is a prayer that has its roots in the Talmud. Originally consisting of three benedictions, it now consists of four. The original three benedictions express thanks to God for providing all His creatures with food; for giving the Jewish people the Land of Israel and its bounty; and for the future redemption of Israel. The additional benediction thanks God for His many acts of benevolence. Originally quite brief, the text has been expanded in two ways over centuries: each of the four benedictions was expanded and elaborated; and an ever-lengthening series of supplications was added after the fourth, each supplication taking the form "May the Merciful One." One of these supplications is a prayer for the head of the household, his family, and the other participants in the meal; the wording of this supplication is varied, depending on who is present.

The first three benedictions follow a general pattern in the liturgy in which we thank God for a universal phenomenon (in this case, food for all creatures), and then for some particular benefaction to the Jewish people (the Land of Israel), then for redemption (the rebuilding of Jerusalem). A similar pattern may be observed in the morning service and elsewhere in the liturgy.

Grace after Meals is preceded by ritual exchange between a leader and the others at the table, in which the leader invites all present to recite Grace and they respond, first with a doxology, and then by reciting the prayer itself.

COMMENTARY ON THE ILLUMINATIONS

irkat hamazon" thanks God for the mysterious-seeming phenomenon of life-giving food arising from inert seed and soil. Yet we now know that neither life nor soil really is inert—the introductory illumination celebrates the germination and growth of wheat from a grassroots view. We see a cross-section of young wheat germinating and growing in the soil that teems with rich minerals, microorganisms, and worms. An ant works its way across the scrub, while a honeybee, that small creature that fertilizes our food crops, climbs a wheat leaf toward the sky. The infinite cosmos and the sun's corona[106] —reminding us of the common origin of all matter, of the all-suffusing presence of the Creator—surround the humble landscape.

The slender paintings at the edges of the text pages of the "Birkat hamazon" pan across an Israeli landscape, the image of Jerusalem sheltered among the hills. Under the sky offering light and rain, Israeli farmers draw grain, grapes, dates, oranges, and other crops from the rocky soil. The apple tree in the foreground suggests the mystical orchard of holy apples, while the eagle in the sky and the caper branch remind us of Israel's ability to persevere through all adversity, with the support of the unseen, but all-infusing, divine.

ADDITIONS FOR SPECIAL SABBATHS

Candle-Lighting

On Shabbat that is also a Yom Tov, cover the eyes with the hands after lighting the candles and say the following
blessing, adding the words in parentheses:

בָּרוּךְ אַתָּה יהוה אֱלֹהֵינוּ מֶלֶךְ הָעוֹלָם, אֲשֶׁר קִדְּשָׁנוּ בְּמִצְוֹתָיו, וְצִוָּנוּ לְהַדְלִיק נֵר שֶׁל שַׁבָּת וְשֶׁל

Yom Kippur: יוֹם הַכִּפּוּרִים *Festivals:* יוֹם טוֹב

Blessed are You, Lord our God, King of the Universe, Who has made us holy through His commandments, and has
commanded us to light the Sabbath light and the (Yom Kippur or festival) light.

The Sheheḥeyanu blessing is said on Yom Tov evenings except on the last evenings of Pesaḥ:

בָּרוּךְ אַתָּה יהוה אֱלֹהֵינוּ מֶלֶךְ הָעוֹלָם, שֶׁהֶחֱיָנוּ וְקִיְּמָנוּ וְהִגִּיעָנוּ לַזְּמַן הַזֶּה.

Blessed are You, Lord our God, King of the Universe, Who has given us life, sustained us, and brought us to this time.

Kiddush

On the intermediate Sabbath of Sukkot, if kiddush is made in the sukkah, add:

בָּרוּךְ אַתָּה יהוה אֱלֹהֵינוּ מֶלֶךְ הָעוֹלָם, אֲשֶׁר קִדְּשָׁנוּ בְּמִצְוֹתָיו וְצִוָּנוּ לֵישֵׁב בַּסֻּכָּה.

Blessed are You, Lord our God, King of the Universe, Who has made us holy through His commandments and has
commanded us to dwell in the sukkah.

Counting the Omer

The Omer is counted each night from the second night of Pesaḥ until the night before Shavuot.
Some say the following meditation before the blessing:

לְשֵׁם יִחוּד קֻדְשָׁא בְּרִיךְ הוּא וּשְׁכִינְתֵּהּ, בִּדְחִילוּ וּרְחִימוּ, לְיַחֵד שֵׁם י״ה בּו״ה בְּיִחוּדָא שְׁלִים, בְּשֵׁם כָּל יִשְׂרָאֵל.

הִנְנִי מוּכָן וּמְזֻמָּן לְקַיֵּם מִצְוַת עֲשֵׂה שֶׁל סְפִירַת הָעֹמֶר, כְּמוֹ שֶׁכָּתוּב בַּתּוֹרָה: וּסְפַרְתֶּם לָכֶם מִמָּחֳרַת הַשַּׁבָּת מִיּוֹם הֲבִיאֲכֶם אֶת עֹמֶר הַתְּנוּפָה, שֶׁבַע שַׁבָּתוֹת תְּמִימֹת תִּהְיֶינָה. עַד מִמָּחֳרַת הַשַּׁבָּת הַשְּׁבִיעִת תִּסְפְּרוּ חֲמִשִּׁים יוֹם, וְהִקְרַבְתֶּם מִנְחָה חֲדָשָׁה לַיהוה. וִיהִי נֹעַם אֲדֹנָי אֱלֹהֵינוּ עָלֵינוּ, וּמַעֲשֵׂה יָדֵינוּ כּוֹנְנָה עָלֵינוּ, וּמַעֲשֵׂה יָדֵינוּ כּוֹנְנֵהוּ.

בָּרוּךְ אַתָּה יהוה אֱלֹהֵינוּ מֶלֶךְ הָעוֹלָם, אֲשֶׁר קִדְּשָׁנוּ בְּמִצְוֹתָיו, וְצִוָּנוּ עַל סְפִירַת הָעֹמֶר.

For the sake of the unification of the Holy One, blessed be He, and His divine presence, in reverence and love, to unify the
name *yud-hay* with *vav-hay* in perfect unity in the name of all Israel.

I am prepared and ready to fulfill the positive commandment of counting the Omer, as it is written in the Torah, "shall count
seven complete weeks from the day following the [Pesaḥ] rest day, when you brought the Omer as a wave-offering. To the day
after the seventh week, you shall count fifty days. Then you shall present a meal-offering, new grain to the Lord." May the
pleasantness of the Lord our God be upon us. Establish for us the work of our hands, establish the work of our hands.

Blessed are You, Lord our God, King of the Universe, Who has made us holy through His commandments, and has commanded us about counting the Omer.

טו בניסן, ב׳ של פסח (בא״י: א׳ של חול המועד) הַיּוֹם יוֹם אֶחָד לָעֹמֶר. חסד שבחסד

יז בניסן, א׳ (בא״י: ב׳) של חול המועד הַיּוֹם שְׁנֵי יָמִים לָעֹמֶר. גבורה שבחסד

יח בניסן, ב׳ (בא״י: ג׳) של חול המועד הַיּוֹם שְׁלֹשָׁה יָמִים לָעֹמֶר. תפארת שבחסד

יט בניסן, ג׳ (בא״י: ד׳) של חול המועד הַיּוֹם אַרְבָּעָה יָמִים לָעֹמֶר. נצח שבחסד

כ בניסן, ד׳ (בא״י: ה׳) של חול המועד הַיּוֹם חֲמִשָּׁה יָמִים לָעֹמֶר. הוד שבחסד

כא בניסן, שביעי של פסח הַיּוֹם שִׁשָּׁה יָמִים לָעֹמֶר. יסוד שבחסד

כב בניסן, אחרון של פסח (בא״י: מוצאי יום טוב) הַיּוֹם שִׁבְעָה יָמִים שֶׁהֵם שָׁבוּעַ אֶחָד לָעֹמֶר. מלכות שבחסד

כג בניסן, מוצאי יום טוב (בחו״ל) הַיּוֹם שְׁמוֹנָה יָמִים שֶׁהֵם שָׁבוּעַ אֶחָד וְיוֹם אֶחָד לָעֹמֶר. חסד שבגבורה

כד בניסן: הַיּוֹם תִּשְׁעָה יָמִים שֶׁהֵם שָׁבוּעַ אֶחָד וּשְׁנֵי יָמִים לָעֹמֶר. גבורה שבגבורה

כה בניסן: הַיּוֹם עֲשָׂרָה יָמִים שֶׁהֵם שָׁבוּעַ אֶחָד וּשְׁלֹשָׁה יָמִים לָעֹמֶר. תפארת שבגבורה

כו בניסן: הַיּוֹם אַחַד עָשָׂר יוֹם שֶׁהֵם שָׁבוּעַ אֶחָד וְאַרְבָּעָה יָמִים לָעֹמֶר. נצח שבגבורה

כז בניסן: הַיּוֹם שְׁנֵים עָשָׂר יוֹם שֶׁהֵם שָׁבוּעַ אֶחָד וַחֲמִשָּׁה יָמִים לָעֹמֶר. הוד שבגבורה

כח בניסן: הַיּוֹם שְׁלֹשָׁה עָשָׂר יוֹם שֶׁהֵם שָׁבוּעַ אֶחָד וְשִׁשָּׁה יָמִים לָעֹמֶר. יסוד שבגבורה

כט בניסן: הַיּוֹם אַרְבָּעָה עָשָׂר יוֹם שֶׁהֵם שְׁנֵי שָׁבוּעוֹת לָעֹמֶר. מלכות שבגבורה

ל׳ בניסן, א׳ דראש חדש: הַיּוֹם חֲמִשָּׁה עָשָׂר יוֹם שֶׁהֵם שְׁנֵי שָׁבוּעוֹת וְיוֹם אֶחָד לָעֹמֶר. חסד שבתפארת

א׳ באייר, ב׳ דראש חדש: הַיּוֹם שִׁשָּׁה עָשָׂר יוֹם שֶׁהֵם שְׁנֵי שָׁבוּעוֹת וּשְׁנֵי יָמִים לָעֹמֶר. גבורה שבתפארת

ב׳ באייר: הַיּוֹם שִׁבְעָה עָשָׂר יוֹם שֶׁהֵם שְׁנֵי שָׁבוּעוֹת וּשְׁלֹשָׁה יָמִים לָעֹמֶר. תפארת שבתפארת

ג׳ באייר: הַיּוֹם שְׁמוֹנָה עָשָׂר יוֹם שֶׁהֵם שְׁנֵי שָׁבוּעוֹת וְאַרְבָּעָה יָמִים לָעֹמֶר. נצח שבתפארת

ד׳ באייר: הַיּוֹם תִּשְׁעָה עָשָׂר יוֹם שֶׁהֵם שְׁנֵי שָׁבוּעוֹת וַחֲמִשָּׁה יָמִים לָעֹמֶר. הוד שבתפארת

ה׳ באייר, יום העצמאות: הַיּוֹם עֶשְׂרִים יוֹם שֶׁהֵם שְׁנֵי שָׁבוּעוֹת וְשִׁשָּׁה יָמִים לָעֹמֶר. יסוד שבתפארת

כז באייר: הַיּוֹם שְׁנַיִם וְאַרְבָּעִים יוֹם שֶׁהֵם שִׁשָּׁה שָׁבוּעוֹת לָעֹמֶר. מלכות שביסוד

כח באייר, יום חרות ירושלים: הַיּוֹם שְׁלֹשָׁה וְאַרְבָּעִים יוֹם שֶׁהֵם שִׁשָּׁה שָׁבוּעוֹת וְיוֹם אֶחָד לָעֹמֶר. חסד שבמלכות

כט באייר: הַיּוֹם אַרְבָּעָה וְאַרְבָּעִים יוֹם שֶׁהֵם שִׁשָּׁה שָׁבוּעוֹת וּשְׁנֵי יָמִים לָעֹמֶר. גבורה שבמלכות

א בסיון, ליל ראש חדש: הַיּוֹם חֲמִשָּׁה וְאַרְבָּעִים יוֹם שֶׁהֵם שִׁשָּׁה שָׁבוּעוֹת וּשְׁלֹשָׁה יָמִים לָעֹמֶר. תפארת שבמלכות

ב׳ בסיון: הַיּוֹם שִׁשָּׁה וְאַרְבָּעִים יוֹם שֶׁהֵם שִׁשָּׁה שָׁבוּעוֹת וְאַרְבָּעָה יָמִים לָעֹמֶר. נצח שבמלכות

ג׳ בסיון: הַיּוֹם שִׁבְעָה וְאַרְבָּעִים יוֹם שֶׁהֵם שִׁשָּׁה שָׁבוּעוֹת וַחֲמִשָּׁה יָמִים לָעֹמֶר. הוד שבמלכות

ד׳ בסיון: הַיּוֹם שְׁמוֹנָה וְאַרְבָּעִים יוֹם שֶׁהֵם שִׁשָּׁה שָׁבוּעוֹת וְשִׁשָּׁה יָמִים לָעֹמֶר. יסוד שבמלכות

ה׳ בסיון, ערב שבועות: הַיּוֹם תִּשְׁעָה וְאַרְבָּעִים יוֹם שֶׁהֵם שִׁבְעָה שָׁבוּעוֹת לָעֹמֶר. מלכות שבמלכות

הָרַחֲמָן הוּא יַחֲזִיר לָנוּ עֲבוֹדַת בֵּית הַמִּקְדָּשׁ לִמְקוֹמָהּ, בִּמְהֵרָה בְיָמֵינוּ אָמֵן סֶלָה.

May the Compassionate One restore the Temple service to its place speedily in our days. Amen. Selah.

ENDNOTES

NOTES ON PREFACE

i *Nefesh Yetera*. Elliot K. Ginsburg, *The Sabbath in the Classical Kabbalah* (Portland, Ore.: Littman Library of Jewish Civilization, 2008), 66.

ii The Soul's Arrival. Zohar 1:48a.

iii The Order of Kabbalat Shabbat. *Sha'ar ha-Kavvanot*, chapter 6 (Jerusalem, 1873), 64c.

iv Lekha dodi. R. Kimelman, *Lekha Dodi ve-Kabbalat Shabbat*, (Jerusalem: Magnes, 2002).

NOTES ON INTRODUCTION

[1] Cathedrals in Time. Abraham Joshua Heschel, *The Sabbath* (New York: Farrar, Straus and Giroux, 2005), 8.

[2] Sacks Quotation. Rabbi Jonathan Sacks, *The Great Partnership: Science, Religion, and the Search for Meaning* (New York: Schocken, 2011), 29. Sacks references Ludwig Wittgenstein's *Tractatus Logico-Philosophicus* (1922).

[3] *Shefa*. The felicitous translation "everflow," for *shefa*, is suggested by Avi Weinstein in Joseph Gikatilla, *Gates of Light: Sha'are Orah*, trans. Avi Weinstein (San Francisco: Harper Collins, 1994), xviii.

[4] *Sefirot*. This version of the sefirotic scheme is drawn from Daniel C. Matt, trans., *The Zohar* (Stanford, Calif.: Stanford University Press, 2004), 1:xi.

[5] Scholem on Background of Kabbalah. Gershom Scholem, *On the Kabbalah and Its Symbolism*, trans. Ralph Mannheim (New York: Schocken, 1996), introduction.

[6] Luria and Kabbalat Shabbat. Arthur Green, "Some Aspects of Qabbalat Shabbat," in *Sabbath: Idea, History, Reality*, ed. Gerald J. Blidstein (Beersheva: Ben-Gurion University Press, 2004), 105–6.

[7] Luria Invokes Elijah. Scholem, *On the Kabbalah and Its Symbolism*, 21.

[8] Ḥayyim Vital. Lawrence Fine, *Physician of the Soul, Healer of the Cosmos: Isaac Luria and His Kabbalistic Fellowship* (Stanford, Calif.: Stanford University Press, 2003), 108.

[9] The *Shefa* as Light. Quoted in Alan Unterman, ed. and trans., *The Kabbalistic Tradition: An Anthology of Jewish Mysticism* (London: Penguin, 2008), 10–11.

[10] *Ḥemdat yamim* is contemporary with the foundation of the mystical Hasidic movement in Europe, now a major stream of Judaism. That statement linking the book to the messianic era associates it with the notorious seventeenth-century false messiah, Sabbatai Tsvi. While my study partners and I have found no direct references to Sabbateanism in the portions dealing with Shabbat preparations, we have encountered frequent references to the author's declared master, Isaac Luria, linking the customs and symbolism that he described for messianic times directly back into the Lurianic community from which the Kabbalat Shabbat tradition sprang. See Anonymous, *Ḥemdat yamim* (Hebrew) (Jerusalem: Yerid Hasefarim, 2003).

[11] *Sod ha-Shabbat*. Elliot K. Ginsburg, trans. and ed., *Sod ha-Shabbat: The Mystery of the Sabbath, from the Tola'at Ya'aqov of Meir ibn Gabbai* (Albany: State University of New York Press, 1989).

[12] Gradual Jewish Acceptance of Modern Astronomy. See Josh. 10:13, Eccles. 1:5, and Isa. 38:8 for mentions of the sun standing still. The gradual acceptance of modern astronomy among Jewish scholars is recounted in Jeremy Brown, *New Heavens and a New Earth: The Jewish Reception of Copernican Thought* (New York: Oxford University Press, 2013).

[13] The Big Bang. See Steven Weinberg, *The First Three Minutes: A Modern View of the Origin of the Universe* (New York: Basic Books, 1988). Personal note: as a way of preparing me for the adventure of marrying into the world of astrophysics, my then-fiancé, David, handed me a copy of the first edition of the Weinberg book for light reading while I acquired a suntan to prepare for the white wedding dress that I would wear two weeks later.

[14] Common Origins. Neil Shubin, *The Universe Within: Discovering the Common History of Rocks, Planets, and People* (New York: Pantheon, 2013), ix.

[15] Cosmology and Kabbalah. Howard A. Smith, *Let There Be Light: Modern Cosmology and Kabbalah—A New Conversation between Science and Religion* (Novato, Calif.: New World Library, 2006).

[16] The Grand Unification. The confirmation of the Higgs Boson in 2013 provided a step toward tying gravity into the model.

[17] Oneness. Smith, *Let There Be Light*, 48.

ENDNOTES

[18] The Ashkenazic rite, as reflected in Rabbi Lord Jonathan Sacks, trans. and ed., *The Koren Sacks Siddur: Hebrew English Translation and Commentary*, compact ed. (Jerusalem: Koren, 2013).

[19] Disguised Symbolism. Erwin Panofsky, *Early Netherlandish Painting: Its Origins and Character*, 2 vols. (New York: Harper and Row, 1971), 201.

NOTES ON COMMENTARIES

[20] Taking Challah *Tehine*. Aliza Lavie, ed., *A Jewish Woman's Prayer Book* (New York: Spiegel & Grau, 2008), 188.

[21] Olive Shoots and Children. See Ps. 92:13, "The righteous will flourish like a palm tree," and Ps. 128:3, "your sons, like olive saplings around your table."

[22] Shekhinah and Leaves. In his masterwork, *Gates of Light*, in which he observes divine presence in the natural world, the thirteenth-century Castilian Jewish mystic Joseph Gikatilla suggests that Israel resembles the leaves of a tree, whose trunk is the Shekhinah. See Joseph Gikatilla, *Gates of Light: Sha'are Orah*, ed. and trans. Avi Weinstein (San Francisco: Harper Collins, 1994), 37.

[23] Candle-Lighting and the Additional Soul. Anonymous, *Hemdat yamim* (Hebrew) (Jerusalem: Yerid Hasefarim, 2003), 142.

[24] Deep Sky Image. NASA, ESA, G. Illingworth, D. Magee, and P. Oesch (UCSC), R. Bouwens (Leiden Observatory), and XDF Team, *The Hubble Extreme Deep Field, Astronomy Picture of the Day*, Oct. 14, 2012. See http://apod.nasa.gov/apod/ap121014.html.

[25] Geometric Pattern. Keith Critchlow, *Islamic Patterns: An Analytical and Cosmological Approach* (London: Thames and Hudson, 1976), 9, 99.

[26] Yemenite *Tehine*. Lavie, *A Jewish Woman's Prayer Book*, 165.

[27] The Royal Crown. Peter Cole, trans. and ed., *Selected Poems of Solomon Ibn Gabirol* (Princeton, N.J.: Princeton University Press, 2001), 146. Five centuries before Copernicus discovered that Earth orbits the sun, Ibn Gabirol followed the ancient Ptolemaic belief that Earth stood still at the center of the cosmos.

[28] German Candle-Lighting *Tehine*. From "As Sabbath Enters—After Candle Lighting," in Dinah Berland, *Hours of Devotion: Fanny Neuda's Book of Prayers for Jewish Women* (New York: Schocken, 2007), 42.

[29] Translation of Papercut Border. Nahum N. Glatzer, ed., *Language of Faith* (New York: Schocken, 1975), 254.

[30] Their Soul … Garden. *The Holy Scriptures According to the Masoretic Text: A New Translation* (Philadelphia: Jewish Publication Society, 1917), Jer. 31:12.

[31] A Powerful Woman. See the illuminations and commentaries on "A Powerful Woman" in this volume.

[32] Palm Trees. The final passage of Psalm 92: "[13]The righteous bloom like a date-palm; they thrive like a cedar in Lebanon; [14]planted in the house of the LORD, they flourish in the courts of our God. [15]In old age, they still produce fruit; they are full of sap and freshness, [16]attesting that the LORD is upright, my rock, in whom there is no wrong."

[33] Pink Lilies. H. Freedman and M. Simon, eds., Maurice Simon, trans., *Midrash Rabbah*, vol. 4, *Leviticus*, trans. J. Israelstam and Judah J. Slotki (London: Soncino, 1961), 293.

[34] Palmette Design. Yael Israeli et al., *Treasures of the Holy Land: Ancient Art from the Israel Museum* (New York: Metropolitan Museum of Art, 1986), 168.

[35] Midrash on Psalm 95. William G. Braude, trans. and ed., *The Midrash on Psalms*, 2 vols. (New Haven, Conn.: Yale University Press, 1969), 2:136.

[36] Most Common Chemical Elements. For the listing and diagrams of the spectra, see http://laserstars.org/data/elements. Viewed July 3, 2015.

[37] Ten Great Songs. This list is given by the Targum on The Song of Songs, the Aramaic paraphrase of the biblical book. Rabbi A. J. Rosenberg, trans., *The Books of Esther, Song of Songs, Ruth* (New York: Judaica Press, 1992), Song of Songs, p. 2.

[38] The Dove. The dove brings to mind the "dove in the cranny of the rock," in the Song of Songs. See the discussion of the traditional Jewish dove symbolism in Debra Band, *The Song of Songs: The Honeybee in the Garden* (Philadelphia: Jewish Publication Society, 2005), 21.

[39] Ode to Jerusalem. Raymond P. Scheindlin, *The Song of the Distant Dove: Judah Halevi's Pilgrimage* (New York: Oxford University Press, 2008), 172 ff.

Endnotes

[40] Caper Plant. The caper plant—which still springs from stone walls (such as the Western Wall) throughout Israel and, despite drought and scarce soil, can withstand charring and repeated attempts to eliminate it—symbolizes the Jews' ability to persevere through difficulty with only God's unseen hand as support, based on the passage from the Babylonian Talmud, Beitza 25b: "As Rabbi Shimon the son of Lakish said: 'Three persevere: Israel among the nations; a dog among the animals; and a chicken among fowl.' And there are those who add a goat among the beasts. And there are those who add a caper among trees." The Tosafot, Rashi's immediate followers, comment on this passage: "And the caper among trees: Rashi commented 'and I do not know what is its perseverance' and the Tosefta commented 'because it makes three fruits—the leaves, the fruit, and the buds—and also because it puts on fruit every day, as opposed to all other trees.' " Trans. David Band, in Band, *The Song of Songs*, 20. For a lengthy discussion of the caper and its rabbinic symbolism, see Nogah Hareuveni, *Tree and Shrub in Our Biblical Heritage*, trans. Helen Frenkley (Kiryat Ono: Neot Kedumim, 1984).

[41] Almond Branch. Following Koraḥ's rebellion, Moses orders each tribal chieftain to present his staff for a test of divine appointment; only the staff of Aaron, chieftain of the tribe of Levi, bursts into sprout, blossom, and fruit (Num. 17:21). An almond branch is first among the visions that God gives Jeremiah, signaling the prophet's appointment (Jer. 1:11).

[42] The Eagle and Divine Providence. The image of the eagle draws upon a midrashic expansion of a metaphor in the Song of the Sea (Exod. 5:4), describing God's rescue of Israel from Egypt: "How I bore you on eagle's wings and brought you to Me." "How is the eagle distinguished from all other birds?" asked the rabbis. "All other birds carry their young between their feet, being afraid of other birds flying higher above them. The eagle, however, is afraid only of men who might shoot at him. He therefore prefers that the arrow lodge in him rather than in his children…. As it is said: 'And in the wilderness, where thou has seen how that the Lord thy God bore thee, as a man doth bear his son' [Deut. 1:21]." Jacob Z. Lauterbach, trans., *Mekhilta de-Rabbi Ishmael* (Philadelphia: Jewish Publication Society, 1933), 2:202–3.

[43] The Eagle and the Soul. Gikatilla, *Gates of Light*, 38.

[44] Calling Out Divine Names. Arthur Green, *Be'er Kabbalat Shabbat*, an in-progress unpublished commentary of the prayer book (Hebrew).

[45] The Captive Soul. Arthur Green, *Be'er le-ḥai Ro'i*: an in-progress unpublished commentary of the prayer book (Hebrew).

[46] Beautiful Gazelle Poem. Raymond P. Scheindlin, *The Gazelle: Medieval Hebrew Poems on God, Israel, and the Soul* (Philadelphia: Jewish Publication Society, 1991), 53.

[47] Initial Letters. Green, *Be'er le-ḥai Ro'i*.

[48] Structure of Lekha Dodi. Reuven Kimelman, *The Mystical Meaning of "Lekha Dodi" and "Kabbalat Shabbat"* (Hebrew) (Jerusalem: Magnes, 2003).

[49] The Transformation of the Groom. Reuven Kimelman, "Lekha Dodi: The Divine Union of Bride and Groom," in Lawrence A. Hoffman, ed., *My People's Prayerbook: Traditional Prayers, Modern Commentaries*, vol. 7: *Shabbat at Home* (Woodstock, Vt.: Jewish Lights, 2004), 128.

[50] Four Streams. Seth Brody, trans. and ed., *Rabbi Ezra ben Solomon of Gerona: Commentary on the Song of Songs and Other Kabbalistic Commentaries* (Kalamazoo, Mich.: Medieval Institute Publications, Western Michigan University, 1999), 87.

[51] "Flee, my love." Trans. David Band, in Band, *The Song of Songs*, 70.

[52] Kabbalistic Interpretation of "Flee, my love." See S. Brody, *Rabbi Ezra ben Solomon of Gerona*, 145.

[53] The Field of Holy Apples. The oft-cited image of the Shekhinah as a fragrant field of holy apples appears to be rooted in a phrase in B. Ta'anit 29a, associating orchards with fragrance, and pervades the mystical literature, such as the early-thirteenth-century kabbalist Ezra of Gerona's commentary on the Song of Songs and the writings of Isaac Luria's disciple Ḥayyim Vital. See Gershom Scholem, *On the Kabbalah and Its Symbolism*, trans. Ralph Mannheim (New York: Schocken, 1996), 140; S. Brody, *Rabbi Ezra ben Solomon of Gerona*, 31; and Arthur Green, "Some Aspects of Qabbalat Shabbat," in *Sabbath: Idea, History, Reality*, ed. Gerald J. Blidstein (Beersheva: Ben Gurion University Press, 2004), 103–4.

[54] Psalm 93. Nahum Sarna, *On the Book of Psalms* (New York: Schocken, 1993), 178.

[55] Crown. The crown is adapted from a Torah crown made in Berlin around 1870, rescued among the synagogue art from the destroyed community of Danzig; Vivian B. Mann and Joseph Guttman, eds., *Danzig 1939: Treasures of a Destroyed Community* (Detroit: Wayne State University Press; New York: Jewish Museum, 1980), 95. For the palmette design, see Israeli et al., *Treasures of the Holy Land*, 168.

[56] *Mishneh Torah*. Maimonides, *The Complete Restatement of the Oral Law* (*Mishneh Torah*), ed. and trans. staff of Mechon Mamre (Jerusalem: Mechon Mamre, 2022), www.mechon-mamre.org/p/p0000.htm, 1–2.

[57] Ten Fingers. See Seth Brody, "Human Hands Dwell in Heavenly Heights: Worship and Mystical Experience in Thirteenth-Century Kabbalah" (diss., University of Pennsylvania, 1991), 9.

[58] Palm Tree Symbolism. Braude, *The Midrash on Psalms*, 2:119.

[59] Hubble Photograph. NASA et al., *The Hubble Extreme Deep Field*, *Astronomy Picture of the Day*, Oct. 14, 2012.

[60] Palmette Design. Israeli et al., *Treasures of the Holy Land*, 168.

[61] Burning Bush. H. Freedman and Maurice Simon, eds., *Midrash Rabbah*, vol. 3, *Exodus*, trans. S. M. Lehrman (London: Soncino, 1961), 53.

[62] Pink Lily. Freedman and Simon, *Midrash Rabbah*, *Leviticus*, 293.

[63] The Powerful Woman Compared to Tree of Life. Maurice Simon and Harry Sperling, trans. and ed., *The Zohar* (New York: Soncino, 1934), 5:4.

[64] The Strong Tree. *Pirkei avot*, 4:22.

[65] Israel Compared to Terebinth and Oak. Isa. 6:13, in *JPS Hebrew-English Tanakh: The Traditional Hebrew Text and the New JPS Translation*, 2nd ed. (Philadelphia: Jewish Publication Society, 1999), 859.

[66] The Dove. Freedman and Simon, *Midrash Rabbah*, vol. 9, *Song of Songs*, ed. M. Simon (London: Soncino, 1961), 129.

[67] Pink Lilies. Freedman and Simon, *Midrash Rabbah*, *Leviticus*, 293.

[68] The Gazelle. Scheindlin, *The Gazelle*, 25.

[69] Rosebush. On the rose as the Burning Bush, see Louis Ginzberg, *The Legends of the Jews*, trans. Henrietta Szold (Philadelphia: Jewish Publication Society, 1910), 2:303.

[70] *Alef*. Scholem, *On the Kabbalah and Its Symbolism*, 30–31.

[71] Kabbalistic Ideas in "Lekha Dodi." In translating the poem and in the few notes added here, I have mainly relied on the commentary by Yehuda Liebes, "Hymns for the Sabbath Meals Composed by the Holy Ari" (Hebrew), *Molad* 4 (1971/72): 540–55; and on the study and partial translation by Gershom G. Scholem, "Tradition and New Creation in the Ritual of the Kabbalists," in his *On the Kabbalah and Its Symbolism*, 142–45. I am grateful to Professor Daniel Matt for his generous help with part of this poem.

[72] *Shamor* and *Zakhor*. Eliyahu Munk, trans., *Kedushat Levi Torah Commentary by Rabbi Levi Yitzchak of Berditchev*, vol. 2, *Exodus* (New York: Lambda, 2009), 444.

[73] Early Universe. See note 59 above, "Hubble Photograph."

[74] *Tiferet*. For kabbalistic association of *tiferet* with the color green and myrtle branches, see Elliot K. Ginsburg, *The Sabbath in the Classical Kabbalah* (Portland, Ore.: Littman Library of Jewish Civilization, 2008), 36.

[75] Creation of Souls. Daniel C. Matt, trans., *The Zohar* (Stanford, Calif.: Stanford University Press, 2004), 4:507.

[76] Wine and Kisses. S. Brody, *Rabbi Ezra ben Solomon of Gerona*, 34.

[77] Wisdom and Water. Ibid., 38.

[78] Sefirotic Colors. These colors are scattered throughout Ezra of Gerona's commentary on the Song of Songs, mentioned above, and other sources, and are listed in order in Amir D. Aczel, *The Mystery of the Aleph: Mathematics, the Kabbalah, and the Search for Infinity* (New York: Washington Square, 2000), 33–34.

[79] Pythagorean Pyramid. Aczel, *The Mystery of the Aleph*, 16.

[80] Wisdom and Rocks. S. Brody, *Rabbi Ezra ben Solomon of Gerona*, 35.

[81] Zohar on the Field of Holy Apples. Scholem, *On the Kabbalah and Its Symbolism*, 140.

[82] Vital on Field of Holy Apples. Green, "Some Aspects of Qabbalat Shabbat," 116–17.

[83] Washing. See Elliot K. Ginsburg, trans. and ed., *Sod ha-Shabbat: The Mystery of the Sabbath, from the Tola'at Ya'aqov of Meir ibn Gabbai* (Albany: State University of New York Press, 1989), 22, and idem, *The Sabbath in the Classical Kabbalah*, 227.

[84] Perl's *Teḥine*. Lavie, *A Jewish Woman's Prayer Book*, 192.

[85] Mystical Meaning of Two Loaves. Ginsburg, *Sod ha-Shabbat*, 118–19.

[86] Twelve Challahs. *Ḥemdat yamim*, 139.

[87] The Supernal Feast. Ginsburg, *Sod ha-Shabbat*, 32–33.

[88] Seraphim. Isaiah 6 describes the seraphim.

[89] Rewards for Shabbat Preparations. Ginsburg, *Sod ha-Shabbat*, 22.

[90] Pomegranate Garlands. The designs are based on my onsite drawings.

ENDNOTES

[91] The Spirit on Shabbat. Abraham Joshua Heschel, *The Sabbath* (New York: Farrar, Straus and Giroux, 2005), 65.

[92] Hebrew Alphabet and Mysticism. See Lawrence Fine, *Physician of the Soul, Healer of the Cosmos: Isaac Luria and His Kabbalistic Fellowship* (Stanford, Calif.: Stanford University Press, 2003), 155.

[93] Wedding Jacket Brocade. Esther Juhasz, ed., *The Jewish Wardrobe: From the Collection of the Israel Museum, Jerusalem* (Milan: 5 Continents, 2012), 198.

[94] Torah Crown. The crown is among the collection of synagogue artifacts of the community of Danzig (Gdansk), Poland, that were dramatically evacuated to the Jewish Museum prior to the outbreak of World War II. See Mann and Guttman, *Danzig 1939*, 95.

[95] Clouds at Sunset. The sky imagery is based on a photograph titled "Anticrepuscular Rays over Wyoming," by Nate Cassell, on NASA's photographic archive, *Astronomy Picture of the Day*, for Febr. 21, 2012; see http://apod.nasa.gov/apod/ap120221.html.

[96] Dudele. Quoted in Peter Cole, trans., and Aminadav Dykman, *The Poetry of Kabbalah* (New Haven, Conn.: Yale University Press, 2012), 136. The complex Solomon's Knots into which the Hebrew/Yiddish and English poetry are worked draw upon an ancient mystical tradition common to all three Abrahamic religions and attributed to the wisest of kings. See Umberto Sansone, *Il Nodo de Salomone: Simbolo e archetipo d'alleanza* (Milan: Electa, 1998). A variant of the Solomon's Knot, for instance, is included in the mosaic floor of the ruins of the ancient synagogue of Tsippori.

[97] Ibn Gabirol Poem. Scheindlin, *The Gazelle*, 177.

[98] Streams and Wisdom. See note 64 above on "The Strong Tree," regarding the tree's canopy and roots.

[99] Eagle and Divine Providence. See note 42 above.

[100] Israel's Enemies. The original text may be found in Ḥayim Brody, *Diwan yehuda ben shemuel halevi* (Berlin: Mekize Nirdamim, 1910), 3:5–6.

[101] Halevi Verses. The first quotation is from Halevi's "Ode to Jerusalem," the second from "If But My Path to God Were Clear," and the third from "My Heart Is in the East," all in Raymond P. Scheindlin, *The Song of the Distant Dove: Judah Halevi's Pilgrimage* (New York: Oxford University Press, 2008), 173, 83, and 169, respectively.

[102] Ezra of Gerona on the Shekhinah. S. Brody, *Rabbi Ezra ben Solomon of Gerona*, 78.

[103] Balustrade. Found in Israeli et al., *Treasures of the Holy Land*, 170.

[104] Palmette Design. See note 34 above for the explanation of the use of the palmette as an allusion to the Temple.

[105] House of David as a Vine. Tanakh frequently employs grapevines to symbolize Israel's condition: prophesying Israel's rebirth, Isaiah declares that "there shall come forth a shoot out of the stock of Jesse, and a twig shall grow forth out of his roots" (Isa. 11:1). Expressing disappointment with Israel's wayward behavior, Jeremiah laments on God's behalf: "Yet I had planted thee a noble vine, wholly a right seed; how then art thou turned into the degenerate plant of a strange vine unto Me?" (Jer. 2:21).

[106] Solar Corona. Adapted from a photograph of the solar corona. See *Astronomy Picture of the Day*, Aug. 28, 2010, http://apod.nasa.gov/apod/ap100828.html.

BIBLIOGRAPHY

Aczel, Amir D. *The Mystery of the Aleph: Mathematics, the Kabbalah, and the Search for Infinity*. New York: Washington Square, 2000.

Anonymous. *Ḥemdat yamim*. Jerusalem: Yerid Hasefarim, 2003.

Astronomical Data Center. http://laserstars.org/data/elements. Viewed July 3, 2015.

Berland, Dinah, ed. and trans. *Hours of Devotion: Fanny Neuda's Book of Prayers for Jewish Women*. New York: Schocken, 2007.

Braude, William G., trans. and ed. *The Midrash on Psalms*. 2 vols. New Haven, Conn.: Yale University Press, 1969.

Brody, Ḥayim. *Diwan yehuda ben shemuel halevi*. Berlin: Mekize Nirdamim, 1910, 3:5–6.

Brody, Seth. "Human Hands Dwell in Heavenly Heights: Worship and Mystical Experience in Thirteenth Century Kabbalah." Diss., University of Pennsylvania, 1991.

———, trans. and ed. *Rabbi Ezra ben Solomon of Gerona: Commentary on the Song of Songs and Other Kabbalistic Commentaries*. Kalamazoo, Mich.: Medieval Institute Publications, Western Michigan University, 1999.

Brown, Jeremy. *New Heavens and a New Earth: The Jewish Reception of Copernican Thought*. New York: Oxford University Press, 2013.

Cassirer, Ernst, Paul Oskar Kristeller, and John Herman Randall, Jr., eds. *The Renaissance Philosophy of Man*. Chicago: University of Chicago Press, 1948.

Cole, Peter, trans., and Aminadav Dykman. *The Poetry of Kabbalah*. New Haven, Conn.: Yale University Press, 2012.

Cole, Peter, trans. and ed. *Selected Poems of Solomon Ibn Gabirol*. Princeton, N.J.: Princeton University Press, 2001.

Critchlow, Keith. *Islamic Patterns: An Analytical and Cosmological Approach*. London: Thames and Hudson, 1976.

Elbogen, Ismar. *Jewish Liturgy: A Comprehensive History*. Trans. Raymond P. Scheindlin. Philadelphia: Jewish Publication Society and Jewish Theological Seminary, 2003.

Fine, Lawrence. *Physician of the Soul, Healer of the Cosmos: Isaac Luria and His Kabbalistic Fellowship*. Stanford, Calif.: Stanford University Press, 2003.

Freedman, H., and Maurice Simon, eds. *Midrash Rabbah*, London: Soncino, 1961.
—Vol. 3, *Exodus*, trans. S. M. Lehrman, 1961.
—Vol. 4, *Leviticus*, trans. J. Israelstam and Judah J. Slotki, 1961.
—Vol. 9, *Song of Songs*, trans. Maurice Simon, 1961.

BIBLIOGRAPHY

Gikatilla, Joseph. *Gates of Light: Sha'are Orah*. Trans. Avi Weinstein. San Francisco: Harper Collins, 1994.

Ginsburg, Elliot K. *The Sabbath in the Classical Kabbalah*. Portland, Ore.: Littman Library of Jewish Civilization, 2008.

———, trans. and ed. *Sod ha-Shabbat: The Mystery of the Sabbath, from the Tola'at Ya'aqov of Meir ibn Gabbai*. Albany: State University of New York Press, 1989.

Ginzberg, Louis. *The Legends of the Jews*. Trans. Henrietta Szold. 7 vols. Philadelphia: Jewish Publication Society, 1910.

Glatzer, Nahum N., ed. *Language of Faith*. New York: Schocken, 1975.

Green, Arthur. *Keter: The Crown of God in Early Jewish Mysticism*. Princeton, N.J.: Princeton University Press, 1997.

———. "Shekhinah, the Virgin Mary, and the Song of Songs: Reflections on a Kabbalistic Symbol in Its Historical Context." *AJS Review* 26, no. 1 (2002): 1–52.

———. "Some Aspects of Qabbalat Shabbat." In *Sabbath: Idea, History, Reality*. ed. Gerald J. Blidstein, pp. 95–118. Beersheva: Ben-Gurion University of the Negev Press, 2004.

Hakham, Amos. *The Bible: Psalms with the Jerusalem Commentary*. 3 vols. Jerusalem: Mosad Harav Kook, 2003.

Hareuveni, Nogah. *Tree and Shrub in Our Biblical Heritage*. Trans. Helen Frenkley. Kiryat Ono, Israel: Neot Kedumim, 1984.

Heschel, Abraham Joshua. *The Sabbath*. New York: Farrar, Straus and Giroux, 2005.

Hoffman, Lawrence A., ed. *My People's Prayerbook: Traditional Prayers, Modern Commentaries*. Vol. 7, *Shabbat at Home*. Woodstock, Vt.: Jewish Lights, 2004.

Idel, Moshe. *Kabbalah: New Perspectives*. New Haven, Conn.: Yale University Press, 1988.

Israeli, Yael, Miriam Tadmor, et al. *Treasures of the Holy Land: Ancient Art from the Israel Museum*. New York: Metropolitan Museum of Art, 1986.

JPS Hebrew-English Tanakh: The Traditional Hebrew Text and the New JPS Translation. 2nd ed. Philadelphia: Jewish Publication Society, 1999.

Juhasz, Esther, ed. *The Jewish Wardrobe: From the Collection of the Israel Museum, Jerusalem*. Milan: 5 Continents, 2012.

Keskiner, Cahide. *Turkish Motifs*. Istanbul: Turkish Touring and Automobile Association, 1991.

Kimelman, Reuven. "Lekha Dodi: The Divine Union of Bride and Groom," in Lawrence A. Hoffman, ed., *My People's Prayerbook: Traditional Prayers, Modern Commentaries*, vol. 7: *Shabbat at Home*. Woodstock, Vt.: Jewish Lights, 2004.

———. *The Mystical Meaning of "Lekha Dodi" and "Kabbalat Shabbat"* (Hebrew). Jerusalem: Magnes, 2003.

Lauterbach, Jacob Z., trans. *Mekhilta de-Rabbi Ishmael*. Philadelphia: Jewish Publication Society, 1933.

Lavie, Aliza, ed. *A Jewish Woman's Prayer Book*. New York: Spiegel & Grau, 2008.

Liebes, Yehudah. "Hymns for the Sabbath Meals Composed by the Holy Ari" (Hebrew). *Molad* 4 (1971/72): 540–55.

Loewe, Raphael, ed. and trans. *Ibn Gabirol*. New York: Grove Weidenfeld, 1989.

Maimonides. *The Complete Restatement of the Oral Law* (Mishneh Torah). Ed. and trans. Mechon Mamre. Jerusalem: Mechon Mamre, 2011.

Mann, Vivian B., and Joseph Guttman, eds. *Danzig 1939: Treasures of a Destroyed Community*. Detroit: Wayne State University Press; New York: Jewish Museum, 1980.

Matt, Daniel C., trans. *The Zohar*. 8 vols. Stanford, Calif.: Stanford University Press, 2004.

Munk, Eliyahu, trans. *Kedushat Levi Torah Commentary by Rabbi Levi Yitzchak of Berditchev*. 3 vols. New York: Lambda, 2009.

NASA, ESA, G. Illingworth, D. Magee, and P. Oesch (UCSC), R. Bouwens (Leiden Observatory), and XDF Team. The Hubble Extreme Deep Field. *Astronomy Picture of the Day*, October 14, 2012. See http://apod.nasa.gov/apod/ap121014.html.

Neuda, Fanny. *Stunden der Andacht: Ein Gebet- und Erbauungsbuch für Israels Frauen und Jungfrauen*. Prague: Wolf Pascheles, 1858.

Panofsky, Erwin. *Early Netherlandish Painting: Its Origins and Character*. 2 vols. New York: Harper and Row, 1971.

Rosenberg, Rabbi A. J., trans. *The Books of Esther, Song of Songs, Ruth*. New York: Judaica Press, 1992.

Sacks, Rabbi Lord Jonathan. *The Great Partnership: Science, Religion, and the Search for Meaning*. New York: Schocken, 2011.

———, trans. and ed. *The Koren Sacks Siddur: Hebrew English Translation and Commentary*. Compact ed. Jerusalem: Koren, 2013.

Sansone, Umberto. *Il Nodo de Salomone: Simbolo e archetipo d'alleanza*. Milan: Electa, 1998.

BIBLIOGRAPHY

Sarna, Nahum. *On the Book of Psalms*. New York: Schocken, 1993.

Scheindlin, Raymond P. *The Gazelle: Medieval Hebrew Poems on God, Israel, and the Soul*. Philadelphia: Jewish Publication Society, 1991.

———. *The Song of the Distant Dove: Judah Halevi's Pilgrimage*. New York: Oxford University Press, 2008.

Scholem, Gershom. *On the Kabbalah and Its Symbolism*. Trans. Ralph Mannheim. New York: Schocken, 1996.

———, ed. *Origins of the Kabbalah*. Ed. R. J. Zwi Werblowsky, trans. Allan Arkush. Philadelphia and Princeton, N.J.: Jewish Publication Society and Princeton University Press, 1987.

Shubin, Neil. *The Universe Within: Discovering the Common History of Rocks, Planets, and People*. New York: Pantheon, 2013.

Simon, Maurice, trans., and Harry Sperling, ed. *The Zohar*. 5 vols. New York: Soncino, 1934.

Smith, Howard A. *Let There Be Light: Modern Cosmology and Kabbalah—A New Conversation between Science and Religion*. Novato, Calif.: New World Library, 2006.

Steinsaltz, Adin. *The Thirteen Petalled Rose: A Discourse on the Essence of Jewish Existence and Belief.* New York: Basic Books, 2006.

Unterman, Alan, ed. and trans. *The Kabbalistic Tradition: An Anthology of Jewish Mysticism*. London: Penguin Classics, 2008.

Wade, David. *Fantastic Geometry: Polyhedra and the Artistic Imagination in the Renaissance*. London: Squeeze, 2012.

Weinberg, Steven. *The First Three Minutes: A Modern View of the Origin of the Universe*. New York: Basic Books, 1988.

Many Thanks

Much gratitude is due
to the following people for their financial support for this project.
Names are listed first in order of contribution category (without amounts)
and alphabetically within each category.

Sharon and Steven Lieberman

Anonymous
Neal Meiselman and Terry Shuch Meiselman

Anonymous
Dennis and Debra Berman
Abe Cherrick and Debra Sunshine
Robert N. Cohen
Debbie and Jamie Heller
Nancy Schwartz Sternoff
Amy and Judry Subar
Margot and Phil Sunshine

Anonymous
Rachel and Jacob Heitler
Leslie Valas and Alan Finkelstein
Josephine and Arthur Roskies
Elizabeth H. Swift

Anonymous
Leesa Fields and Jonathan Band
Rebeca and Benjamin Grinstein
Sarah and Ed Himmelfarb
Valerie Leman and Ross Cohen

Anonymous
Candace G. Kaplan
Michael Levitt and Laura Greenberg
Ann and Rabbi Jack Moline
Lisa Peckler and David and Batyah Selis
Rena and Mordecai Rosen
Deborah Rosenbloom
Diane M. Sharon
Robin and Jonathan Selinger
Susan Vitale, Henry Levin and Family